CHAGALL | ZADKINE | MIRÓ | MAGRITTE

RE | CALDER | PIAUBERT | MOORE | DELVAUX

. BLUHM | GOTTLIEB | LORJOU | MATTA

HIEU | DAVIE | VASARELY | MOTTET | CÉSAR

THE ARTIST'S WORLD

text and photographs by
DANIEL FRASNAY

THE ARTIST'S WORLD

preface by
RENÉ HUYGHE

a studio book **THE VIKING PRESS** new york

Published in France under the title Leur Monde
Copyright © 1969 by Draeger Frères, Imprimeurs

English language translation Copyright © 1969 by Draeger Frères, Imprimeurs
All rights reserved

Published in 1969 by the Viking Press, Inc.
625 Madison Avenue, New York, N.Y. 10022

Published simultaneously in Canada by
The Macmillan Company of Canada Limited

Library of Congress catalog card number: 69-10630

Printed and bound in France

contents

Preface	5
Arp	13
Braque	23
Sonia Delaunay	33
Magnelli	41
Chagall	53
Zadkine	65
Miró	81
Magritte	99
Herbin	109
Hartung	115
Dali	127
Tobey	141
Bissière	151
Calder	157
Piaubert	167
Moore	179
Delvaux	193
Giacometti	203
Pignon	213
de Kooning	221
New York :	235
Bluhm, Scarpitta, Gottlieb, Brooks, Brusse, Little, Basq, Sander, Lassaw, Solomon	
Lorjou	245
Matta	259
Nevelson	269
Bacon	279
Appel	287
Buffet	299
Mathieu	313
Davie	327
Vasarely	339
Mottet	349
César	359
Acknowledgements	371

preface

If art involves its own psychology, it also lays claim to its own sociology. In the course of the centuries the status of the artist has been utterly transformed and perhaps with it the very meaning of art. At first the painter and sculptor were no more than nameless craftsmen, lay members in a brotherhood entrusted with the execution of important works. The anonymous artisan was absorbed by the work, lost in it. Then one day he became an artist, and his talent, now tamed to his own vision, became his interpreter, manifesting his own unique character and personality.

In order to better instill the idea of this evolution among a reluctant bourgeoisie the nineteenth century never wearied of recapitulating the marvelous symbolic spectacle of his Imperial Majesty, Charles the Fifth, Emperor of Germany and King of Spain, stooping to the floor to pick up Titian's brush. And with his own brush, Ingres recorded the incident for the ages.

There the matter rested.

But the twentieth century went further.
Swept along by the startling turnabout imposed by the revolutionary changes in the air, the bourgeoisie (or what was left of it

or had taken its place) began to revere the artist and his work as financial powers, producers of capital, objects for speculation, economic assets. Until then, the artist had been spoken of in terms of his fame: now deference and curiosity had been aroused, and artists were elevated to the rank of those collective modern myths we call " stars. " The artist's personality took precedence over his work, and, like any movie actors he became vulnerable to the indiscretions of his fans.

Is not the public as fascinated by Picasso as by Brigitte Bardot? Yet how could one appraise even in millions the value of Les Demoiselles d'Avignon, though the ladies were not from Avignon and could scarcely be called damsels? Still, incursions into the private life of the man who painted Guernica are sure best sellers, and a special photographic album has been devoted to Dali's mustache.

Has the painter then so eclipsed his work as to become a sort of sacred freak? Are we to pursue with bated breath the gossip of his love life in the pages of the weekly press?

This book mercifully shields us from perverse curiosity while still affording our wholesome interest some satisfaction.

The style is the man: therefore look at his paintings. But the man is also the setting in which he moves and has his being: so look at his home as well, and observe how he lives in it.

A dual projector is at work throughout these pages: one beam is concentrated on the work, the other ranges freely over environment, within the circle of warmth radiated by each artist.

Daniel Frasnay has caught this warmth with his photographic lens, combining objectivity and sensitivity in the way he conducts his search by inquiry and absorption.

It is said that we have all become audio-visually oriented. In this book, once your eye is satisfied with the revealing pictures set before it, you need only lend an ear to the commentaries that accompany them.

Here are the photographer's own words and those of the painters and sculptors themselves. They are as valuable as those of the critic, who is all too fond of reducing the work to fit his own ideas; the artist prefers to free the idea from the work. Together these form one statement, emanating from one genius, to which they both give expression. Each throws light upon the other (provid-

ed, of course, that the ideas have not been prompted by the reviews...)

Our epoch has essayed and has continuously maintained a tremendous revolution both in art and ideas. Explanation has not been lacking, any more than has criticism, but has any real meaning yet emerged?

The future will have to decide.

Here, then is a good cross section of the artists most discussed internationally today, those who most strikingly epitomize the revolution the public, in fear or exaltation, is presently undergoing. The pyrotechnists engaged in atomizing our cultural inheritance lift their masks before us.

They have taken possession of our visual and mental worlds, penetrated them, transformed them. Now it's our turn to enter theirs.

Their world, " the artist's world, " opens up in these pages.

RENÉ HUYGHE
of the French Academy

THE ARTIST'S WORLD

Arp laughed and the world laughed with him.
All his work breathes joy....

Before reaching the house Arp used to live in at Meudon, you had to skirt a long high wall of grayish stone. This wall enclosed an orphanage, and each time I passed it I used to wonder whether there might have been just one child in it who knew that beyond the wall lived another child—a somewhat older child—a child who wielded the sword of freedom, who engaged himself in slaying the world's figureheads, the better to give new life to the pure Forms of an ideal family, a family conceived with the sleek bodies of shell women—mothers whose secret countenances the Meudon orphans knew well.
Over the dividing wall this free child had for years kept enlarging his own particular world, an uninhibited world, filled with marble toys, fairy totem flowers—and bronzes without thorns. My impression upon passing through the gateway was of a garden spangled with stars : a torso, the bust of a goblin, a siren, an idol, a centaur, all part of the poet's dream constellation.

Jean Arp was 31 years old when he exhibited his first paintings in Zurich in 1915, and when, as he said, the "capital event of his life" took place—his meeting Sophie Taeuber. At the time Sophie Taeuber was painting abstract canvases more or less in the experimental manner typified by the work of Picabia, Delaunay, Kandinsky, and Magnelli, none of whom, as it happened, was aware of what the other was doing. For all these painters pure line and color was the guiding influence.

Jean and Sophie first shared their painterly interest, then their lives. The new influence was seen in 1916 when Arp created his first reliefs, wood cutouts superimposed on each other to form puzzles in soft arabesques painted in vivid colors.

Arp was to live through the Dada adventure in Switzerland and then, quite naturally, he was to take part in the Surrealist explosion in Paris. These powerful movements were to animate his writing, a natural elaboration of his reliefs, his scrappaper work, his collages. Then in 1930 he first took to working with marble, stone, and plaster.

On one of my visits to his studio, in the latter years of his life, Arp raised his arms and spread out his hands as if waiting to embrace the answer to some question he had asked himself. He said he had been trying to work out his feeling of "descending" in his sculpture. "Today I'm merely brushing that deep sense of 'descending'," he said, " but someday we'll come to understand everything, suddenly changed by that thousand-year-long second, that everlasting second of the moment of death. Even as a page of manuscript becomes more and more illegible as you bring it closer and closer to your eyes," Arp continued, "so will the words and phrases that spring from man's subconscious—and which appear unintelligible in the light of day—be understood in another space relationship, at another time. Man must 'stand his distance' as do the painter and the sculptor...."

But now Jean Arp has passed over the high wall and become reunited forever with the children of the great orphanage.

1927 - *Life is the goal of art. True, art can underestimate its capacity and only mirror life instead of creating it—then its productions are merely illusionistic, descriptive, academic.*

1938 - *First you must let forms, colors, words, shadings develop, then explain them. First you have to let legs, wings, hands take shape, then later let them fly, sing, gather together, emerge. For my part, I plan nothing as if it were a timetable, a summing-up, or a war. The art of stars, flowers, shapes, colors belongs to the infinite.*

1943 - *We don't wish to copy nature. We don't wish to reproduce. We want to create. We want to create as a plant does that bears but a single fruit. We want to do this directly and not through a go-between. As there is no least trace of abstraction in this we call our art concrete.*

1948 - *Art is a sort of fruit that grows in man as an apple does on a tree or a child in its mother's womb.*

1952 - *Art is spontaneous and achieves spirituality and refinement with the purification of man. I draw things in repose, things that drift, climb, ripen, fall. I shape fruits at rest, clouds that drift and climb, stars that ripen and fall, all symbols of eternal change in the peace of the infinite.*

1955 - *Sculpture must advance on tiptoe, unassuming and without pomp, light as the track of an animal in the snow. When you drop your eyelids your interior emotion lends your hand greater clarity.*

Apparently inanimate objects
Are not really lifeless
They rub their hands in glee
And laugh up their sleeves
Savoring
The luck they have
Not to be human.

POÈME INÉDIT 1966

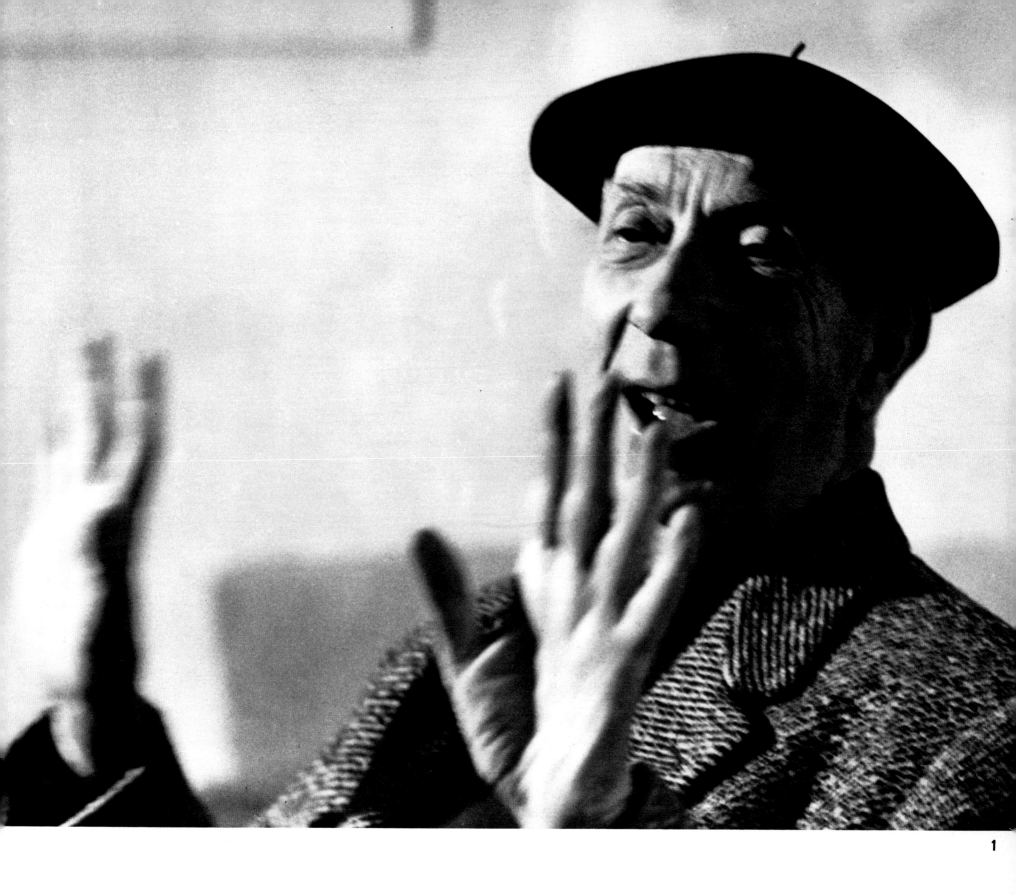

1

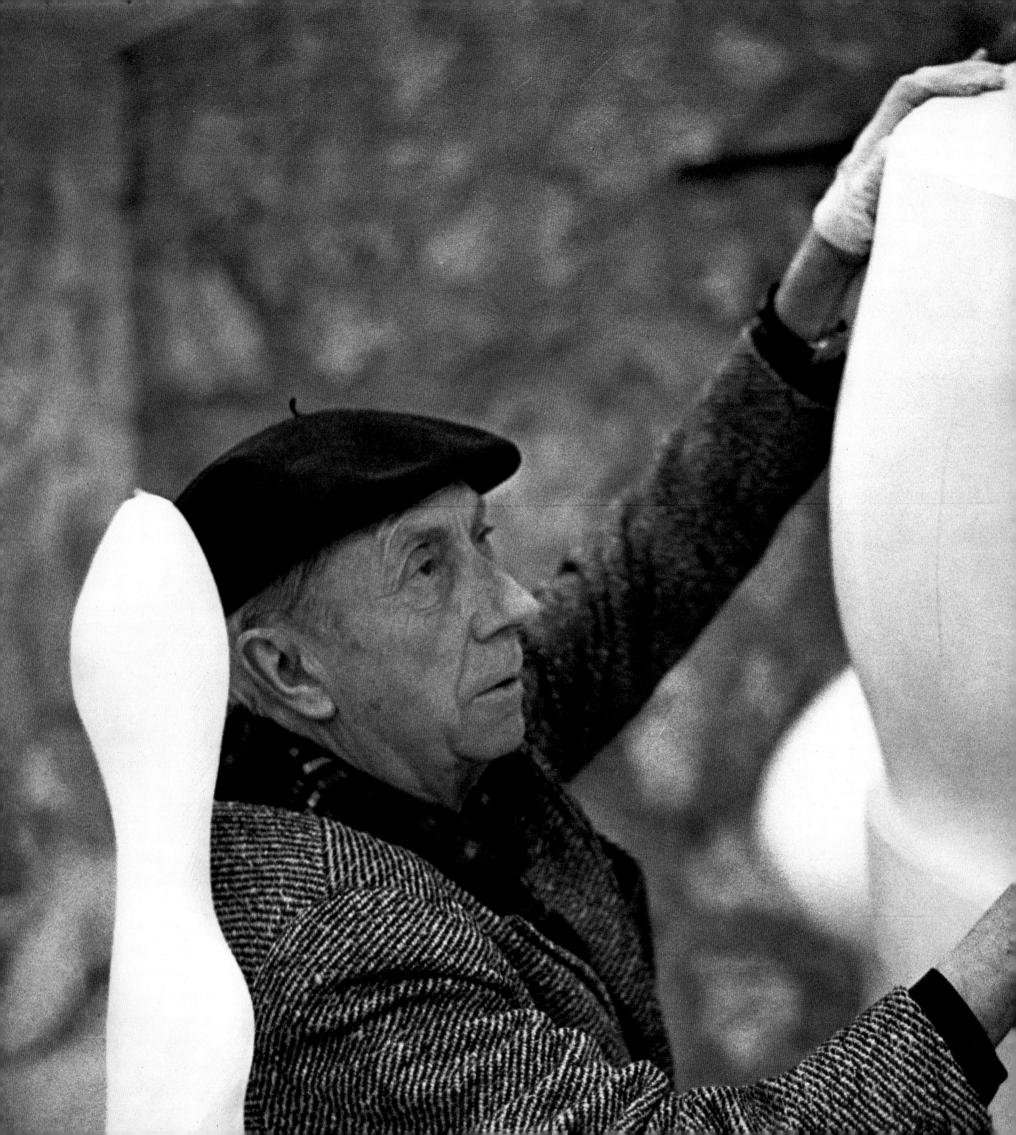

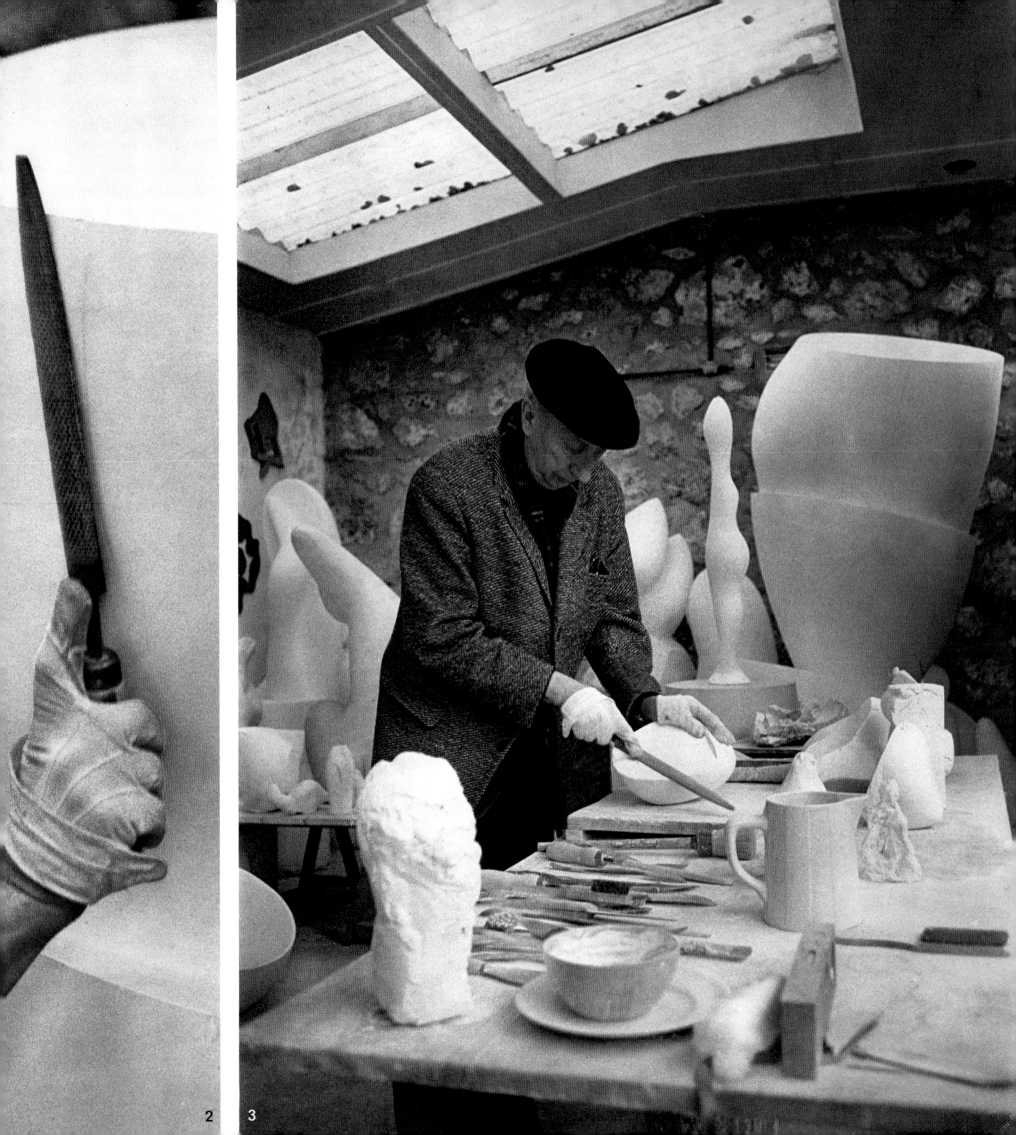

2

3

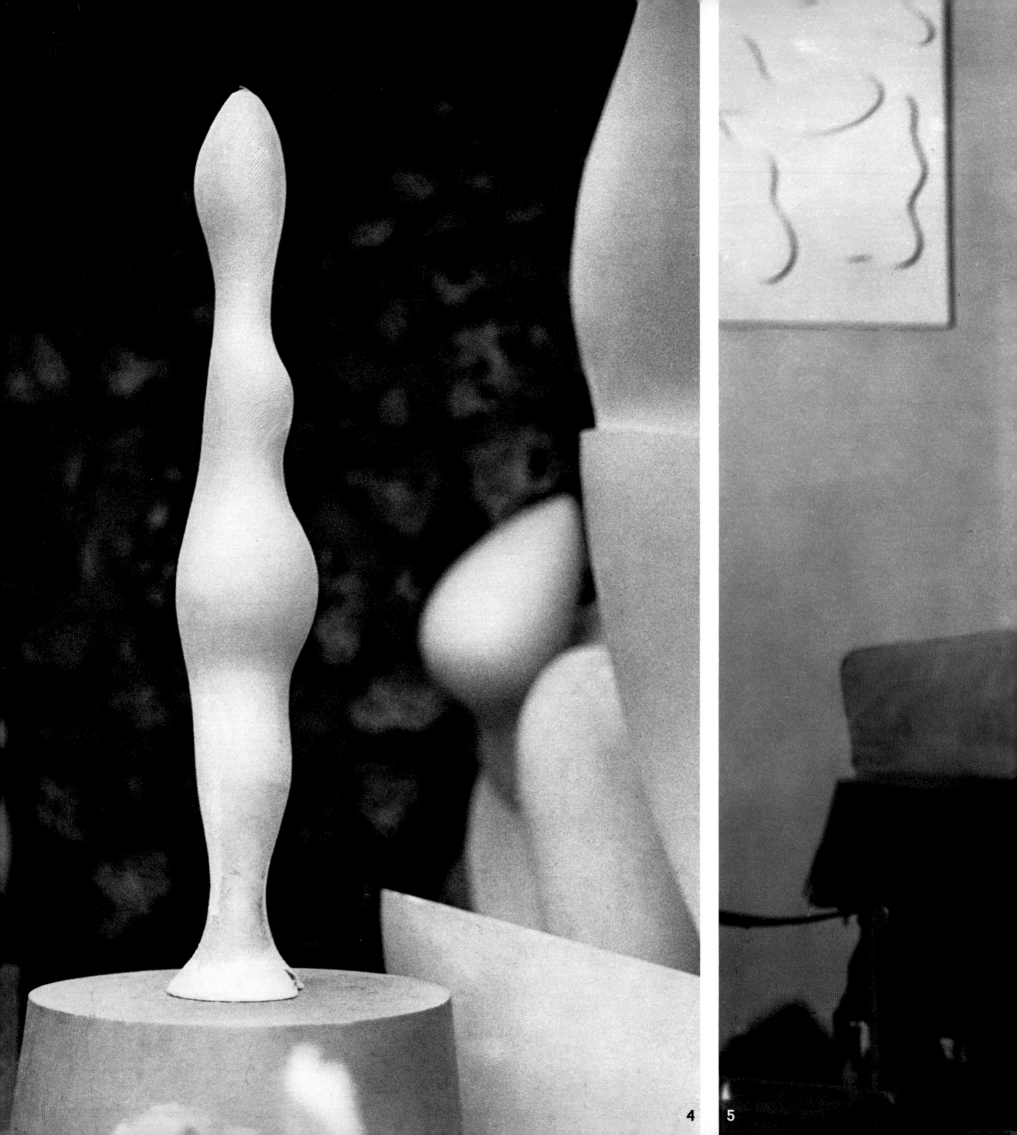

4 5

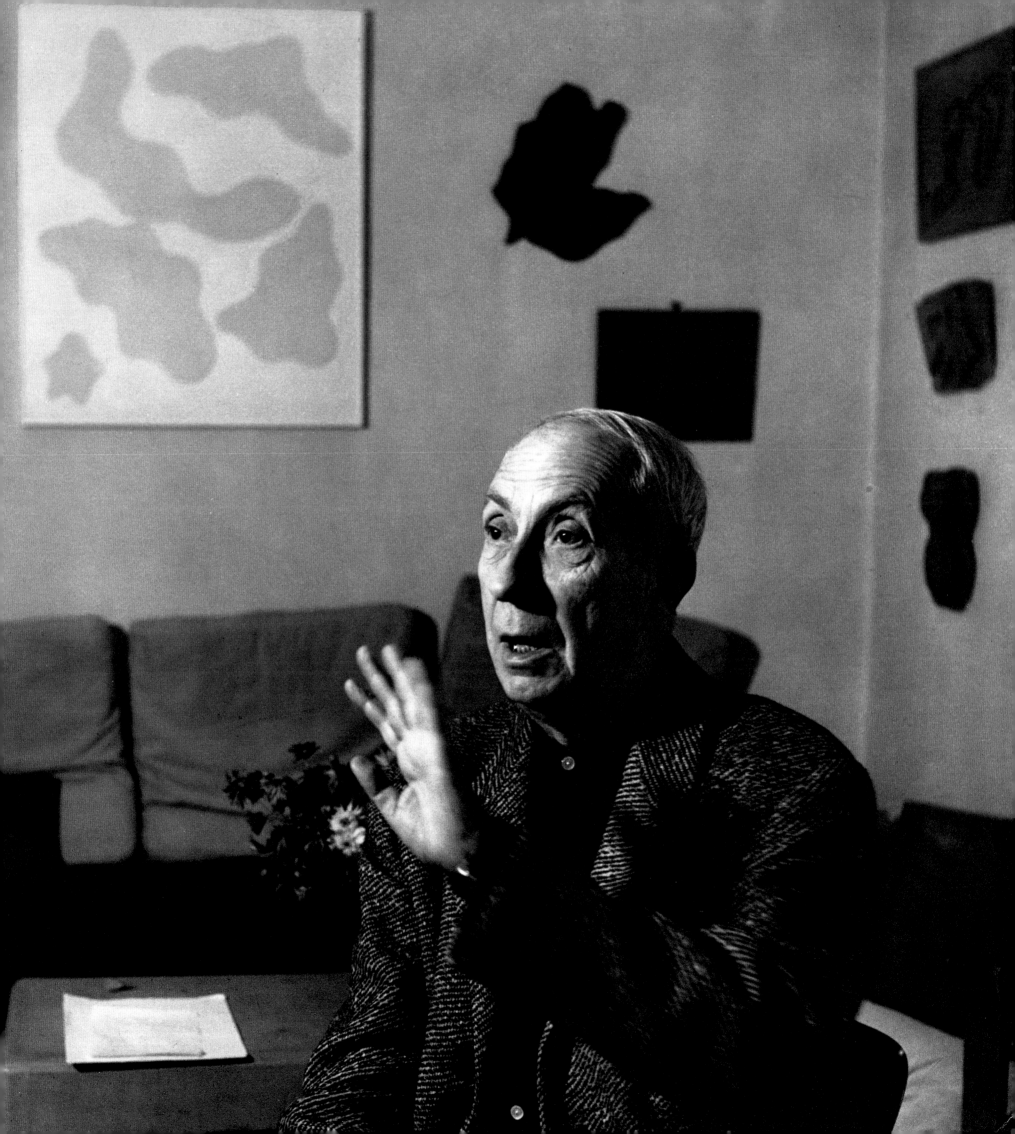

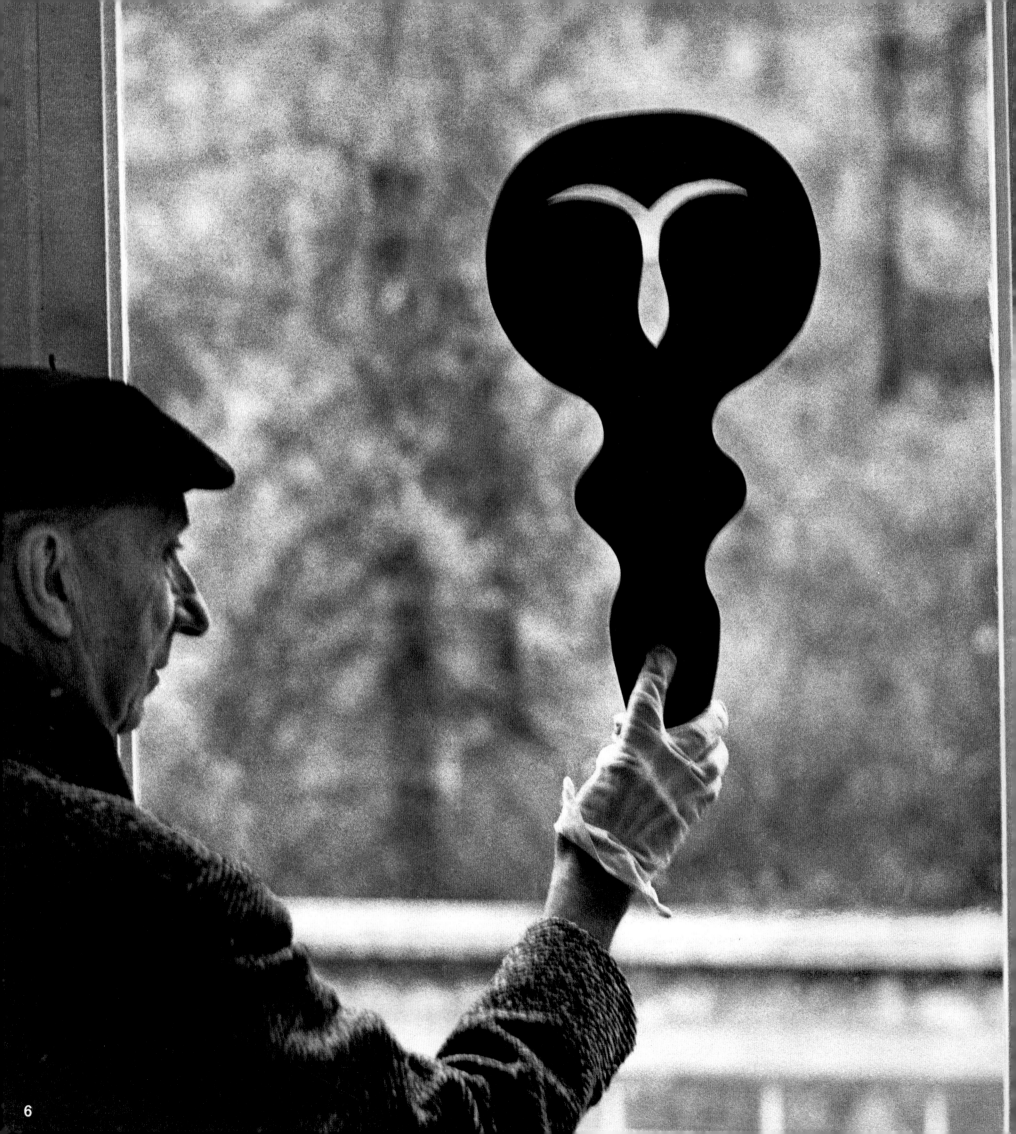

jean arp

1. With a characteristic laugh Arp says, "Art is a fruit born of man."

2-3. In his studio at the back of the garden at Meudon, Arp polishes the plaster molds of *Coupes Superposées*, 1947.

4. Plaster molds. Later, the artist destroyed them.

5. In his study, hung with cut and painted wooden forms. "Man must stand his distance, as painters and sculptors do," Arp says.

6. The artist holding a cutout against a window.

1887 *Born September 16 at Strasbourg.*

1904 *Student at the École des Arts Décoratifs, Strasbourg. First visit to Paris. First poems.*

1905-1907 *Pupil at Weimar Kunstschule.*

1908 *Studied at Académie Julian, Paris.*

1909 *At Weggis, Switzerland.*

1911 *Visited Kandinsky in Munich.*

1912 *Took part in second "Blue Rider" exhibition, Munich.*

1913 *Contributed to magazine, Der Sturm. Showed at Erster Deutscher Herbstsalon, Berlin.*

1914 *Met Max Ernst at Deutscher Werkbund, Cologne.*

1915 *In Paris, became acquainted with Picasso, Apollinaire, Max Jacob, Modigliani (who drew his portrait). Exhibited his first collages and tapestries at Tanner Gallery, Zurich. First made acquaintance of his future wife, Sophie Taeuber, and created rectilinear collages with her.*

1916 *Became one of the founders of Dadaist movement in Zurich.*

1917 *First abstract reliefs in wood.*

1919-1920 *In Cologne with Max Ernst. Made acquaintance of Kurt Schwitters and Dadaist group in Berlin. Exhibited at "First International Dada Exposition." Published Die Wolkenpumpe.*

1921 *With Tristan Tzara, Éluard, and Max Ernst at Tarrenz (in the Tyrol).*

1922 *Took part in international Dada exhibition at Galerie Montaigne, Paris. Married Sophie Taeuber.*

1924 *Published Der Pyramidenrock.*

1925 *Took part in first Surrealist exhibition at Galerie Pierre, Paris.*

1926 *Settled in Meudon, near Paris.*

1926-1928 *Helped Theo van Doesburgh and Sophie Taeuber in decoration of L'Aubette, Strasbourg.*

1930 *First works with torn papers. Became member of Circle and Square group founded by Seuphor.*

1931 *First sculptures in the round. Became member of Abstraction-Creation group. Exhibited at Kunsthalle, Basel.*

1936 *Exhibited at Museum of Modern Art, New York.*

1940-1941 *Sojourn in Grasse. Published Poèmes sans Prénoms.*

1942 *Switzerland.*

1943 *His wife died in Zurich.*

1943-1945 *Stayed at Basel.*

1946 *Returned to Meudon. Published Siège de l'Air.*

1949 *First visit to America. Took part in "First Masters of Abstract Art" exhibition at Galerie Maeght, Paris.*

1950 *Second visit to America. Does work in relief for Harvard University. Exhibited at Galerie Denise René, Paris; Venice Biennial; Sidney Janis Gallery, New York.*

1952 *Visited Greece.*

1953 *Created sculpture, Le Berger des Nuages, for University of Caracas.*

1954 *Awarded Grand Prix for sculpture at Venice Biennial.*

1955 *Second visit to Greece. Traveling exhibition of his work and Sophie Taeuber's in Germany.*

1956 *Arp-Schwitters exhibition at Kunsthalle, Berne.*

1957 *Sculptured relief for UNESCO, Paris. Awarded city of Padua prize for sculpture.*

1958 *Third visit to United States (and Mexico). Retrospective exhibition at Museum of Modern Art, New York.*

1959 *Retrospective exhibition of drawings and engravings at Galerie Denise René, Paris. Married Marguerite Hagenbach in Basel.*

1960 *Visited Egypt and Israel. Executed relief for Braunschweig Hochschule. Made Chevalier of the Legion of Honor.*

1961 *Created a sculpture for Bonn University Library. Awarded Stephan Lochner Medal by city of Cologne.*

1962 *Important retrospective exhibition at Musée d'Art Moderne, Paris. Exhibitions at Basel, Stockholm, Copenhagen, and London.*

1965 *Published L'Ange et la Rose (Éditions Robert Morel). Exhibited in Milan.*

1966 *Published Le Soleil Recerclé (Éditions Louis Broder). Died June 7 in Basel.*

braque

Il ne faut pas s'exprimer comme on sent, mais comme on se souvient.

Looking now at my photographs of Braque, few of them seem to match up to the impact I felt when I visited the artist for this interview. As I sort through them, I find little that recaptures the depth of the experience I had when face to face with the great man in his studio. Yet the only witnesses I can consult are my negatives, flat surfaces, transparencies. . . .

But preparation of this book gave me a pretext to return to the quiet sanctuary that still exists in the Rue du Douanier near the Parc Montsouris in Paris.

The street is flanked and protected on both sides by rows of private houses, small villas, low buildings. One of these is Georges Braque's studio, built by Perret to the artist's specifications. He was working there when the shadow of death passed over him, seizing his heart and closing his eyes and mouth forever. The house itself is behind, rising above it, and is best approached in winter. It is then that the barren trees and leafless shrubbery best reveal, embedded in the garden wall, the mosaic modeled after the ceiling Braque painted for the Louvre in which two black birds, rimmed in white and prisoned in a blue sky, seem to fly toward us.

Softly bathed in light, the studio, the blissful retreat of a man who lived away from the tumult of the world, extends streetward from under the roof of the house.

In one of his *Notebooks*, Braque wrote, *"To define something is to substitute the definition for the thing itself."*

And so, like a fleeting bystander, I try to summon up my remembrance of things seen. My first impression, when standing in his studio in 1962, was of a rising tide of color flooding out from the walls. Then each powerful mass appeared to recede within its own frame to reveal the skillful organization of recognizable shapes.

The canvases ride at anchor against a horizon of brown drapery falling full to the oak floor. Each picture hangs near its own palette, an island of colors, and near each is a particular set of brushes which, soaking in old tin cans, await the reach, the purpose, of the artist.

Studies for lithographs, stained-glass work, canvases, paper paintings, gouaches, drawings in India ink all faced the artist, ever-ready subjects for his master hand.

The larger works were set on easels or, depending on their size and nature, were placed on chairs, propped up against stools or strong wire supports twisted into position and set on the floor by Braque, enabling him to survey all his current problems at a glance and thus to dominate them.

Without revealing its mystery each picture has its reference, a name : *Deux Poissons—Vélo dans la Nature—Les Barques—Citron et Théière—Le Canard et Son Nid— Le Brabant— Oiseaux dans un Ciel Vermillon—Nu— Deux Oiseaux fond Bleu—Oiseau dans les Nuages* (Madder Violet) *—La Charrue—Aquarium—Bouquet de Soleils—Ciel et Oiseau—Oiseau dans le Feuillage du Paulownia.*

An open book for which Braque had been preparing illustrations with colored crayons rested on a table made up of boards set on sawhorses. Braque used to work standing up, but the tall silhouette of his younger days had become stooped with age, and for several years he had painted seated in a low chair. Faced with ten sketches, Braque would square them off, stand them up, polish them. Surrounded by familiar objects, all within easy reach—pebbles, roots, wires, snapshots, masks, Negro sculpture, a shield of many colors—he would drop his work, turn to another, then take up the first one again. While intent upon creating something else, something new, he might suddenly see a painting or object nearby that needed a touch of yellow ochre or toning down a little with a few strokes of burnt umber.

Having renounced nature, models, the geometrical perspective that makes objects fade and disappear, Braque had come to choose the simplest of subjects, such as jugs, tablecloths, fruit, and similar things.

Starting out from the flat surface of the canvas, reconstituting the masses, harmonizing forms and colors *simultaneously*, incorporating such foreign substances as ashes and tobacco with his paint to catch the light, Braque had long celebrated the nobility of man through the profound dignity of things.

A painting by Braque is a breath of mankind made tactile and within reach of the nearest of us.

Le peintre
pense en formes
et en couleurs,
l'objet c'est
la poëtique.

Georges Braque

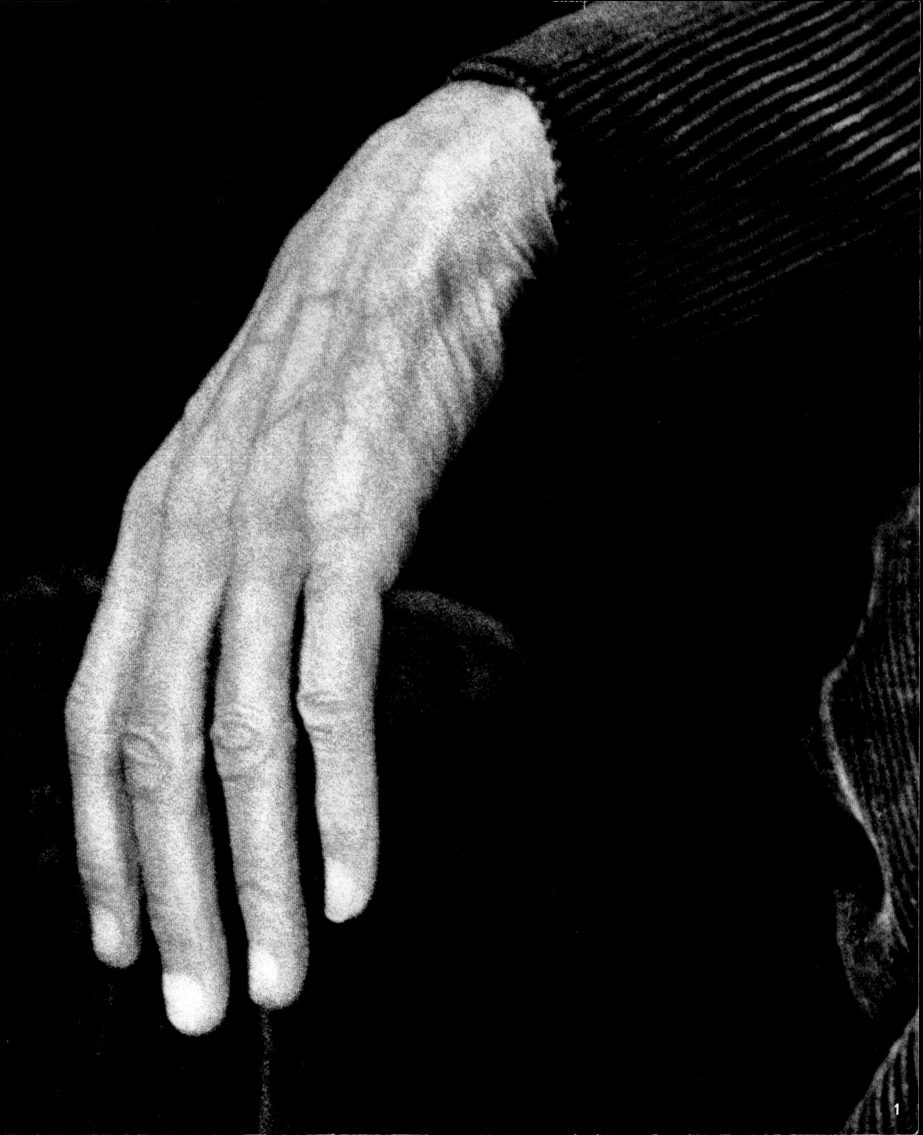

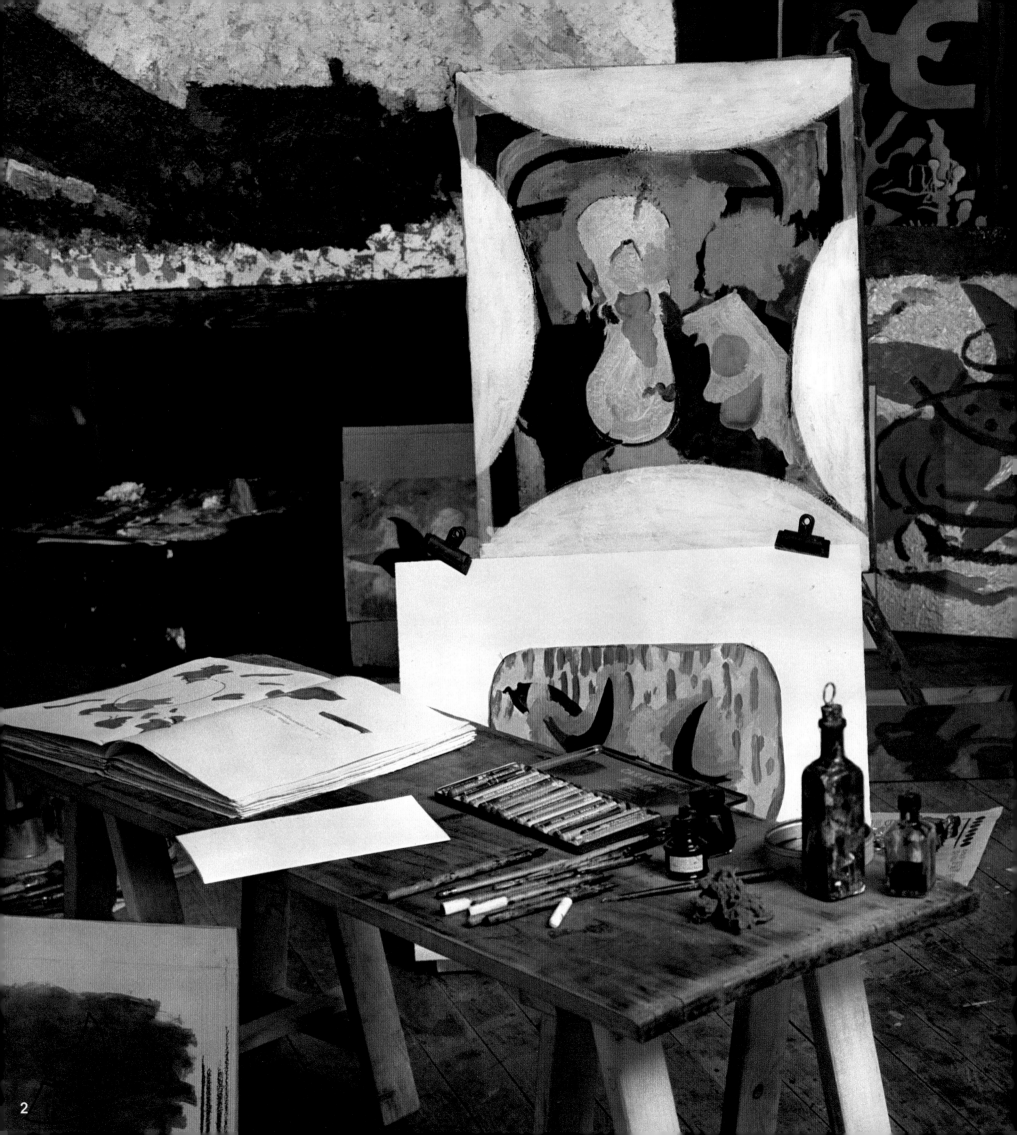

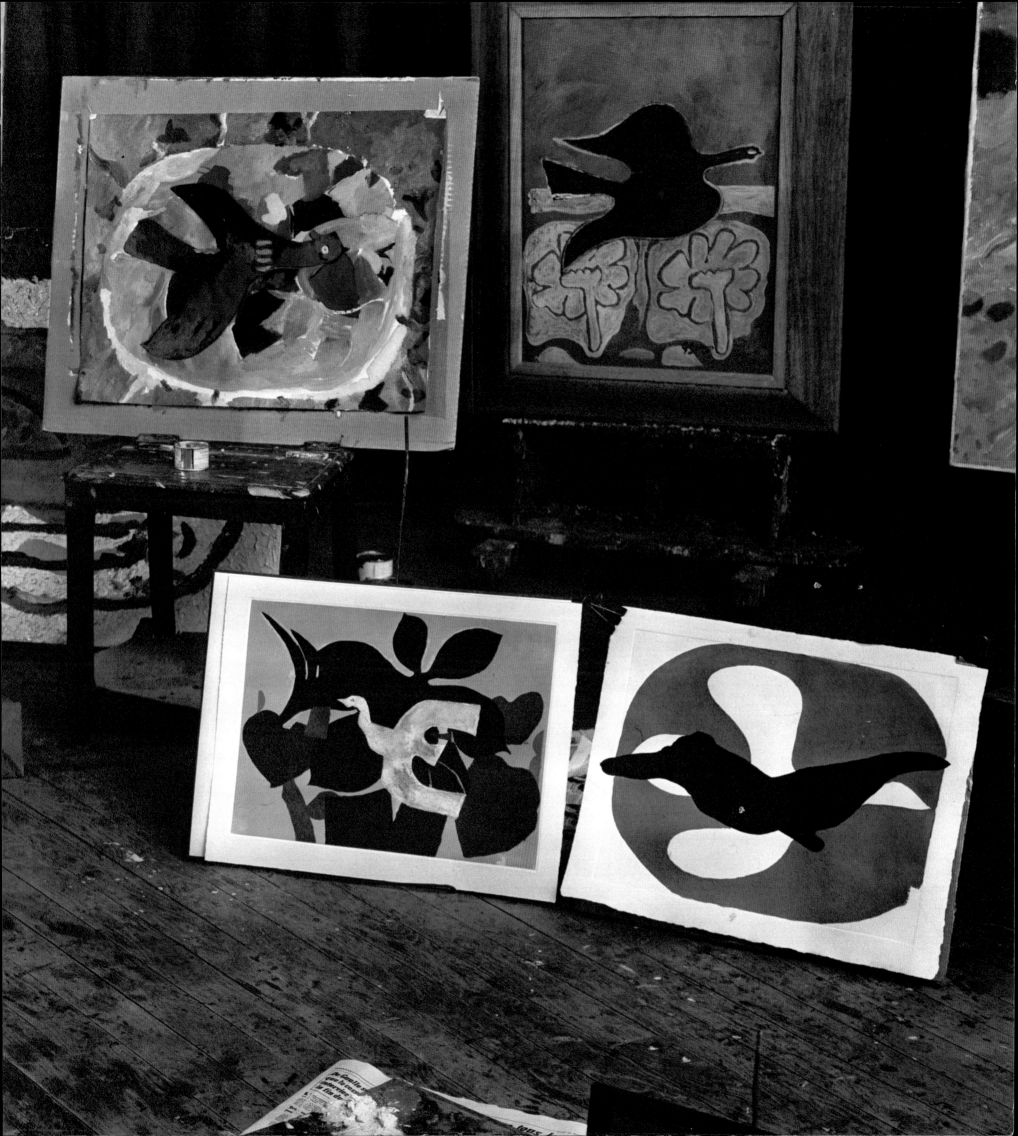

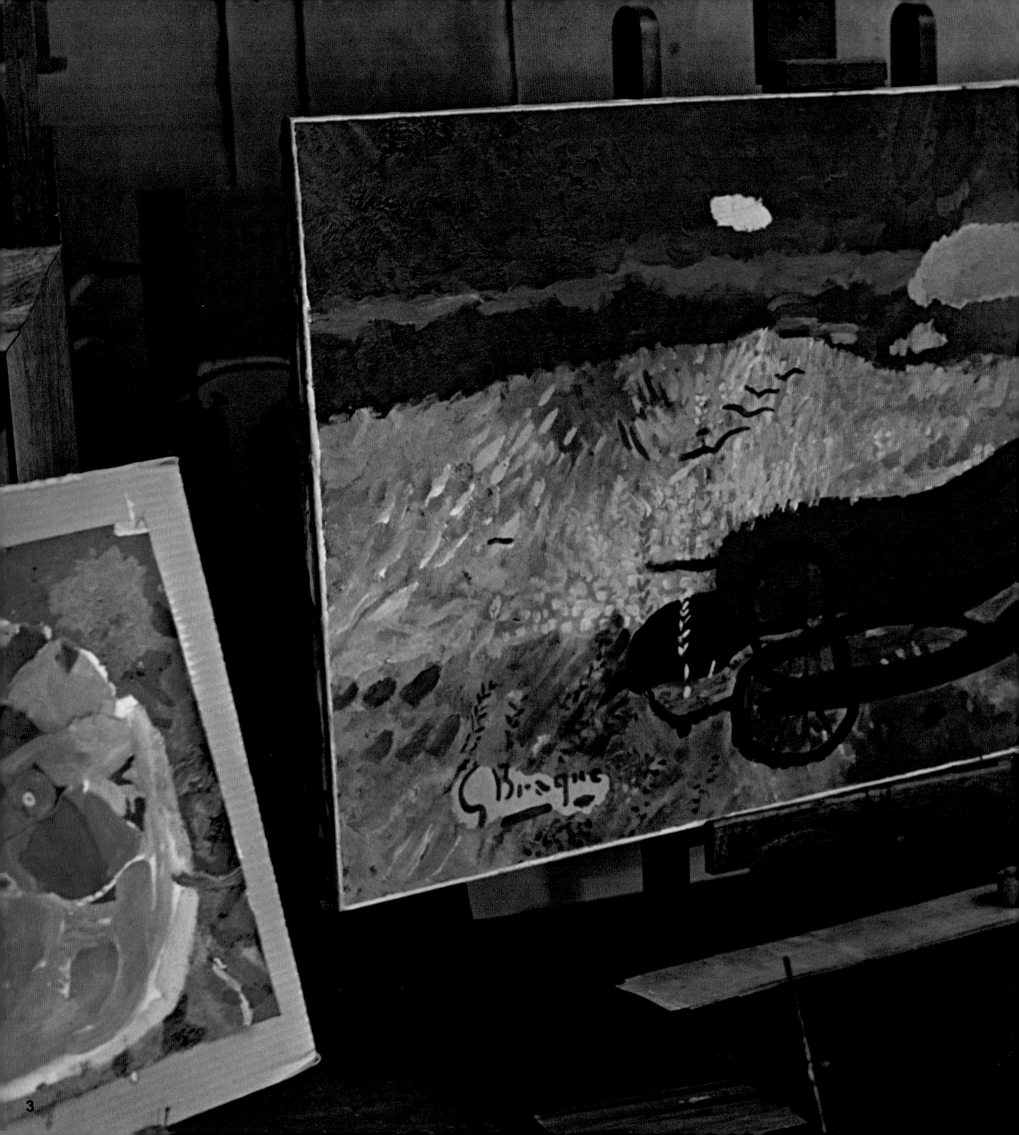

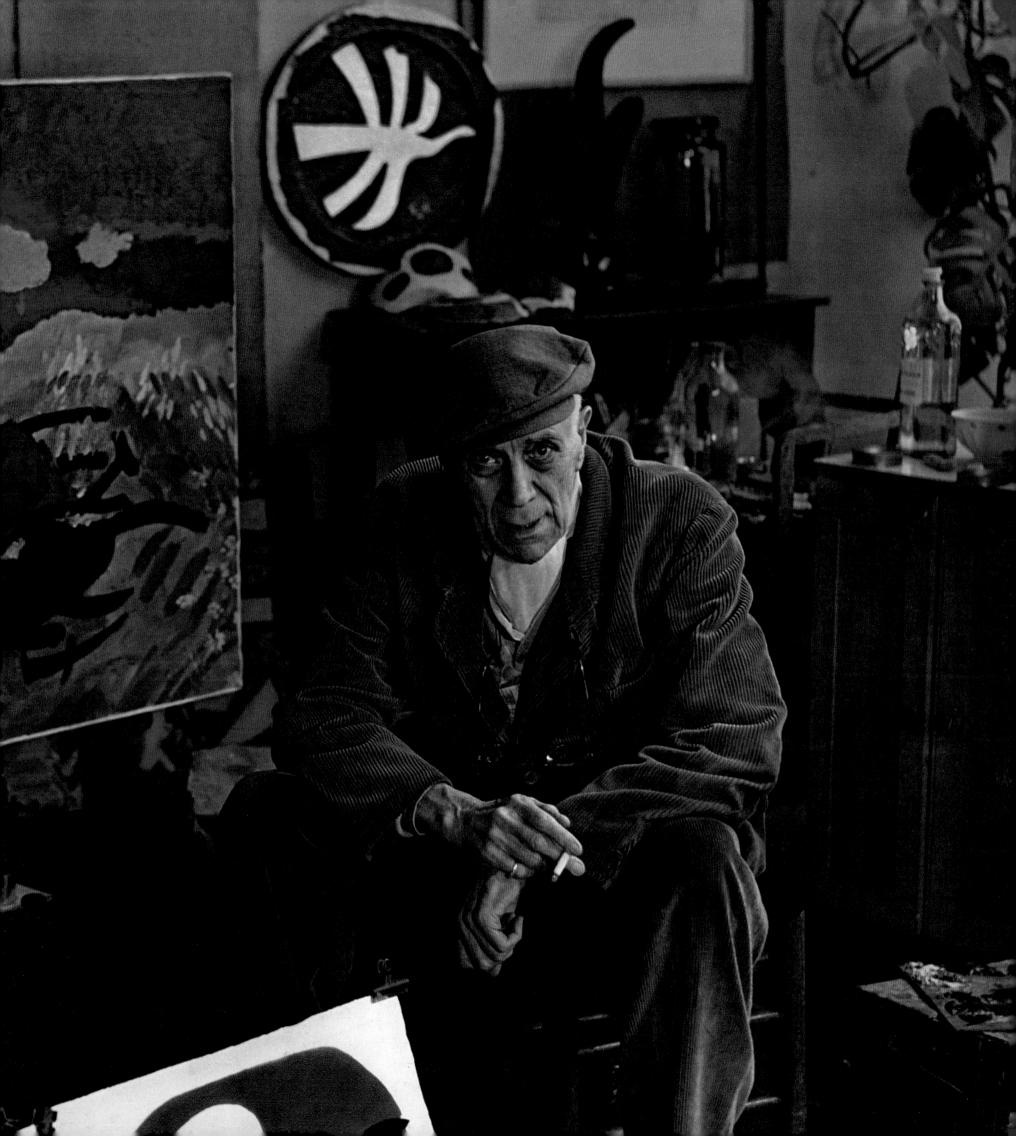

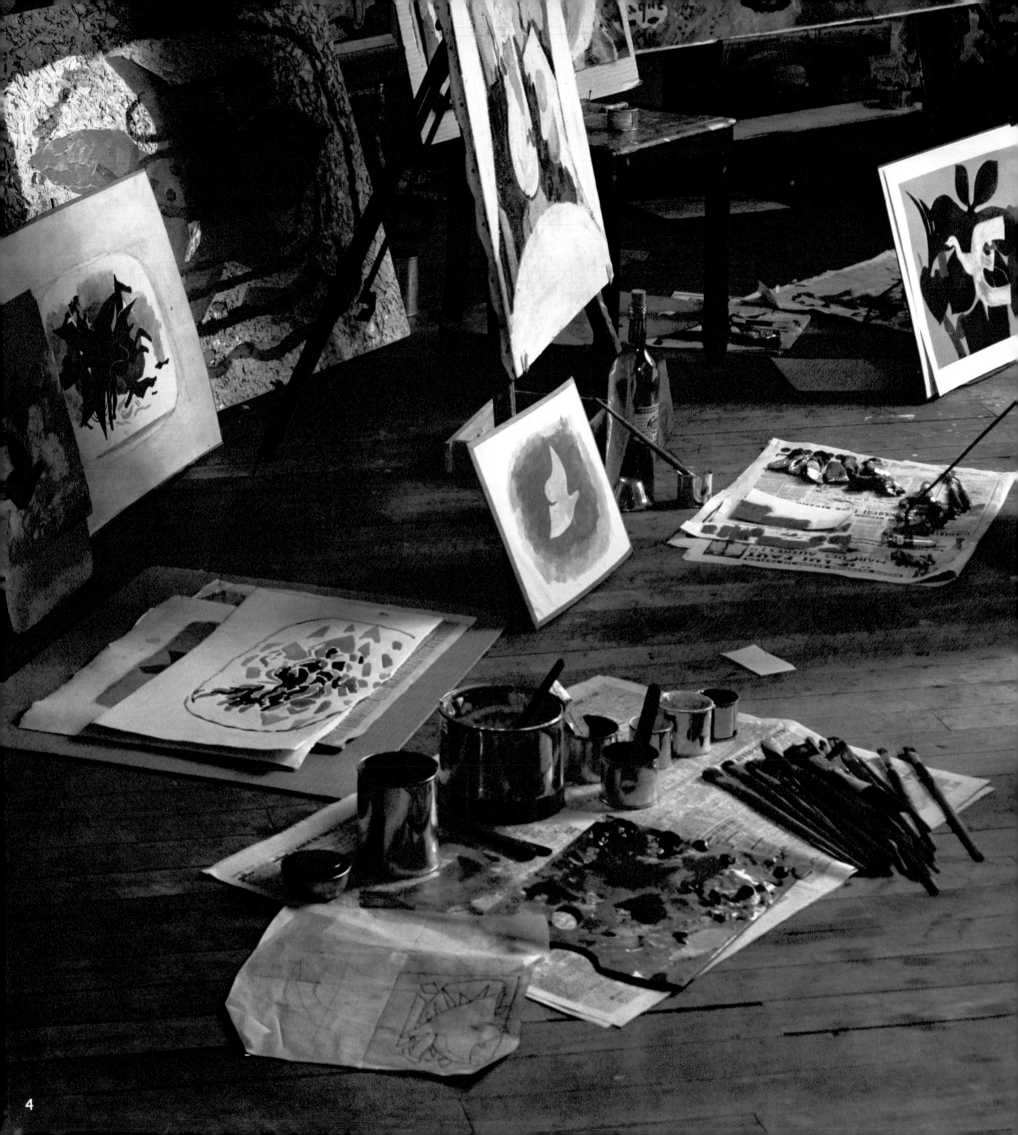

georges braque

1. Braque's hand.

2. In the center of Braque's Paris studio, the flight of *Oiseaux*.

3. Braque, photographed in 1962. On the easel : *La Charrue*.

4. The special paints and brushes Braque used for each work in progress.

Page 24 :
Quotations from The Notebooks of G. Braque, *as published by the Galerie Maeght, are reprinted with the kind permission of C. Laurens.*

1882 *Born May 13 in Argenteuil.*

1890 *His father, a house painter, settled with family at Le Havre.*

1892 *Apprenticed to a colleague of his father's, received training in the trade while taking evening courses in painting.*

1901-1902 *After a year's military service, decided to become an artist. Entered Académie Humbert.*

1904 *Settled in Montmartre, working alone.*

1905 *Impressed by Fauve exhibition at Salon d'Automne. Joined up with Matisse, Derain, Vlaminck, and others.*

1906 *After summer in Antwerp with Friez (Fauve period), spent the winter at l'Estaque.*

1907 *Exhibited at Salon des Indépendants. Spent the summer at Ciotat, then returned to l'Estaque. Greatly impressed by Cézanne retrospective exhibition. Through Apollinaire, he made Picasso's acquaintance. It was the year of* Les Demoiselles d'Avignon, *which could not have left him unaffected.*

1908 *Made first Cubist landscapes at l'Estaque. Paintings rejected by Salon d'Automne. Exhibited by Kahnweiler : Braque's first one-man show.*

1909 *Painted landscapes at La Roche-Guyon. "Analytic" Cubist period. In Paris, friendship with Picasso grew deeper.*

1911 *Spent summer with Picasso at Ceret. "Hermetic" Cubist period.*

1912 *Married Marcelle Lapré. First of fifteen summers spent at Sorgues near Avignon, in company of Picasso. Made first collages. "Synthetic" Cubist period.*

1914 *Exhibited in Germany. Called up for military service.*

1916 *Demobilized with serious head wound that temporarily blinded him.*

1919 *Exhibited at Léonce Rosenberg's Galerie de l'Effort Moderne, Paris.*

1920 *Kahnweiler again became his dealer.*

1922 *Salon d'Automne : eighteen of his picture were sold. Left Montmartre for Montparnasse.*

1923 *Designed first stage sets (for Diaghilev's Les Facheux).*

1924 *Exhibition at Paul Rosenberg's, his new dealer. Moved to new house built for him by Perret, near Parc Montsouris.*

1925 *Designed stage sets for Diaghilev ballet Zéphyr et Flore.*

1928 *Left South of France for northern beaches : Dieppe and Varengeville (where he later built a house). Painted marines.*

1933 *Retrospective show in Basel.*

1934 *Retrospective show in Brussels.*

1937 *Awarded First Prize at Carnegie International Exhibition, Pittsburgh.*

1939-1940 *Retrospective exhibitions in the United States.*

1940 *Took refuge in Limousin, then in the Pyrennees after German invasion. Returned to Paris, where he remained until end of war.*

1946 *Following reduced artistic activity due to poor health, exhibited recent works at Tate Gallery, London.*

1947 *Again ill, but exhibited at Galerie Maeght, Paris, his new dealer.*

1948 *Publication of* Cahiers de Georges Braque 1917-1947. *Awarded First Prize at Venice Biennial. Exhibitions at Cleveland Museum of Art, Museum of Modern Art, New York.*

1949 *Designed stage sets for Molière's Tartuffe (ordered by Jouvet).*

1950 *Exhibition at Galerie Maeght. Among others : the* Ateliers I à V.

1952-1953 *Designed ceiling for Louvre's Etruscan gallery (requested by Georges Salles).*

1953 *Executed decorations at Saint-Paul-de-Vence and stained-glass windows for Varengeville church.*

1959 *In poor health, did little painting, but designed and produced jewelry.*

1961 *Louvre exhibition : "The Studio of Georges Braque."*

1963 *Died August 31, and buried at Varengeville.*

1967 *Le Havre paid tribute to him on the 450th anniversary of city's founding with exhibition at new museum (including forty paintings, some sculptures, ceramics, tapestries, engravings, and lithographs).*

sonia delaunay

Approaching Sonia Delaunay's world is like entering the realm of light. Her home is a dawn in which color proclaims all its power; where every shade and tint is imbued with its own particular splendor, lending a blazing dynamism and cosmic rhythm to the environment.

Fate left Sonia to carry on both her own work and that of Robert Delaunay, her husband. Together they had a passion for painting, and in pursuit of their work they unearthed new plastic means of expression which Apollinaire christened "Orphism."

Their interest in the work of the chemist Chevreul (1786-1889) "on the simultaneous contrast of colors" led Robert and Sonia Delaunay to the realization that the diffraction of light passing through a prism must result in the same sort of diffusion in an object seen in such light. This knowledge guided their inspiration.

ROBERT DELAUNAY...

After first painting from life (when he was still very young), Robert Delaunay became influenced by the Impressionists, then by Cézanne. Later he attempted to free himself from "the tyranny of the subject" without turning to the shattered angularities of analytical Cubism or the blazing splendors of Fauvism. Nor did he try to be "abstract." Rather, he labored to harmonize the figurative and the abstract. He passed through several different periods in the process of developing his personal vision to the point where, little by little, he was able to conceive, execute, and exhibit the great masterly visionary canvases by which we know him.

1885 Born in Paris.

1907-1908 "Destructive period." Painted *Saint-Severin*.

1909-1910 Painted *Les Villes*, using colors in new syntax—"simultaneous contrasts."

1910 Married Sonia Uhde.

1910 Painted *La Tour*, using a theme he repeated again and again.

1913 Created *Manèges Electriques* : the development in colors of rhythms and recollections.

1912-1913 Painted *Les Fenêtres*, which he described as "windows opening out on a new realism. But they are only the fundamentals of the significant extractions that can be drawn from the material constituents of color. Among other things these are contrasts distributed in one or more ways to create architectures, orchestrated arrangements, which unfold like phrases of color."

1912-1914 Development of *Les Formes Circulaires*, a canvas he described as conjuring up "only the subject, the composition, the orchestration of the colors. It's the birth, the first appearance in France of those paintings we call objective."

1914 War declared. Exempted from active service. Settled with wife in Madrid.

1915 Painted *Hommage à Blériot*. Traveled with wife to Portugal.

1916 Painted *La Verseuse*.

1918 Collaborated with wife on stage sets and costumes for Diaghilev ballet *Cléopâtre*.

1920 Settled in Paris. Joined up with poets and writers of Surrealist group.

1922 Painted *Football*.

1924 Painted *Les Coureurs*.

1934 Painted *Rythmes Colorés*.

1935 Painted *Rythmes sans Fin*.

1937 Decoration of several pavilions at Paris International Exposition.

1941 Died October 25 at Montpellier in the South of France.

Sonia Delaunay, speaking of her own painting, said, "Dating back to my very first work, my research in pictorial expression was focused on the purity and exaltation of color. In my first achievements I tried to give colors their maximum intensity. My spiritual masters were Van Gogh for intensity and Gauguin for the application of color laid on flat surfaces.

"Fortunately, before coming to Paris in 1905, I had spent two years at Karlsruhe in Germany with a drawing teacher. He not only taught drawing but also the construction of a plastic idiom, and this with austere discipline.

"This discipline set me apart forever, forcing me into a constructive foundation that could not but lend greater strength to my plastic expression, while also doing away with any slips into the accidental or the facile.

"In the pictures I did in 1907 I arrived at an extreme exaltation of colors laid on with absolute flatness.

"In 1909, while I did not participate in the Cubist movement, it fascinated me. I lived it. It was then too that I met Delaunay and that our lives were linked. Though I never shared in his own research work, the results he obtained inspired me to play with color, freely."

Although her great canvases, such as *Prises Electriques* (1914) and *Le Marché de Minho* (1916), were the highlights of her hymns to pure painting, Sonia Delaunay soon began to infuse their daily life with her sense of color and rhythm. At the same time Robert Delaunay was using their joint efforts as a base for expressing himself in gigantic canvases.

She did not merely create an art of living. Her work enabled the two of them to obtain the financial means necessary to pursue their research. Fabrics, books, stage sets, costumes, carpets, knicknacks, furniture, and in 1967 even automobiles all proved to be areas of light in which Sonia Delaunay made colors dance.

"Color brings rhythm into painting. This movement was never merely descriptive, as in futurism, but entirely plastic, optical, lyrical" (1917). The dance rhythms of Sonia Delaunay, the colors, vibrations, open infinite routes to the poles of creation, where the sun makes love to the earth.

What originality there is in my drawings lies in the over-all construction of extensive surfaces whose detail is composed of floral elements. This is the opposite of the Impressionism which dominates the majority of current work and which allows for the expression of individual sensitivity, but does not subject it to any kind of order. In my own case sensitivity is also the principal element, but it is regulated by a rhythm that generates the covering harmony : construction.

This rhythm is based on the relationships between colors scientifically studied in their interactions and graded according to Chevreul's laws of simultaneous contrasts. These laws, scientifically established by Chevreul and subsequently verified by experiments, were first seen working clearly in nature by my husband and me in Spain and Portugal, where light is purer, less misty, than it is here. Indeed, the quality of the light there enabled us to go further than Chevreul, beyond the harmonies he found based on contrasts, to dissonances, intensified vibrations provoking sharper distinctions observable in the juxtaposition of certain warm and cold colors.

EXAMPLE : *Simultaneous Contrast*

$$\frac{red}{green} \qquad dissonance \qquad \frac{orange\ red}{blue\ green}$$

We divide colors, or rather their nuances, into warm and cool.

Starting from any pure color, we create surfaces, shapes, depth, perspective, out of the color alone. No more streaks or chiaroscuro, which are the province of photography, that mechanism of descriptive cerebration.

Painting and the decorative arts are solely the harmonization of colors, re-creating nature more closely and truly than chiaroscuro. The whole range of colors assembled in this light forms a living harmony.

Moreover, these color relationships in their physical aspect make it possible to produce predictable reflexes in the spectator : colors assembled in gentle accord have a calming effect, while a dissonance of hot and cold tones is stimulating.

Sonia Delaunay

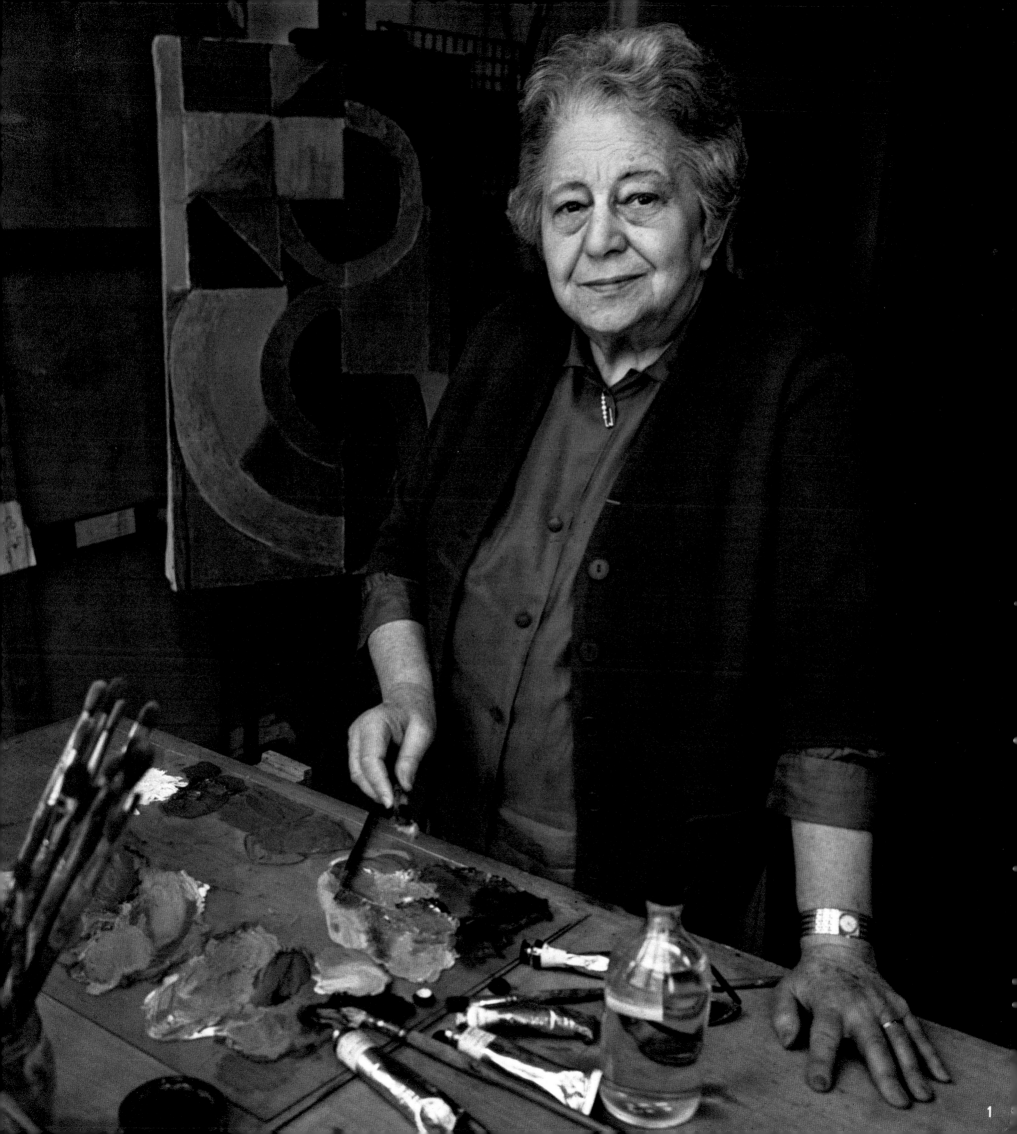

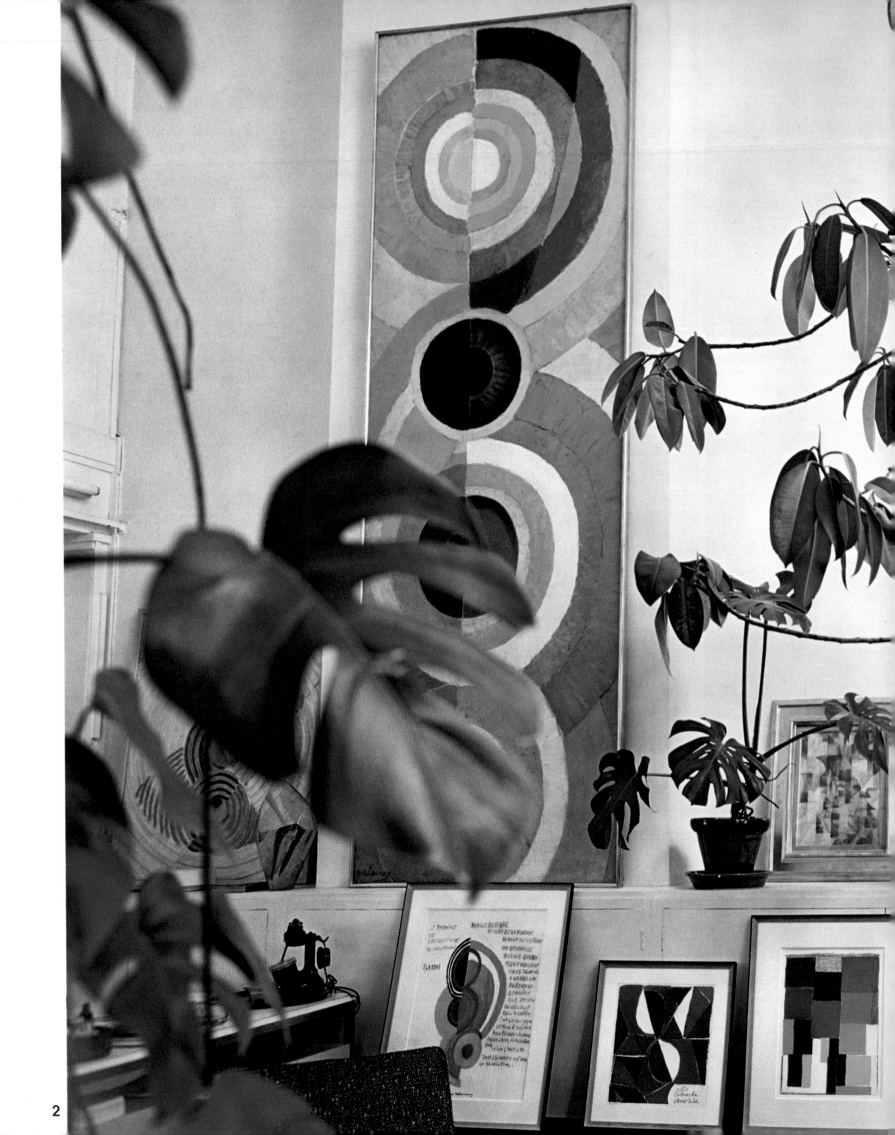

2

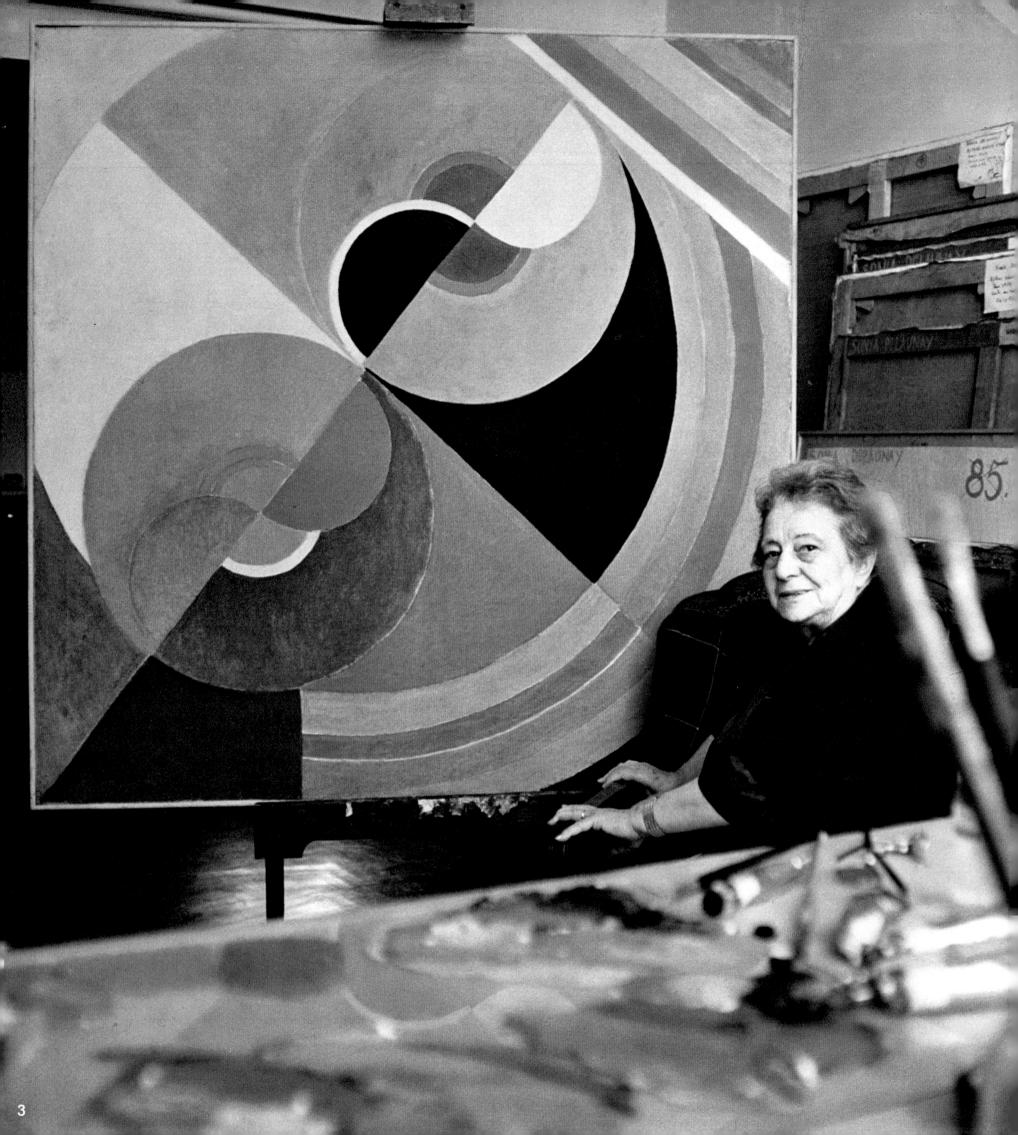

sonia delaunay

1. A privileged moment—in the act of creation.

2. The large living room, a garden of shapes, rhythms, colors.

3. Sonia Delaunay in her studio, selecting canvases to be shown at the retrospective exposition of her work at the Musée d'Art Moderne, Paris, in 1967.

1885 Born November 14 in the Ukraine.

1890 Attended schools in St. Petersburg.

1903 Studied drawing at Karlsruhe.

1905 In Paris, worked at Académie de la Palette.

1907 Painted Fauve canvases (under influence of Van Gogh and Gauguin).

1909 Married W. Uhde.

1910 Divorced Uhde and married Robert Delaunay.

1911 Birth of son, Charles.
First work with appliqué fabrics.

1912 Apollinaire stayed with the Delaunays (November—December). Creation of "multiple veils." Made collages, bookbindings, pastels.

1913 Met Blaise Cendrars and illustrated his poem La Prose du Trans-Sibérien et la Petite Jehanne de France. Created "multiple" robes and vests. Sent twenty canvases and other objects to the Herbstsalon in Berlin.

1914 Exhibited Les Prismes Électriques at Salon des Indépendants (Musée d'Art Moderne, Paris).
Settled in Madrid.

1915 In Portugal with husband.

1916 Painted series of Portugese still-life canvases and Le Marché de Minho at Valenca do Minho.

1917 Deprived of her income by Russian Revolution, began earning living as decorator.
Painted the interior of the Small Casino in Madrid and designed costumes for the first show.

1918 Worked with husband on stage settings and costumes for Cléopâtre (featuring Nijinsky).

1920 With husband moved to Paris.

1922 Created first multiple scarves; also continued her painting.

1923 First order for multiple fabrics (given by a Lyons firm). Designed and executed costumes for Tristan Tzara's play Le Cœur à Gaz.

1924 Multiple-fabric creations. Began producing woolen tapestry coats. Created costumes for poem by J. Delteil.

1925 Shared booth with dressmaker Jacques Heim at Exposition des Arts Décoratifs. An album of her work is published.

1929 Publication of her book Tissus et Tapis.

1930-1935 Devoted most of her time to painting. Joined various groups championing abstract painting.

1935-1937 With husband, was entrusted with execution of large mural paintings for Paris International Exposition (1937) and was awarded Gold Medal.

1939 Assisted by Rambosson, Fredo Sidès, and N. Van Doesburg, she and husband organized first exhibition of "New Realities" at Galerie Charpentier, Paris.

1941 Husband dies after serious illness. Invited by the Arps to Grasse. Found Magnelli there. Continued to paint.

1944 Left Grasse and stayed three months in Toulouse.

1946 Fredo Sidès (adopting the Delaunays' "new realities" idea) asked her to organize with him first Salon of New Realities.

1949 Participated in "The First Masters of Abstract Art," show at Galerie Maeght, Paris.

1953 One-man show at Galerie Bing, Paris.

1958 Large exhibition at Beilefeld Museum. Executed four stencil compositions for Le Fruit Permis, a poem by Tristan Tzara.

1959 Exhibition of her work and husband's at Musée des Beaux-Arts, Lyons.

1960 Created multiple pack of playing cards. Exhibition of her work and husband's at Turin Museum.

1961 Publication of Tristan Tzara's poem Juste Présent, illustrated by her with eight etchings in color. Album of six lithographs in color by her published by Pagani, Milan.

1962 Album with six stencils published by Éditions Denise René, Paris, Delaunay Gift Collection to the Musée National d'Art Moderne (including forty-nine works by Robert and fifty-eight by Sonia) exhibited at Musée du Louvre.

1967-1968 Retrospective show at Musée d'Art Moderne, Paris.

magnelli

During the exodus of 1940, I was obliged to remain hidden under the flatbed of a haycart while it jolted its way slowly through the Morvan District. For five long days I lay watching endless lines of tattered boots with rundown heels and dangling laces as the troops went by. When I stretched out on my back to try to snatch some sleep I could see a woodman's ax lying on the bottom of the wagon just a few inches from my eyes. I had seen such misery, lived through so much splattered mud, and heard such cursing around me, that I formed my own idea of Heaven from the blue steel of the ax.
Fleeing a domestic crisis in 1947, I went to live alone in a hotel room in Levallois-Perret.

The rooms there were gray with accumulated dust shot with still-dirtier stains, grim reminders of the gloomy lives led by the poor laborers who lived in the hotel on a monthly basis.

Somehow I had to establish a standard for the life ahead, to choose a discipline. I was eighteen.

One day I bought a postcard and pinned it to the wall above the head-board of my shaky bed. I'd found my own sky again.

The card was a reproduction of a Magnelli canvas.

Nothing seemed more real to me after that than the world the painter had invented. Every night I saw the world of my own future in it—there, already set up, I could see my sphere of love peopled with ideal figures bathed in the colors of benevolence.

Just twenty years later I met Alberto Magnelli himself and was over-joyed to have the privilege of being shown around his studio.

Magnelli works on the top floor of a large house in Meudon which is like an island in a sea of flowers.

A huge tree leans against the house. Its topmost branches fill the view with strong black strokes, a visual interplay of lines, space, and painter.

Near the window, Magnelli drew at a flimsy table strewn with papers. Silhouetted against the tree, he traced a line. On an easel facing the door was his latest canvas. Lines sketched in the notebook had undergone a metamorphosis, transformed by the creative inspiration of the painter. Taut, upright, a mesh of black lines dominated a wide stretch of canvas quartered in comforting grays. A ring resembling a strip of bark united a background in three shades of green which bordered on a secondary area in black. A triangle half black, half brown, pointed downward from the top of the canvas. On either side, two stripes, one in black and ochre, and one brown rimmed with white, modulated the composition.

These were shapes invented by Magnelli, outside memory yet recognizable as the architecture of an external world.

Magnelli seems to delineate a world with his heartstrings, a world in which form can never be debased, for it is refined by the same wit, the same earnestness, the same scruples practiced by the Dutch masters. But Magnelli also adds : "Don't forget Piero della Francesca. . . . It was through him that I learned to organize surfaces. He taught me the relationship between solids and space. From him I learned that my art, my canvases should always be directed toward the architectural."

Under the great beams that hold up the roof of his studio were masks, statues, stones, driftwood, dried flowers, and other objects, uniden-tifiable things that gleamed in the filtered light that enters through a transom. Slipping out of cardboard boxes were scraps of multi-colored and many-textured papers, saved for collages that resembled forgotten collections of pressed flowers.

But it was time for me to go down, through the other rooms; and along hallways whose walls Magnelli seemed to thrust aside with his broad shoulders I studied his erect stature, the determined set of his head, and his dark and burning gaze. Throughout the house the walls were hung with pictures marking old encounters, old discoveries : The shattered outlines and floating cities of his 1931 "stone"-period canvases recalled his visit to the quarries of Carrara; in the paintings dating back to 1918-1920, colors burst their bonds and engaged in explosive, lyrical combat.

There was a landscape he did in 1907 in Florence, when he was nineteen, executed in a devout blue. There were also canvases of his 1914 period, in pure vivid colors that foreshadowed the architectural constructions that were to come; among them, *Les Mariés, La Marchande d'Oranges, La Japonaise,* and *Le Paysan au Parapluie.*

Finally, Magnelli showed me the imposing abstract canvases he had made in 1915, paintings which were very soon to light a permanent flame in the heart of modern art.

The whole business of painting depends entirely on the man, on his abilities and talents. If his work merely brushes the surface of things, it will never be anything but decorative.

There is a whole body of art that we can term "geometrical" without disparagement.

What matters most is the composition of a work of art, the "layout." This is the skeleton—the armature—upon which specific predetermined forms are built.

All the enthusiasm, all the desire for evolution one can muster, must and should enter into this basic structure if one's labors are to develop into a work of art, in the best sense of that word. If the seed be healthy, "if it be sown in the richest earth," it will ripen some day and be laden with all the fruit it can bear.

A true work of art needs curved forms as well as straight lines. It is the proper proportion of these two elements that will lead to creation, to creation as logical as that of nature.

There will always be artists who can work in a state of anguish. For me it would be unthinkable to pick up a brush in a moment of instability. Of course there are always times when you doubt yourself, but you have to learn how to master those moments ; you must know how to wait, to overcome negatives.

Once I have determined the drawing, the composition, I begin to study and arrive at the coloring.

The word "abstract" was given (to painting) because people always have to give a name to everything.

It was not a happy choice.

When I worked out my first "invented" canvases in Florence in 1915 (I was the only artist doing that sort of thing at the time), I intended to go on from a carefully thought-out mode of expression. We were totally isolated in Florence, far from everything, without any possible point of reference.

Things had to be INVENTED.

I felt it was necessary to make completely invented pictures, set apart from any way of life, any objects, or the people around me. I had to invent the new in painting just as others were producing the new in music and architecture.

In 1915 the word "abstraction" had never entered my mind. I was merely painting, I wasn't trying to "paint philosophy." I was dead set against the idea of the literary entering into my work.

I thought only of those shapes and colors that were necessary for "invention," for creating something that did not exist, even for me, yet to which I would and could give a shape that would be mine alone.

There are abstractions and abstractions.

Art—if it really exists—is never abstract.

Everything is both abstract and concrete.

Art, whether it is abstract or figurative, is a poor thing if it lacks inspiration.

I was working and thinking like that even in 1913-1914.

You have to be as sure of each "full" space as of each "empty" space, to know how to fill up all areas in the richest possible way. "Monumentality" in art is the result of a complex of facts and possibilities. There is always a magnificent art which is never "monumental" and in which you discern no need for "monumentality."

Each artist carries his own world within himself, his substance, his own emotions. I believe that a song will always be a song, music will always be music, architecture will ever be architecture, and that art and its plastic expression will, happily, always be art, the fruit of a necessity as explicit as it is poetic and fundamentally human.

It is inconceivable that humanity be lost in a void or that it should become the prey of the impossible and the antihuman. Beings may perhaps go on to live in opposite ways, some given to the most logical and others to the most absurd novelties, but they will nevertheless make "tomorrow."

Magnelli

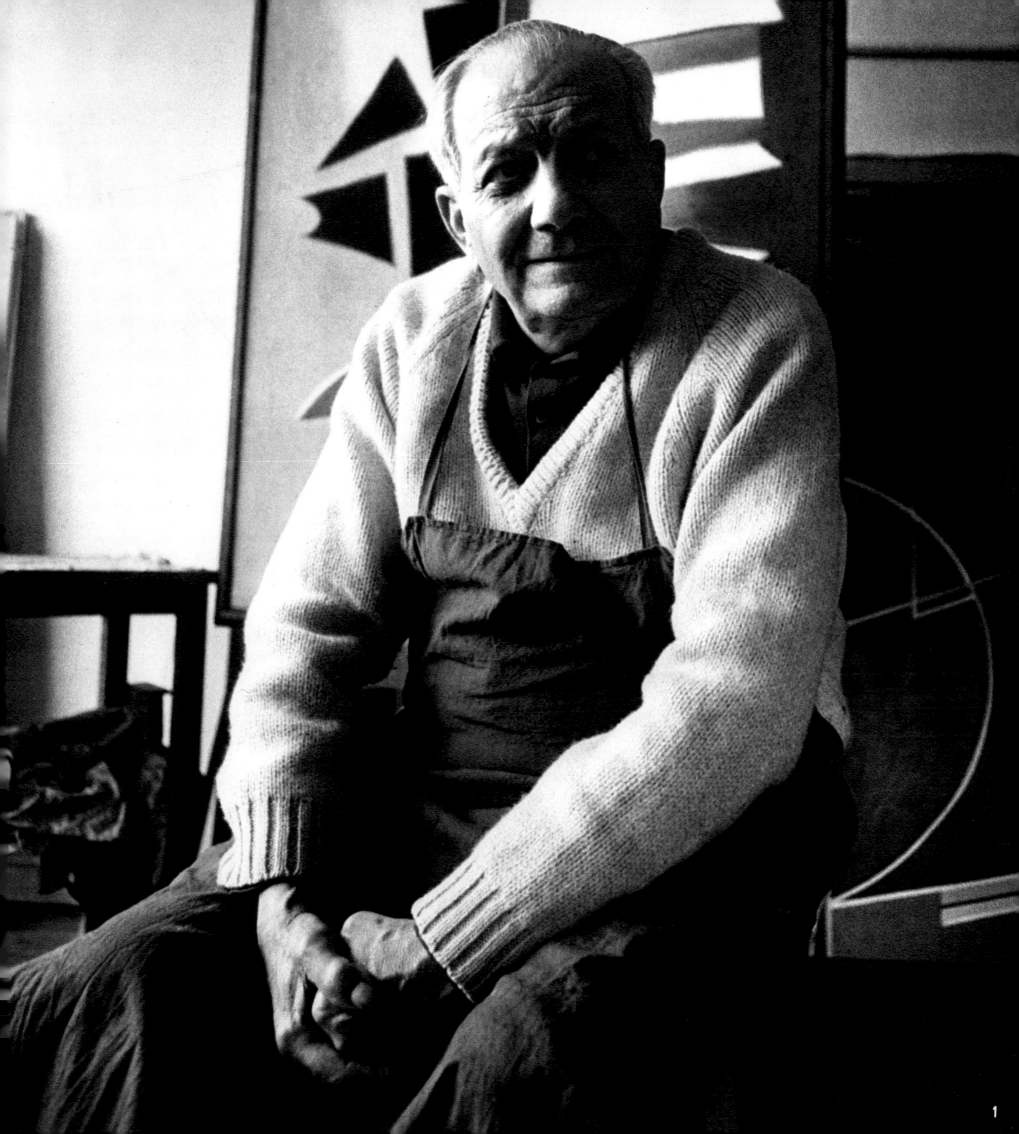

1

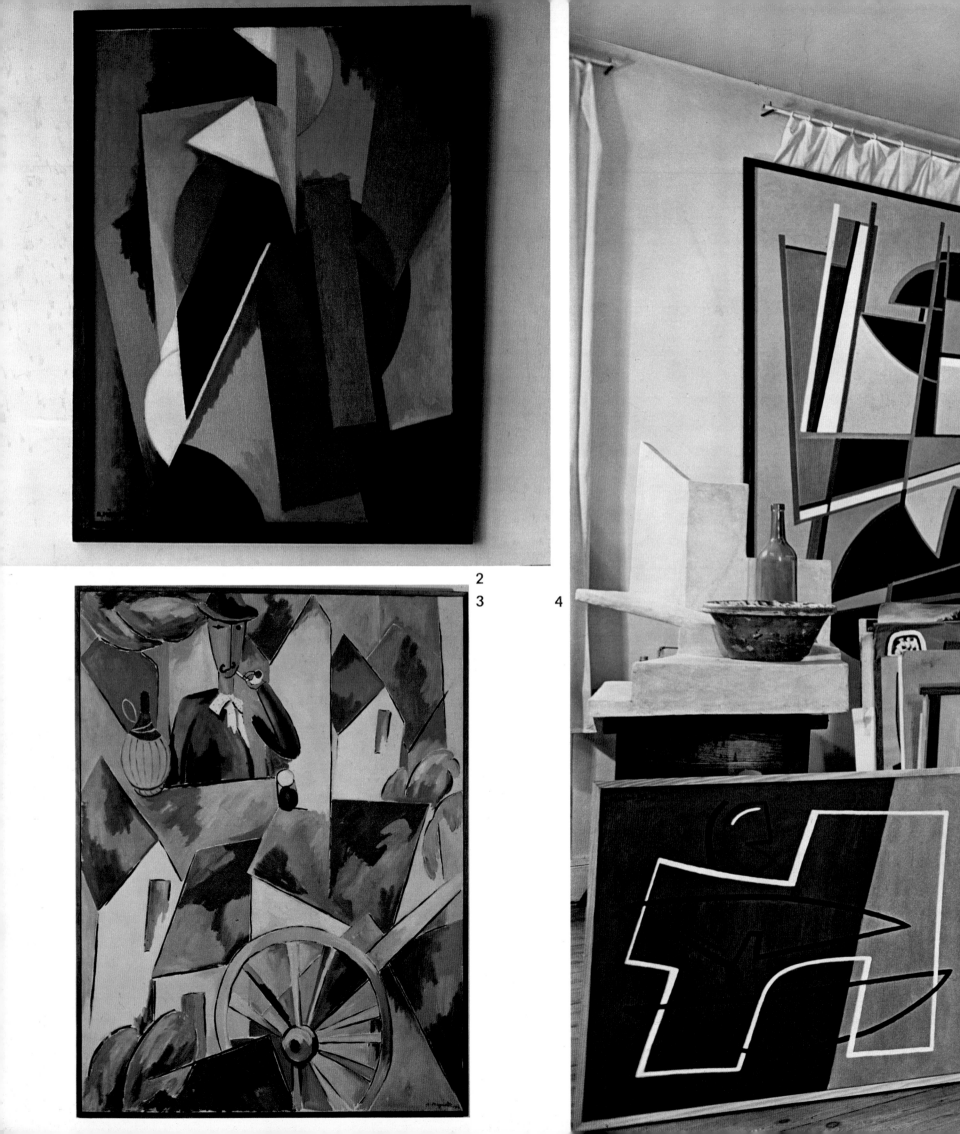

2
3
4

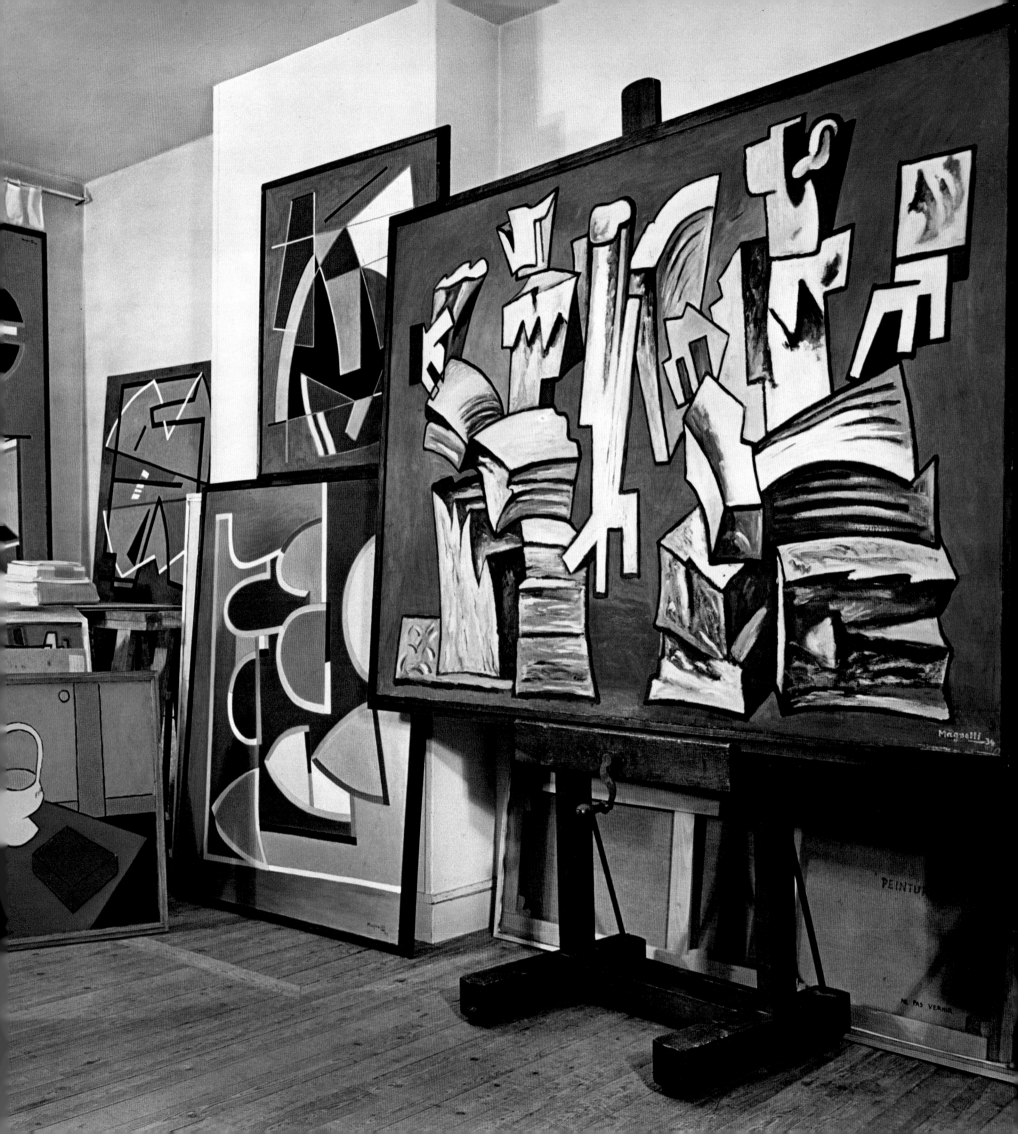

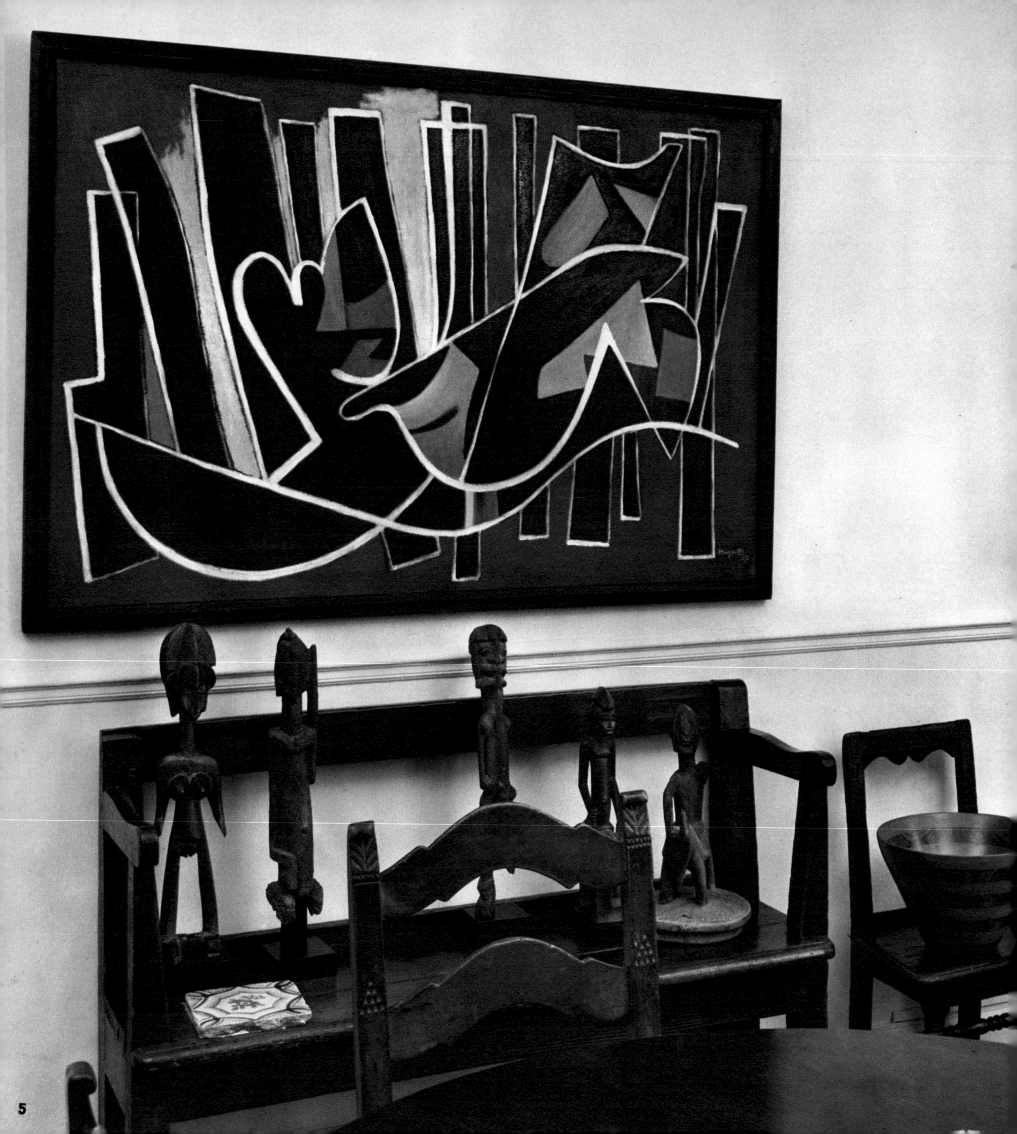

5

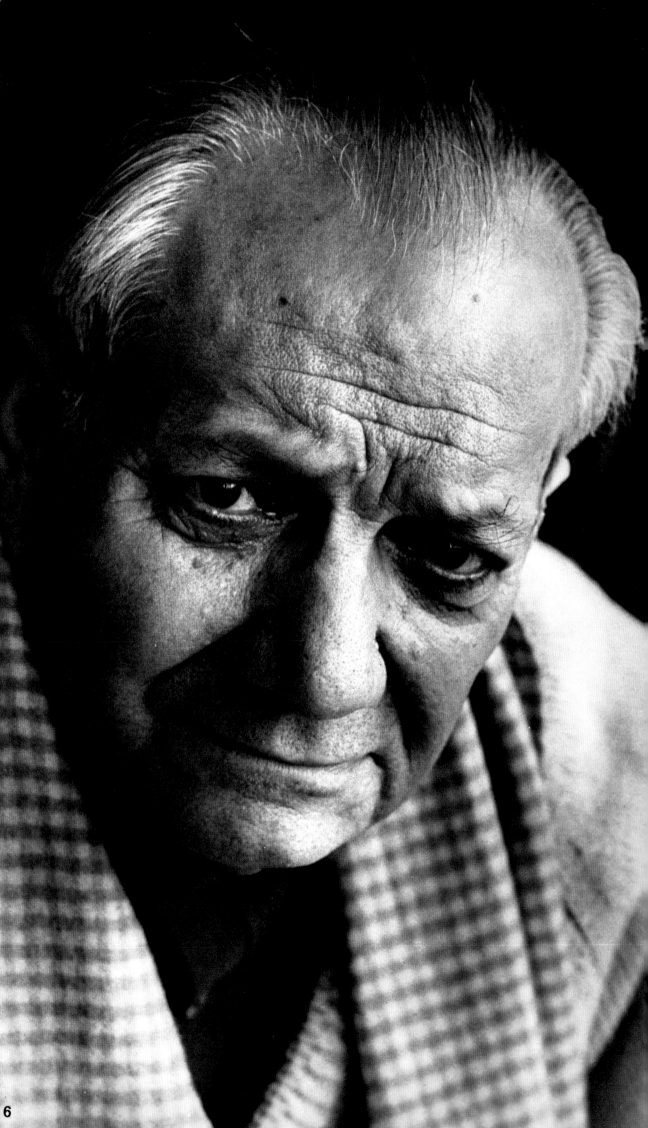

6

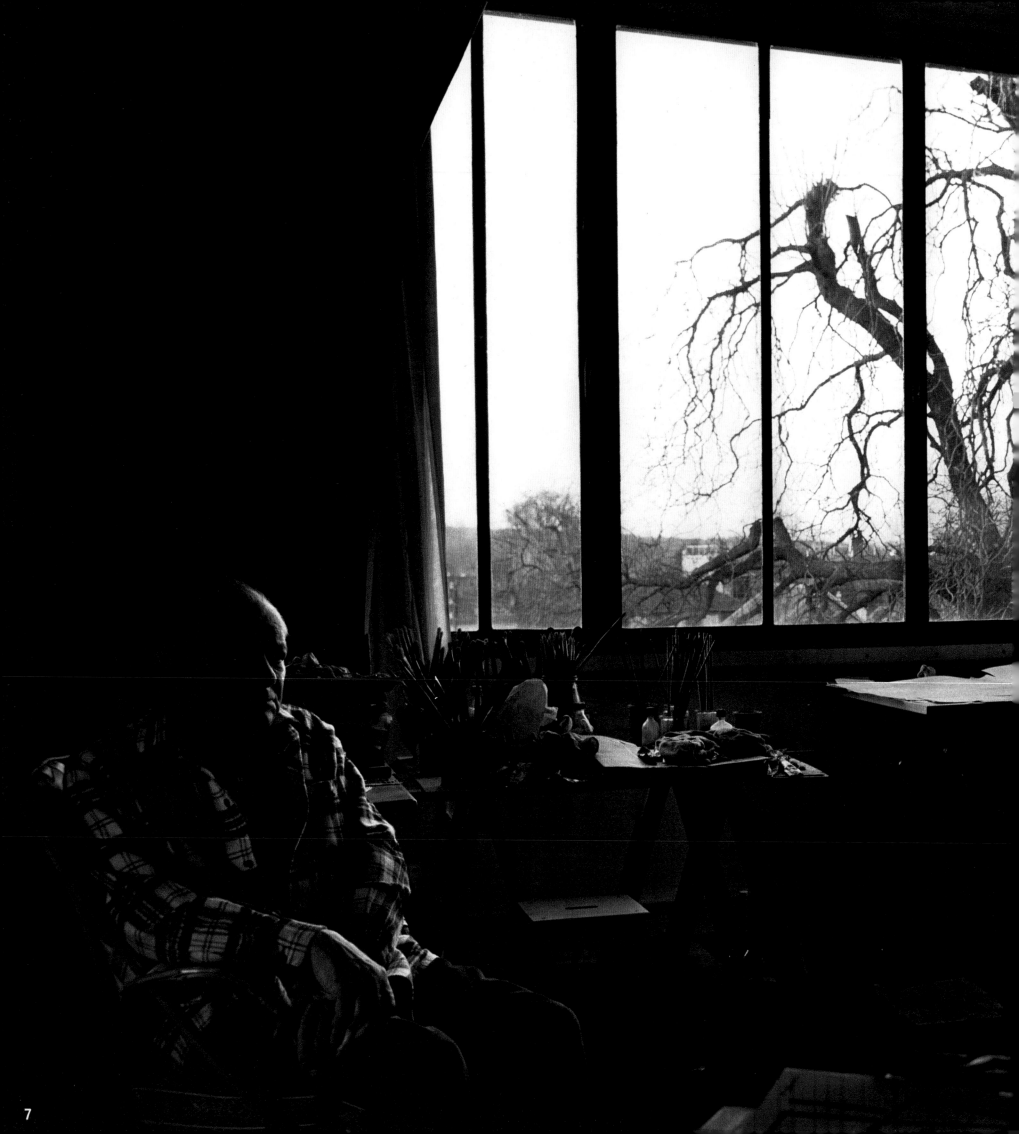

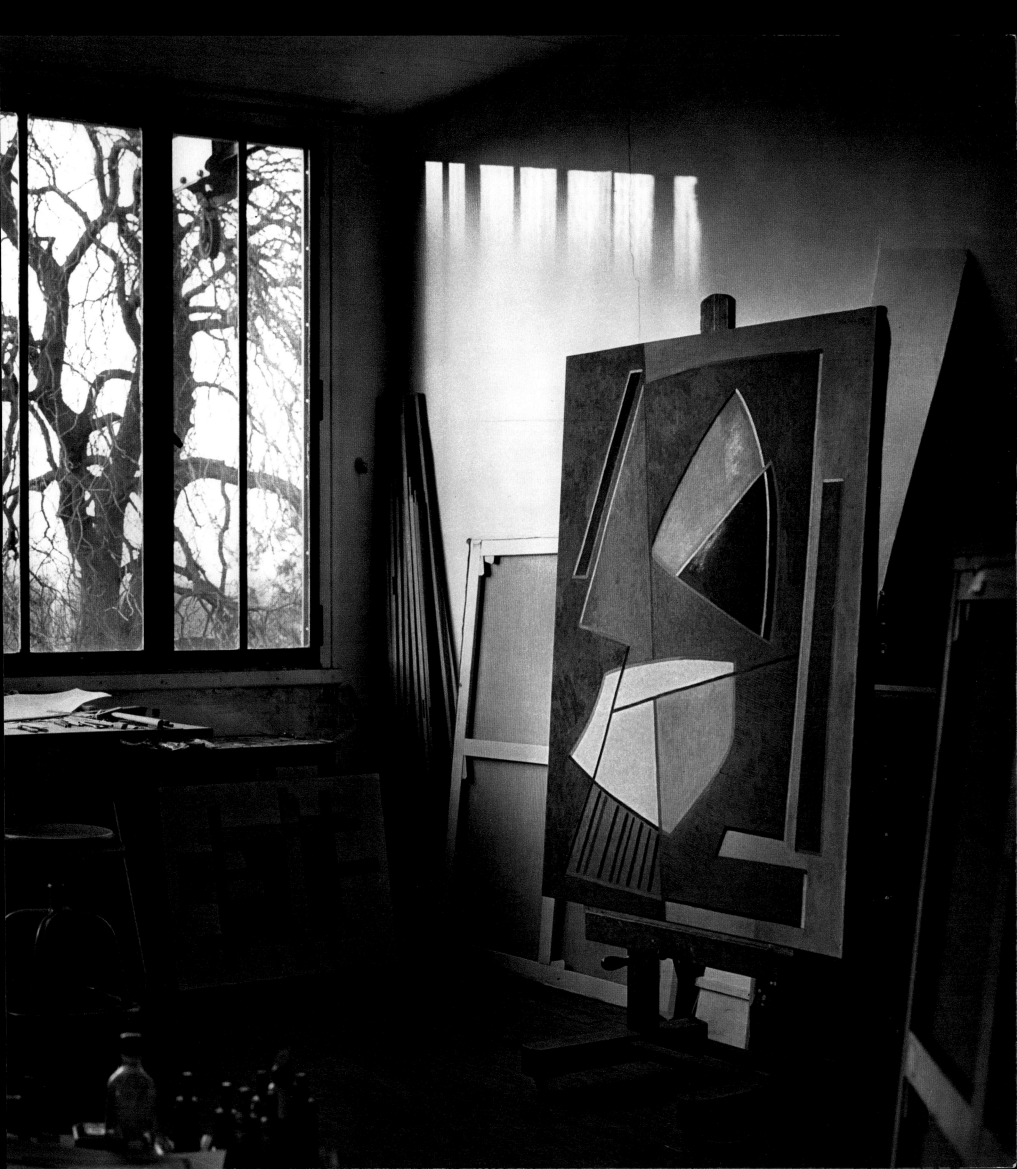

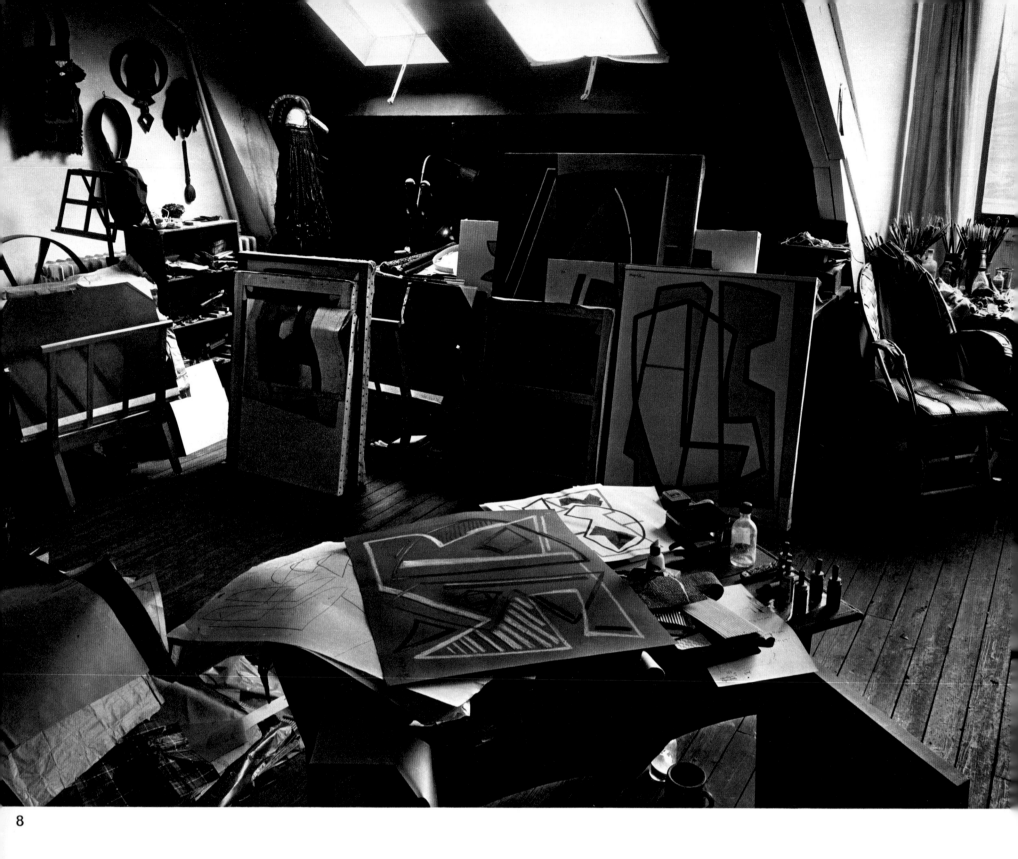

alberto magnelli

1. "Art is a tough and difficult task that can be pursued only by paying heavily for the time it takes to achieve something positive and worthwhile" : Magnelli.

2. *Abstrait 0530*, 1915.

3. *L'Homme à la charrette*, 1914.

4. Counterclockwise :
Pierres, 1934.
Point Fort, 1949.
Profond et Apparent, 1964.
Mesures No. 3, 1959.
Nature Morte à la Boîte Rouge, 1914.
Ecriture, 1965 and
the sculpture, *Nature Morte*, 1914.

5. In the living room, above the bench that serves as a sanctuary for Negro sculpture :
Accords Alternés, 1937.
To the right : *Sculpture*, 1914.

6. "Man looks at himself in the mirror without seeing himself" : Magnelli.

7. The man, face to face with his work.

8. The far end of the studio.

1888	*Born in Florence, July 1.*
1910-1911	*Initial contacts with the Futurists and Cubists in Paris.* *Sold a picture exhibited at Venice Biennial.*
1914-1915	*During stay in Paris, made contact with prominent artists:* *Apollinaire, Max Jacob, Léger, Matisse, and Picasso.* *As of the outbreak of war, made Florence his home.* *Made first progress (in 1915) with austere abstract canvases.*
1915-1931	*In Florence, painted works showing extreme formal severity.*
1931	*Settled at Meudon-Bellevue, France.* *Returned to nonobjective painting.*
1933	*Member of the Abstraction-Création convention.*
1934	*Exhibited at Galerie Pierre, Paris.*
1937	*Exhibited at Nierendorf Gallery, New York.*
1946	*Exhibited at Galerie d'Art Moderne, Basle.*
1947	*Retrospective show at Galerie René Drouin, Paris.*
1949	*Exhibited collages, gouaches, and drawings at Galerie Denise René, Paris.*
1950	*Exhibited at Venice Biennial.*
1953	*Took part in São Paulo Biennial and was awarded second prize.*
1954	*Exhibited one hundred canvases at Palais des Beaux-Arts, Brussels.*
1955	*Took part in São Paulo Biennial, receiving first prize.* *Exhibited at Eindhoven Museum and at Musée Grimaldi, Antibes.*
1957	*Exhibition of collages at Berggruen Gallery.* *Exhibition, "Ten Years of Painting by Magnelli," at Galerie de France, Paris.*
1958	*Exhibited at Liège Palais des Beaux-Arts with Picasso, Matisse, and others (part of Brussels Universal Exposition).* *Awarded Guggenheim prize for Italy.*
1960	*Exhibited at Venice Biennial.* *Took part in exhibition, "The Origins of the Twentieth Century," in Paris.* *Exhibited at Galerie de France, Paris.*
1963	*Retrospective exhibitions at Museum of Modern Art, Zurich, and at Palazzo Strozzi, Florence.*
1964	*Exhibition at Folkwang Museum, Essen.*
1965	*Took part in the "Traum, Zeichen, Raum" exhibition in Cologne.* *Included in exhibition, "The Grain-d'Orge Collection," Copenhagen.*
1966	*Exhibited at La Polena Gallery, Geneva, and at Halverson Gallery, Oslo.*
1968	*Retrospective show at the Musée d'Art Moderne, Paris.*

chagall

He lifts
his head

Chagall's
childhood
is our own
hooked
to the pendulum
of a clock
that winds up
time.

Like him
I have smelled
the stench
of slaughterhouses,
I have drunk
all the blood-reds
in his canvases
out of the glass
intoxicated
by the muffled groans
of calves
writhing
emptied
in freshets
of blood
similar
to those
of women
giving birth
to their
first-born.

If he can close in
on the anguish
of man
it's because he has
the innocence
of animals
in his eyes.

It does not always
return
to its place.

Chagall
composes
a picture
like an acrobat,
turning,
working in orbit
around
his heart.

After gazing
at the pages
of a bestiary,
he works up
a scattered world
composed of fawn,
fish,
donkeys,
lovers,
cocks,
Paris,
musician
Bella—
all make manifest
the sky of Vitebsk
that we wish
were our earth.

Chagall,
lighter than air,
dances
in his head
to the tune
of his Uncle Néoh's
violin.

His vision
of the world
is that
of the birds
that look down
on Golgotha.

He looks
at himself
and uses
his own body
to paint us.

I am a painter, and I would almost say a painter who, unwittingly, is conscious of being one. There are so many things in the world of art for which key-words are hard to find. But why should one always be bent on opening those gates? Sometimes, they seem to open of themselves, effortlessly, without need of words.

I left my native country in 1910 having realized that Paris was necessary to me. Of course the soil that nourished the roots of my art lay in Vitebsk—but my art needed Paris as a tree needs waters—it would have perished without it.

Russia has two forms of traditional art:
Folk art and religious art.
I sought an earthy form of art, not intellectual art.

I had the good fortune to be of plebeian stock. Nevertheless, much as folk art was dear to me, it could not satisfy me. It was too exclusive; it completely ignored the subtleties of civilization. I have always been attracted by the fine points of communication, by culture; but in my country such art was always directed to religious ends.
I could, of course, even in my distant native town, argue these questions with my friends. Yet I wanted to see with my own eyes what I had only heard about: that visual revolution, that rediscovery of colors which, spontaneously and intelligently blended, could be tamed by carefully thought-out linear compositions as in the work of Cézanne, or be allowed to vibrate freely as demonstrated by Matisse.
Nothing like that could be seen in my own country, where the sun of art never shone as brightly as it did in Paris. It seemed to me at the time (as it still does today) that there never was a greater revolution in vision than that which I lived through on my arrival in Paris in 1910.
I was overwhelmed by the landscapes and the figures in the work of Cézanne, Manet, Monet, Seurat, Renoir, Van Gogh, the Fauves and in that of many other painters. They drew me to Paris with an elemental urge.

While I was taking part in this unprecedented revolution in French art my thoughts kept going back to my native land. I could say that I lived with my eyes turned to the past. The doubts, the dreams that had tortured me at home, left me no respite. What sort of painter had I wanted to be—and perhaps without success? I was young and I did not look on art as a profession or a way of making money. Pictures didn't seem to me to be made decoration. For me, art was a sort of mission, or perhaps I should say a philosophy, a creation exceeding the subject or the eye.

In my pictures there are no anecdotes, no fairy tales, no legends.

Maurice Denis told the French Synthesists in 1889 that their canvases were flat surfaces covered with colors applied in precise arrangements. To the cubists a painting was a flat surface covered in methodically combined structures. For me a painting is a flat surface displaying the representation of objects, animals, or human beings in a manner in which neither logic nor story content has any importance. The important thing is the visual impression the composition makes. Any other nonstructural consideration is secondary. My first concern is to build up my picture architecturally, just as the impressionists and the cubists did in their own ways, using the same structural means. The impressionists filled up their canvases with blobs of light and dark areas, the cubists with cones, triangles and cubes. In my paintings the subjects and figures are handled as shapes, shapes ringing as harmonies, passionate shapes intended to introduce a new dimension that neither the geometry of the cubists nor the blobs of the impressionists can match.
We were always against whatever might be "literary." But have we enriched ourselves with a new language or found a new direction? Wars and revolutions take place because men try to bring about some new line of clear and flawless conduct. When we have found it we shall see the birth of a new language of art, a new shape to things.

Marc Chagall

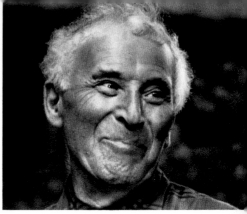

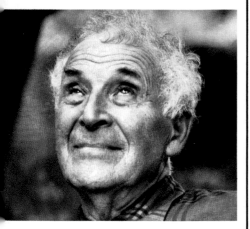

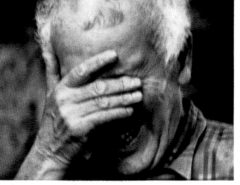
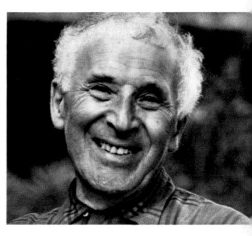
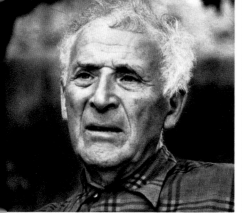
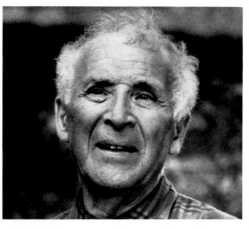

1

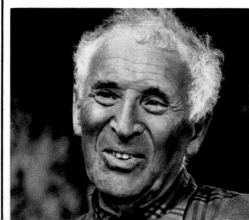

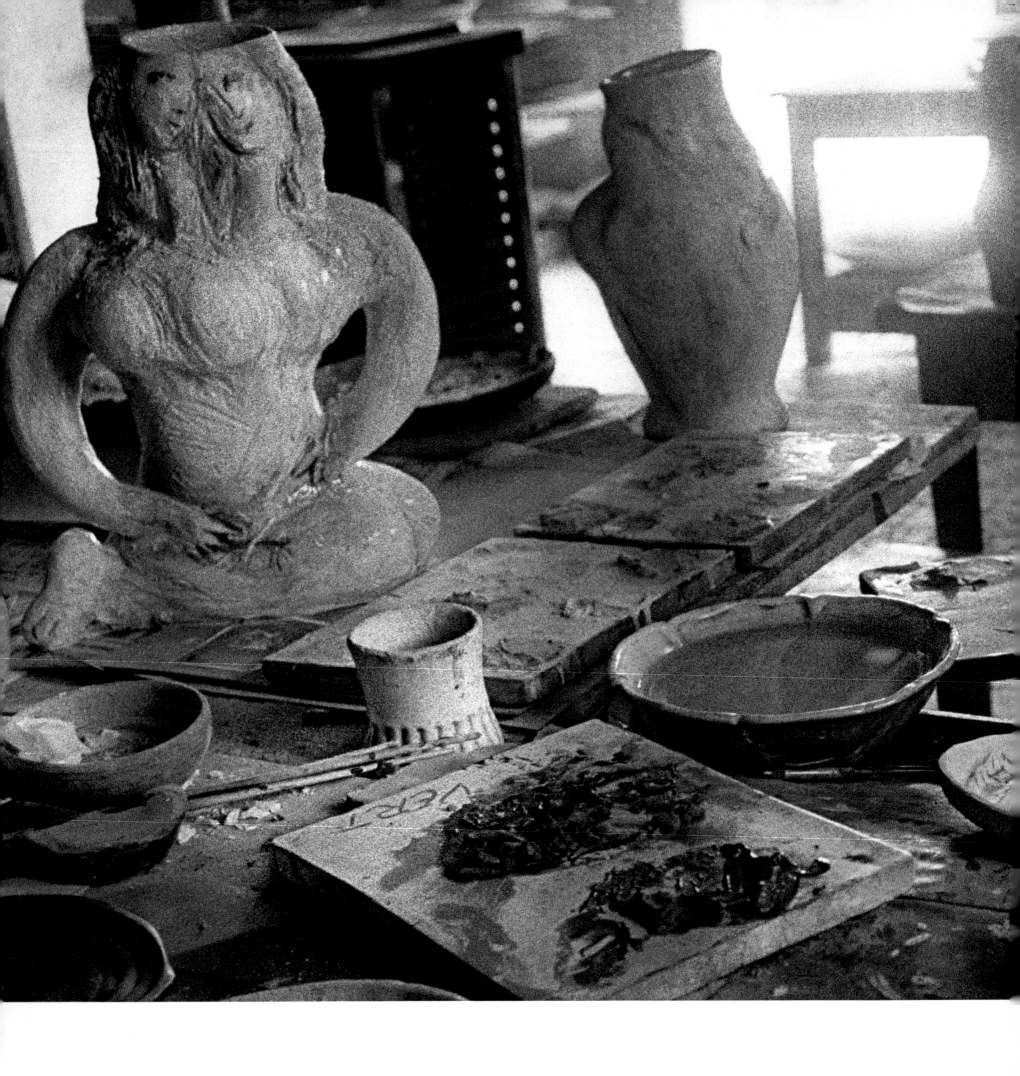

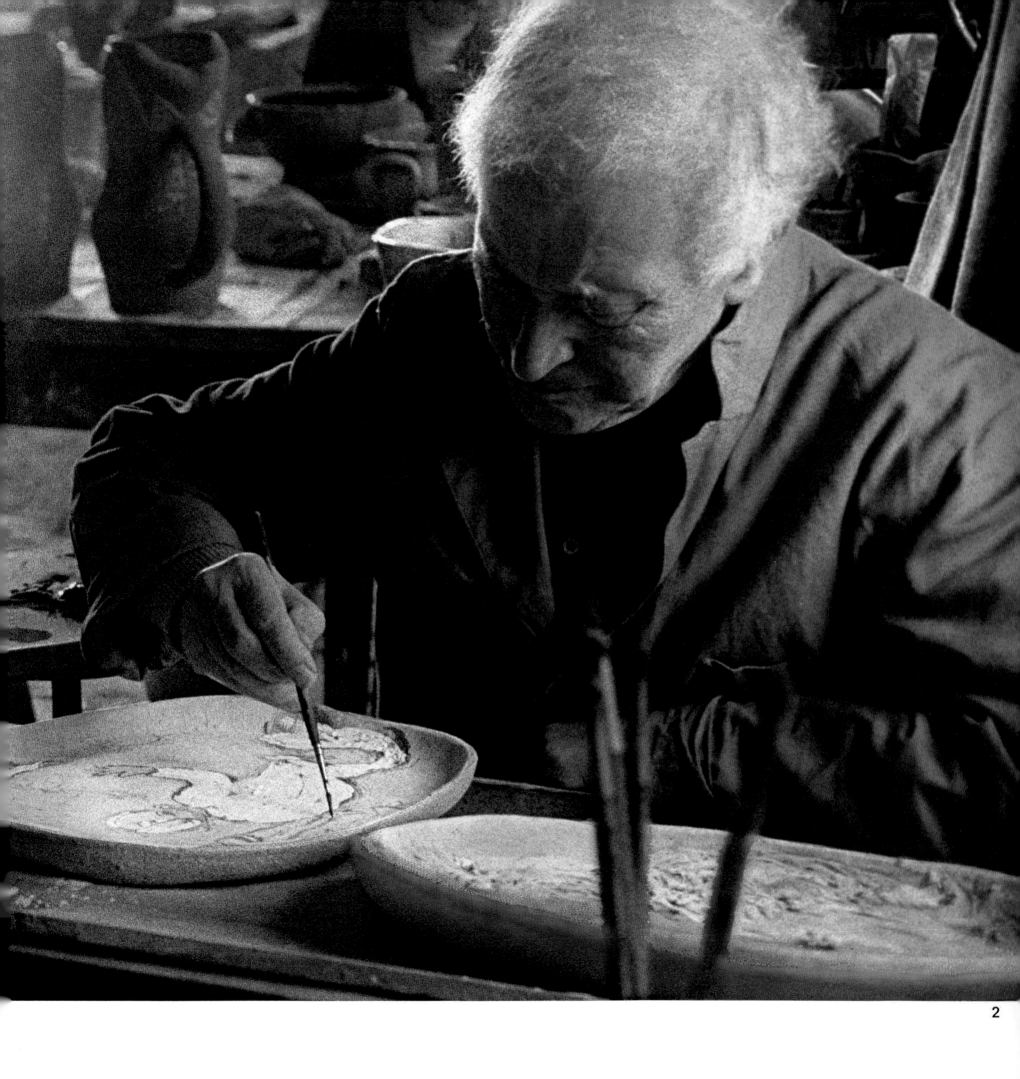

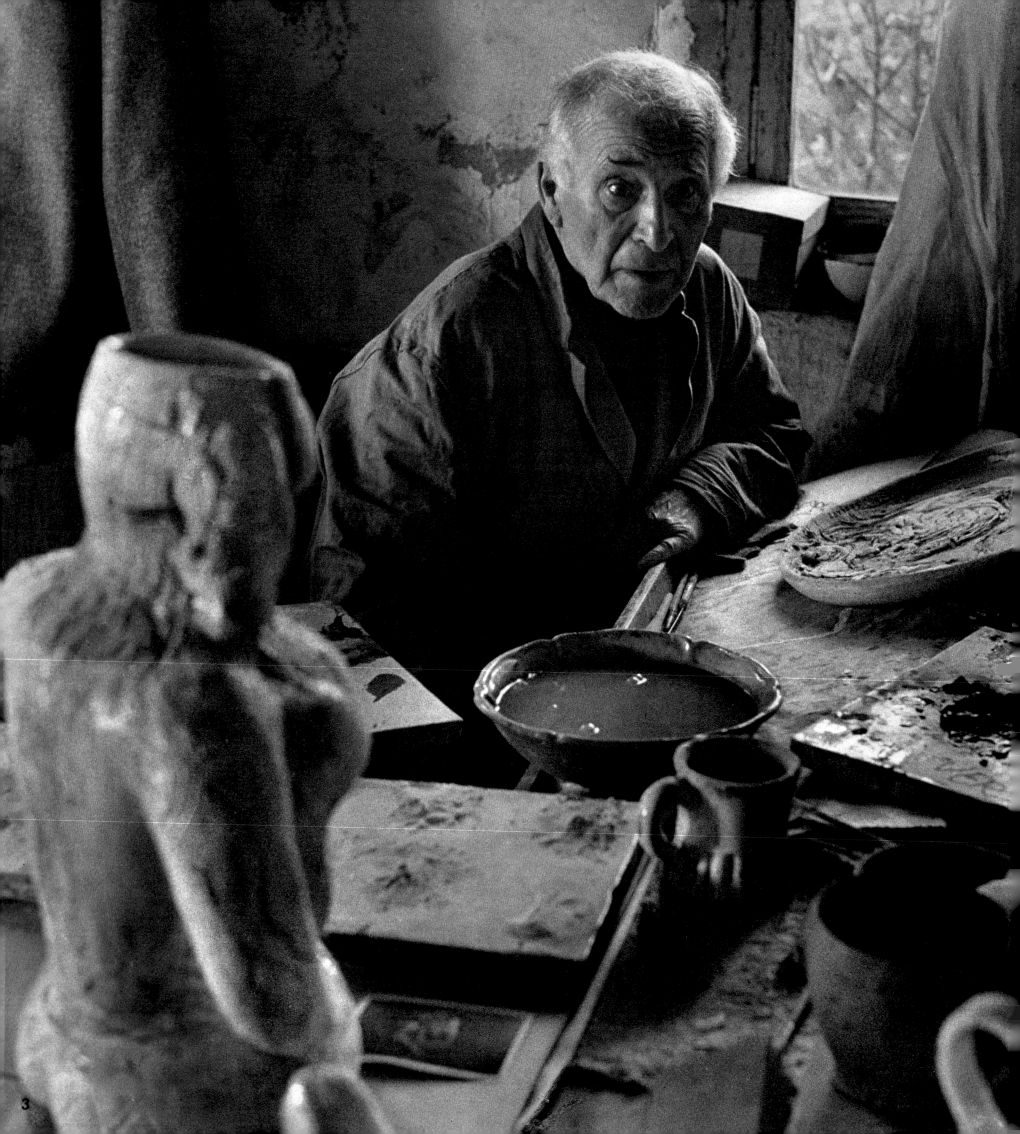

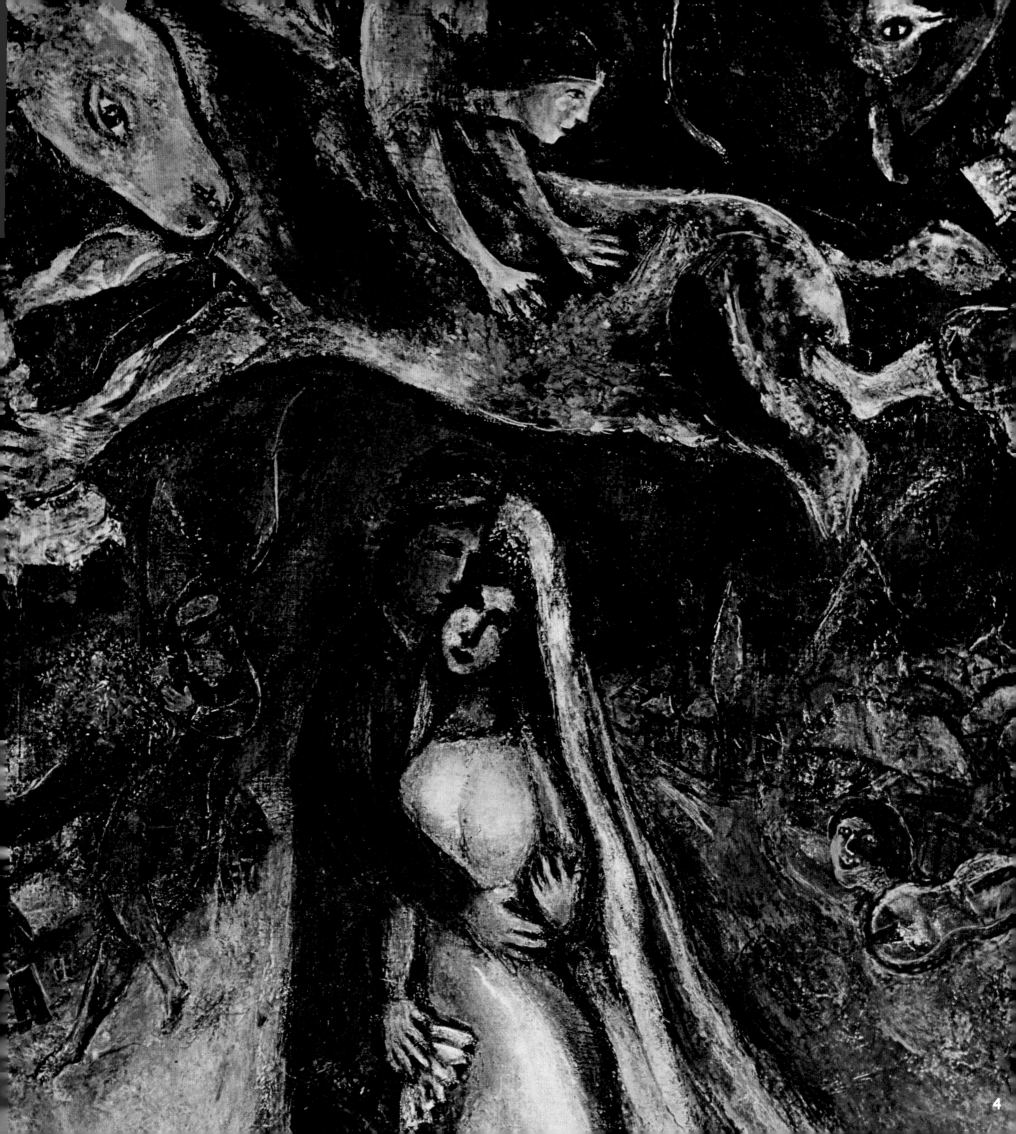

4

5 6

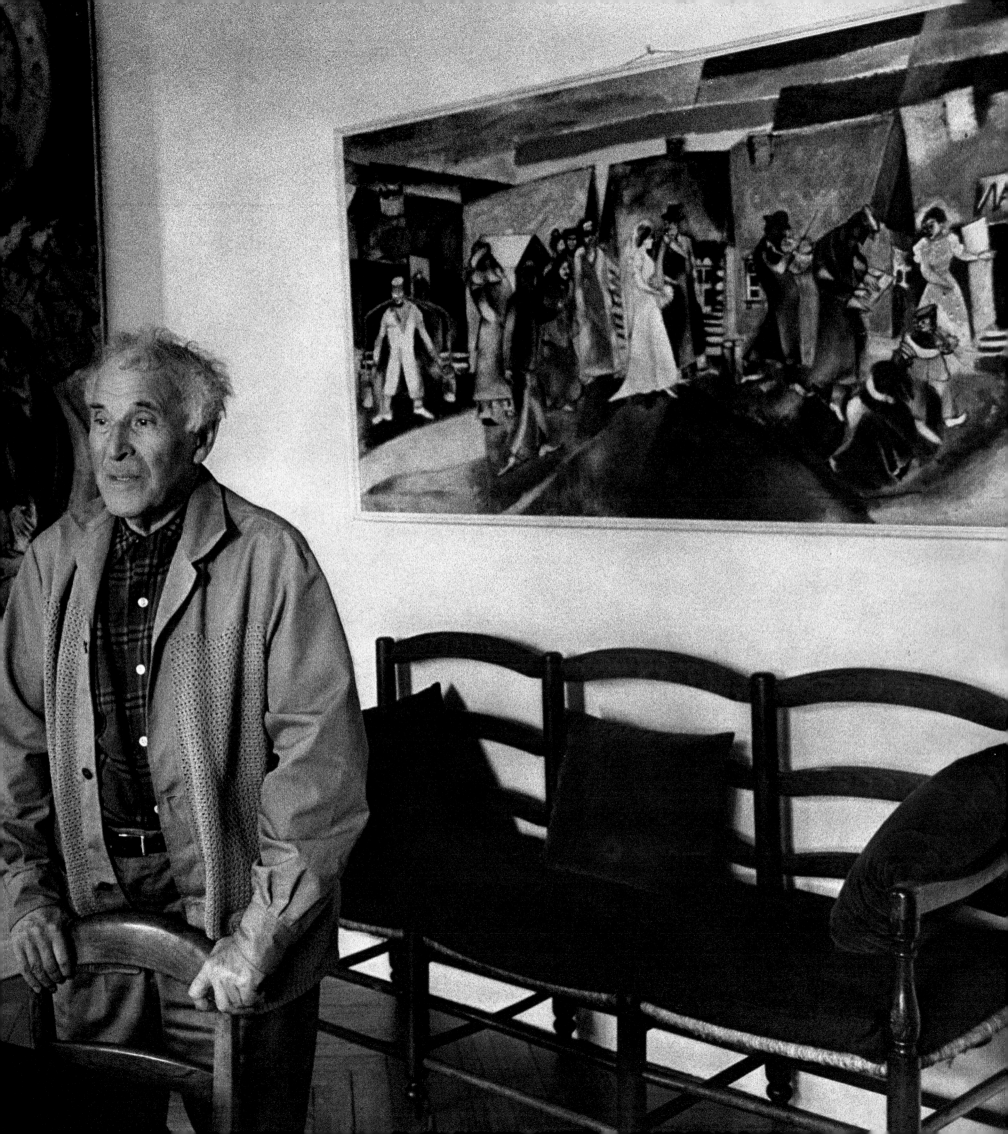

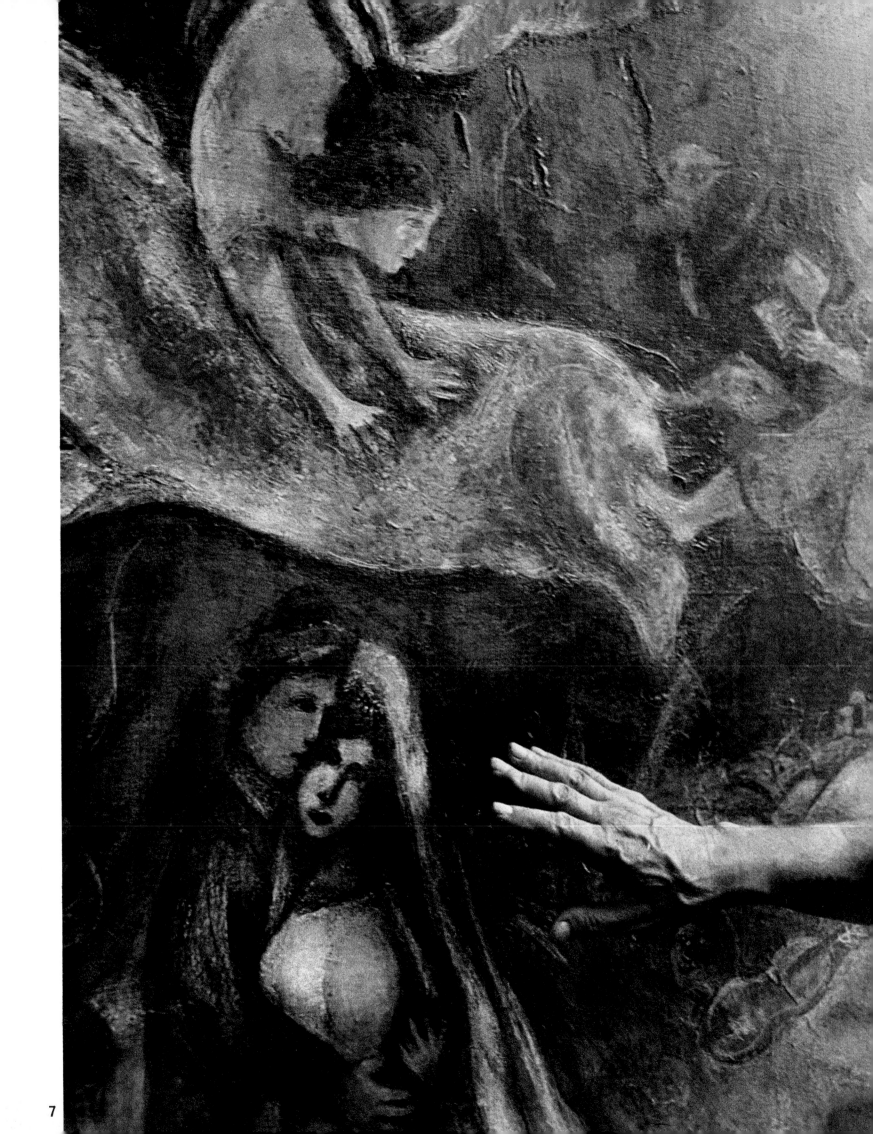

marc chagall

1. . . . I don't remember his body; Chagall is all head.

2. The master works at the owner-artisan's bench in Madoura's studio at Vallauris, creating ceramics.

3. During a break in his labors Chagall asked : "Which of us can visualize his destiny and his art in their entirety?"

4. The lovers, detail from *Cheval Rouge*, 1938-1944.

5. Chagall teaching in Vitebsk during the Russian revolution.

6. Chagall in his home in Saint-Paul-de-Vence. "This artistic revolution troubled me with its prodigious display of dynamism that only man can wholly pierce."

7. "And God blessed Noah and his sons, and said unto them. Be fruitful, and multiply, and replenish the earth."

1887 *Born July 7 at Vitebsk, Russia, of a pious Jewish family. At the end of elementary schooling, became pupil in studio of Jehuda Pen, an academic painter whose teaching he soon was unable to endure.*

1907 *Left for St. Petersburg. After spending time in two different schools, entered the Swanseva school. His teacher, Léon Bakst, introduced him to French painting: Cézanne, Van Gogh, Gauguin.*

1909 *Made acquaintance of Bella Rosenfeld, who later became his wife.*

1910 *Journeyed to Paris. Saw works of Van Gogh.*

1911 *Settled down at the Ruche. Met Montparnasse artists Léger, Delaunay, Archipenko at the Dôme, and writers including Apollinaire.*
Participated in Salon d'Automne and Salon des Indépendants, Paris.

1914 *Exhibition of works in Berlin. This greatly influenced German painting of the period.*
Went back to Russia when war was declared.

1915 *Married Bella Rosenfeld on July 25.*

1918 *Appointed Arts Commissar at Vitebsk, where he founded a school.*

1919 *Took part in first exhibition of Revolutionary Artists (where he was represented by fifteen large canvases and some dravings).*

1920 *Decorated the Theater of Jewish Art, Moscow.*

1921 *Wrote and illustrated his autobiography, My Life.*

1922 *Left Russia.*
Learned technique of engraving in Berlin.
Settled in Paris again. Made acquaintance of Vollard (for whom he illustrated Gogol's Dead Souls with etchings).

1924 *First retrospective show, at Galerie Barbazanges, Paris.*

1926 *Vollard ordered gouaches from him to illustrate Fables de La Fontaine.*

1927 *Planned gouaches on circus themes.*

1930 *Vollard asked him to illustrate the Bible, for which he made etchings after visiting Palestine (1931).*

1931 *French edition of My Life.*

1932-1937 *Traveled through Holland, Spain, Poland, Italy.*

1939 *Awarded prize by Carnegie Foundation.*

1940 *After moving to unoccupied zone at Gordes, he left for the United States,*

where he found many French artists and intellectuals : Léger, Masson, Breton, etc.

1942 *Went to Mexico where he designed settings, stage sets, and costumes for Tchaikovsky's ballet Aleko.*

1944 *Death of his wife, Bella, September 2.*

1945 *Designed stage settings and costumes for Stravinsky's Firebird, presented at the Metropolitan Opera Company, New York.*

1946 *Retrospective show at Museum of Modern Art, New York.*

1948 *Returned to France.*

1950 *First ceramic works at Venice.*

1951 *Second visit to Israel.*

1952 *Remarried. With his new wife, Valentine (Vava) Brodsky, traveled in Greece while preparing lithographs for Daphnis et Chloé.*

1957 *Third visit to Israel—for inauguration of Maison Chagall, Haifa. Executed large ceramic work and stained-glass windows for church of Assy in Savoy.*

1958 *With his settings and costumes, opens Daphnis et Chloé at Paris Opéra. Already doctor honoris causa of Glasgow University, he was awarded Erasmus prize in Copenhagen, and title of* doctor honoris causa *by Brandeis University.*

1960 *Completed stained-glass windows for Metz Cathedral.*

1961 *Executed stained-glass windows for Hadassah Synagogue, near Jerusalem (first exhibited at Musée des Arts Décoratifs, Paris).*

1964 *Completed work on new ceiling at the Paris Opéra.*

1965 *Executed murals for the new Metropolitan Opera House, Lincoln Center, New York.*
Made doctor honoris causa *of the University of Notre-Dame.*

1966 *Maquette for Jerusalem Parliament (ceramic wall).*
Settled in Saint-Paul-de-Vence.

1967 *Visited the United States again.*
Inauguration of his stained-glass windows for the Rockefeller Chapel, New York.
First presentation of The Magic Flute *at the Metropolitan Opera, with settings and costumes by him.*
The Louvre paid him tribute with exhibition: "The Biblical Message of Marc Chagall."

zadkine

At Les Arques, the shape of the stone you picked up was unimportant; what counted was the attraction you felt for one stone over another. And if you were unable to close your hand over it, Ossip Zadkine was delighted. After leading me through the woods that surround his house, we came upon the stone seat which the sculptor called his "Bench of Friendship. "By adding a stone, each friend and visitor continued to extend it.

All around the "Bench of Friendship" were trees : oaks, which Zadkine had seen grow up, and which now cast their panoply of green over the entire hillside. Zadkine pointed out the gnarled roots that had worked up through the ground—earth masks, carved out by ants—and his face seemed to dissolve into an elfinlike expression. Suddenly I had the feeling, looking at him, then at the woods and at the trunks and roots of the trees, of the inspiration that guided his chisel; the suggestion of

a sprite with dancing feet,
and the vision of a lean
half-man, half-tree,
clasping the lyre of Orpheus
to his breast.

And then,
everywhere in the woods
I was aware of trunks,
torsoes,
Zadkine's chiseled women,
who, like the living stumps of trees
seemingly
confide their ecstasy
to the earth.

At the time of my visit, it was more than thirty years since Zadkine had acquired his manor house at Les Arques. He spent the sunny summers there with his painter wife, Valentine Prax, leaving behind the Paris studio near Montparnasse which they called "Folie d'Assas" for the street in which it was situated.

Here in the barn, which had become a second studio, Zadkine's attention was currently concentrated on a portion of a great elm that had been felled in a storm.
He shall be Orpheus, his breast his lyre !

Accordingly, under the impact of the sculptor's chisel the elm trembled into life again, became a man. Straining every nerve, the poet Zadkine breathed life and soul into the wood, watching it respond; watching it grow into a newly born image.

Surrounding his newest creation was Zadkine's private collection of his own sculptures. And, back in the shadows, were the original plaster casts, granites, bronzes, wood carvings, bearing witness to his life's work. These pieces were destined to be the first tenants of a Zadkine museum.

To be seen in the studio were *Le Joueur d'Accordéon*, *Le Guitariste*, and *Le Trio Musical*, all of which felt the steely breath of Cubism during his 1915-1920 period. Representing the next ten years were the more romantic *Vénus* and *Discobole*; and for the years 1937-1938, Zadkine's radiant tributes to the poets Apollinaire, Lautréamont, and Rimbaud.

Along a sunlit wall were ranged *La Prisonnière*, in which the artist paid respects to the enemy-occupied France of 1943; *Le Poète* (1954) graven with Paul Éluard's verses; *La Ville Debout*, a cast of the masterpiece that towers over the harbor of Rotterdam, expressing the horror of man's inhumanity to man. Here too was the *Monument à Van Gogh*, which, after receiving a battery of criticism, was carted through Paris on truck to find a setting at Auvers-sur-Oise.

Next in line to join the distinguished collection : *La Forêt Humaine*, from the bronze in Jerusalem, and *La Force Atomique*.

Paris, August 1966

Born for larger journeys than this life has to give,
I never land on earth unless the step I take
impales me on a hundred thousand flowers.
With my eyes bound by the metaphor of colors
I dream of a single grain of sand,
the humble heir of our protean mountains,
and seed of earth's yesterdays.

I no longer see my way
toward the flotsam of my imagination.
Where is the genius of my impertinence,
of my heart laid bare?
What do my eyes see at all,
stuffed as they are with sunlight?
I'm winning back my dullish diffidence,
welcomed by a sunless day.
No more mountains!
Only a poor little grain of sand,
confirming the vanities of time.
What shall I ask for a tomb?
That same simple stony speck
whose invisible rock-crystal edge
reflecting it, perks up the sun's last blazing.

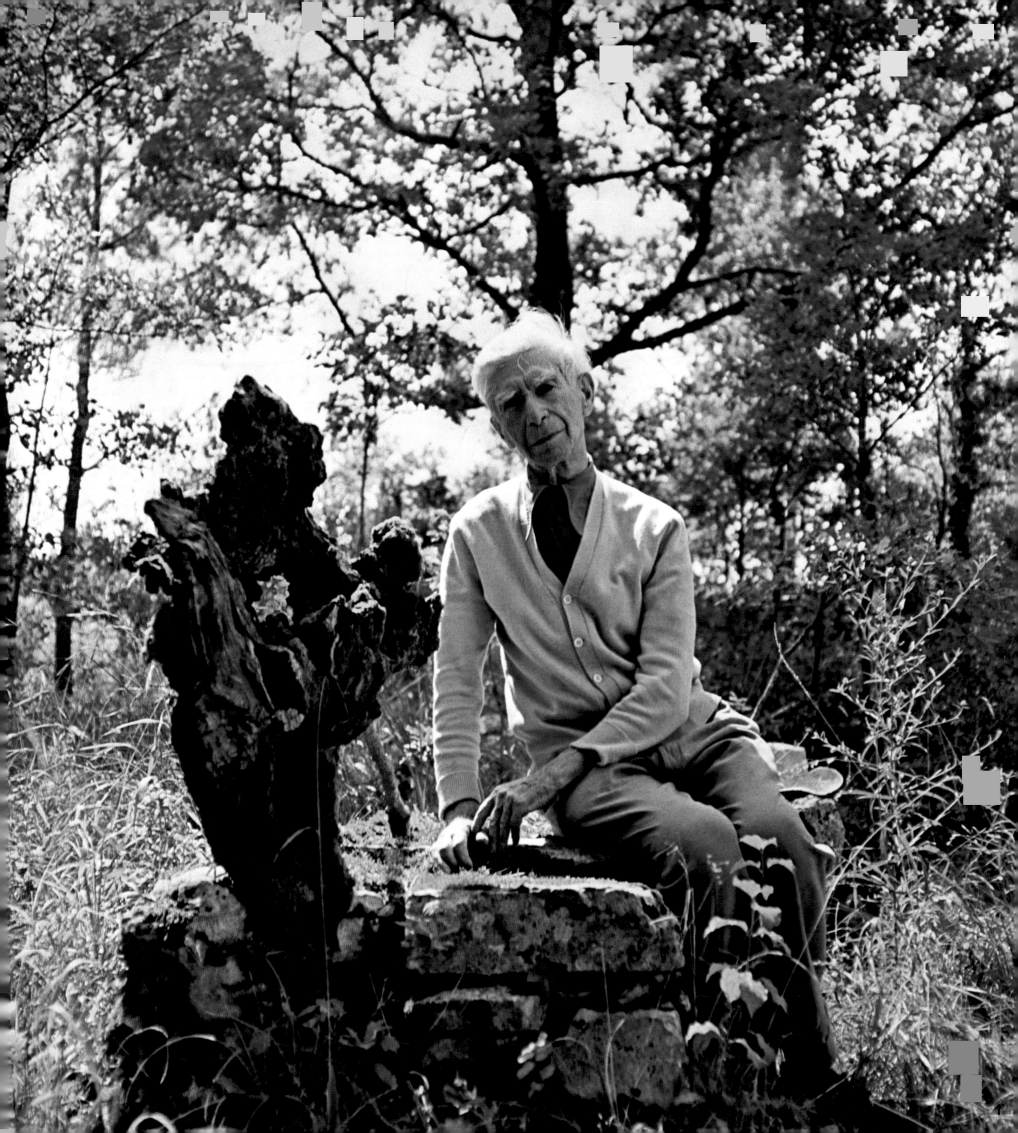

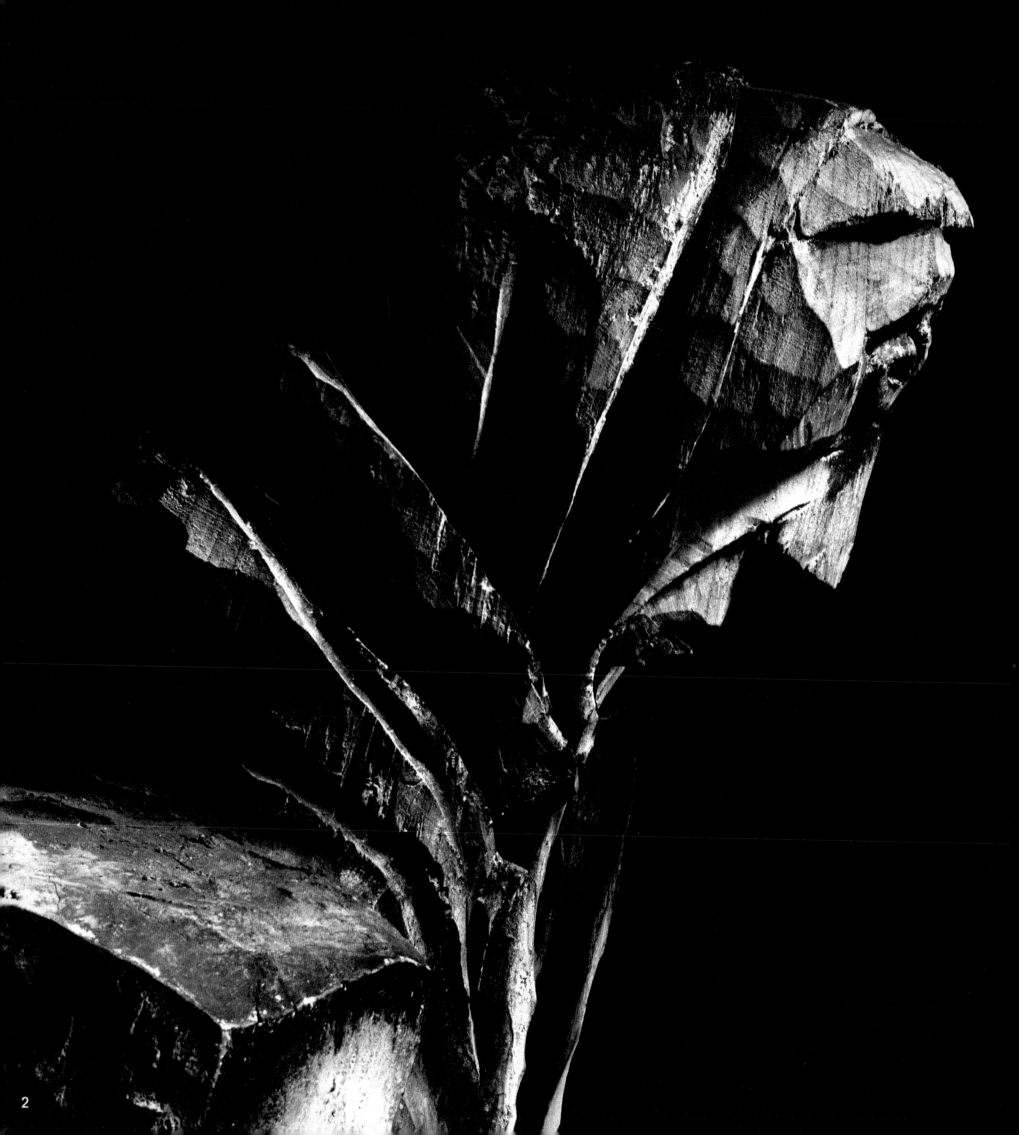

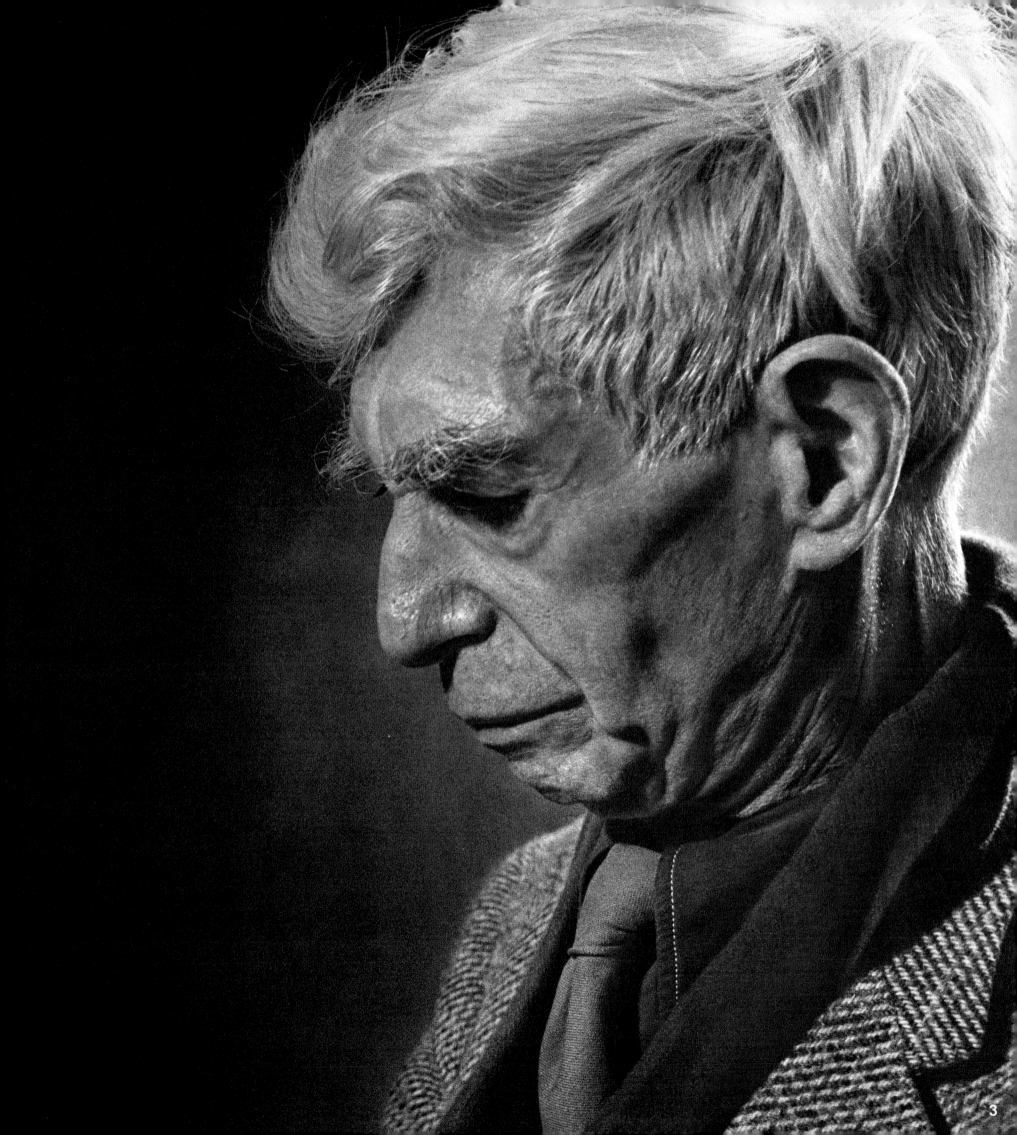

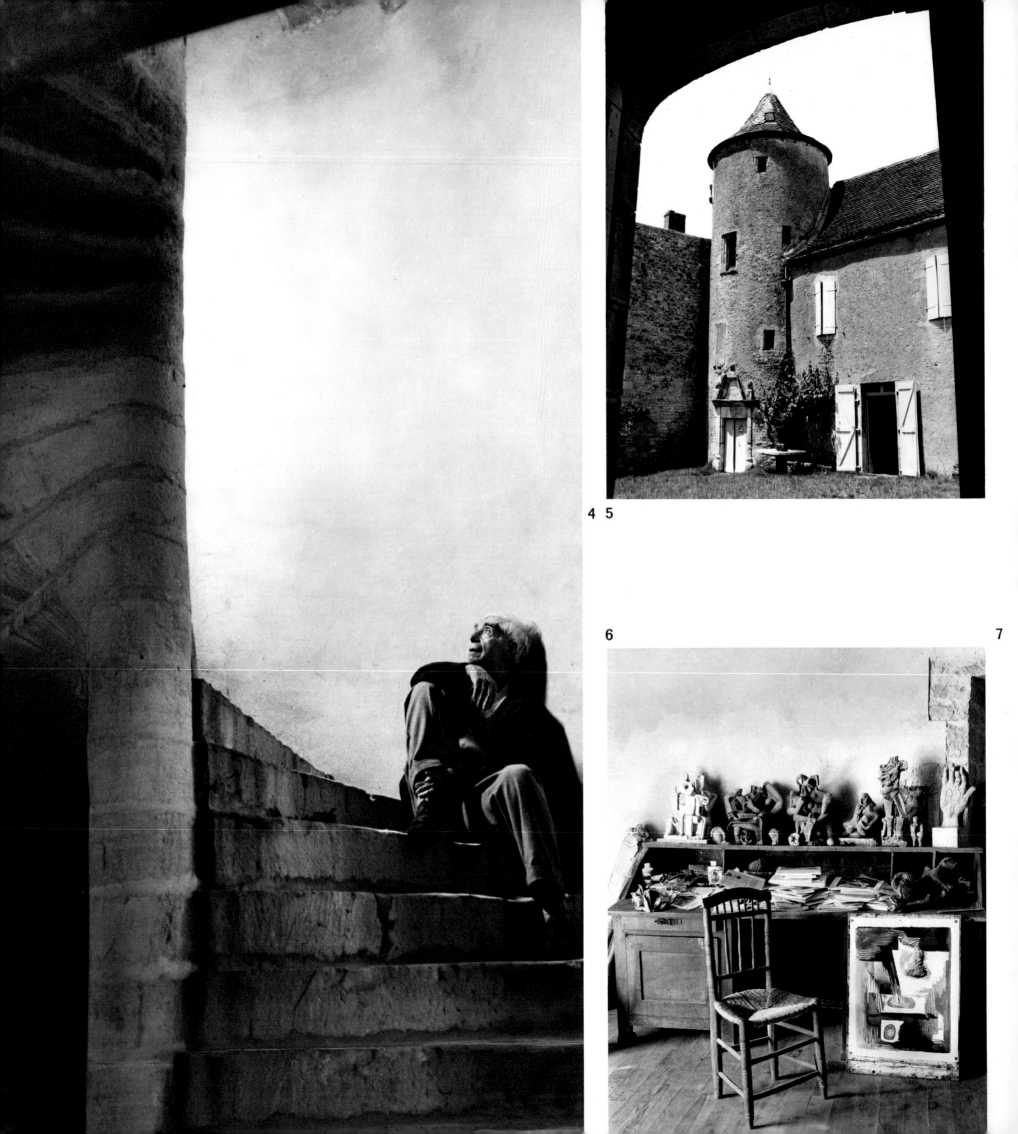

4 5

6 7

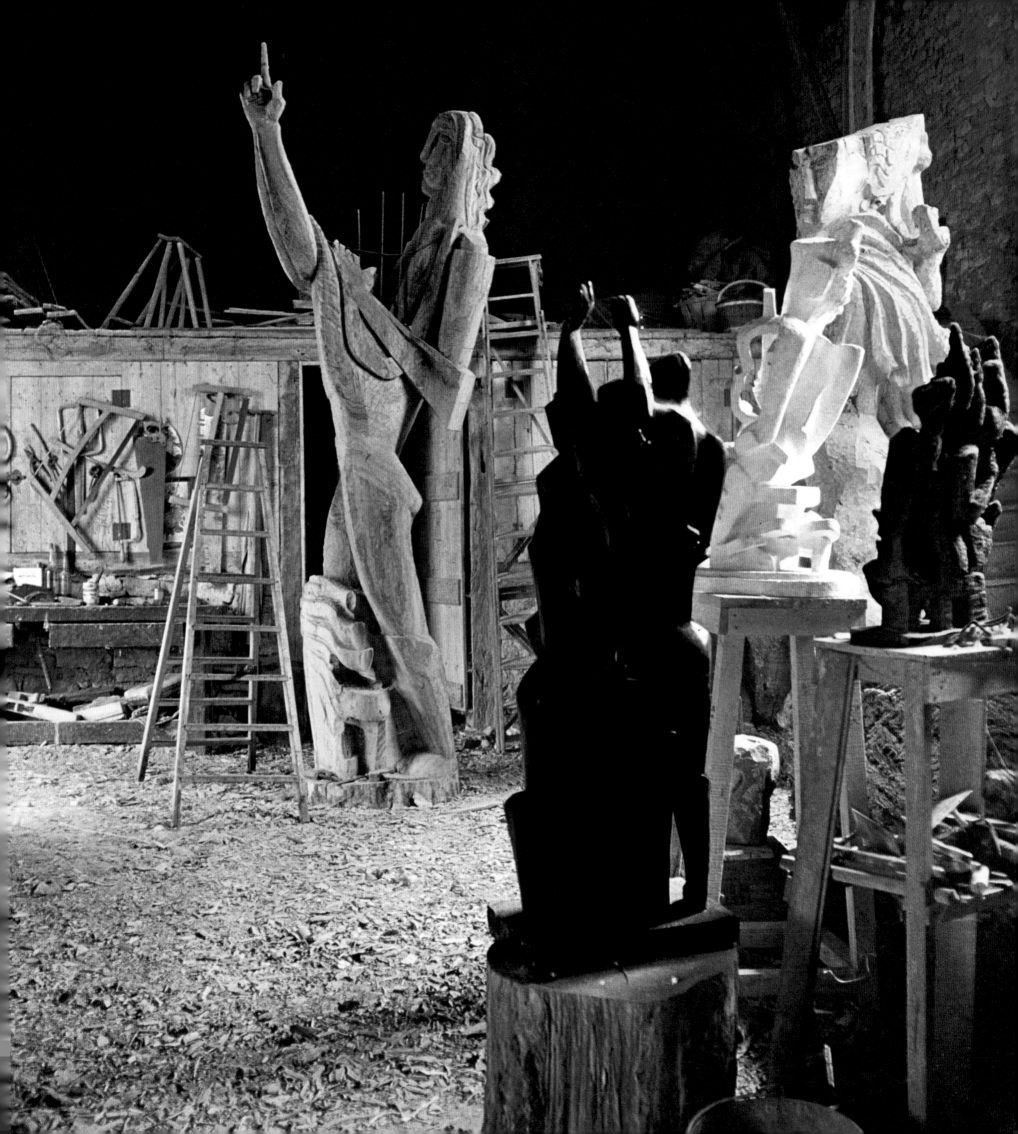

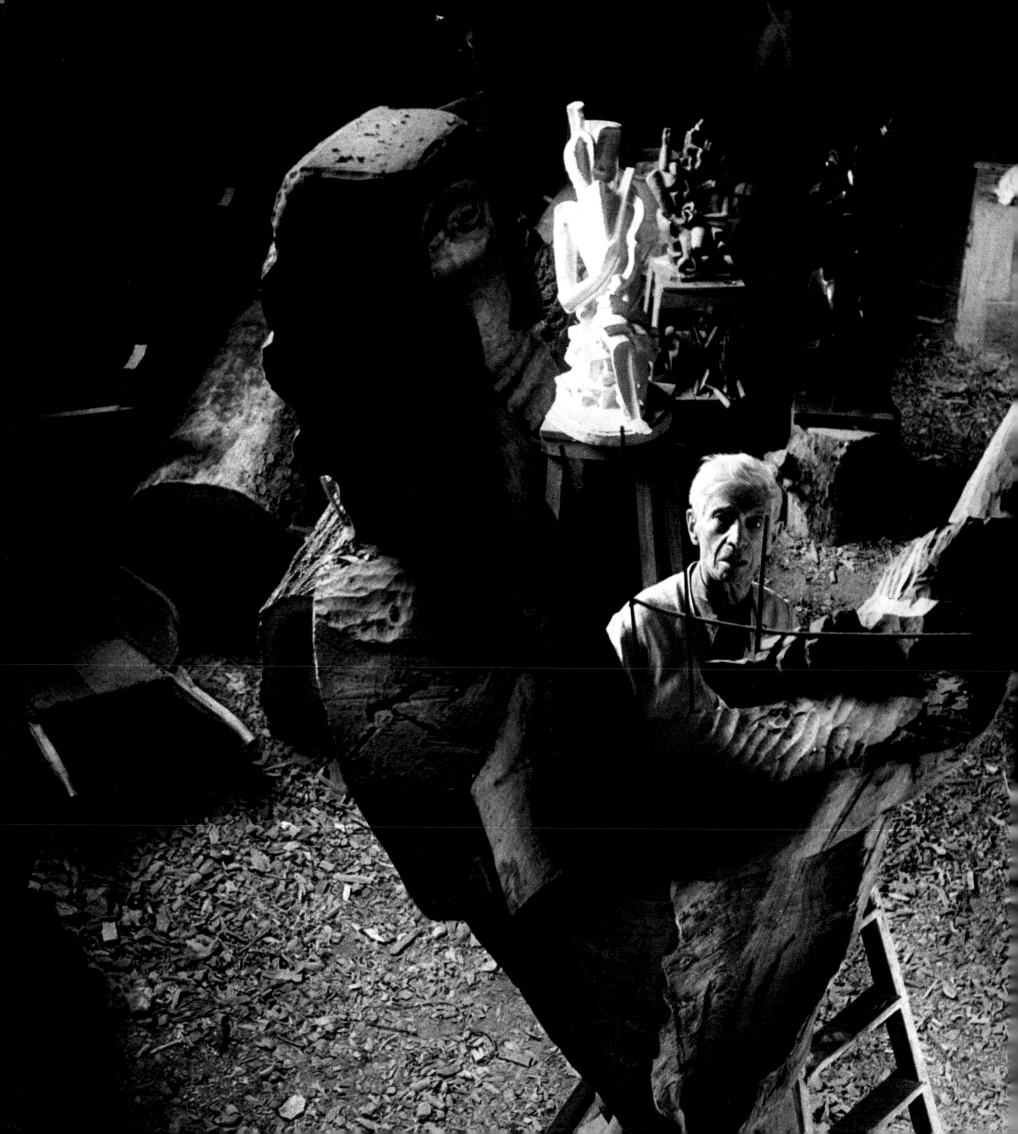

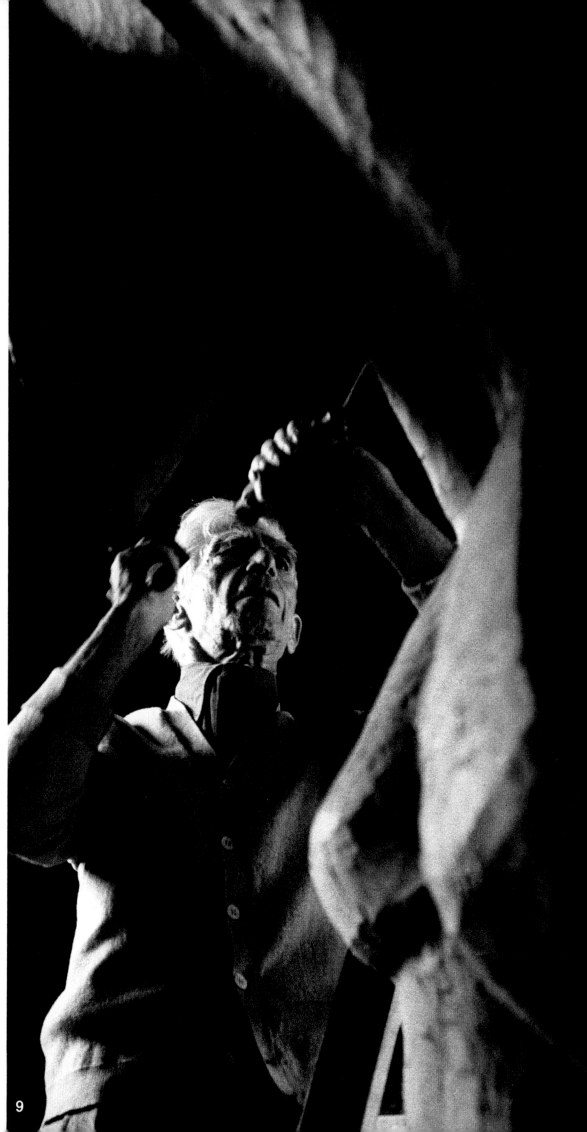

8 9

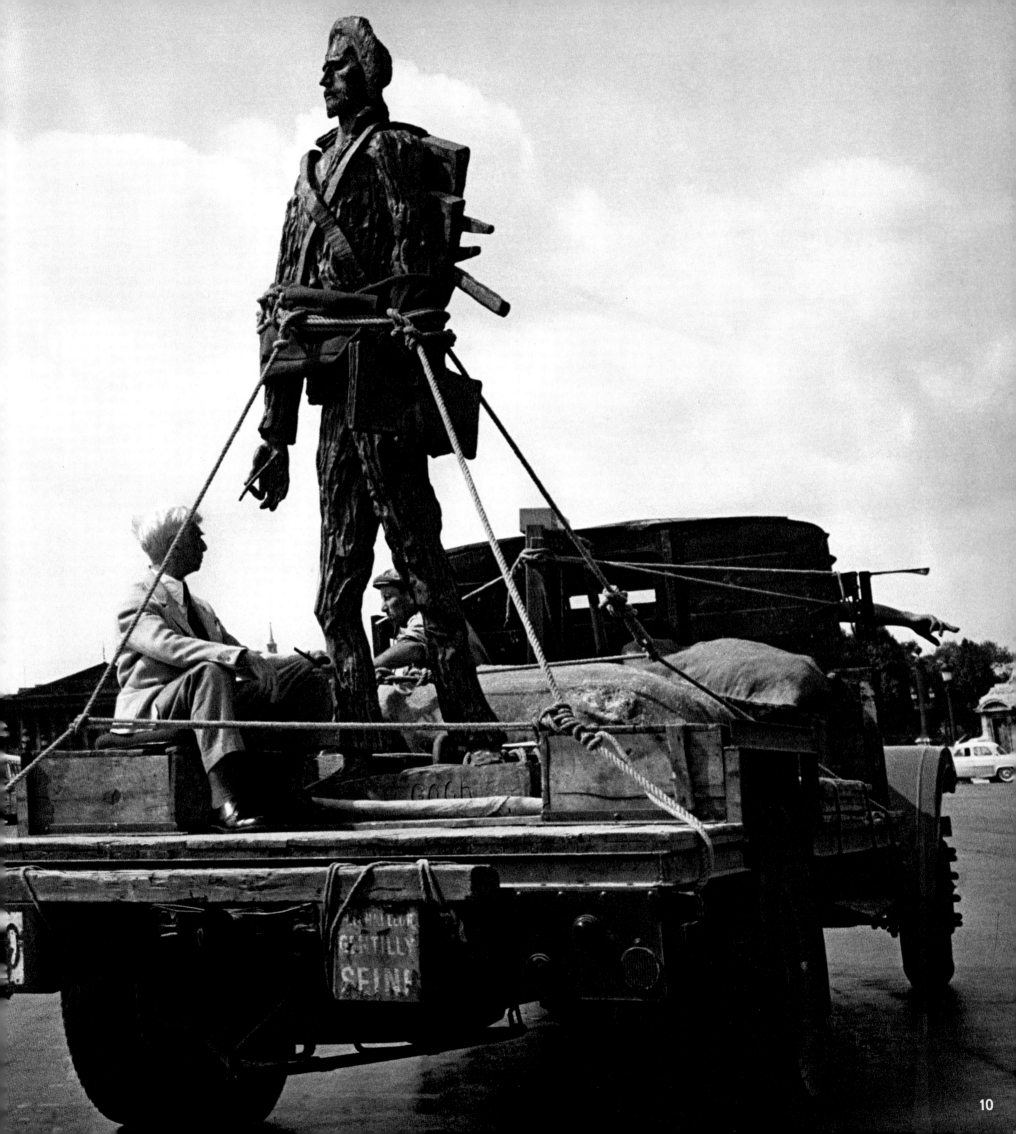

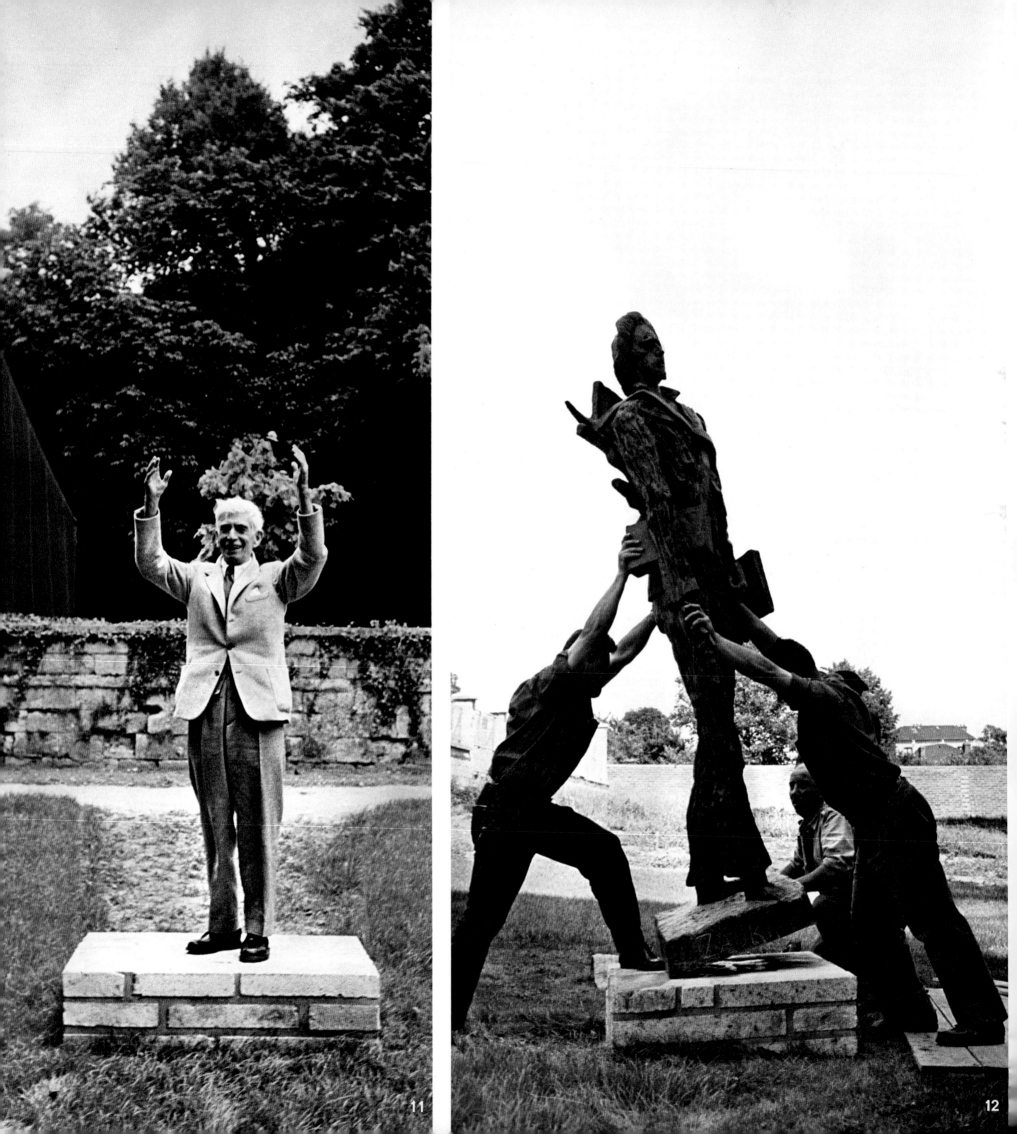

11

12

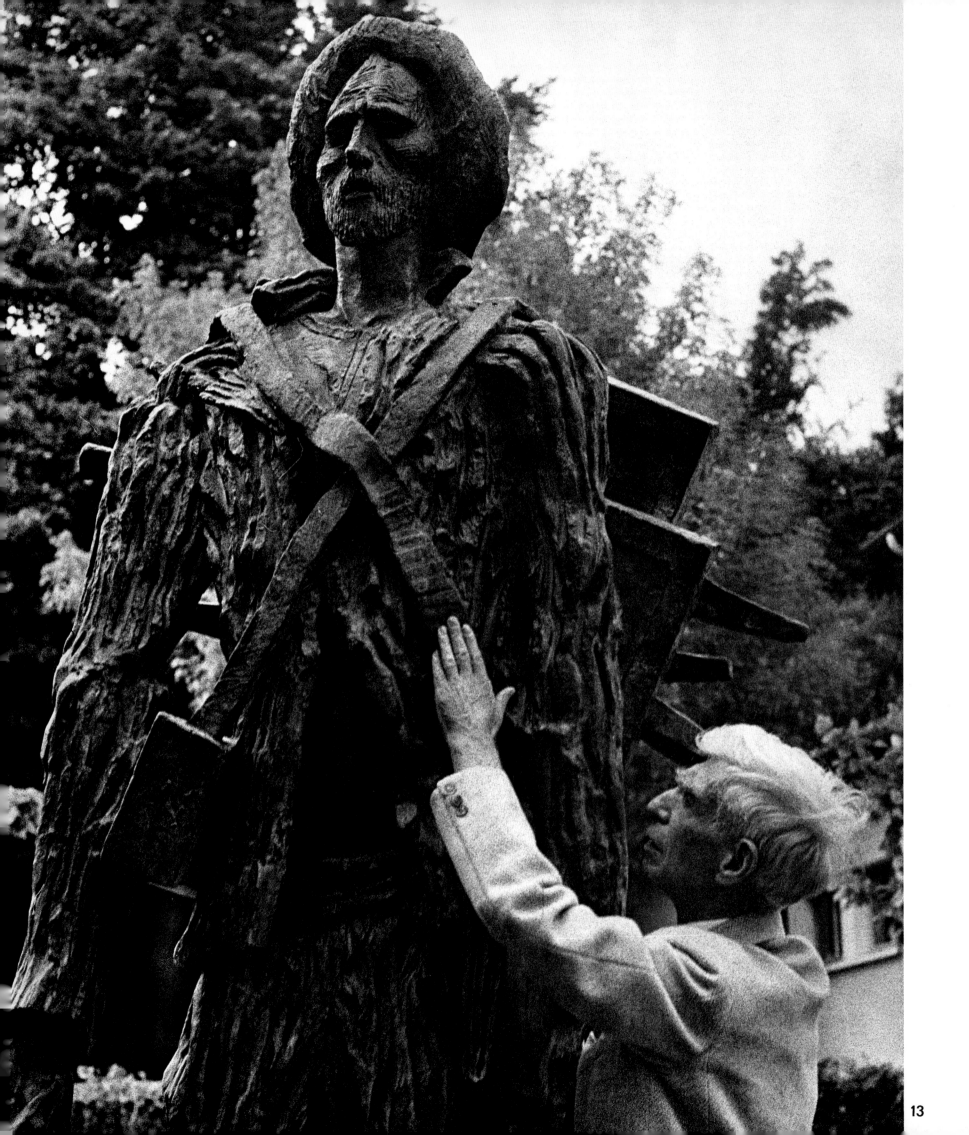

13

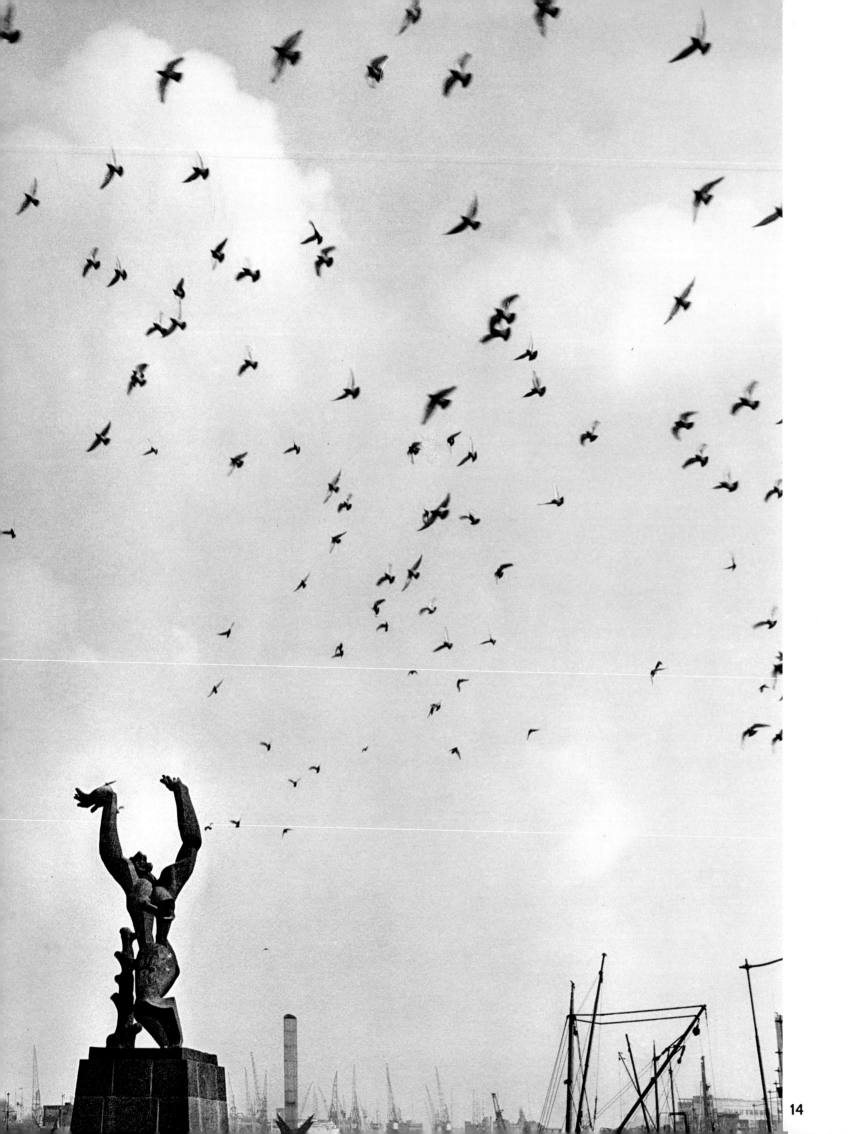

ossip zadkine

1. Zadkine seated on his "Bench of Friendship" at Les Arques, facing a tree stump that became a mask.

2-3. The artist and his features as projected into his *Pietà*.

4-5. Zadkine seated in the manor house at Les Arques.

6-7. Row of models for earlier sculptures, and, in the barn-studio, the great *Orphée* in elmwood.

8-9. Zadkine at work. As if racked with uncertainty he chips away at the torso of *Orphée*.

10. The "tribute" Paris paid Zadkine's *Van Gogh*. Ever optimistic, the happy sculptor is seated on the flatbed of the truck as it makes its way to Auvers-sur-Oise.

11-12. Zadkine is joyous as he welcomes the return of the old satanic painter.

13. . . . and breathes a little life into him.

14. Zadkine's masterpiece, *La Ville Détruite*, towers over Rotterdam's harbor as sea gulls swoop and swirl like death-dealing planes over the city.

1890 *Born July 14, in Smolensk, Russia. His mother was of Scottish origin.*

1905 *Sent to England to a Sunderland school where he improved his English and learned modeling.*

1906 *Left for London (against parents' wishes) and worked as an apprentice in a furniture factory.*

1907 *After a brief visit to Russia, returned to London. Became a pupil at Regent Street Polytechnic School and Central School of Arts and Crafts.*

1909 *Returned to Russia. Saw Chagall. Decided (with father's approval) to go to Paris. Became a pupil at École des Beaux-Arts but rebelled at academic teaching.*

1910 *Began to work independently in studio at the Ruche.*

1911 *Saw Roman gateways at Moissac and Autun, and was deeply stirred by them.*

1912 *The "great days" of Montparnasse. He haunted the Rotonde and the Dôme in the company of Apollinaire, Max Jacob, Cendrars, Brancusi, Picasso, etc.*

1915 *Enlisted in French army (and was gassed in 1916).*

1919 *Exhibited (with moderate success) at the Galerie Le Centaure, Brussels, and in Paris at the Rue La Boétie. Lasting friendship started with André de Ridder.*

1920 *Married Valentine Prax.*

1924 *Exhibition at Takenodai Gallery, Tokyo.*

1926 *Exhibition at the Galerie Barbazanges, Paris. The seventy sculptures proved sufficiently successful to free him from materially worries for a while; but his health was poor.*

1927 *Joined group exhibition of new artists at the Galerie Le Centaure, Brussels. Worked for a time in London.*

1928 *Set up new studio at 100 bis Rue d'Assas (which he kept up until his death).*

1931 *Spent summer in Greece, a dazzling revelation. (His Travel Notes were to be published in 1955).*

1933 *Retrospective exhibition (139 sculptures) at Brussels' Palais des Beaux-Arts.*

1934 *Bought house at Les Arques.*

1940 *Because of Jewish origin, obliged to escape German occupation of France. Left for the United States, where he worked until the end of the war, exhibiting and lecturing to earn a living.*

1945 *Returned to his adopted country, France, where he had to start all over again (his house at Les Arques plundered; his Paris studio still partly occupied). Became professor at Académie de la Grande Chaumière (a position he held until 1958).*

1950 *Awarded Grand Prix for sculpture at Venice Biennial.*

1951 *Deeply upset by horrors of war. Carved the memorial La Ville Détruite for Rotterdam, bombed in 1940 (Leuvehaven Quay, Rotterdam).*

1953 *La Ville Détruite unveiled in Rotterdam.*

1954 *Traveling exhibitions in Germany.*

1956 *Traveling exhibition in Canada and the United States. Made series of Van Gogh portraits. (The monument at Auvers-sur-Oise cemetery was one of the most moving.)*

1958 *Retrospective exhibition at Maison de la Pensée Française, Paris.*

1960 *Awarded City of Paris Grand Prix for sculpture.*

1962 *Lectured at École des Beaux-Arts, Paris.*

1963 *Retrospective show, "The Works of Zadkine," at Casino of Knokke-le-Zout, Belgium (140 sculptures, tapestries, lithographs, gouaches, and sketches).*

1964-1967 *Many exhibitions all over world including in the U.S.S.R., his native land.*

1967 *Died November 25.*

The sun-bird rises from the sea and darts toward the hill, curves to avoid the windmill, pierces the square of light framed by the studio window and, scarcely out of breath, ends its flight on a rectangle of paper set out for it by Miró. Ruffling feathers iridescent with sea spray, the sun-bird scatters the dewy drops, fixing all their intense blue forever on the paper, and wipes its beak right and left, striking in the rungs of a ladder by which, no doubt, it will ascend again to the sky. It hops once, twice, to mark its ownership, cocks its head to listen for the painter's footsteps and, when Miró appears, flies off trailing the shimmering gold of the morning light.

As Miró continues drawing, he *becomes* the bird. He squirts black gouache into its footprints; then stars appear, illuminating the whiteness of the paper.
Miró places a smooth, round red stone on the paper to keep it from flying off, and goes away. At once, the stone seems to draw erect, displaying its color and taking its place in the composition.
Thus Miró "seems" to work, today assisted by the sun-bird; yesterday his hand was guided by the brilliance of the moon-bird. Imagination becomes reality in the artist's mind, and he communicates the excitement in symbols of color.

This Catalonian artist, in order to be close to his world, has dug his feet deep into the red dust of the hill of Calamayor, which overlooks the beach at Palma de Majorca. In 1956, the architect Josep-Lluis Sert built Miró a large studio close to the house in which the painter lives with his wife, Pilar. The studio is of strictly functional design, allowing the maximum of light to penetrate into the working area. Along the walls paintings of different sizes, meticulously arranged, seem to be measuring each other's importance, proud in their black pictographs. Bird-women, dragonfly-women freely uncoiling from dark silhouettes flit past each other like green moons surrounded by yellow sparks.
An alphabet of symbols scampers wildly about, impetuously exploring areas of madness.
On a table, the artist's brushes, like impotent bystanders, stand guard over tubes of colors which lie there on their sides with screwed-up eyes, ready at an instant touch to shatter the calm of a canvas with lightning flashes of vermilion.

And all the while, grazing the roof, the great sun entwined in palm fronds bought at the Barcelona Palm Sunday fair watches everything, squinting with the effort.
A seventeenth-century farmhouse, recently incorporated into Miró's estate, has also been elevated to the rank of a studio. The two-story building has walls of golden stucco and includes several large flagstone-paved rooms on both floors, spacious enough to let the artist allot a particular spot to each sketch or picture which is still in the process of development. Miró works there from very early in the morning, the sun laying down its long bright rectangles of light through the windows and wide-open doorways.

Each room contains mementos, souvenirs of Miró's early life. This treasured childhood accounts largely for the dazzling purity of Miró's art. There are family photographs, multicolored boxes, glass balls, open fans, collections of tiny colored clay animals which are actually little whistles called *xiurelles*, and Catalonian figurines, all forms of folk art from which Miró is never separated. Here, there is a ship's anchor, there, random pebbles, tortuous roots gathered from the beach, scrap iron selected from dustbins, old woven baskets full of holes, and other objects assembled by Miró with a puckish sense of humor. Many of these objects are given a new life, transformed into monumental silhouettes charcoaled on walls, into sculpture; or they may serve as models for ceramics in which his potter friend, Artigas, may take a hand.
Besides his masterful use of color and the never-ending fountain of his imagination, part of Miró's genius lies in his ability to reveal the humility in his heart to the most casual eye and in the strength he draws from his native soil.
To watch Miró paint is to share his silences. After each brush stroke with which he creates a symbol or pursues the delineation of a line, Miró walks away from the canvas and sits down on the floor.
His closed mouth becomes a tight hard line, his face a mask, through which his keen eyes roam over the wide stretches of the canvas, while his spirit organizes the ballet of the configuration to come. The sun turns to shadow, and again Miró picks up his brush; his arm darts out like that of a swimmer and color seems to burst from his fingers like lightning.

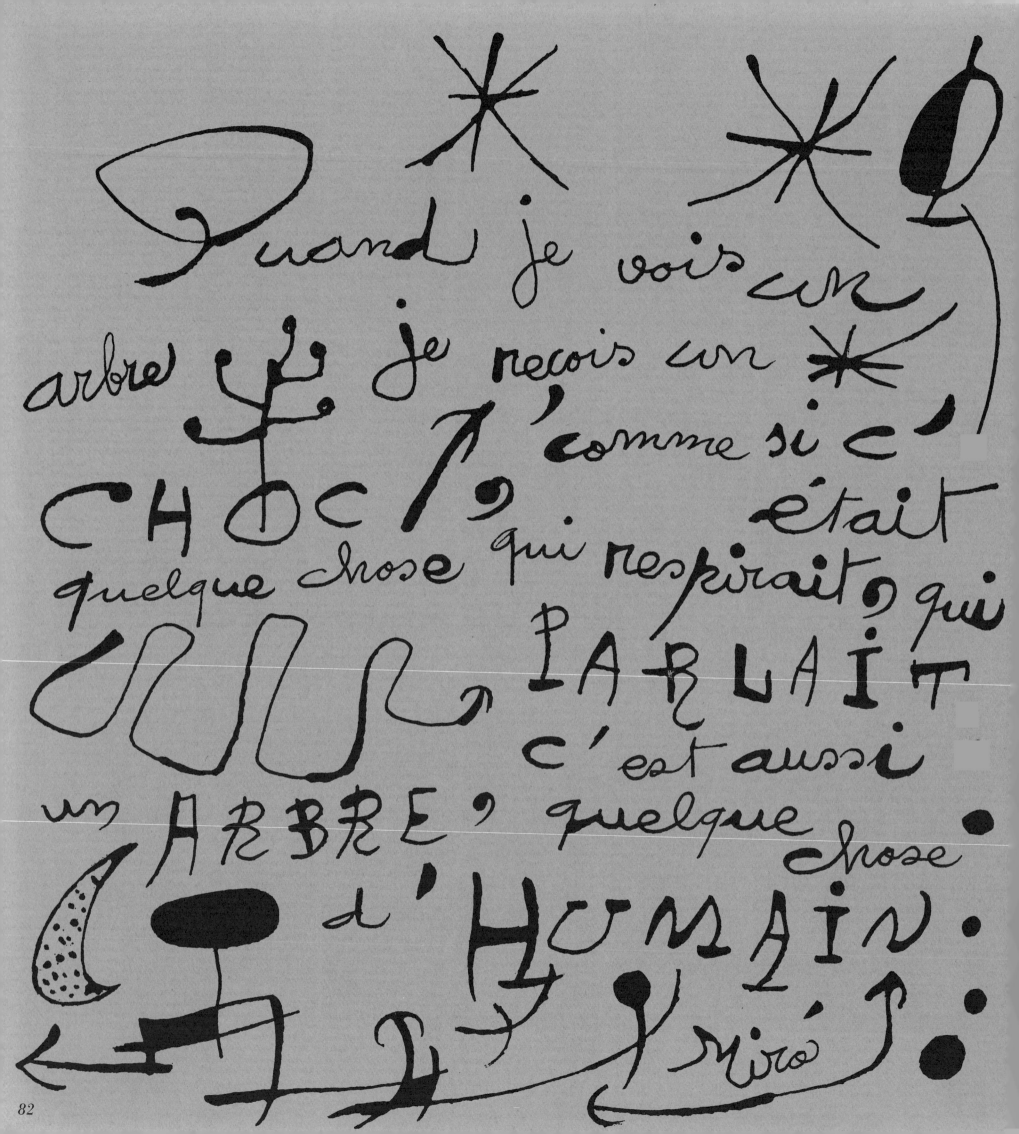

Quand je vois un arbre [...] je reçois un [...] comme si c'était quelque chose qui respirait, qui PARLAIT c'est aussi un ARBRE, quelque chose d'HUMAIN :

Miro

82

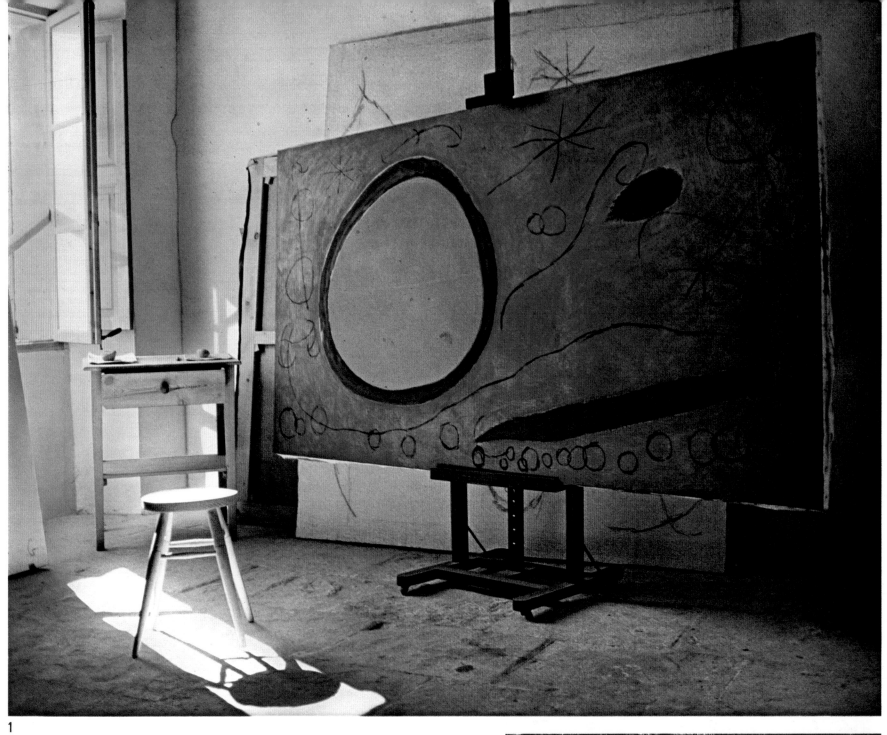

1

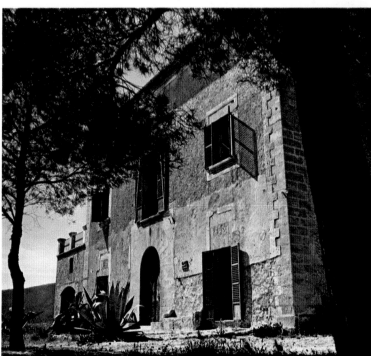

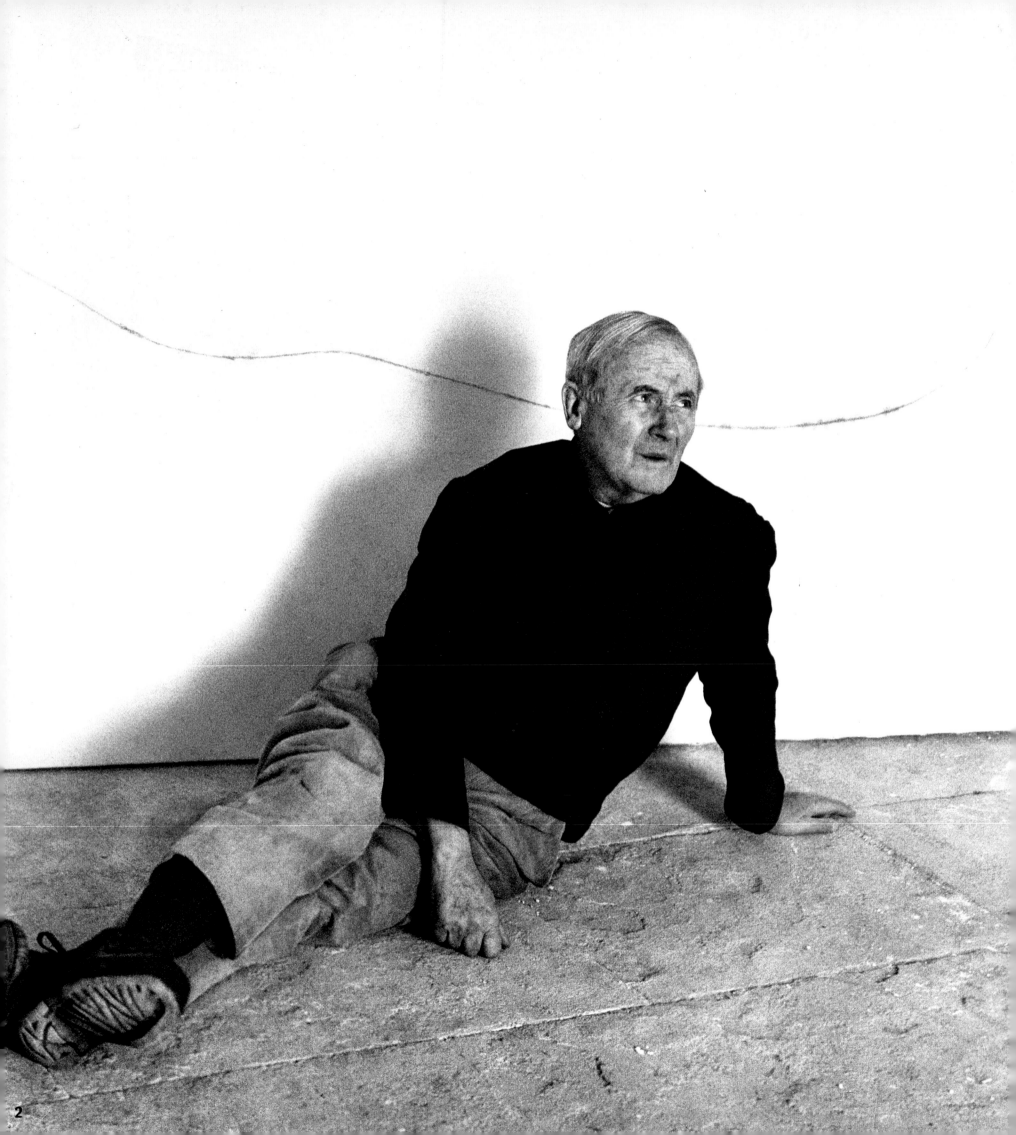

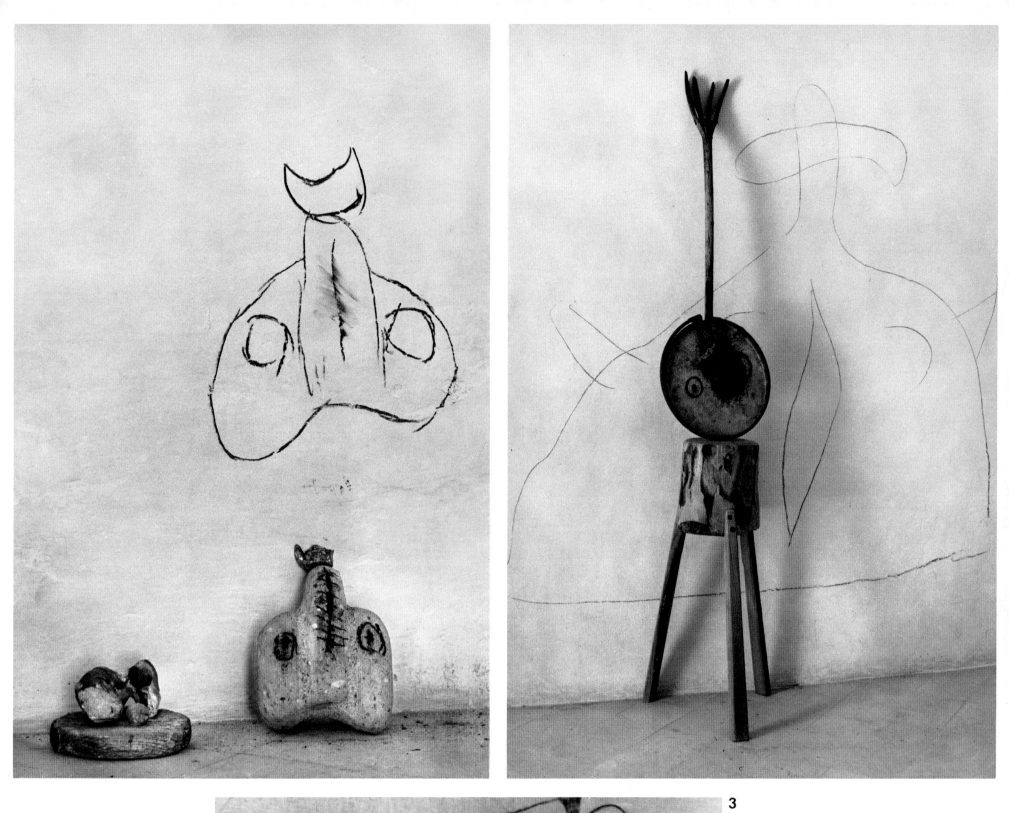

3

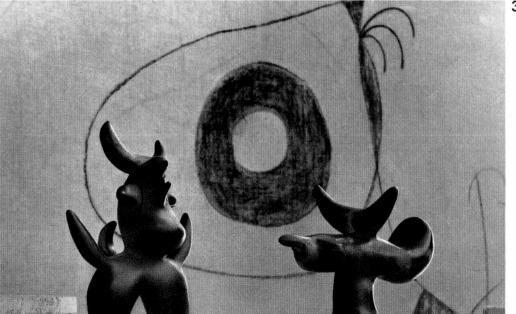

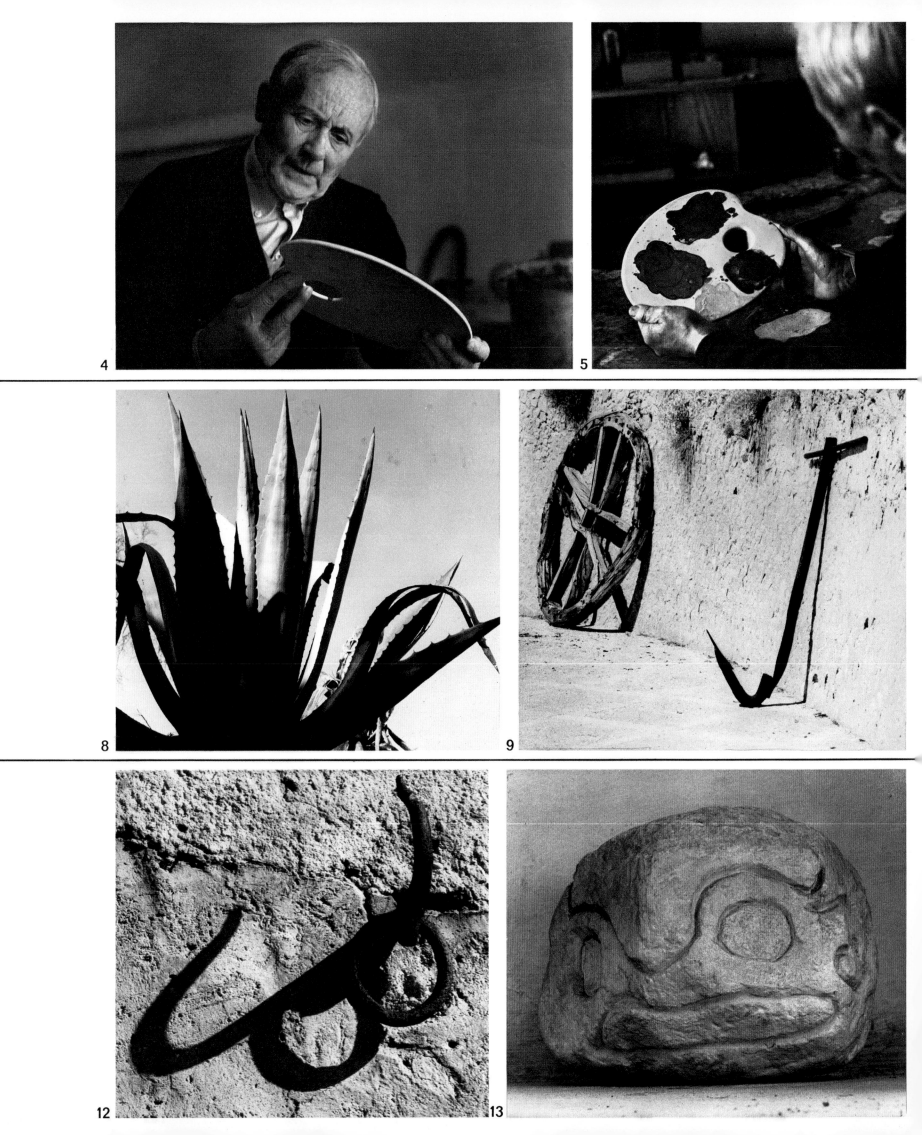

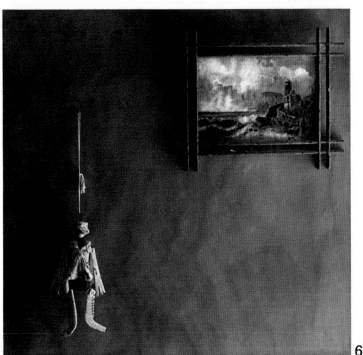

6

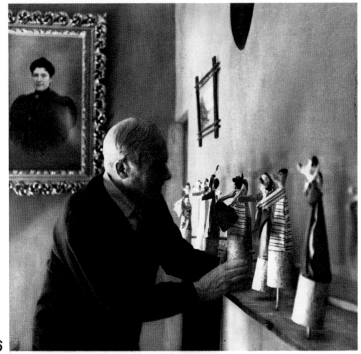

7

10

11

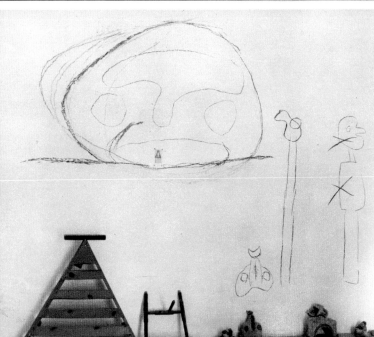

14

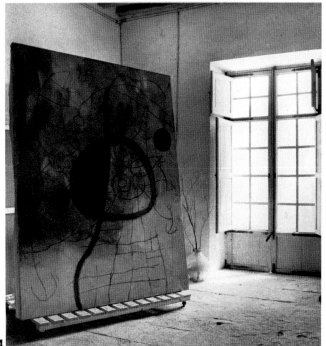

15

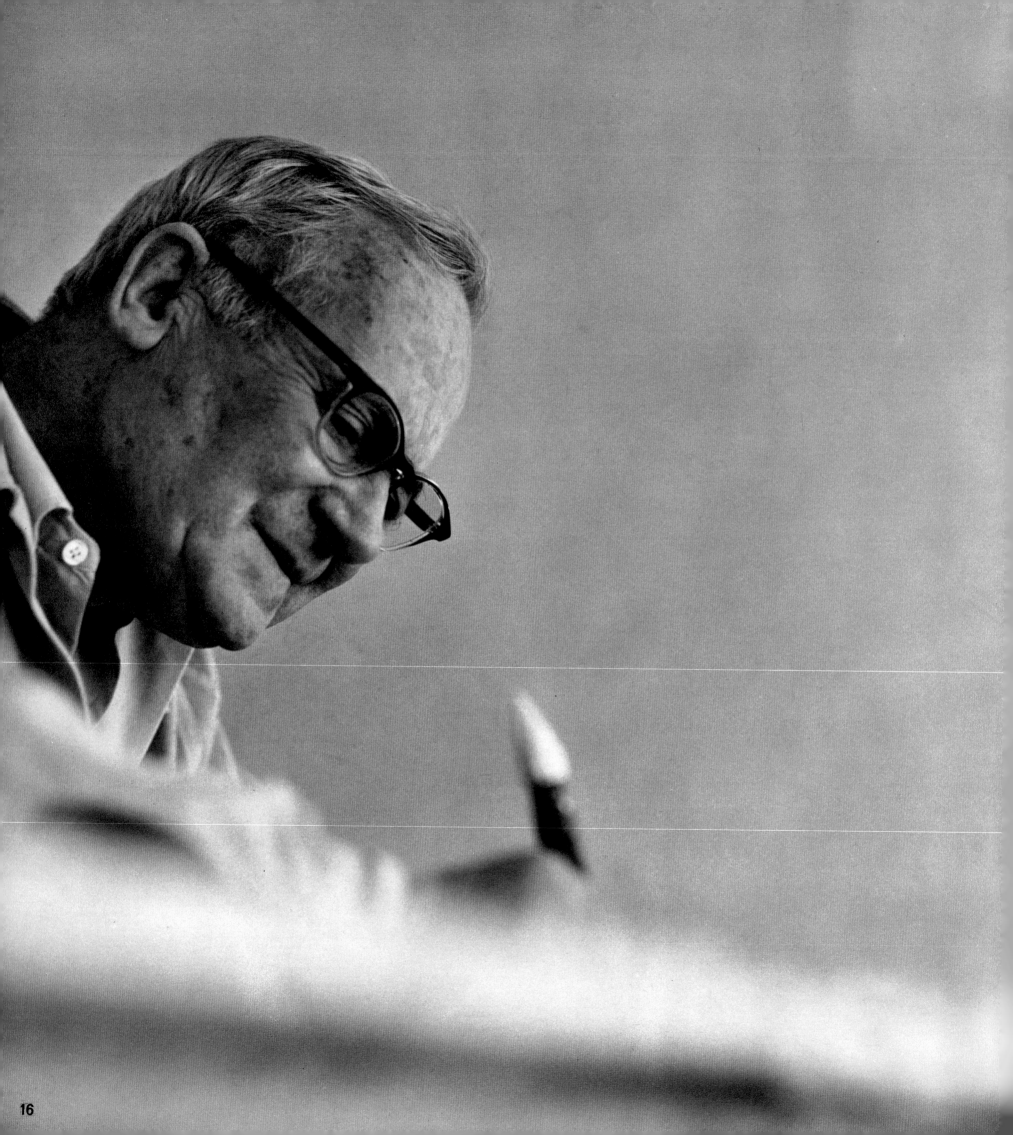

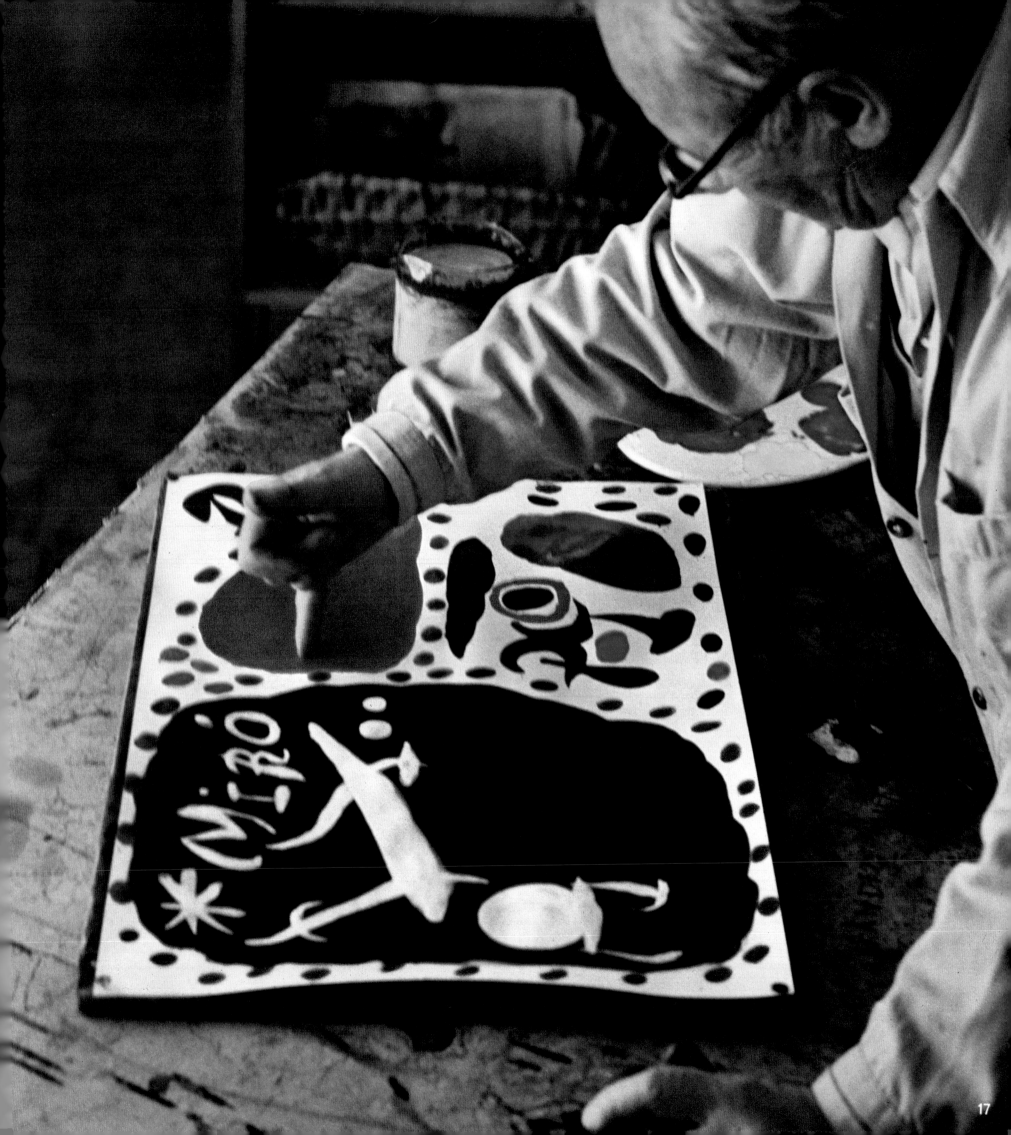

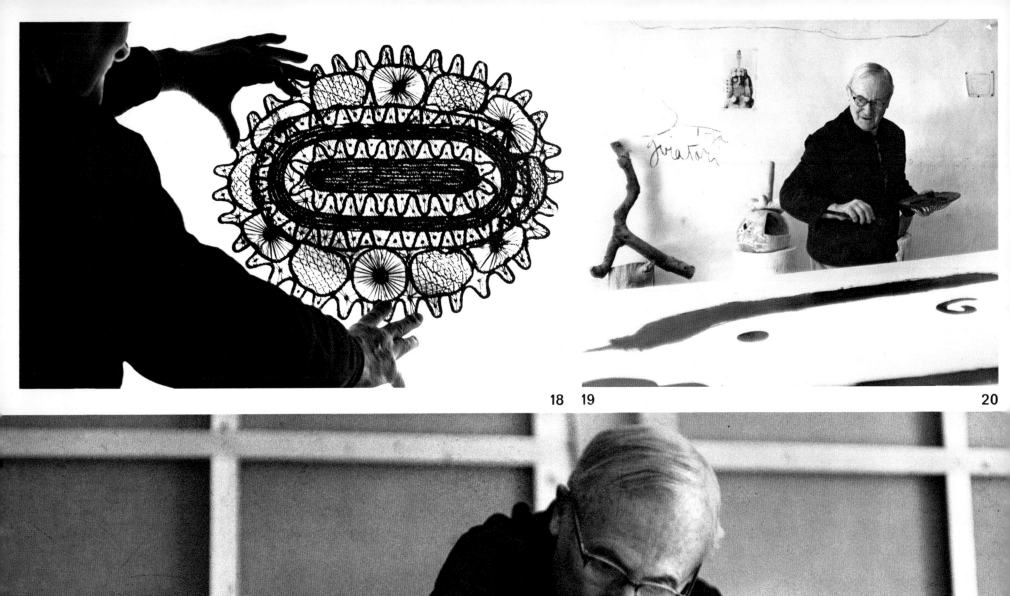

18 19 20

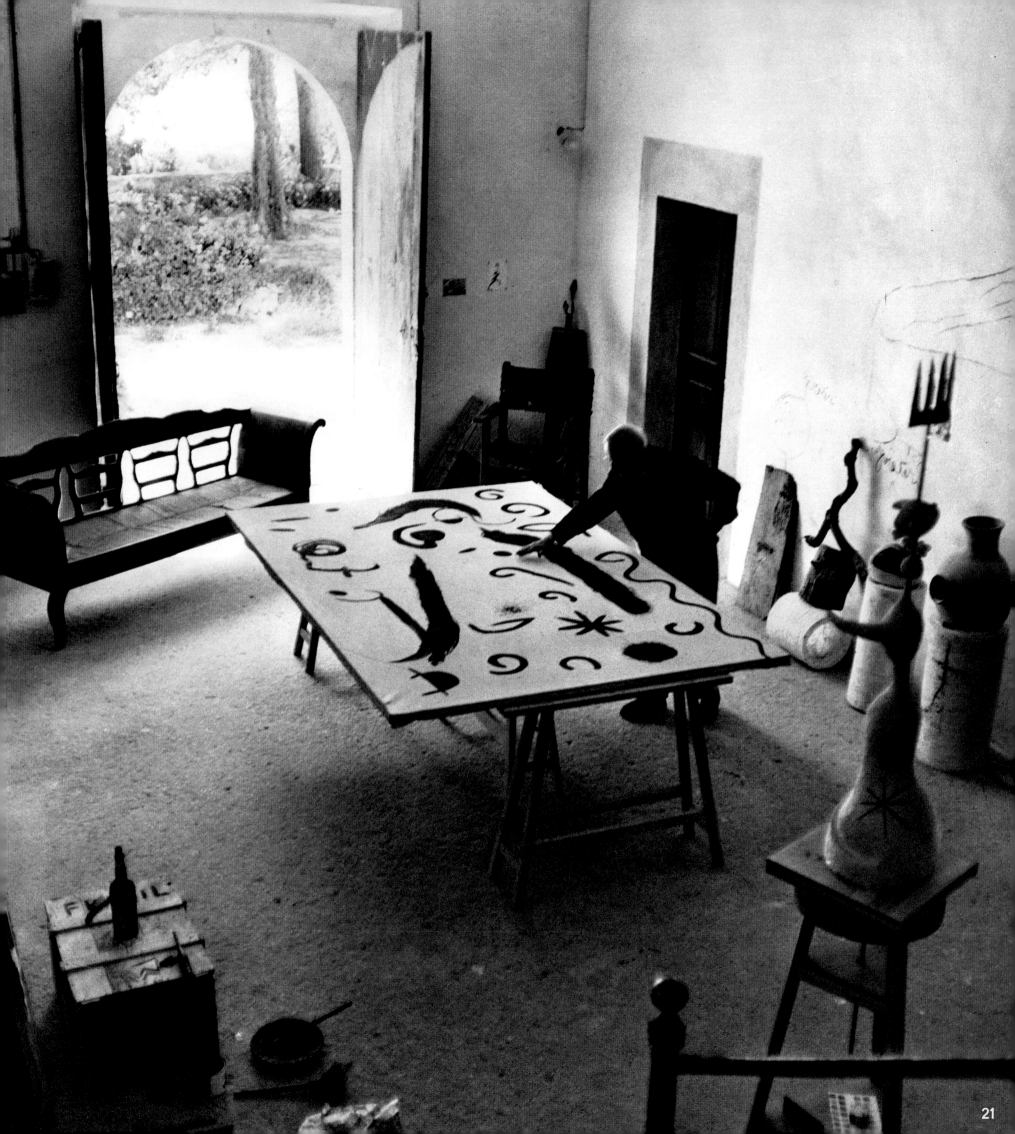

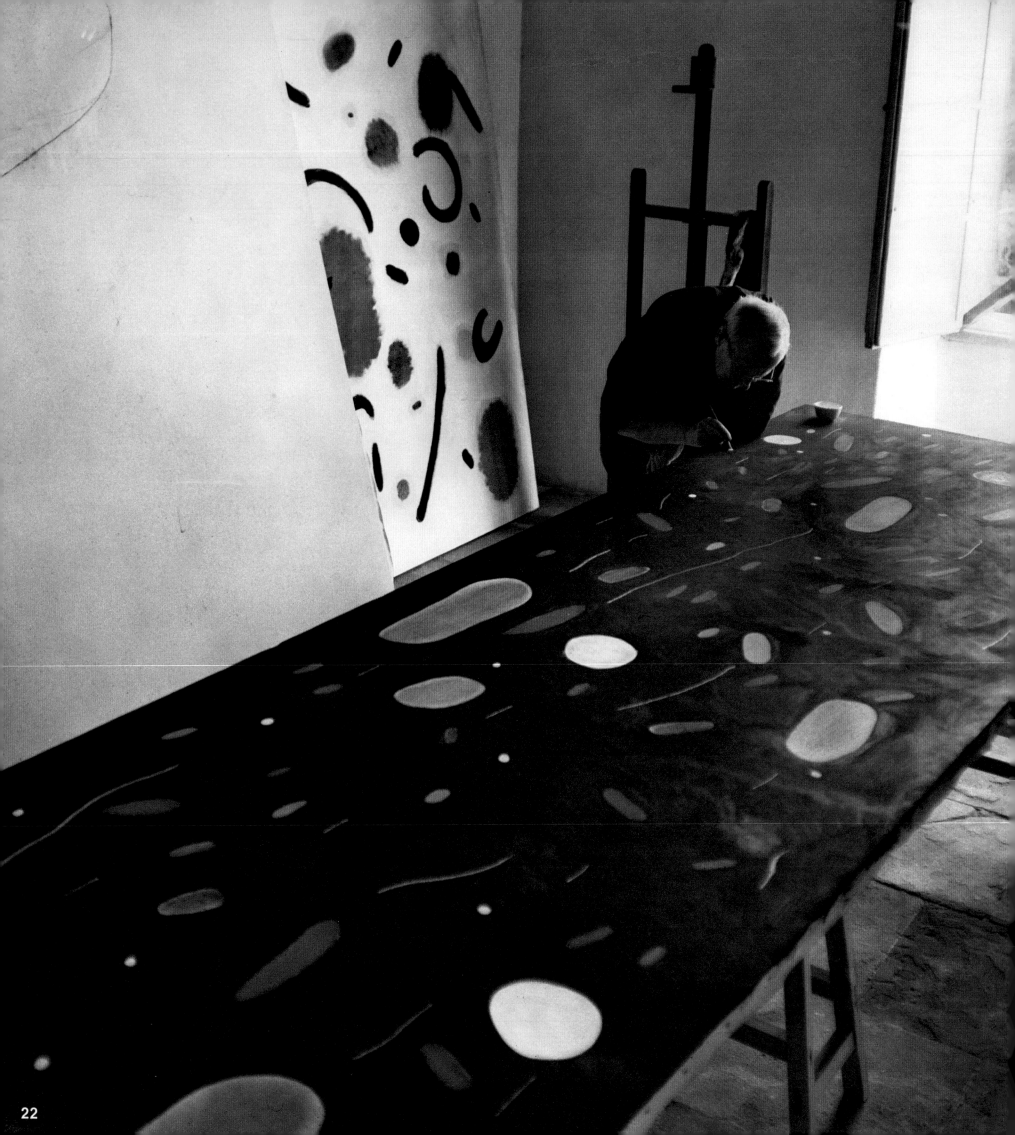

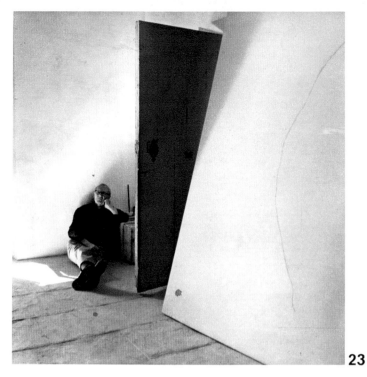

23

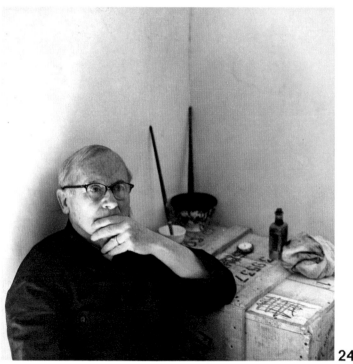

24

25

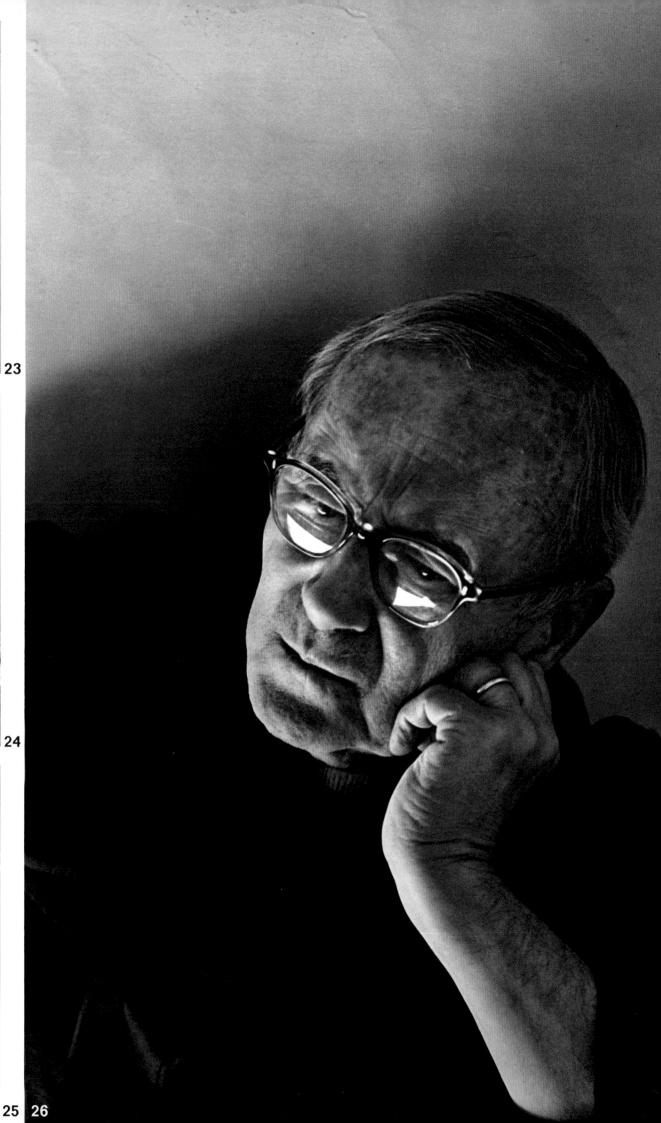

26

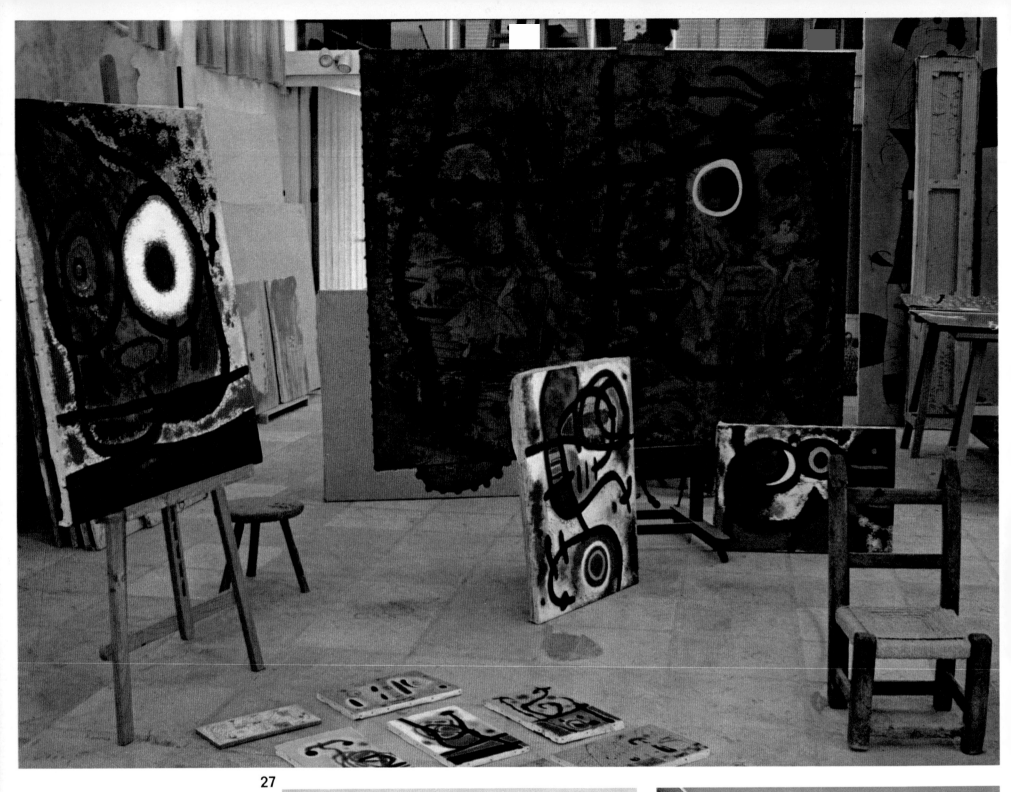

27

28

29

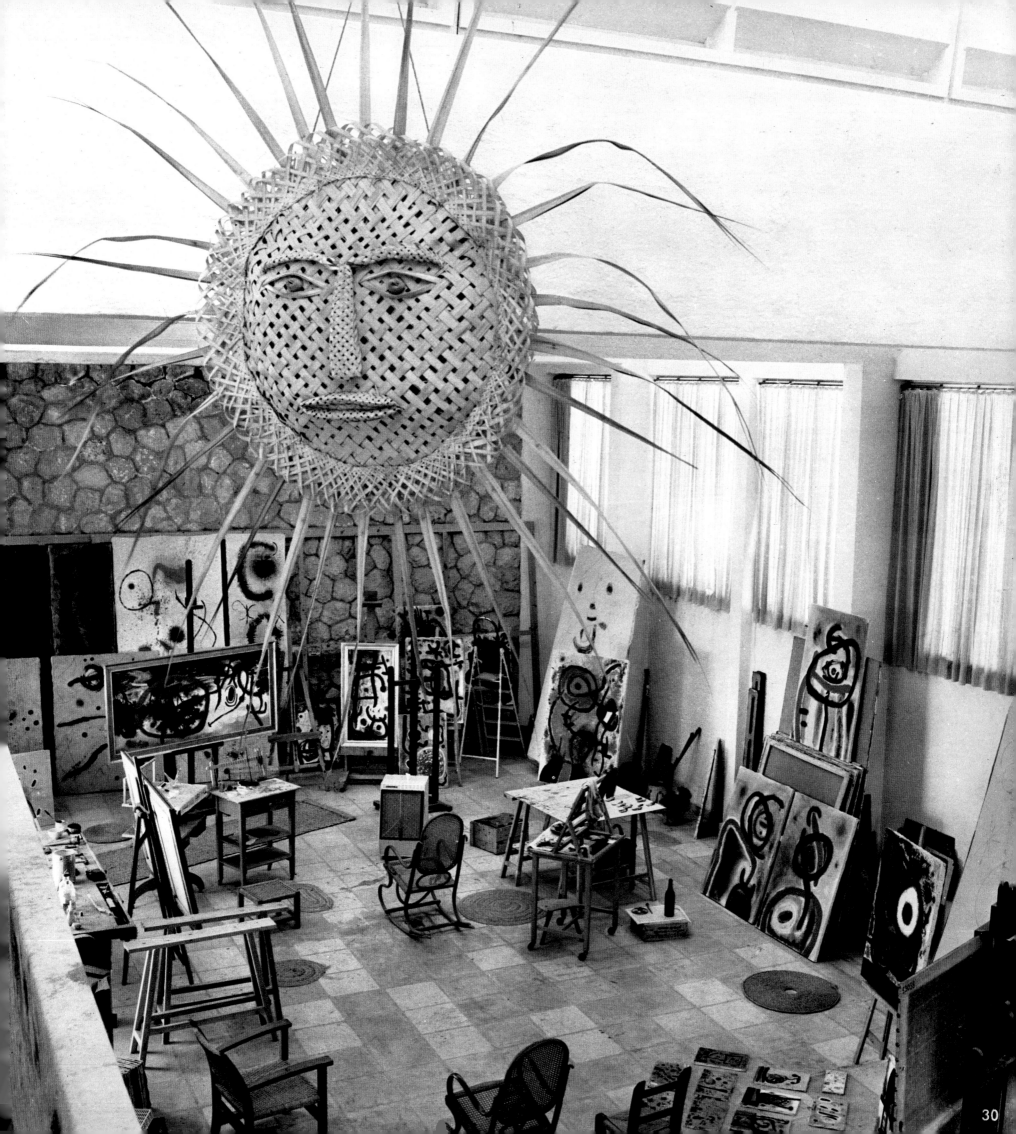

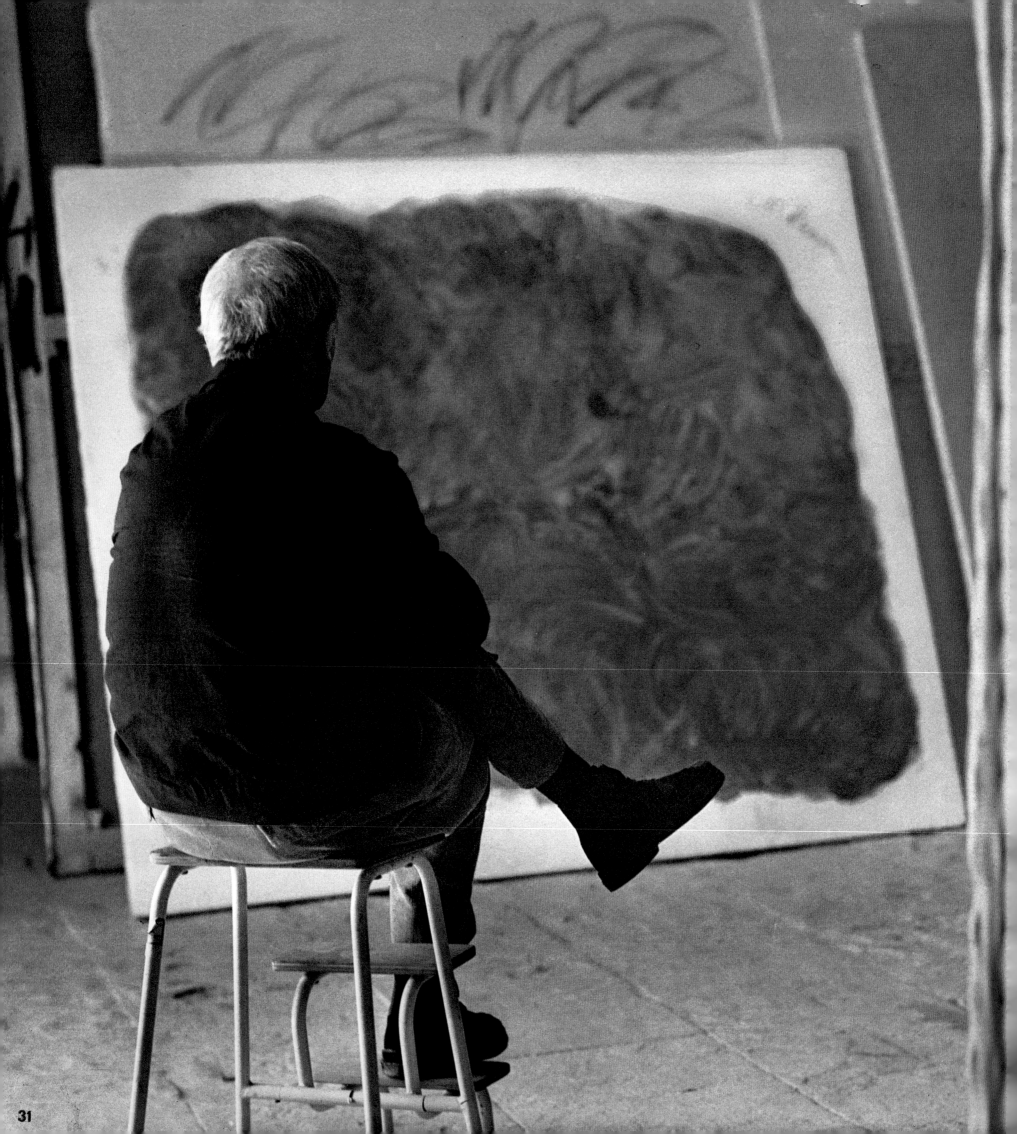

joan miró

1. The farmhouse. In each sunny room a canvas awaits the painter's attention.

2. Contact with the earth. . . .

3. Some of the odds and ends picked up by Miró that have become "Mirós" themselves.

4-5. The white porcelain palette Miró's grandmother bought him when he was twelve. He still uses it.

6. A doll Alexander Calder made out of bones, and on the wall, a gouache painted by Miró's mother.

7. Miró straightening dolls with masks painted to represent characters from Goya's works. Behind him is a photograph of his mother, Dolores Ferra.

8-9-10. Shapes from which the artist chose certain characteristics to be found in. . .

11. . . . the finished picture.

12-15. Further mutations of similar shapes introduced into various Miró works.

16-17. Miró designs a poster.

18. The artist knows every inch of this folk-art straw mat by heart.

19-20-21. Working over the large white area of a canvas to be called *Poésie*.

22-26. Miró working.

27-30. The great "sun" bought by Miró at the Palm Sunday fair in Barcelona watches over the studio built for him by the architect Sert.

31. Miró meditates before a painting.

When I see a tree
I get a shock
as if it were something alive
with a voice of its own.
But of course—it's a tree
something human.

Miró

1893 *Born April 20 in Barcelona.*

1905 *Made his first drawings from nature (Palma, Majorca) while still a child.*

1907 *Student at a business school, and attended art classes at La Lonja. His teachers were Modest Urzell and J. Pasco.*

1910 *Worked as a clerk in a business firm.*

1911 *Became seriously ill; for his convalescence, his parents bought a house at Montroig.*

1912 *Struck up a friendship with E.C. Ricart at the Francisco Art School where he was a pupil.*

1915 *Shared a studio with Ricart. Drew nudes and made first try at still lifes in Fauve manner.*

1916 *Contact with French art through exhibition organized by Vollard at Barcelona. Discovered Apollinaire.*

1917 *Picabia started Dada magazine 391 in Barcelona, influencing Miró.*

1918 *First exhibition, at the Dalman gallery ("detailist" landscapes).*

1919 *First stay in Paris. Made acquaintance of Picasso.*

1920 *Settled in Paris for winter (returning to Montroig in summer). Met Reverdy, Tzara, and Max Jacob. André Masson became his neighbor on the Rue Blomet.*

1921 *First Paris exhibition, at Galerie La Licorne.*

1922 *Masson, Miró, and young writers organized Rue Blomet Group.*

1924 *Took part in Surrealist manifestations with Aragon, Breton, Éluard.*

1925 *One-man show at Galerie Pierre. Also took part in Surrealist shows with Arp, de Chirico, Ernst, Klee, Masson, and Picabia.*

1926 *Designed settings, with Ernst, for Russian Ballet (Roméo et Juliette). Strong criticism from their Surrealist friends.*

1927 *Lived (like Arp, Ernst, Éluard, and Magritte) in the Cité des Fusains, one of oldest artists' communities in Paris.*

1928 *Visited Holland, and on return to Paris, painted Dutch interiors. First experiments with collages.*

1929 *Married Pilar Juncosa in Palma, October 12.*

1930 *Exhibition of pasted scrap paper in Galerie Pierre, Paris. First exhibition in New York, at Valentine Gallery.*

1931 *Birth of his daughter Dolores.*

1932 *Designed stage set and costumes for ballet Jeux d'Enfants.*

1934 *His so-called "savage" period. Experimented with painting on sandpaper.*

1936 *In Paris during Spanish War.*

1937 *Took part in decoration of Spanish pavilion at Paris International Exposition.*

1939 *Made Varengeville his home.*

1940 *During war, withdrew to Paris, then to Catalonia.*

1941 *First retrospective exhibition at Museum of Modern Art, New York.*

1942 *Settled in Barcelona.*

1947 *Visited the United States.*

1954 *Awarded Grand Prix International for engraving at Venice Biennial.*

1954-1959 *Devoted all his time to ceramics.*

1957 *Produced Le Mur de la Lune and Le Mur du Soleil for UNESCO, Paris.*

1958 *Illustrated poetry of Éluard.*

1959 *Traveled to United States to attend retrospective exhibition in New York and Los Angeles.*
 Awarded International Grand Prix by the Guggenheim Foundation for UNESCO wall.
 Started painting again.

1960 *Made a ceramic mural for Harvard University.*

1961 *Exhibition at Galerie Maeght, Paris. Third visit to the United States.*

1962 *Paris Musée d'Art Moderne holds retrospective show of his work.*

1964 *Inauguration of the Fondation Maeght in Saint-Paul-de-Vence: his ceramic sculptures decorate garden.*

1967 *Exhibition at Galerie Maeght, Paris.*

magritte

The fuse was lighted in 1922 when Magritte saw a reproduction of Chirico's *Le Chant d'Amour* depicting, in juxtaposition, a pair of surgical gloves with the head of an antique statue. Yet, although he intended to be, and (in 1925) became, an artist professing a similar nonconformity of style, Magritte did everything he could, as a man, to look as unlike an artist as possible. He avoided the corduroy jacket; he bought a derby hat, hoping to conceal the whole thing; he chose to live in a suburb of Brussels, in a small villa built in classical style; and he decided to work in the small sitting room just off his bedroom. Gathered together, his whole artist's wardrobe took up very little space on the floor of his clothes closet. His wife never had to wipe even a single spot of paint from the highly waxed floor boards. And yet !

The explanation of Magritte's art probably lies in his *single duality*. The exterior aspect, the man, remains faithfully attached to solid everyday facts; the other, the soul of Magritte, relies on poetry for its devastating power.

The resulting conflict, the picture itself, is the combination of these two characteristics expressing themselves *at the same time*. This helps clear up the mystery of Magritte's systematic dynamiting of our urban landscapes, where the ambiguities of our secret longings reside. There, the orderly arrangement of our public places is cut up and disturbed as if by the zealous scissors of some twisted virgin. Small bells fly about freely in space, denying the validity of established musical scores.

The royal eagle becomes a mountain and anguish fills the nest. Sovereign blue cities are slyly undermined, laid bare as by a blind witch.

Magritte washes out the scars of memory retained from the playground of our childhood by making us take part in his basic agitation.

Je conçois la peinture comme art de juxtaposer des couleurs de telle sorte que leur aspect effectif s'efface et laisse apparaître une image où sont unies – dans un ordre poétique – des figures familières du visible : ciels, personnes, arbres, montagnes, meubles, astres, solides, inscriptions, etc. La poésie de cette image se passe de significations symboliques anciennes ou nouvelles.

L'image poétique ne cache rien : elle ne montre que des figures du visible, puisque la peinture est impropre à représenter de l'invisible.

L'invisible, c'est-à-dire ce que la lumière ne peut éclairer, a une valeur inestimable. Mais il faudrait la méconnaître pour désirer rendre visibles, par exemple : le plaisir et la douleur, la connaissance et l'ignorance, la voix et le silence.

Après avoir voulu comprendre la peinture non-traditionnelle, on admet qu'il ne faut pas la comprendre. Dans les deux cas, l'on n'assume aucune grave responsabilité : il ne s'agit dans cette affaire que d'irrationnel imaginaire. L'image poétique, elle, a été imaginée pour répondre à l'intérêt que nous éprouvons naturellement pour l'inconnu, elle évoque directement le mystère qui est un irrationnel réel.

On peut prendre en soi les images poétiques en se gardant de réduire à du connu ce qu'elles ont d'inconnu, leur réalité étant du même genre, que la réalité de l'univers.

René Magritte
Mai 1967

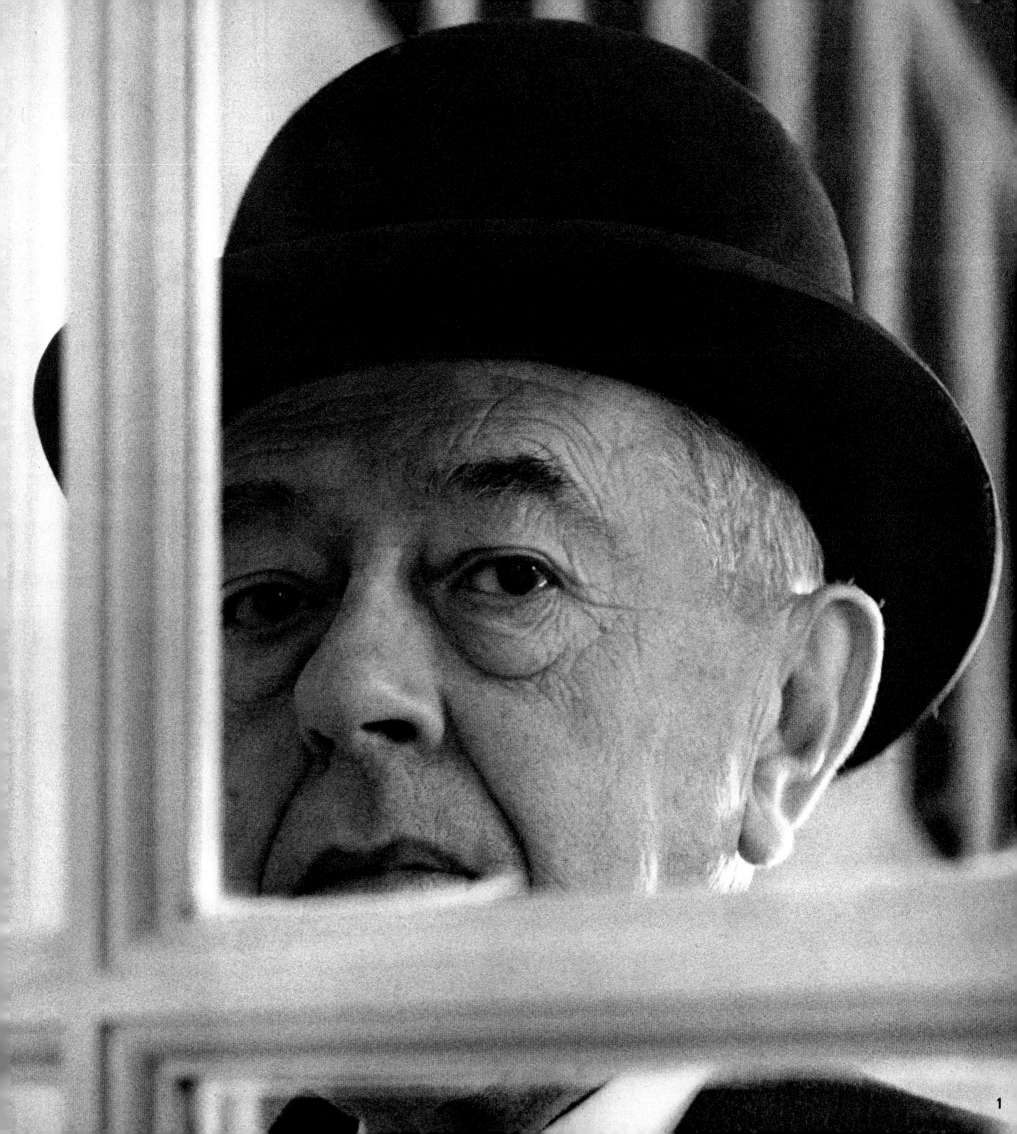

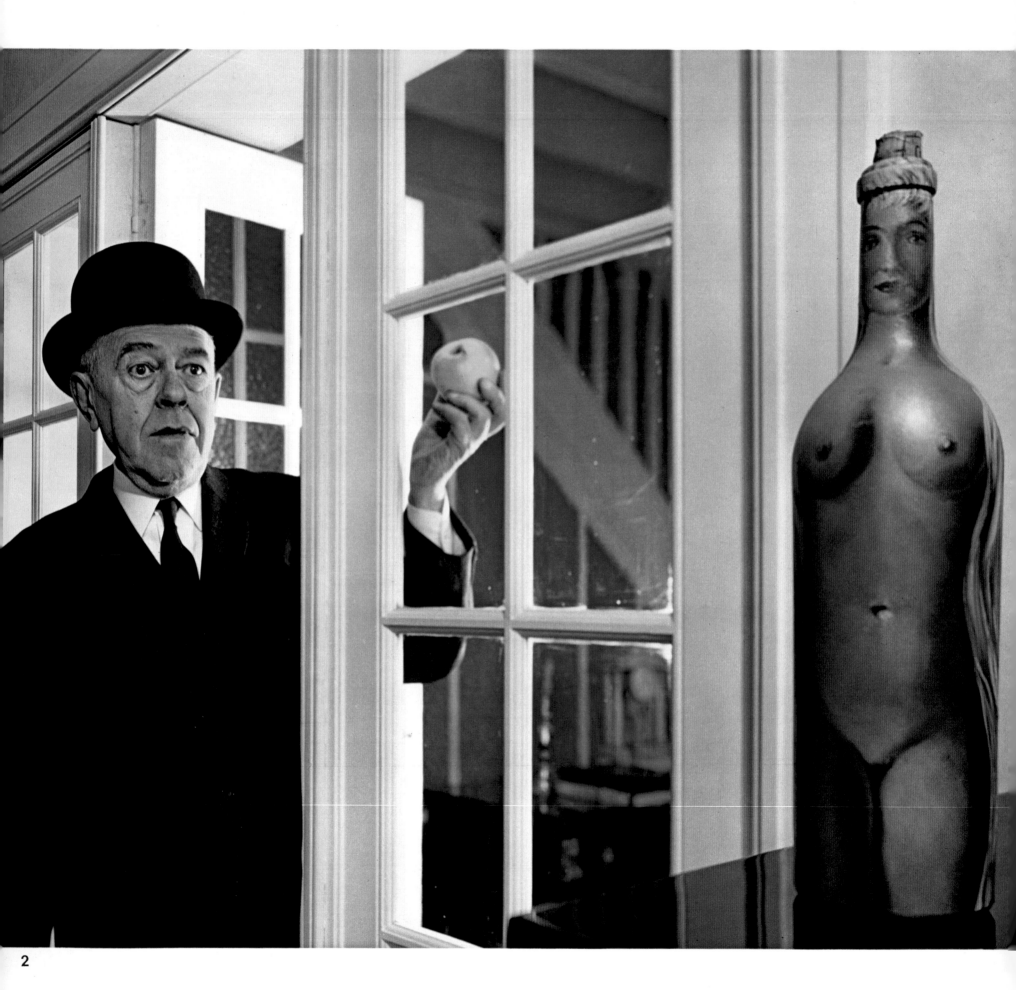

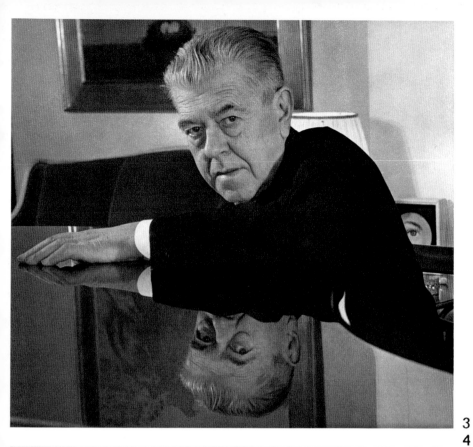

3
4

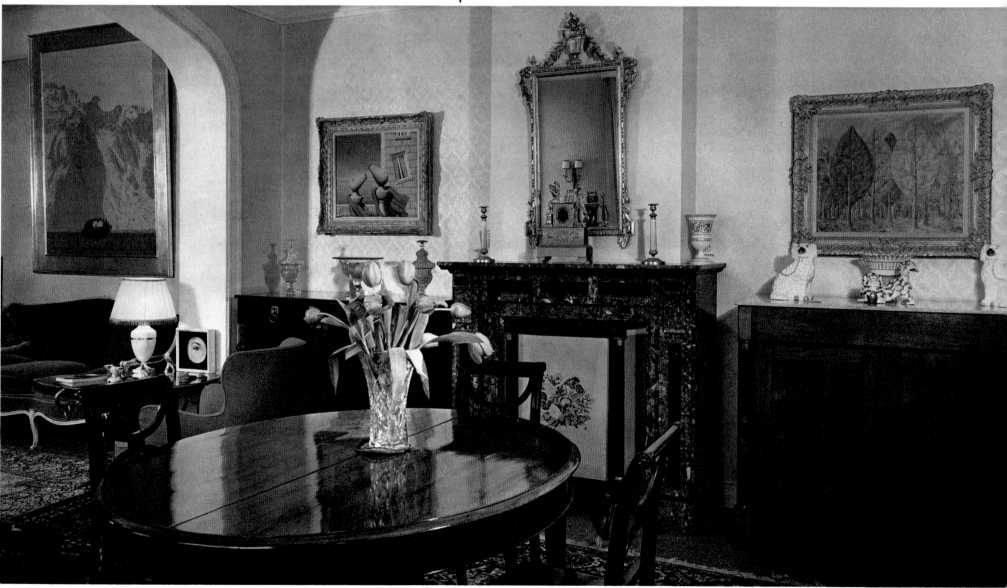

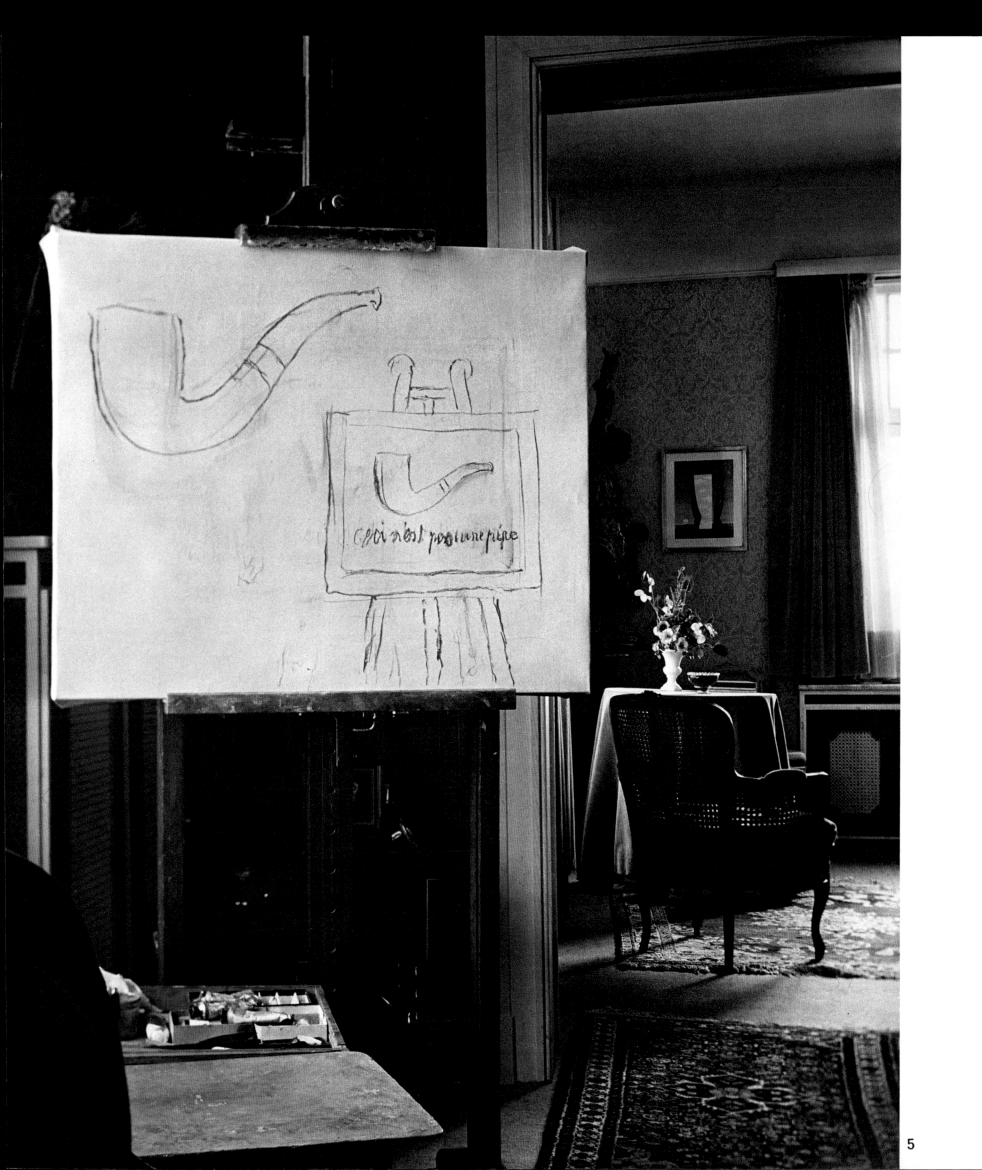

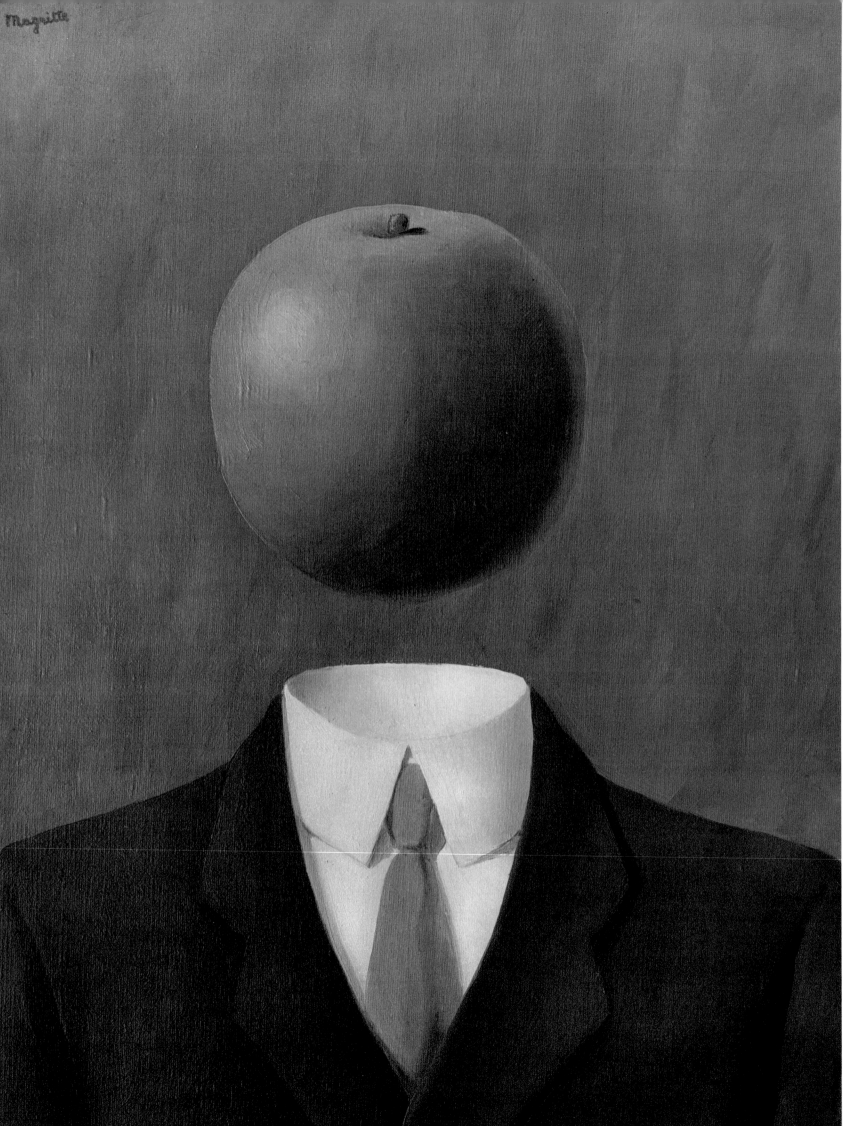

6

rené magritte

1. Portrait of a terrorist.

2. ... And the woman said : The serpent beguiled me and I did eat.

3. Magritte's polarity.

4. The large Empire-style salon in Magritte's home near Brussels. On the walls are works by the painter.

5. Magritte about to paint ... a new climate, the art of the Surrealist painter, is established.

6. *La Grande Guerre.*

(Page 100)

I think of painting as the art of putting colors side by side in such a way that their real aspect is effaced, so that familiar objects— the sky, people, trees, mountains, furniture, the stars, solid structures, graffiti—become united in a single poetically disciplined image. The poetry of this image dispenses with any symbolic significance, old or new.
The poetic image conceals nothing. It merely portrays the visible, since painting is inapt for representing the invisible.
The invisible, that is to say that which light cannot illuminate, has incalculable value. But you would have to misinterpret it to illustrate, for instance, pleasure or pain, knowledge or ignorance, speech or silence.
Anyone having attempted to understand nonconformist painting must admit that it's not meant to be understood. In either case, one doesn't shoulder any particular responsibility : the only concern is the imaginary irrationality of the work. The poetic image itself has been invented to nourish the interest we quite naturally have in the unknown; it directly evokes the mystery that is a true absurdity.
You can then accept the poetic image without reducing the unknown to the familiar. Its reality is of the same order as the reality of the universe.

René Magritte
May 1967

1898 Born November 21, in Lessines, Belgium.

1902 Birth of his brother Paul, who was to prove a great friend.

1912 Suicide of his mother, who drowned herself in the Sambre River.

1913 Aged 15, at a fair, first made acquaintance of Georgette Berger, whom he later met again and married.

1916 Journeyed alone to Brussels and entered Académie des Beaux-Arts. (His family joined him a year later.) Disappointed in his masters (Van Danne, Sylvin Combaz, Montald) he resorted to extensive reading : children's books, but also Baudelaire, Poe, Mallarmé, Villiers de l'Isle-Adam, and others.

1919 Did his military service and painted a portrait of his commanding officer.
Became interested in work of the Italian Futurists.

1920 Ran into Georgette Berger while out for a walk.
First exhibition (with Pierre Flouquet) held at Centre d'Art, Brussels.

1922 Married Georgette.
Exhibition at Salon de la Lanterne Sourde, Brussels.
Discovered de Chirico's Le Chant d'Amour, which remained important to him.

1923 Sold first picture to the singer Evelyne Brelia.

1924 In group exhibition at Cabinet Maldoror.
Interested in Breton's new Surrealist manifesto.

1925 Showed canvases at the Galerie Le Centaure, Brussels.

1926 With friends (including the musician Moesens ; the writer Lecomte ; Goemans, who was later to have a gallery in Paris, Nougé ; Souris ; and the poet Scutenaire) organized La Société du Mystère in Brussels.
Painted first version of Jockey Perdu.

1928-1929 Journeyed to Perreux-sur-Marne, France.
Attended Paris Surrealist meetings (at Breton's or at the Cyrano, Place Blanche). Relations with Breton became strained, but La Société du Mystère did not break with Surrealist group.

1930 Back in Brussels, made acquaintance of Paul Colinet.

1934 Exhibition at the Galerie Le Minotaure, Paris (organized by the publisher Skira).

1936 Exhibition at Julien Levy Gallery, New York (to be succeeded by two others in following years).

1943 One-man show organized for him in Brussels by Dietrick (two more were to be held : in 1943 and 1946).

1945-1948 His period of "plein soleil" painting was followed, in sharp contrast, by the "époque vache" (awkward period).

1946 Broke off relations with Breton.

1947 Exhibition at Hugo Gallery, New York.

1948 Participated in Venice Biennial.
Illustrated Lautréamont's Les Chants de Maldoror.

1953 One-man show at Obelisco gallery, Rome.

1954 Retrospective show at Palais des Beaux-Arts, Brussels.

1960 Exhibition at Musée des Beaux-Arts, Liège.

1967 Died August 15.

herbin

Auguste Herbin's first canvases, painted between 1904 and 1908, were bright lively flames arranged as bouquets, portraits, and landscapes. Then cubism was born, and he took to it immediately. Beginning with this analytical breakdown of shapes into their fundamental structural components, Herbin forced himself to conventionalize the human figure. Erasing any sentimental approach deriving from nature or inherent in the object itself, and refraining from any imitation of reality, he established new laws based on a geometry of lines and curves, and, with these, he created nonfigurative rhythmical color contrasts in space.

From 1918 onward, Herbin gave form to matter in a purely optical way; he introduced it first into frescoes, then into polychromatic constructions in wood—complex pyramids, highly detailed emblems, endless rows of columns. These combinations joined the play of pure shapes to the evolution of the rhythmic brushwork, occasionally obtained by mechanical means. Herbin wanted these shapes to serve as the elements of the monumental decorations of the architecture of the future.

But the atmosphere of the times, the indifference to his experiments, forced him to relegate these works to an obscure corner of his studio where they were to remain, undeveloped, for forty years.

As a reaction to the rejection of his lyrical abstractions, in 1922 Herbin returned to picturization of the object. But, all the time, he kept on struggling with the structure of things, occasionally weeping at his impotence, his inability to transcend the form of his models. Then suddenly, in 1927, things changed. He became free. Nonobjective work had begun to yield a far deeper meaning for him.

When I went to take pictures of him in 1958, Herbin was seventy-five years old. He was living with his wife in one room on the Rue Falguière, near Montparnasse. Cheap wooden dividers had been set up here and there to make the room seem larger than it was. Herbin was still living like an art student! The room as a whole was bathed in the gloom of things that have lasted too long. But I was shortly to understand why the small unkempt garden outside did not bother him, why Herbin, who was not without funds, "couldn't see" that the quarters he lived in were no better than those of a janitor.

Taking me by the arm, Herbin led me to the mantel, which held up a large canvas; when he turned it to the light, psychologically the outward poverty of his surroundings began to disappear. In the painting, circles, squares, and triangles—all the stresses and strains of plane geometry—controlled the color in a powerful spiritual harmony. To understand what Herbin sought and found, to understand his art, one must know the delight of his painstaking discoveries, the *correspondences* existing between shapes and colors on the one hand and tonal values and their alphabet on the other, and the laws he set up to govern them : a specific reality forged out of the man himself.

It was a pictorial idiom meant not only for his own use but which he also saw as universal in scope.

As with every inventor—though in his case the term genius might be more appropriate—the message Herbin carried, the language he meant to transmit, was the result of many years of struggle, many misgivings sweated through at his easel, all endured that he might extract the truth real artists seek to discover for themselves.

And he had found it.

All his so-called "abstract" work rests on this article of faith, the fruit of a long ascetic life devoted to

materializing the spirit, spiritualizing the material, identifying so far as possible the idea and the technique, the objective and the means.

The severity of Herbin's nature, his conception of the apprehensible and the spiritual universe around all men who have the patience, fervor, and strength to question and discover themselves, make of him a true enlightener.

Should man ever attain that state of innocence no doubt approachable only with the help of God, should man ever discover within himself the resources that will lift him up into the realm of pure knowledge, should his reasoning ever permit him consciousness of his enormous powers of creation, it shall be in the work of an atheist—Herbin—that he shall recognize himself.

The chemistry of science rediscovers
what the chemistry of nature has determined
by the interaction of all its forces.

Black and white are the extreme opposites. The square, the triangle, the circle, the semicircle, and their corresponding colors, violet, yellow, red, and blue insert themselves between the extremes of black and white. For this reason both white and black may take any shape, and its significance and purpose will be totally different depending on whether it is black or white.

PLASTIC ALPHABET:

A : *Pink. Emerging from the interaction of the four ethereal powers, pink shall be associated with shapes resulting from a combination of the spherical, the triangular, the hemispheric, and the quadrangular. Musical equivalent: do, re, mi, fa, sol, la, ti.*

B : *Red-purple; a combination of spherical and quadrangular shapes; sonority do, ti.*

C : *Deep red; a combination of spherical and quadrangular shapes; sonority do, sol.*

D : *Light red; spherical shape; sonority do, re.*

E : *Red; spherical shape; sonority do.*

F : *Orange-red; a combination of spherical and triangular shapes; sonority re, do.*

G : *Deep orange; spherical and triangular shapes combined; sonority re, do, sol.*

H : *Orange-yellow; a combination of spherical and triangular shapes; sonority re, mi.*

I : *Orange; a combination of spherical and triangular shapes; sonority re.*

J : *Deep yellow; a combination of triangular and spherical shapes; sonority mi, re, do.*

K : *Medium yellow; a combination of triangular and spherical shapes; sonority mi, re.*

L : *Lemon yellow; triangular shape; sonority mi.*

M : *Barium yellow; triangular shape; sonority mi.*

N : *White; may take any shape; sonority do, re, mi, fa, sol, la, ti.*

O : *Green: a combination of triangular and hemispherical shapes; sonority fa.*

P : *Light green; a combination of triangular and hemispherical shapes; sonority fa, mi.*

Q : *Dark green-blue; a combination of triangular and hemispherical shapes; sonority fa, sol.*

R : *Light blue; a combination of hemispherical and triangular shapes; sonority sol, fa, mi.*

S : *Dark blue-green; a combination of hemispherical and triangular shapes; sonority la, sol, fa.*

T : *Dark blue-violet; a combination of hemispherical and quadrangular shapes; sonority la, sol, ti.*

U : *Blue; hemispherical shape; sonority sol, la.*

V : *Black, may take any shape; sonority do, re, mi, fa, sol, la, ti.*

W : *Violet-blue; a combination of quadrangular and hemispherical shapes; sonority si, la.*

X : *Violet-red; a combination of quadrangular and spherical shapes; sonority ti, do.*

Y : *Violet; quadrangular shape; sonority ti.*

Z : *Deep violet; a combination of quadrangular, spherical, and hemispherical shapes; sonority ti, do, la.*

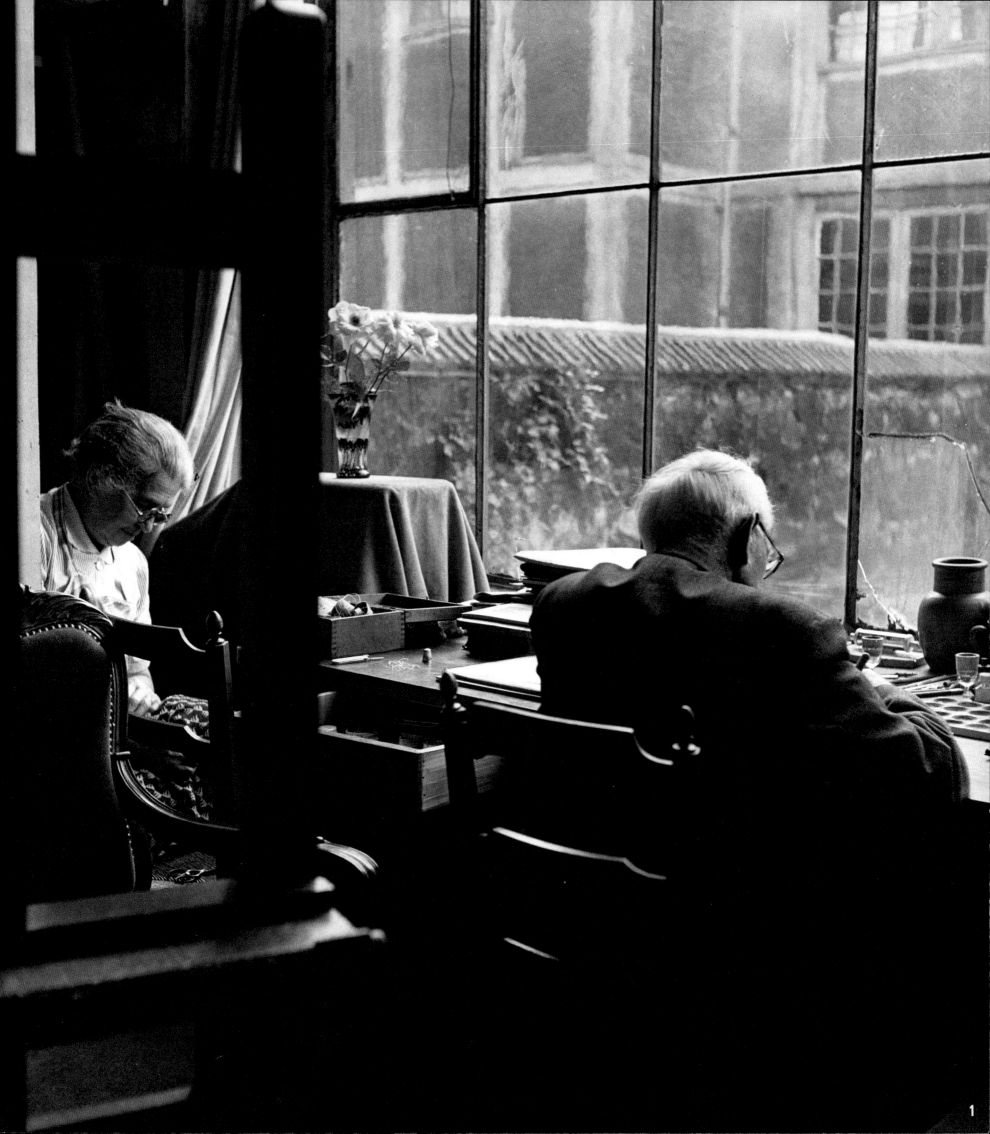

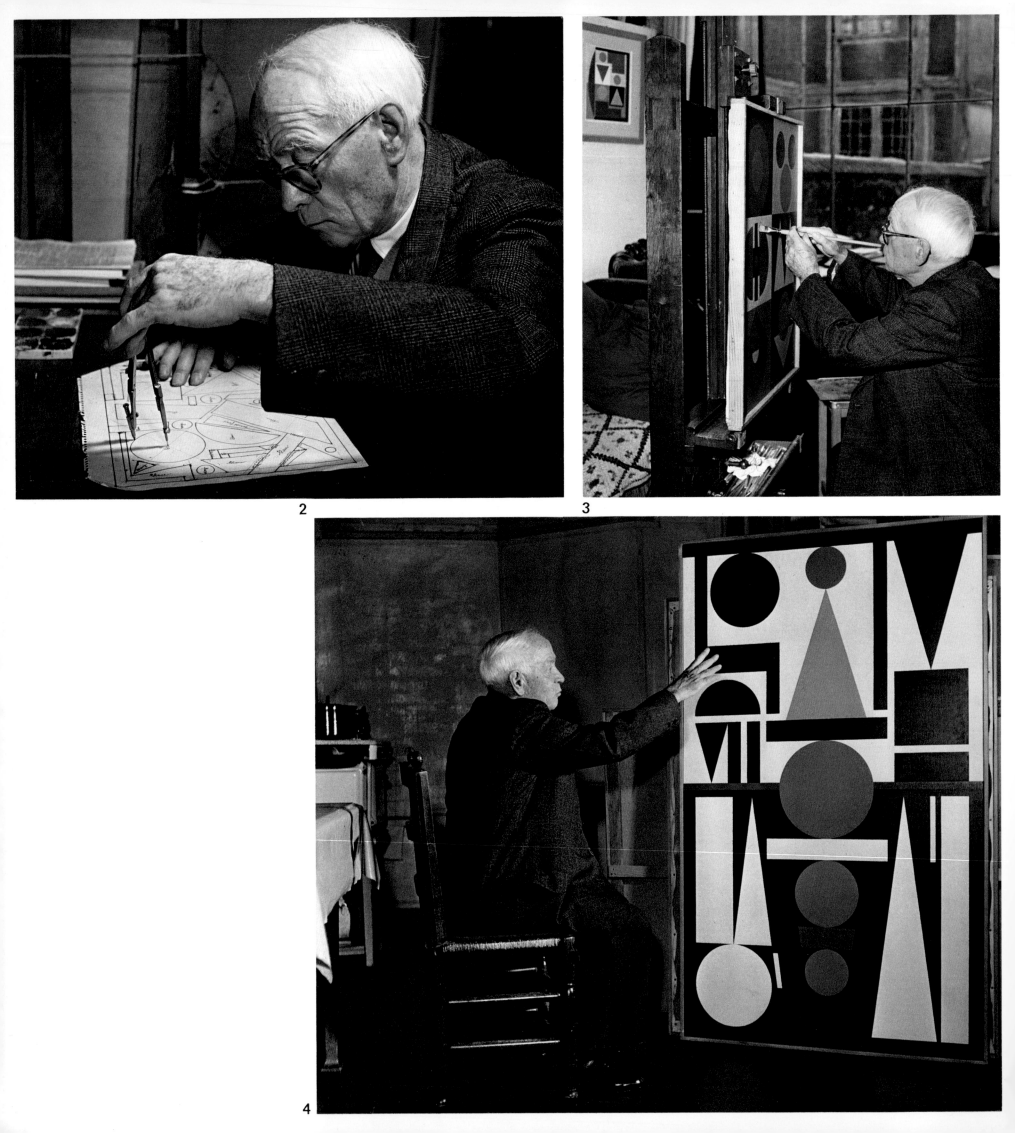

auguste herbin

1. In the one room serving as kitchen, bedroom, drawing room, and studio, facing a small neglected garden, Herbin draws while his wife sews, 1958.

2. Herbin organizing shapes in a composition.

3. His left hand guides the half-paralyzed right hand.

4. "Divine form, living form, will emerge from the interaction of colors that are more or less profound, more or less violent, more or less distinguishable, as appropriate to the two-dimensional shapes conceived by the painter" : Herbin.

1882 *Born April 29 in Quievy near Cambrai, Nord.*

1898 *Pupil at École des Beaux-Arts, Lille.*

1903 *Arrived in Paris and studied at École des Beaux-Arts, working alone.*

1905 *Exhibited at Salon des Indépendants (again in 1906 and 1909).*

1907 *Met Wilhelm Uhde and traveled abroad with him. Corsica exposed him to the southern sun, a sharp change from the northern mists of Bruges or the Dutch ports, so often the theme of his paintings.*

1912 *Occupied studio at Bateau-Lavoir. Exhibited at Galerie Clovis Sagot, Paris.*

1913 *Visited Céret, the haunt of Braque and Picasso. Group exhibition at Sturm Gallery, Berlin.*

1918 *Exhibited in L'Effort Moderne, at Léonce Rosenberg's, who had him under contract from 1916. Period of semiabstract Cubism.*

1919 *Still under charm of sunny South, returned to Céret.*

1922-1925 *Lived in Vaison-la-Romaine, and reverted to figurative painting. Exhibited rather brownish landscapes at the Leicester Gallery, London.*

1924 *Became interested in Goethe's color theory.*

1925 *Exhibited at Mak gallery, Amsterdam.*

1926 *First attempts at entirely abstract painting.*

1930 *Exhibited at Galerie Braun, Paris.*

1931-1933 *Formed Abstraction-Creation group with friend Van Tongerloo.*

Together they published an annual under that name, and organized exhibitions in the Avenue Wagram from 1933 on.

1937 *Took part in Paris exhibition, "Masters of Independent Art."*

1945 *One-man show at Denise René's (exhibited there again in 1951, 1955, 1960).*

1948 *Participated in group exhibition, "Trends in Abstract Art," at Denise René's.*

1949 *Publication of his work L'Art non-figuratif, non-objectif by Galerie Lydia Conti, Paris (in which he explained his new system of abstract painting). The influence of Goethe's color theory was now apparent.*

1951 *Group exhibitions in which he participated in France (Galerie Bernheim, Paris) and abroad (Stockholm, Brinken gallery; Copenhagen, Waldorf gallery) had marked influence on all abstract painting.*

1952 *Exhibited "12 Tapisseries d'Aubusson en Diagonale" at Denise René's. One-man show at Sidney Janis Gallery, New York.*

1953 *Exhibitions in Chicago, San Francisco, Washington, New York.*

1956 *Retrospective show at Palais des Beaux-Arts, Brussels. Continued to participate in many group exhibitions in France.*

1959 *Last one-man show (during his lifetime) at Simone Heller's gallery, Paris.*

1960 *Died January 31 in Paris.*

1963 *Exhibition (115 items, canvases, gouaches, frescoes) held in tribute, at the Stedelijk Museum, Amsterdam.*

hartung

The town has imposed a white house, meant to be **seen,** across the street from Hartung's windows, but when he confronts a canvas, his gaze passes high above the rooftop. The sound and fury of the city beats against the window, and the house rising from the pavement opposite seems to lean forward and flatten its nose against the pane. What prevents the white house from moving comfortably into the painter's room is a mob... a whipped and tortured mob showing its sores, its eyes seared by arrested lightening, a painted mob — the work of Hartung.

Massive brow above an inquisitor's stare, the painter receives his guests in a studio high in a large, square tower. Canvases of many sizes turned against the wall make a ring around the room. The latest painting stands on an easel, submitting to the silent scrutiny of the artist.

Hartung works sitting down. And when he stretches forward to add another powerful stroke to his emotional sign painting, the power of his torso supplements the strength in his arms.
A Bach cantata swells through the room, and for a moment the painter seems to be imprisoned in a cathedral of music.
A canvas, or a sheet of paper tacked to the easel, serves as the ground on which Hartung's brush or crayon, knotted proudly, agonizingly between his fingers, will depict some quick impression or distil some inconsolable pain born of his private passions. The painter becomes the historian; and in his vision the letters of the words "life" and "liberty" become the symbolic, spiritual hieroglyphs of the conquest of self.

The relationships between the reality of a painting and exterior reality are complex.

A work of art is a manifestation paralleling the artist's life, the externalization of the powers within him, of everything that comes into play to push him into action, of everything that brings his impulses, his tendencies, his experience into play.
A vestige of recognizable things often exists in a painting, even an abstract painting, though nothing else in the canvas may remind you of anything.
This is brought about by the power, the unexpectedness, the rigidity or the flexibility of a stroke manifesting itself as a spot, a shape, or a color.
We see a curved line as pliable and flexible. For those who have no sense of the thrust of growing, burgeoning things, it can only be an abstract or mathematical curve.

As a child I used to fill whole sketchbooks with drawings of lightning. I had to seize them, set them down, before the thunder crashed. Those terrifying flashes, those stormy, jagged lines sometimes still find their way into my painting.
It makes me feel that there must be certain relationships between them and my inner impulses, my psychic nature.

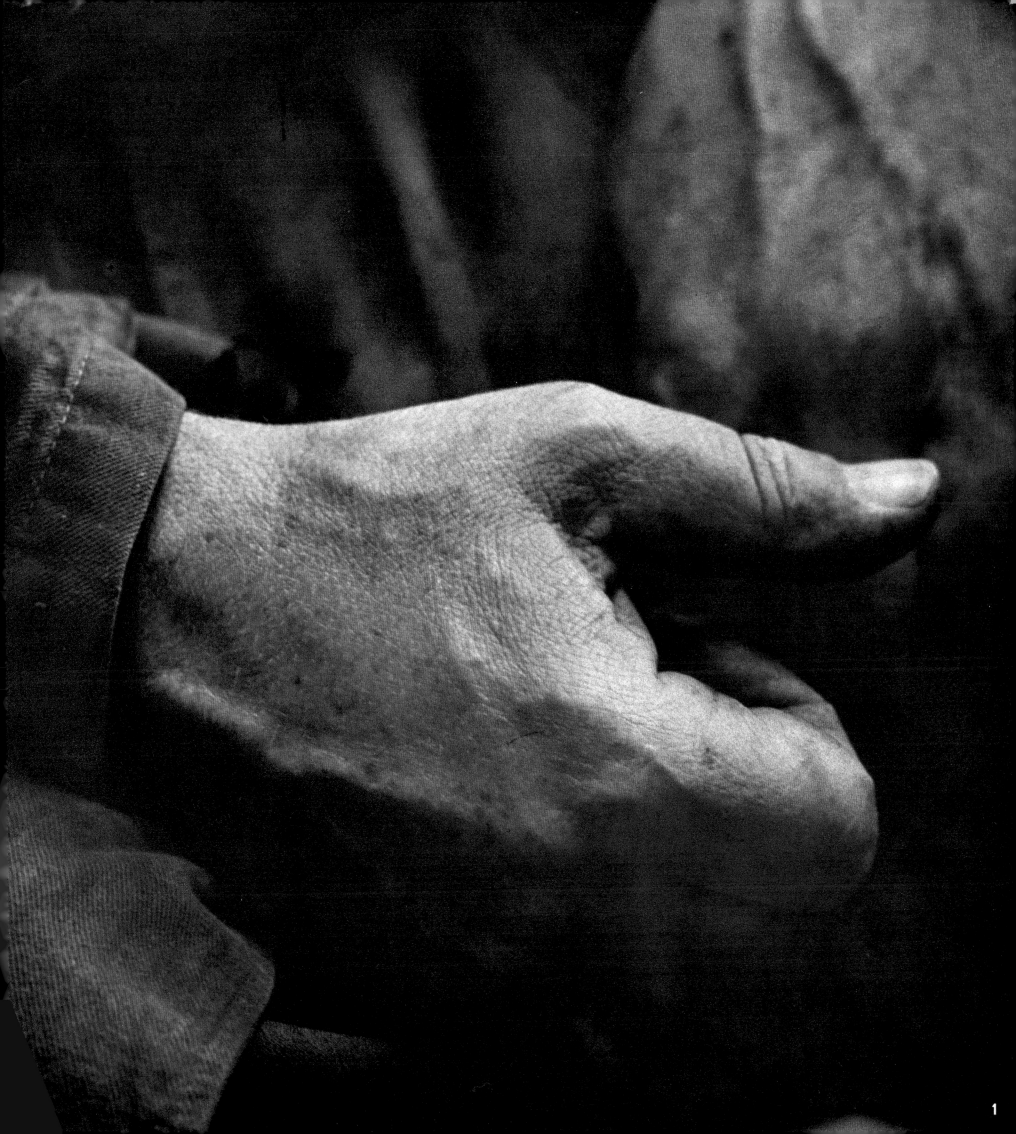

3

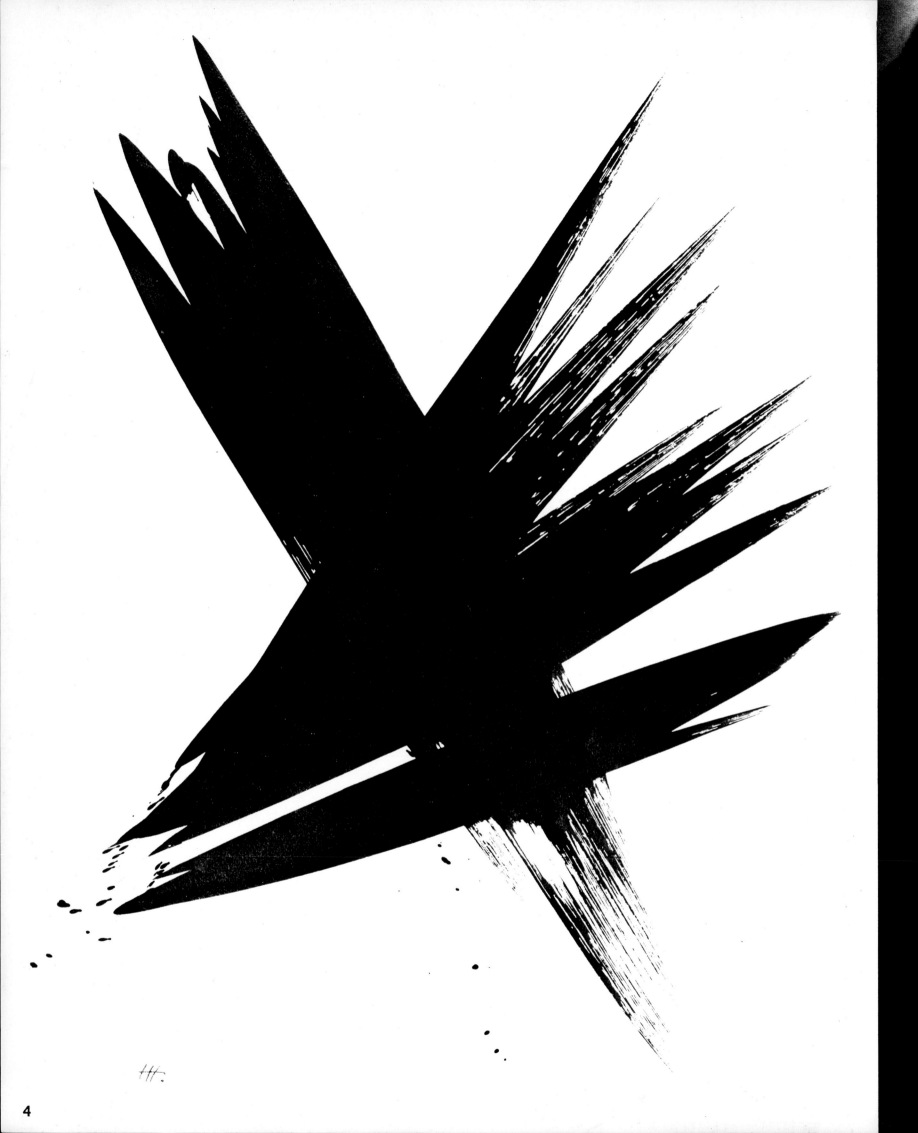

4

hans hartung

1. Hand at rest.

2. Hands in action.

3. *T, 1966.*

4. Composition.

5. "... our contemporaries or the coming generations will learn to read and, one day, will accept our direct calligraphy as more normal than figurative painting, just as we find our alphabet—abstract and with unlimited possibilities as it is—more rational than the figurative script of the Chinese " : Hartung.

6. The finished work.

1904	*Born in Leipzig, September 21.* *(His father and grandfather were physicians.)*
1915	*Became student at Dresden high school, but painting soon occupied all his energy.*
1921-1922	*Greatly attracted to nature and religion. Impressed by Rembrandt, then by Corinth, Nolde, and Kokoschka. Abandoned figuration, and made informal ink drawings and watercolors.*
1924-1930	*Devoted himself to classical studies of painting techniques and history of art at Leipzig University.* *Traveled in Italy, Holland, Belgium, as well as in France, where he studied French Impressionism and Cubism.* *In museums made copies of old masters: Goya, El Greco, Frans Hals.*
1931	*First exhibition, at Kuhl gallery, Dresden.*
1932	*Established himself (for two years) in the Balearics.*
1935	*After short stay in Berlin, left Germany forever to escape Nazism. Settled in France.*
1939	*Joined Foreign Legion.*
1940	*Discharged from Foreign Legion, following armistice.*
1943	*Obliged to flee to Spain, he was imprisoned there. Released seven months later, he returned to North Africa and again joined the Legion.*
1944	*Badly wounded at the front in Alsace.*
1945	*Back in Paris, he started painting again (after an interval of six years).*
1946-1956	*Several one-man shows in different countries.* *Took part in numerous international exhibitions.*
1956	*Awarded Europe-Africa Prize of the Salomon R. Guggenheim Foundation.*
1958	*Town of Siegen presented him Rubens Prize.*
1960	*Awarded Grand Prix for painting at Venice Biennial. One room of French Pavilion was given to his works.*

dali

On his head is
a ruby
a tongue of fire,
the Catalan barretina.
Seated,
the garlanded prince of some nearby Araby,
Dali,
a spectacled unicorn,
wets his brush
with a little yellow amber.
In a ballet
of royal piety
his hand woos the canvas;
sanctifying the prosperous assassins
of tuna fishing.

Just as a child in its mother's womb
sees unfolding
beyond
the diapered softness of the uterine bud
the red, yellow,
and blue of a divine mystery,
Salvador Dali
from the window of his studio
lets his gaze fall on the baroque crags protecting Port Lligat
from the north winds.
Lusting after himself
Dali feeds his phantasms
on through the placenta of the landscapes that fired his
childhood.
In most of his pictures is
depicted
the mesomorphy of the geological whimsicalities
encountered in the coves of Cape Creus;
rocks human in their delirium
sweetmeat-pebbles
succulent hard and soft shapes
in which Dali recognized himself.
The agonizing apocalypse of his genius
belches forth the scintillating molecules of manifestations
that his defiant humor
masks with despair :
of a work,
paranoia-critic,
the true mirror of a world that refuses to recognize itself
there
lest it lose itself
in the fixations of its memory.

A few miles from Figueras, the birthplace of Salvador Dali, Port Lligat elbows Cadaques, a small Catalonian port near the French border.

This has been Dali's " spiritual prison " since 1930.

Oddly made up of houses assembled on different levels, the home of the painter and his wife, Gala, gives the impression of having been designed by a Cubist architect. The painter lives there every year from May to October, working throughout the day.

Born of his childhood memories and a "Surrealist" imagination, the greater part of Dali's paintings were done at Port Lligat. He lived his early youth in the magnificent, fantastic surroundings of this part of the Ampurdan coast.

Amid this cosmic architecture, hacked by the winds of Catalonia and Mediterranean storms, Salvador Dali has given concrete expression to the subconscious obsessions that his reactionary poetic urge impelled him to paint realistically, for "the ultra-retrograde technique of Meissonier is the one best suited to portray ultra-modern biological and nuclear subjects so that they may be given credence."

127

"Comme-vous le savez certes,

Je suis un génie

un génie capable de cocufier ses ennemis, ses détracteurs et ses amis. Quand on aura compris Salvador Dali, dans les limites tout compris la qualité de ce COCUFIAGE, on aura compris son approche. Car l'hypocrisie, vertu éminemment au moins où il entend permettre son approche. Car l'hypocrisie, vertu éminemment méditerranéenne, demeure pour MOI le rempart le plus efficace contre la fade promiscuité de mes contemporains, absorbés dans la monotone construction de leurs vaisseaux spatiaux. Pendant ce temps, ils ont oublié la tradition pour le futur, la perennité pour le progrès, la religion pour la philosophie, les montres molles pour le temps.

Aussi, comme l'a dit le philosophe catalan Francesco Pujols : "Il était temps que Dali arrive et soit reconnu comme le sauveur de l'art moderne."

Le manque de métier des peintres de notre temps me donne toujours envie de leur crier ;
"Ne craignez pas la perfection, vous n'y parviendrez jamais et je le dis aux médiocres, même s'ils s'efforcent de peindre très, très mal, on verra toujours qu'ils sont médiocres".
Pour moi, l'ambition de peindre doit consister à matérialiser les images de l'irrationalité concrète avec la plus impérialiste rage de précision.
Mais tout le monde ne peut être Dali,

Je suis un génie

ne craignez pas de le dire, ou de le répéter, car vous le savez, je hais sous toutes ses
formes la simplicité."

128

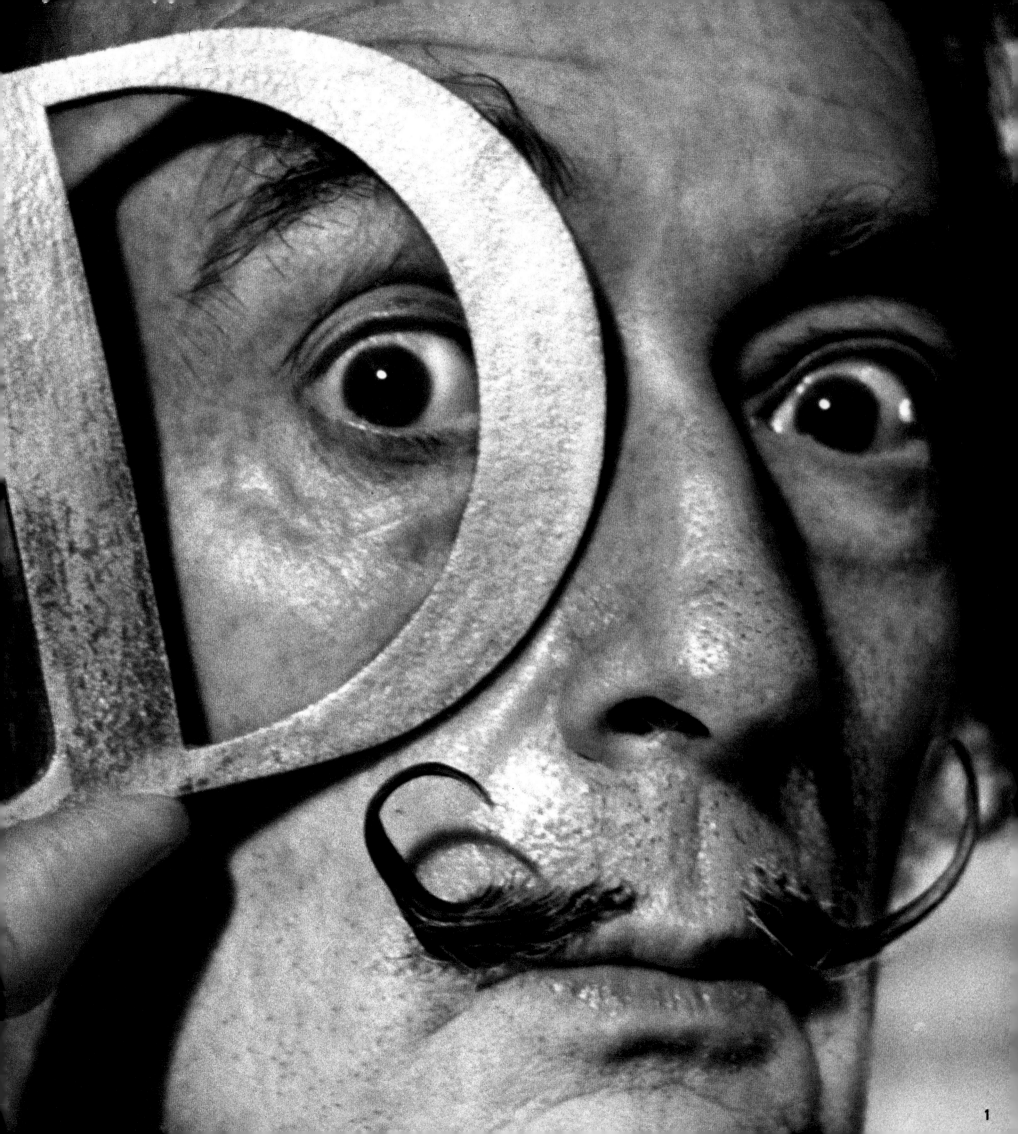

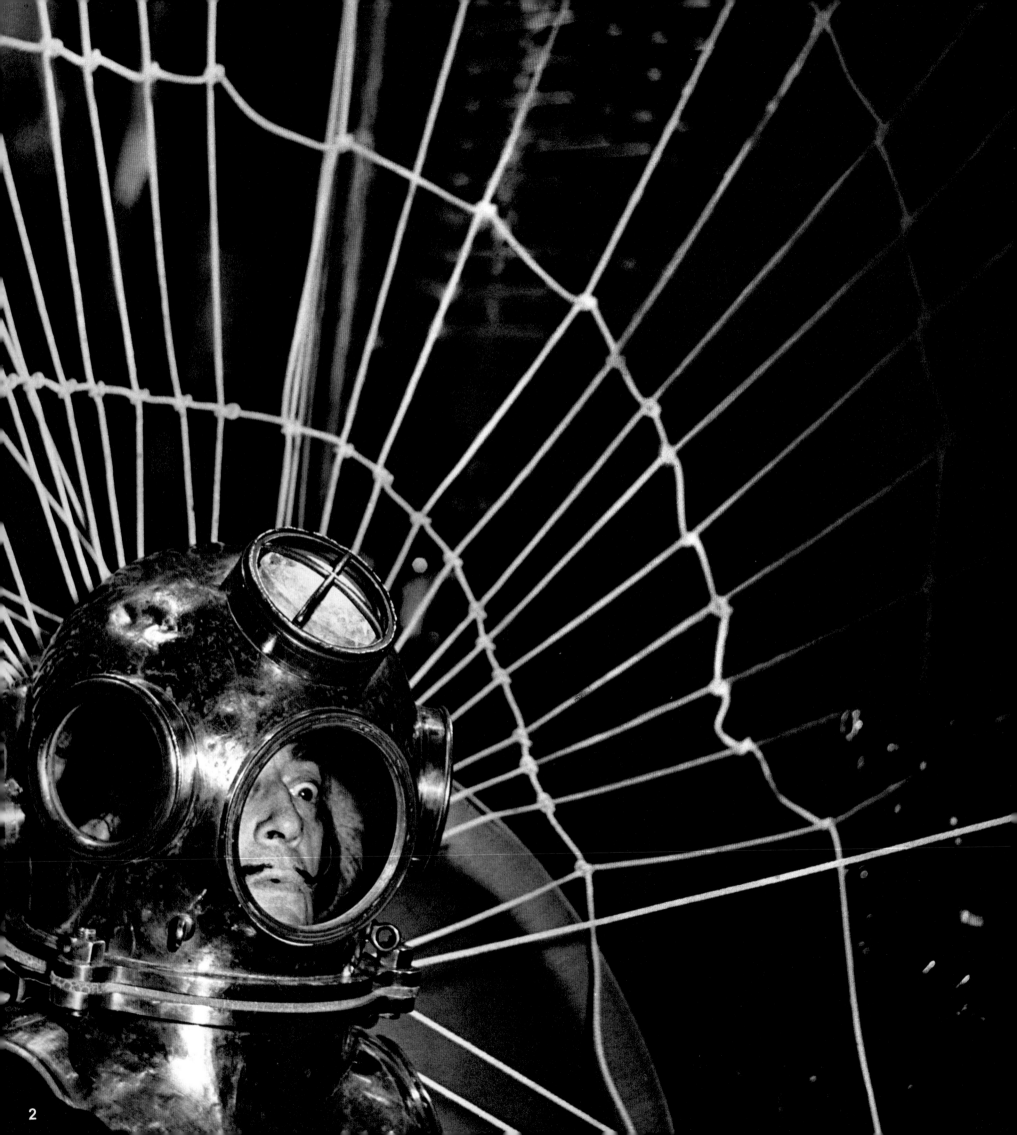

Tobey

Surrounding Mark Tobey's house, his immediate world, is the heartening reassurance of Basel. The building the artist lives in, erected long ago, was designed and constructed, undoubtedly, for some renowned personality. The Rhine, ever a source of legends, washes at its foundations, and through other windows you can see and enjoy the quiet garden of Pastor Hassler.

And yet, to the visitor, Tobey's solidly built house seems like a transient stopping place, the shaky shelter of some traveler whose fixed eyes study the unknown horizons of the world he contemplates. The house, permeated by soft shadows like the aura of a mysterious god, dimly reveals a litter of bags and trunks and open chests. Men seem to be equally ready for a sudden departure or to remain here forever—but who can determine which it will be?

The principal room, the one Tobey prefers to use, contains various pieces of furniture—a round table, a writing desk with drawers overflowing with correspondence, and, anchored on its three legs, a grand piano, an immobilized fugitive holding its breath. Tobey uses the piano to play Bach, Scarlatti, Schumann, Beethoven, Debussy, Gershwin, and his favorite American "blues."

The artist's studio with its easels and canvases lies beyond this living room. To keep the room warm, there is a large white porcelain stove that Tobey feeds with the things he no longer has use for. A painting by Tobey impresses you as the result of a quick moment of discovery yet, at the same time, as a product of almost limitless investigation. It is complicated, yet extraordinarily unified. Long ago Tobey "forgot" the center of the canvas, the measured white surface which determines and imprisons, which compels yet limits the act of painting. Standing erect in front of a new canvas, Tobey studies it, and then, as the atlas of his mind opens, he forgets it. Soon it is as if his fingers are dancing along the coasts of the world. With fingertips smeared with color, impulsively Tobey retraces the long ocean voyages of ancient icebergs; he contemplates, then sees, then paints the meditated rhythms of cosmic tides; he envisions the neons of celestral cities or, with earthy color and equal inner equilibrium, delineates the human resurrection of the act of love.

I ought not to write about modern art, for I am too greatly involved in it. However, I have read a good deal and after discovering that there have been 32 "isms" since the birth of cubism, I have reached the conclusion that, all said and done, the two time-honored tendencies subsist, the romantic and the classical. We have been upset by the storm, period. Science and psychology, not to mention sexuality, have played an important part, and therein lies our almost exclusive interest. We do not even imagine that during our times there are perhaps great men in the field of religion who have quite as much and even more to offer to contemporary man, solely because we are far too blinded by our narcissistic interest in the marvels of science and what they offer us and because we thought that in relegating our inhibitions to the racial and ancestral background, we had solved everything. But such is not the case. Religion needs, just as science does, to possess balance, as Bahaullah said in the middle of the nineteenth century; and is it not still our great need today? The faith of our ancestors has to be understood in the new light thrown on it by Bahaullah. This is an evolution on the level of religion that we have to become conscious of. It is a new shaping of our religious self. Kneeling down to pray on Sunday or absolutely denying the Creator, as more expedient and better adapted to modern life, is not a solution. The solution is to be found in the harmony of powers that will bring man into a state of balance, and that alone will lead to Peace.

During the past fifteen years my approaches have varied, sometimes depending directly on the brushwork, sometimes on the furrows, dynamic white flashes blended in geometric space. I have, however, never sought to carry on my work in accordance with a particular style. For me, the path was a zigzag within and beyond the old civilizations, seeking new horizons in meditation and contemplation. The themes that inspired me have changed from those of my native Middle West to those of the most microscopic of worlds. I have discovered whole worlds on street pavement and on the bark of trees. I know very little about what is generally called "abstraction." For me, pure abstraction would be painting in which one could find no affinity with life, a thing I consider impossible. I have sought a "single" world in my paintings but to achieve it I have used what might be termed a whirling mass.

I take no definite position. Perhaps this explains the remark made by someone who was looking at one of my pictures: "Where is the center?"

Mark Tobey.

142

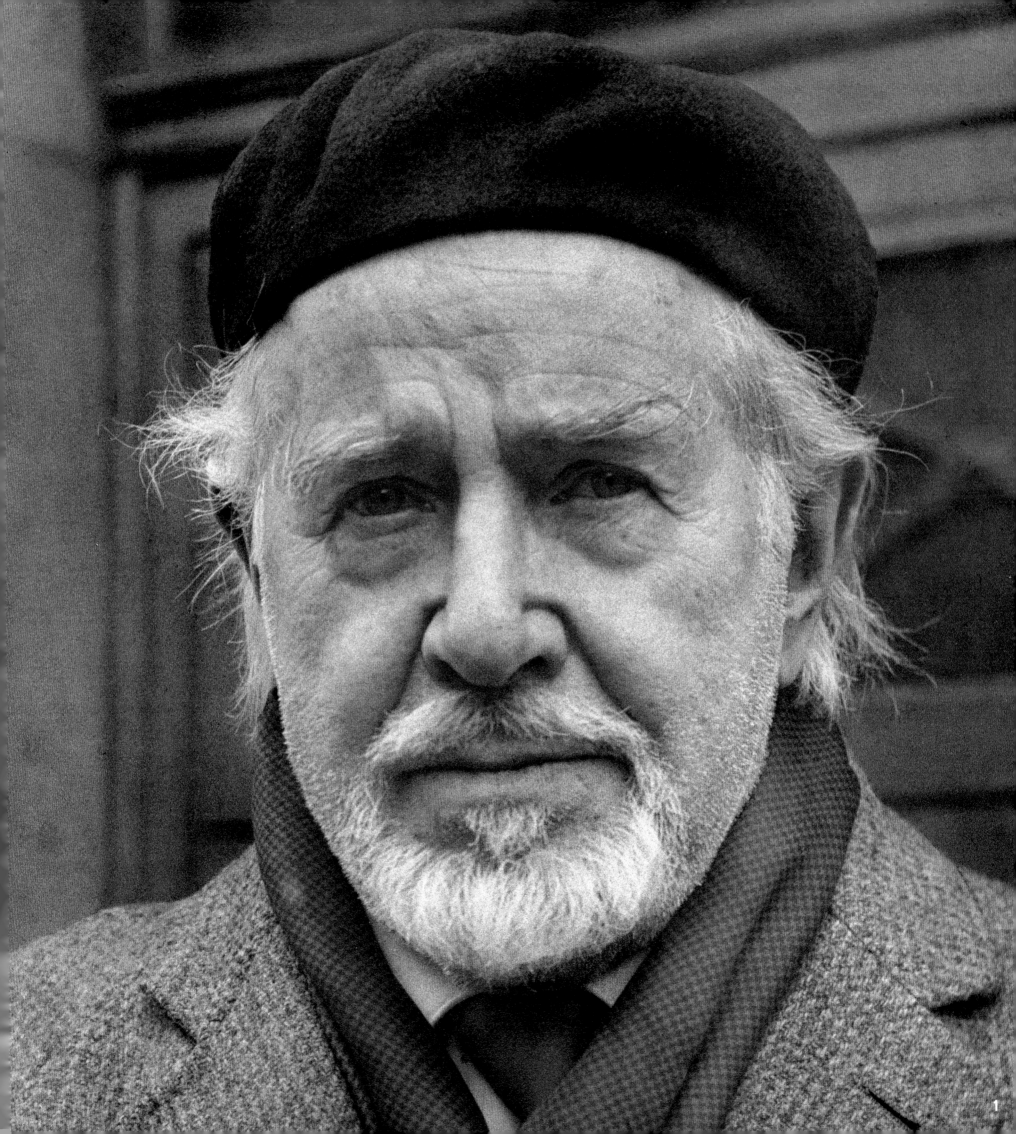

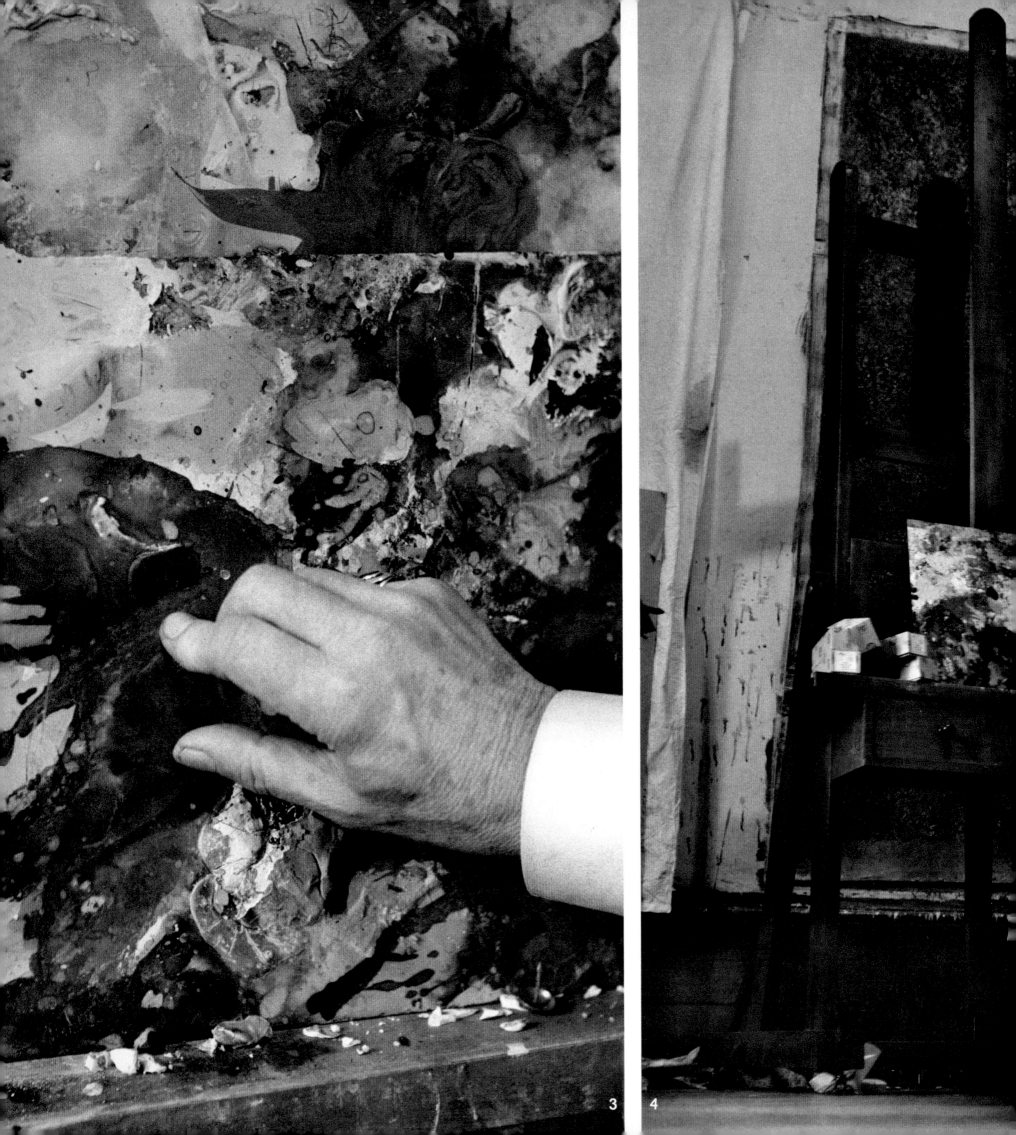

3 4

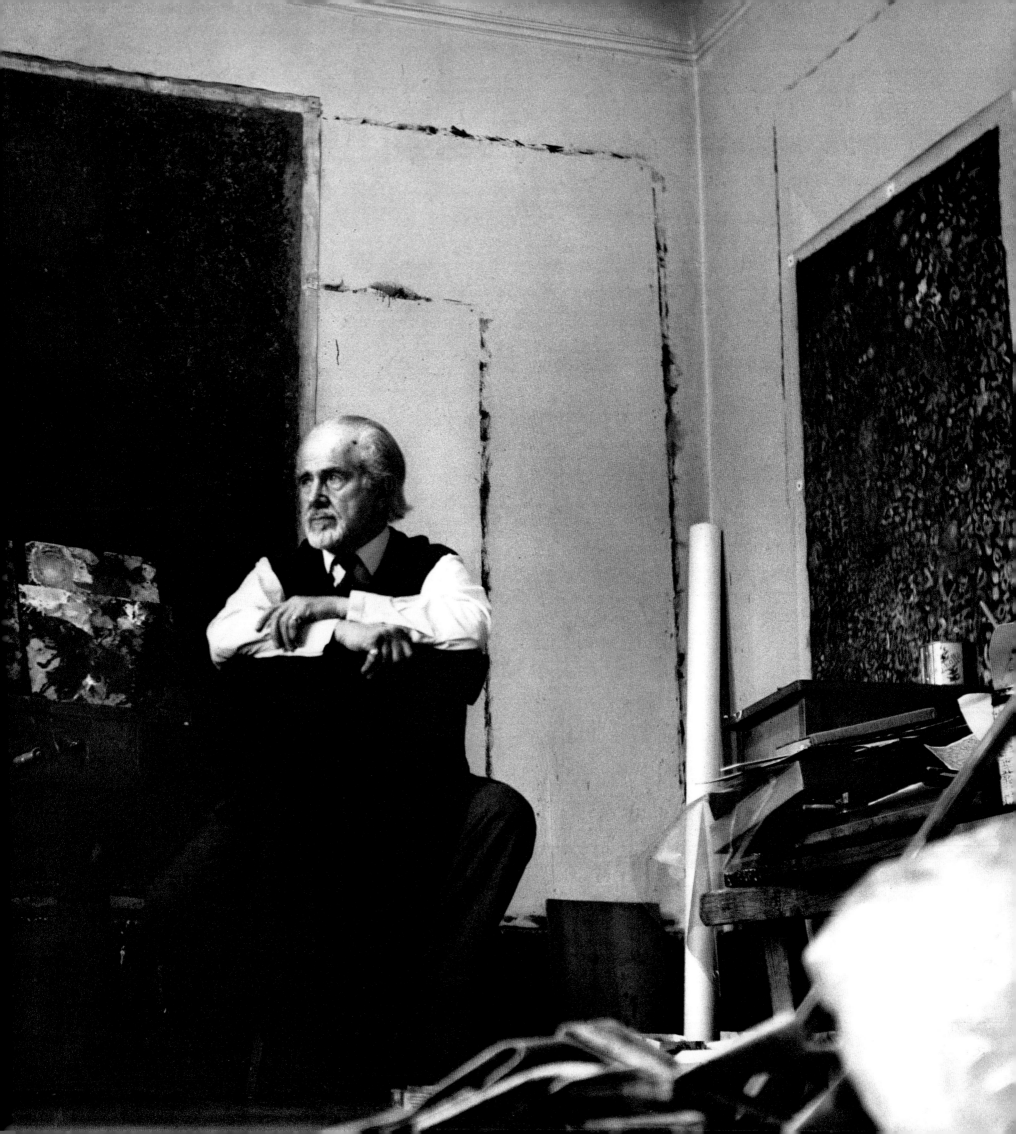

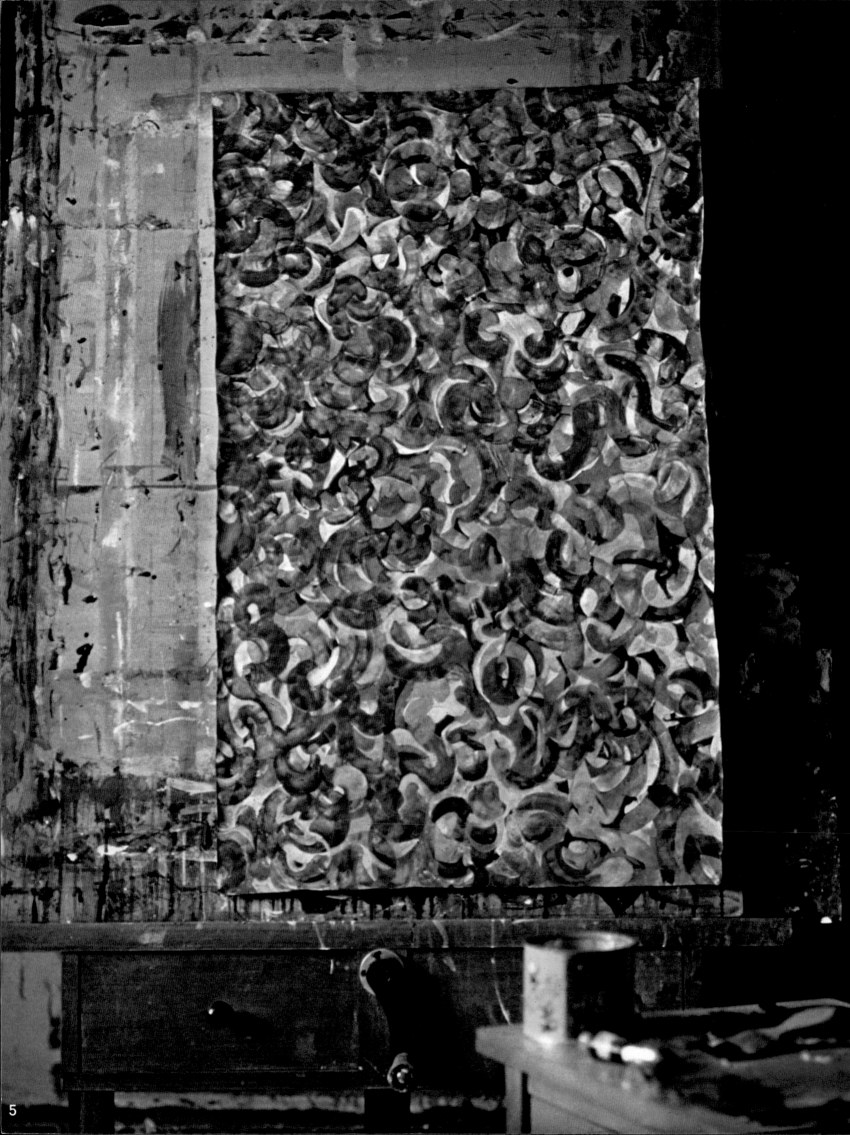
5

mark tobey

1. "From the artistic viewpoint, I have already lived several lives" : Tobey.

2. *Gouache*. A world seen from above.

3-4. Tobey in his studio : "... it is the privilege of the senses in balance to perceive outer space all well as inner space.

5. On the easel : *Study*.

1890	*Born December 11 in Centerville, Wisconsin. His father practiced carpentry and farming.*
1894	*Family moved to Trempealeau on the Mississipi, and the wild countryside impressed him deeply.*
1906	*Family moved to Illinois, near Chicago. Attended high school and, on Saturdays, studied at the Art Institute.*
1909	*Father's illness forced him to interrupt art studies and to earn a living. He soon elevated himself from errand boy at a dress-designer's studio to fashion artist. Discovered the Jugendstil painters.*
1911	*Visited New York and stayed there as a fashion artist, living in Greenwich Village.*
1912	*Returned to Chicago.*
1913	*Impressed by the famous "Armory Show"; decided to become a portrait painter.*
1917	*First exhibition of portraits at Knoedler Gallery, New York. As well as painting portraits, he worked as an interior decorator.*
1918	*Discovered the teachings of Bahaism—a system of universal religion.*
1920	*Took up residence in New York and made acquaintance of Marcel Duchamp. His married life floundered and he divorced his wife within a year.*
1922	*Went to the west coast to teach painting at Cornish School, Seattle. Became friendly with a Chinese student, Teng Kuei, who initiated him in the religious art of the Far East, which became an important factor in the development of his art.*
1925	*First trip to Europe. He stayed in Paris, then near Chartres.*
1926	*Visited Greece and Turkey.*
1927	*Returned to Seattle.*
1929	*Took part in the exhibition "Painting and Sculpture of Living American Artists" at Museum of Modern Art, New York.*
1930	*Went to England and taught at Dartington Hall school.*
1931	*Visited Mexico. (When not traveling, he lived at his school and got to know many writers, including Huxley, Tagore, Pearl Buck.)*
1934	*Journeyed to China, staying for a while with Teng Kuei's family, then discovered Japan and was impressed by No and Kabuki theater, Zen philosophy and painting.*
1935	*Returned to Seattle where he held his first one-man show. Beginning of his "white writing."*
1942	*His canvas, Broadway, was awarded prize at "Artists for Victory" exhibition at Metropolitan Museum of Art, New York.*
1944	*One-man show at the Willard Gallery, New York.*
1948	*Exhibited at Venice Biennial.*
1955	*Another trip to Europe included Paris, London, Basel, and Berne. Show at Galerie Jeanne Bucher, Paris.*
1956	*Returned to Seattle; now a member of the National Institute of Arts and Letters; received a Guggenheim award.*
1958	*Awarded International Grand Prize for Painting at Venice Biennial. Traveled in Europe, visited Brussels International Exposition.*
1959	*Executed a mural for Library of the State of Washington.*
1960	*Settled in Basel.*
1961	*Retrospective exhibition at Musée des Arts Décoratifs, Paris.*
1962	*Retrospective exhibitions are held at Museum of Modern Art, New York; Cleveland Museum; and Chicago Art Institute. Spent the summer in Seattle.*
1966	*Returned to Basel, his permanent home. His work of the past ten years exhibited at Beyeler Gallery.*

bissière

At first I thought I heard a prayer! It helped me to climb toward Boissièrettes, the Bissière's home. The muttered prayer became a lamentation, a dull staccato. Reaching the top, in front of the house, I saw thousands of black caterpillars devouring the leaves of the trees. They clung in clusters to the branches. The woods were on the verge of death. Soon there would be nothing but skeletons reaching toward the sky like the pillars of ruined cathedrals.

Louttre, the son of Bissière, and also a painter, mounted on a huge mechanical shovel, was bringing up tons of sand and cement and erecting enormous tall, solid blocks of concrete, at which he would subsequently hack away with an ax, making them into gigantic, indestructible sculptures which would shortly become the home of the voracious caterpillars. In his hands a new forest was rising to exorcize the demons.

The front door opened onto two studios, Louttre's on the right and Roger Bissière's on the left—it had been maintained just as the artist had left it that December evening when he lay down to die, his will to live spent, as gaunt then as the trees he had planted are today. I took these photographs in the month of August 1966. The studio was still the retreat of the big dog named Baritch, whose habit was to stretch himself out at the foot of the empty chair, just as he used to do when his master was alive and painting.

Hanging up behind the studio door were Bissière's cap and scarf. On the walls, resting on a narrow shelf encircling the room, and on the floor itself, were paintings, small ones, inspired by trees, sun-pierced clouds, melodies heard in the still of the night, the garden, daybreak. There was a reclining nude (painted in 1935) of a generously proportioned woman being teased by an attendant cherub. And, as if a summation of the festivities of his existence, a day-to-day document or calendar of Bissière's soul, was his great composition, *Le Silence du Crépuscule*, made with subtle strokes applied with a perfect sense of the harmonies between light and color, for this ingenuous master had inherited the best that earth has to give to man.

Bissière was so steeped in the equanimity he had absorbed from nature that he was able to communicate it strongly, in essence.

And now the red chair, empty, offers its back, its arms. Piled up on a table are pots of paint, bottles of varnish, oil, rows of brushes, and Bissière's palette, still alive with the vivid colors that nourished the painter at Boissièrettes : the ripe, rich yellow of harvests the ochre and orange of the earth at Quercy, a dark red, suggestive of the suffering of mankind, a clear, pure blue, and a thick blotch of black impasto that contributed to the darkness of his last picture, *La Forêt Noire*—a darkness that was already taking possession of him.

I have a horror of all systematic things,
of all that tends to pen me in behind barriers.
My painting is the image of my existence,
the mirror of the man I am,
complete with all his failings.
Facing my canvas I am not thinking of a masterpiece or of the outcome;
I beguile myself with improbable stories and paint them.
The colors and forms I use on canvas have no other
aim than to reflect those in my dreams,
my joys and my sorrows.
I offer them to you just as I created them,
without shame for their weaknesses
or pride in their successes.
To me strength and weakness are equally moving,
perfection being impossible, inhuman.
A faultless picture would lose its warmth and radiance,
it would cease to be the living, concrete expression
of a man who dares to stand up and face you as he really is,
and not as he would like to be.
My pictures do not aim to prove or affirm anything;
they are the only way I have of expressing
otherwise inexpressible emotions.
I paint in order to feel less alone in the world;
I am a living being addressing other living beings
in order to feel less cold.
Few things in this world require such sincerity as painting.
It is a faithful mirror, a complete image of the painter as he is,
without a mask. If some would dissemble,
conceal their failings,
imitate emotions that are not their own,
their pictures at once betray them.
The masks become a mockery.
No painting attains validity without confronting danger;
risk is the very condition
of all plastic creation.
A picture is not the sum of our experience,
rather it is an eternally renewed adventure,
a battle whose outcome can never be foreseen,
and herein lies the risk of losing all.
And yet he who paints cannot have partial victory or defeat.
Painting is like shooting at a target;
if you miss the bull's-eye, it matters
little how wide you were.
To miss a train by a second
or an hour is still to miss it.
I dread approximations, and therefore I refuse
to resort to them.
Within the bounds of my ability
I endeavor to push my picture onward,
to the limit of my strength.
The elements that make
up any plastic creation are indissoluble.
If a single gap exists
in the texture of a picture,

the whole thing collapses.
Yet lost battles are often the most glorious;
they have the nobility that an accepted
risk confers on all things,
the grandeur of the game of life and death.
In a sense, the finest picture in the world is still a defeat,
for what is achieved always falls short
of the conception.
I do not ask for admiration but only
for some measure of sympathy.
I should like those who see these pictures
to glimpse a little of my joys
and sorrows which are also theirs.
Such a conception implies precariousness without end,
a departure toward the unknown.
When I begin a picture,
I never know whether it will lead me to happiness or despair.
Thus I can believe neither in experience nor in education,
and even less in intelligence.
I believe only in the most primitive of instincts,
that which comes up out of the dimmest past.
Also I believe, perhaps,
in what Pascal called "l'esprit de finesse."
I have always denied myself any title
at the foot of a picture.
Giving a title is using literature as a prop for painting.
A picture needs no crutches.
If it is not good, the finest title
in the world will not give a picture the life it lacks.
Those with something to say always
find the right way to express it.
Painting is a way of fulfilling their existence,
and, likewise, of giving it a meaning.
Beyond death an artist's paintings
will stand as testimony to a man who had his share
of happiness and suffering.
There are those who believe they are entrusted
with divine missions, with essential messages.
I have less ambition,
I would merely like to find myself.
This is a difficult task,
requiring great courage;
the courage to make a journey
to the end of the night,
toward a faint and perhaps inaccessible light.
Work thus envisaged cannot progress according to a true,
harmonious curve, but rather along
a broken line marked with doubts and regrets,
like life itself.

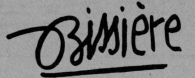

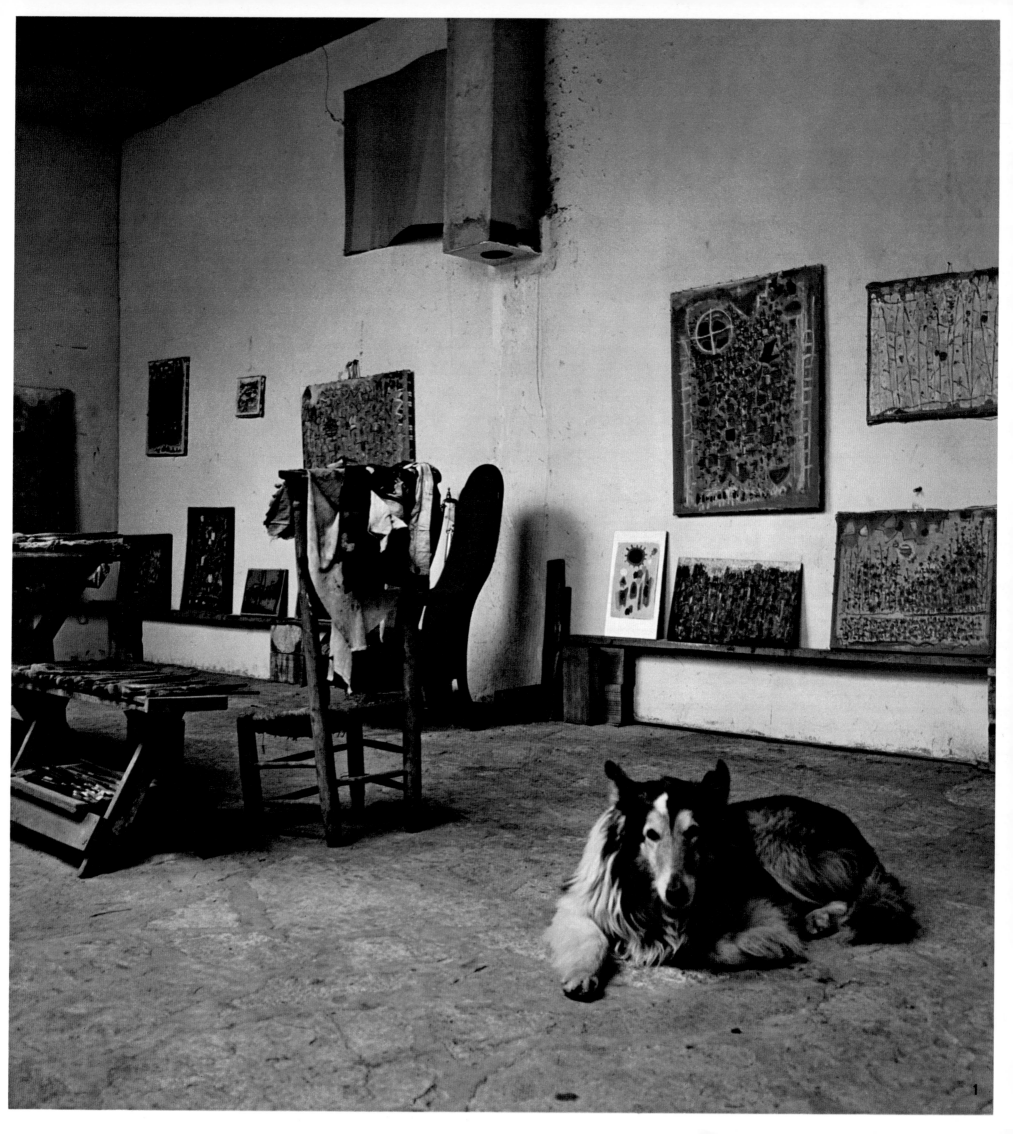

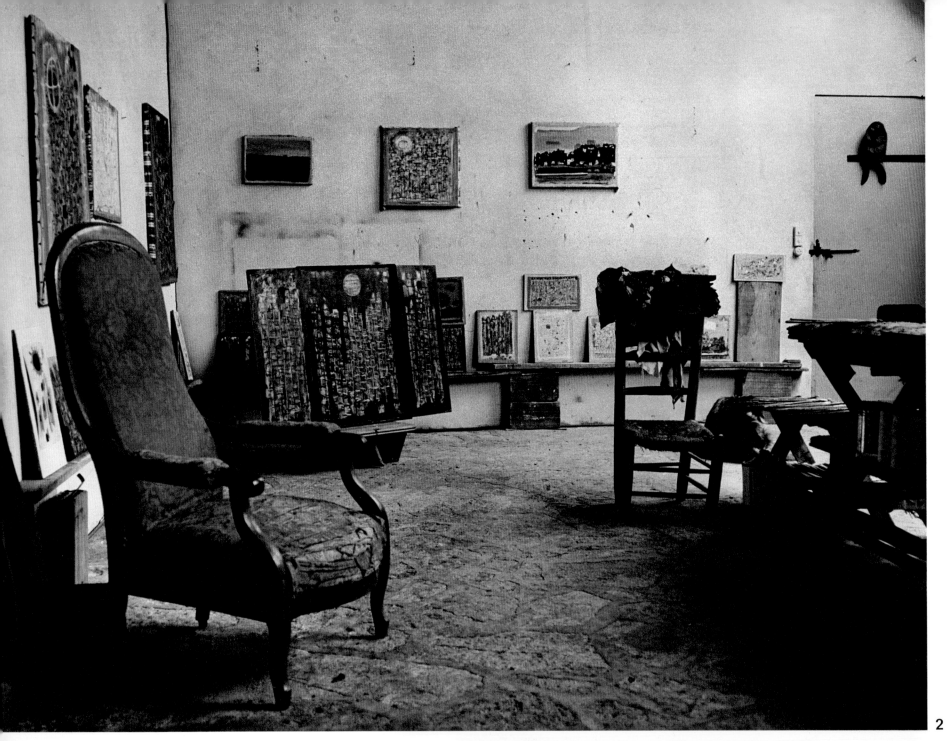

2

3

roger bissière

1-2-3. The studio at Boissièrettes.

. .

The sole value of a confession
is that it shall be complete and shameless.
Pride comes through saying all
and hiding nothing.
It may be said that nobody asked me
for a confession, or cares a rap about it.
I do not doubt this, yet I still hope
that it will reach some hearts.
Men I tenderly despise because,
being one of them, I am no more worthy
than they ; I share their wretched state,
the infinite sadness
of their kind.
If I have lost and no one puts out a hand
I'll put mine back in my pockets,
'way down deep.

1886 *Born September 22 at Villeréal, Lot-et-Garonne.*

1905 *Student at École des Beaux-Arts, Bordeaux.*

1910 *Left Bordeaux for Paris, exhibited work at Salon des Artistes Français.*
Academic training stirred into curiosity by new departures in contemporary painting. Earned money as art critic for L'Opinion.

1913 *Showed work in Salon d'Automne and Salon des Indépendants. A friend of André Lhote since his Bordeaux days, met Juan Gris, whose disciplined work he admired.*

1920 *Met Braque.*
First exhibition with his friends at the gallery of Berthe Weil. His Notes sur l'Art de Seurat appear in October 15 issue of L'Esprit Nouveau.

1921 *Published his Notes sur Ingres and Notes sur Corot in L'Esprit Nouveau. Paul Rosenberg became his dealer. Showed work with group of French painters at the Modern Effort gallery, Amsterdam.*

1923 *Left Paul Rosenberg for Galerie Druet.*

1925 *Became professor at the Academie Ranson (a post the retained until 1938).*

1926 *Birth of son, Marc-Antoine, called Louttre.*

1929 *Stayed on friendly footing with Braque, whose work he admired, but remained true to classical tradition.*

1937 *Participated in exhibition, "Masters of Independent Art" at the Petit Palais, and in Paris International Exposition decorations.*

1938 *Illness compelled him to return to his home town.*

1939 *Settled down with Mousse, his wife, and son in Les Boissièrettes, which they had spent several summers restoring.*

1940-1945 *The war passed, seemingly remote, yet close.*
Nature and light played a large part in his painterly meditations.
Experimented with new techniques, assembled fabrics sewn and embroidered by his wife. Made metal constructions.

1947 *Exhibition of paintings and tapestries at Galerie Drouin, Paris, was not well received by the public.*
In danger of blindness, tried new technique using more intense colors.

1950 *Underwent successful eye operation.*

1951 *Exhibition of work at Galerie Jeanne Bucher sufficiently successful to ease financial difficulties.*

1952 *Awarded Grand Prix National des Arts.*

1954 *Changed technique again. Painted in a manner to permit transparencies. Broke from traditional culture which had been the bedrock of his personality.*
Published Cantique à Notre Frère Soleil de François d'Assise. Took part in Venice Biennial.

1955 *Second São Paulo Biennial.*

1956 *Exhibition at Jeanne Bucher's.*

1957 *Retrospective exhibition shown at Hanover ; also at Recklinghausen and Lubeck.*

1958 *Stained-glass windows designed by him installed at Cornol and Develier in the Swiss Jura.*
Contributed to exhibition, "A New Religious Art," at Brussels International Exposition.

1959 *Retrospective show at the Musée National d'Art Moderne, Paris.*

1960 *Created stained-glass windows for Metz Cathedral.*
Exhibition at World House Gallery, New York.

1962 *Thirty-four paintings successfully displayed at new gallery of Jeanne Boucher, in the Rue de Seine.*
Awarded engraving prize at Tokyo Biennial.
His wife died, leaving him grief-stricken.

1964 *At the Venice Biennial his work contrasted with Pop Art. Received special honorable mention.*
Died December 2nd, and was buried near his wife at Boissièrettes.

1965 *The Musée National d'Art Moderne, Paris, paid official tribute to his work.*

1966 *Retrospective exhibitions in his honor were held at Bordeaux, Amsterdam, Düsseldorf, and Paris.*

calder

As a beginning, Calder created a heaven and an earth.
For his heaven he created
something that moved.
And since everything must be given a name, this
was called a
mobile.
For his earth, Calder created
another, related object that did not move
and since everything must be given a name, this was called a
stabile.
Graduate engineer,
poet of the mechanical,
Calder
first made scale models
and dummies of all that would become
humanity—
The world,
his world,
fashioned of sheet aluminum
emerged from the skilled hands of the giant.

Stretching out ribs,
cutting out flippers,
raising sharp paws,
scissoring arched wings,
buttressing vertebrae,
juxtaposing
aggressive shapes and pure unsullied lines,
the disturbing and the soothing
coupling of metal
became a geometry of forms.
Thus Calder created a dynasty of sculpture,
a kingdom of
the animal, the vegetable, and the mineral.
immobile . . . stabile.
As he looked at his work
the studio and the scattered tools and materials of his trade vanished.
He brought his eye close to his work,
very close,
so near that he came to give the primitive work of his creation
the spatial dimensions of the universe.

White and Black are
 the Strong colors
Red is not far behind,
 but off at an angle
Next come Blue, Yellow
 and Orange, rather pasty
Green should be like
 a billiard table
And Purple as in the
 Spanish Loyalist flag.

 Calder

Saché
 8 Sept 67

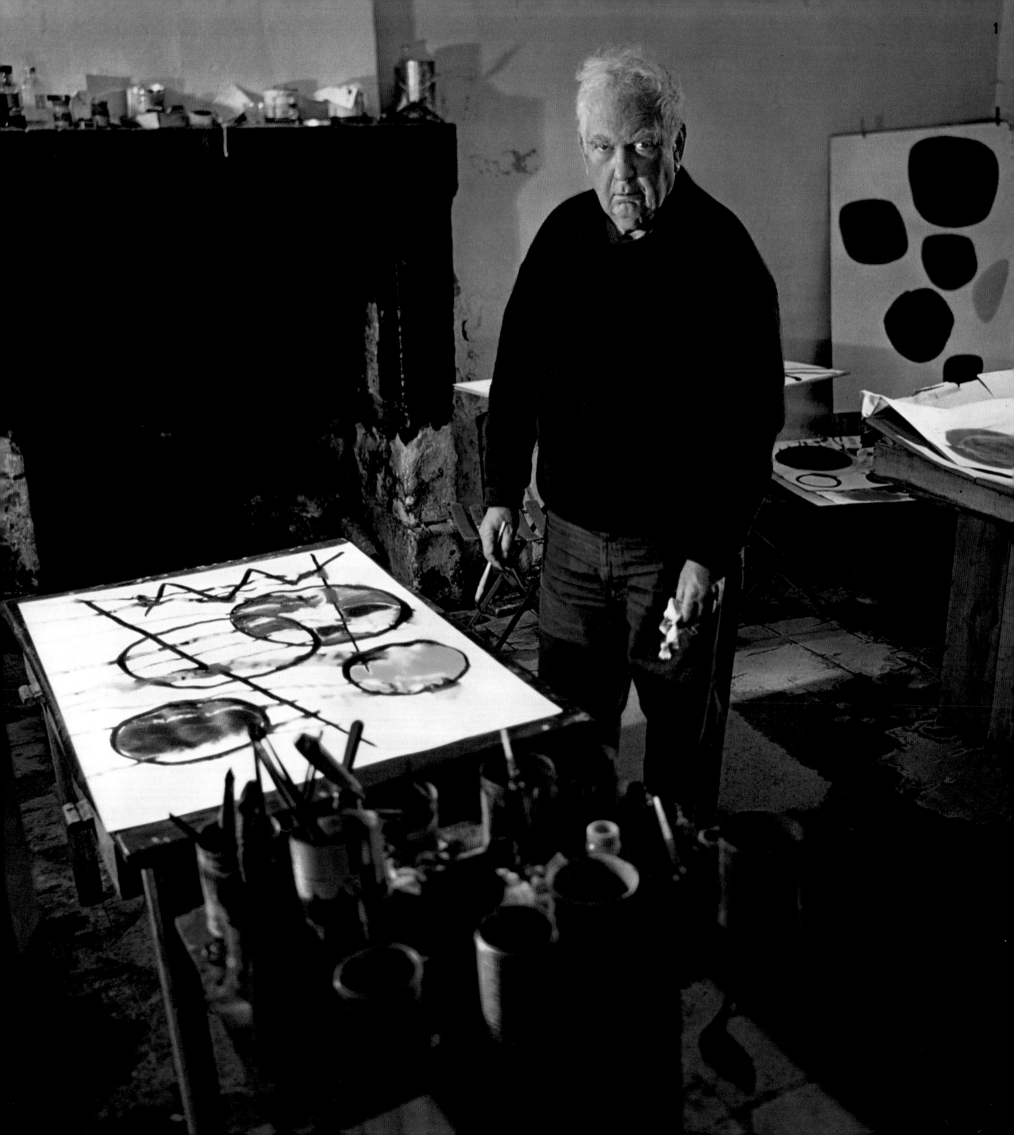

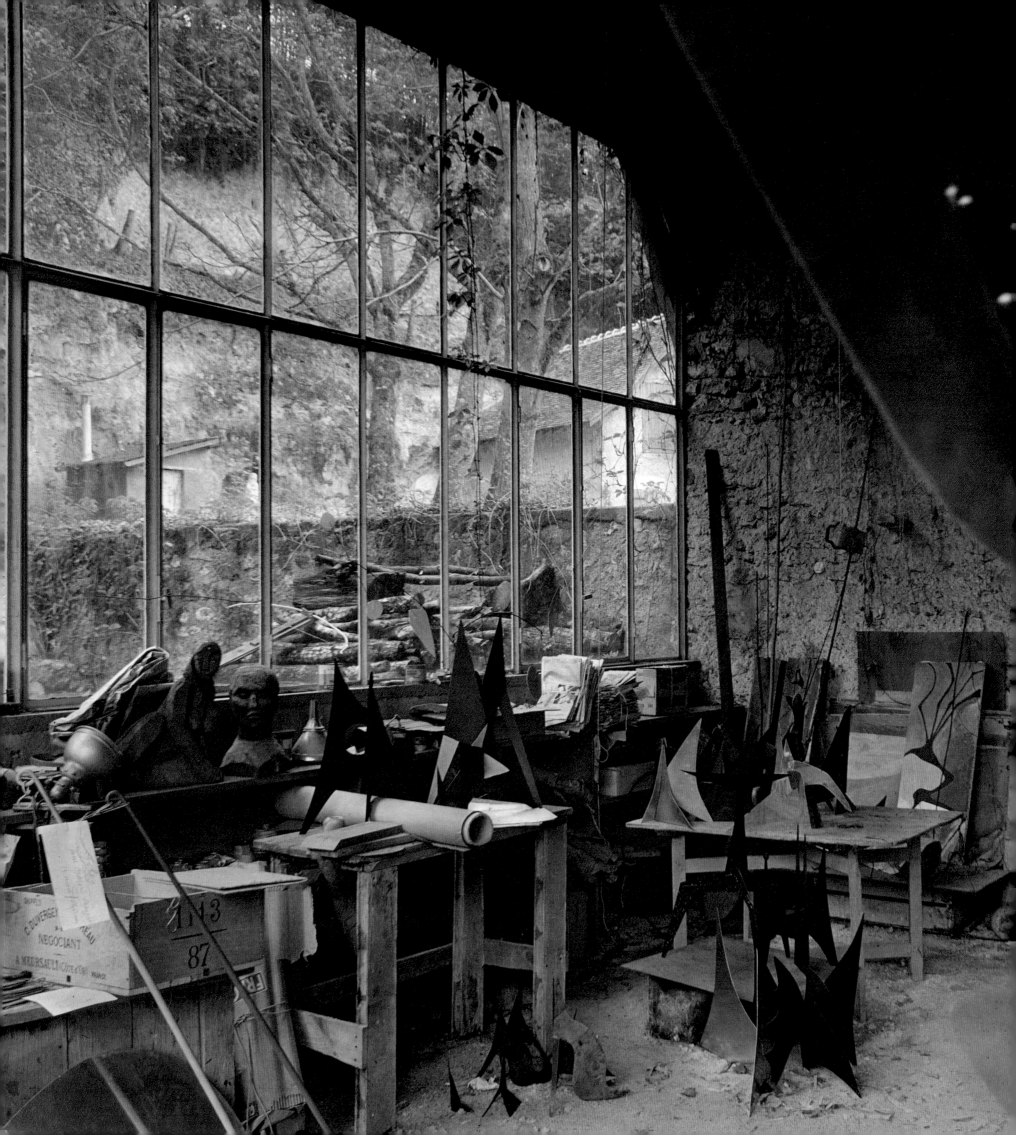

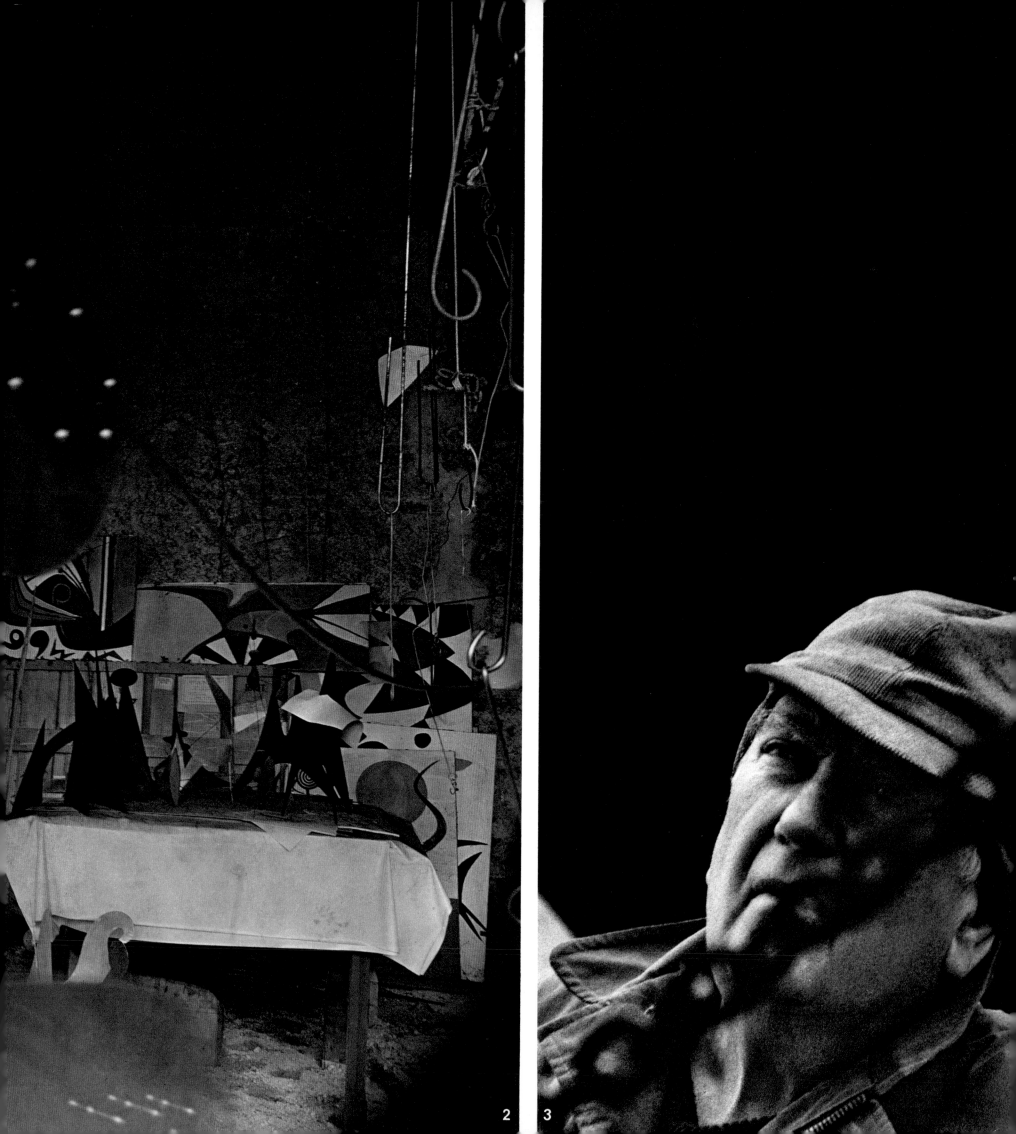

2 3

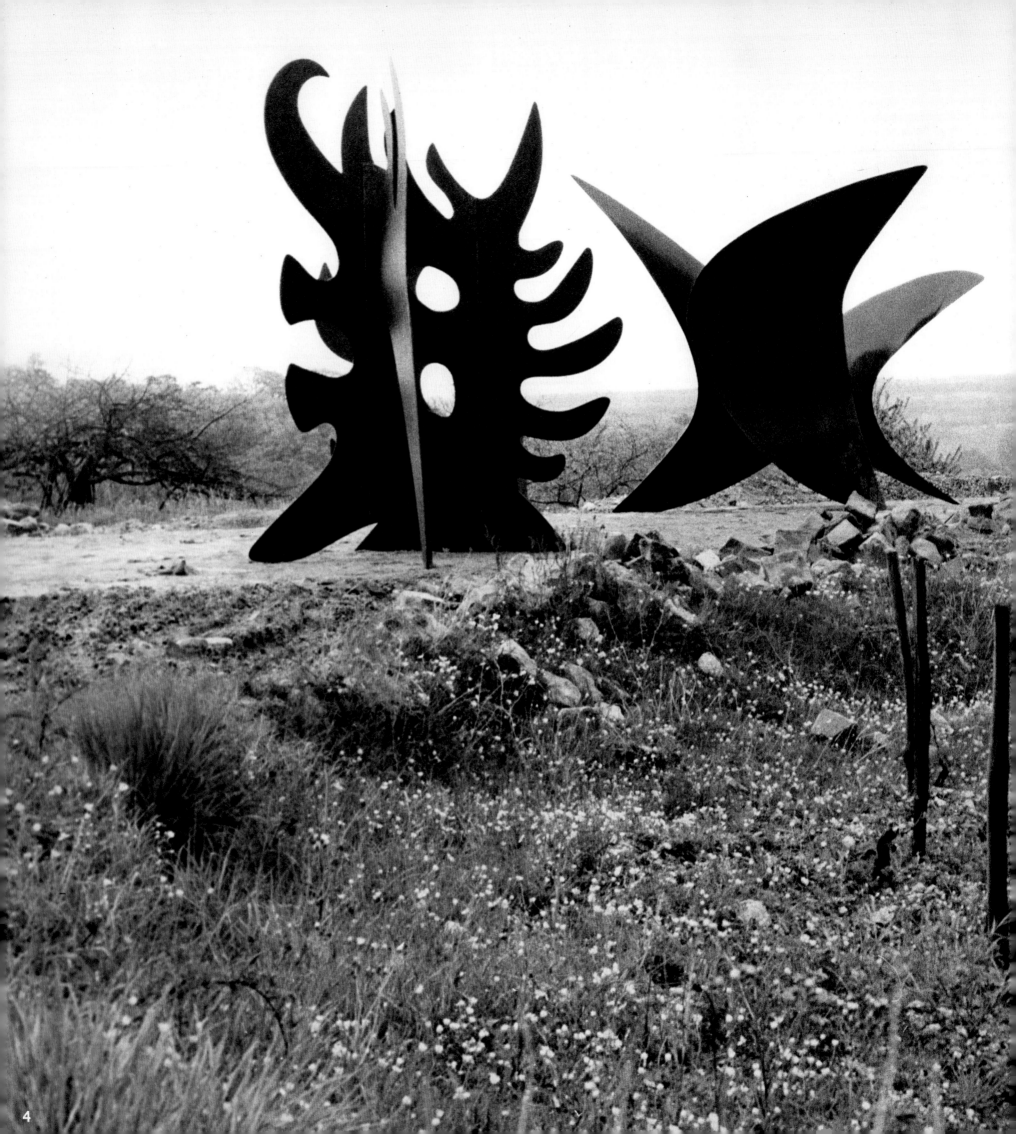

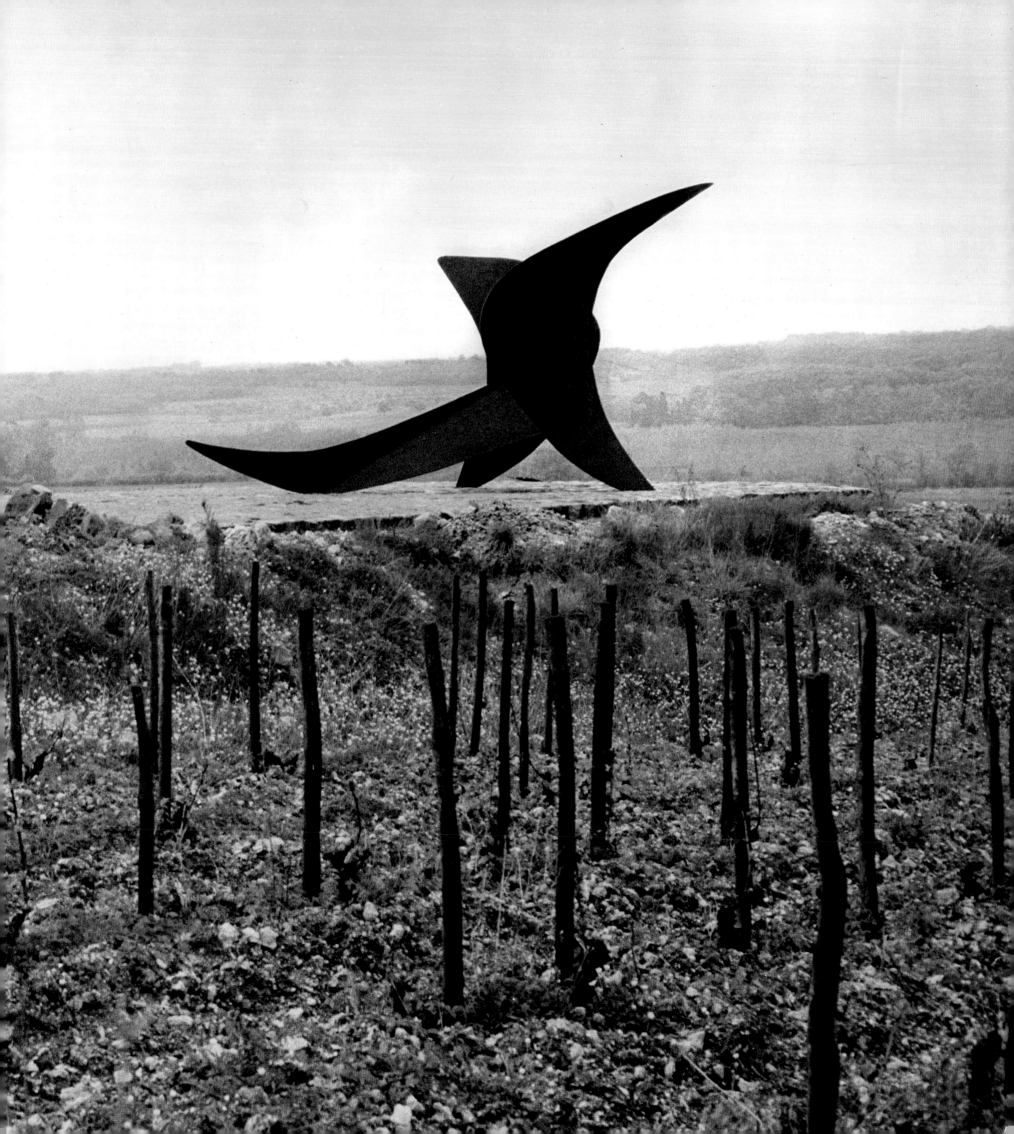

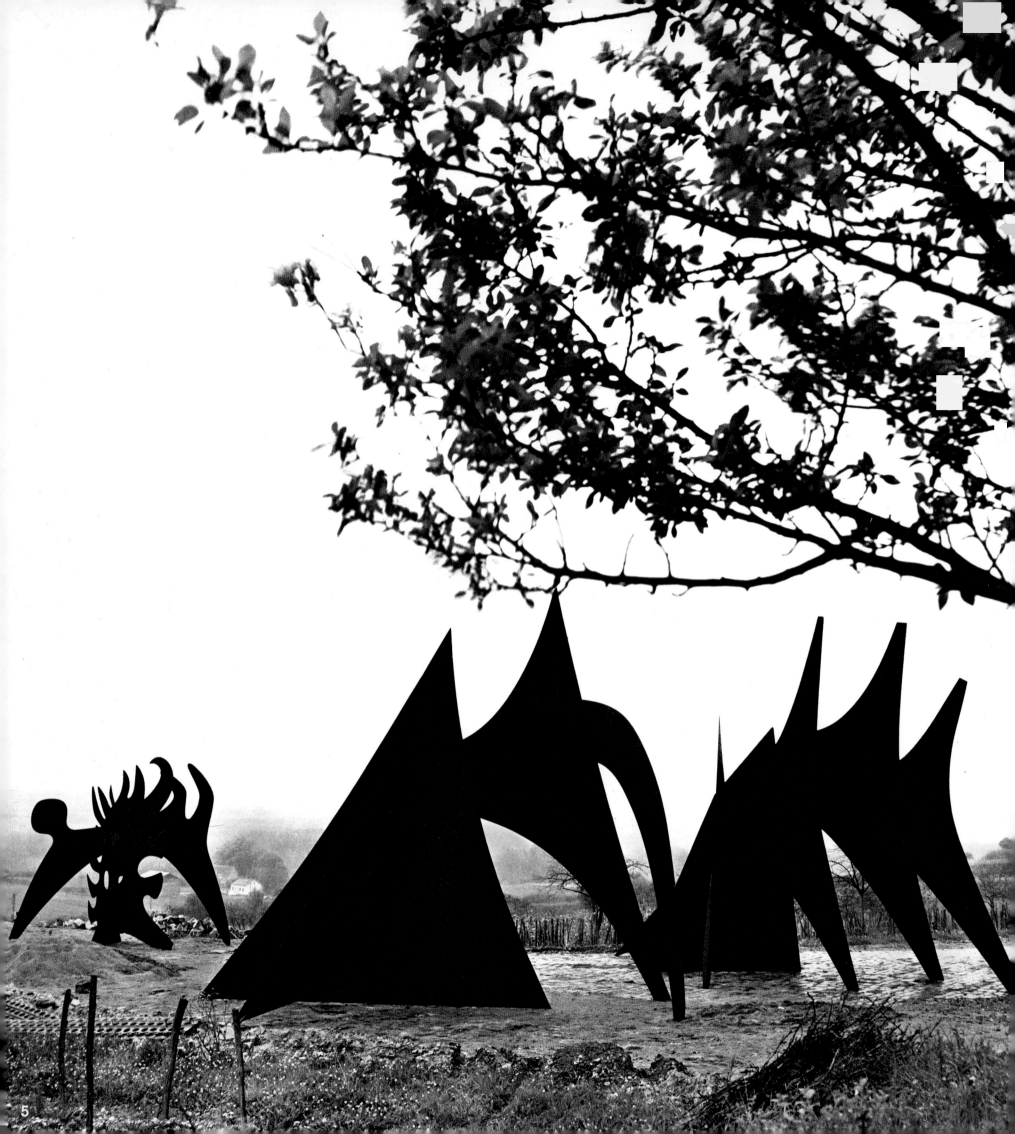

alexander calder

1. The sketching studio at Sache, a small village in the Touraine. Calder creates simple shapes in joyous colors.

2. The workshop of the structural engineer, the poet of the mechanical, where models for the stabiles are designed and the mobiles learn to breathe.

3. His eyes scan a certain world. . . .

4. A primitive world, another world, peopled by stabiles.

5. Some morning you'll open your shutters. . . .

1898 *Born in Philadelphia. His father was a sculptor, his mother a painter.*

1915 *Student at Stevens Institute of Technology. Displayed natural talent for descriptive geometry.*

1918 *Served in the Navy.*

1919 *Accepted first engineering job.*

1920 *In turn a journalist, sailor, and an accountant in a forestry development. Interest in drawing led to enrollment in night school.*

1923-1926 *Studied at Art Students' League, New York.*
Continued practice of engineering without entirely giving up journalism.

1926 *Start of artistic career. Exhibition of paintings and his first sculpture,* The Flattest Cat.
Animal Sketching *published.*
In Paris, began creating first animated figures for The Circus.

1927 *First showing of* The Circus, *in Paris. At the Salon des Humoristes showed animated toys. Made acquaintance of Miró.*

1929 *Held exhibitions in Paris and United States.*
Created his first bronze sculptures, some jewelry, and first animated constructions—to become known as mobiles.

1930 *Traveled to Spain, Corsica, South of France.*
Exhibitions of The Circus *proved a success with artist visitors (Léger, Le Corbusier, Mondrian).*

1931 *Married.*
Met Arp and Helion. Joined Abstraction-Création movement. Illustrated Aesop's Fables.

1932 *First exhibition at Galerie Vignon of work Marcel Duchamp baptized as "mobiles" (thirty mechanically operated sound-producing constructions).*

1933 *His mobiles now activated only by air currents.*
Showed with work of Arp, Helion, Pevsner, Miró, Seligmann.

1934 *Exhibition at Pierre Matisse Gallery, New York.*

1935 *Designed stage sets for Martha Graham ballets and Erik Satie's Socrate.*

1937 *Created* Fontaine de Mercure *for Paris International Exposition (Spanish Pavilion).*

1940 *Exhibition of jewelry in New York.*

1943 *Made* Constellations, *in wood and wire. Important retrospective exhibition at Museum of Modern Art, New York. First "stabile," in painted sheet-metal.*

1944 *Exhibition of mobiles at Galerie Louis Carré, Paris. (Preface to catalog by J.-P. Sartre.)*

1945-1949 *Exhibitions of his work in Berne, Amsterdam, Rio de Janeiro, São Paulo.*

1950 *First exhibition at the Galerie Maeght.*

1952 *Received Grand Prix for sculpture at Venice Biennial.*

1953 *Bought house at Saché, near Tours (which was to become his principal residence from 1957 on).*

1958-1960 *In addition to sculpture, began producing engravings, paintings, gouaches, and full-sized sketches for tapestries.*

1961 *Produced* Four Elements *(33 feet high and motor-driven) for Museum of Modern Art, Stockholm.*
Carlos Viardebo shot his film The Circus.

1962 *Built a large studio on hill near his house at Saché made necessary by the growing proportions of his works (such as a 59-foot-high stabile for town of Spoleto).*

1964 *Created* Renforts, *a stabile for the Fondation Maeght, at Saint-Paul-de-Vence.*
Retrospective exhibition at Guggenheim Museum, New York.

1965 *Retrospective exhibition at Musée National d'Art Moderne, Paris.*

1967 *Man, 72-foot-high stabile, exhibited in Montreal.*

1968 *Started work on giant production, for Olympic Games, Mexico City.*

piaubert

The secret's out—Piaubert has always loved kites. I've never made a trip with him. He says there's only room for one aboard, and kites are tricky to handle.

Nevertheless Jean Piaubert must be the only cosmonaut to have claimed to have grazed Mars at nine a.m., greeted the sun at midday, and ravished Venus between five and seven.

But then, it's Piaubert who says it's a kite. Have *you* ever seen a kite in a man's eyes? And yet I must believe Piaubert dreams that way to bring mankind what he finds in the cosmos—the fountainhead of fresh visions.

I visited Jean Piaubert twice in his studio-laboratory, and the first impression of his work was of red-golds and hyacinth-yellows. The colors seemed to be dripping from his fingertips as he shaped new continents on canvas with the exact science prophets possess. Had he encountered the red, black, and yellow silhouettes he was painting in some rough, corroded landscape that was their dwelling place?

Determined, obstinate goldminer that he is, Piaubert brings us the earthy messages he finds engraved on frozen lava.

A master practitioner of his art, he knows how to organize the dying matter secreted in metaphysical space.

Full of courage, he quit art school in his native Bordeaux when he was twenty and went to Paris.

He was soon to feel the impact of Kandinsky at an exhibition of that painter's work. Then, in painting a vineyard, he noticed that other mysterious landscapes were defined in the sheer physical strength displayed by the grays, blacks, and whites of the furrows.

Figuration became secondary to him. The rhythm of colors traced the space-way to his dreams.

Frasnay has caught me in his piercing eye and framed me with his pen. He has x-rayed the planets within me, photographed my good profile, made me look younger—flattered me, what?

While some people see only my multiplicity, others my candor, he has pictured my firmament. And whereas I seem to be a metaphysician to some, others know I love to laugh. To Frasnay I look like Aquarius, the water bearer. That says it all. I live, therefore I vary. I am not rigid stone. Man seeks his balance, his equilibrium, between the extremes of impulse and meditation. In a lifetime of movement and changes it's impossible to maintain either of these positions alone, and a man's mental existence, with all the creative talents it develops, shows signs of both the harmonies and the collisions between them. Impulses lead to baroque expression, meditation to the classical.

My painting seems to my critics to be a synthesis of stimulations and impulses, the welding of memories and omens, a confrontation between the innate and the metaphysical.

To me it's principally sensory, often impregnated by some protracted dream state. Sometimes the deep shock caused by a single word serves to release to my inner eye elemental forms that keep renewing themselves and engendering their plastic offspring. My painting is never static, it moves about, it breathes. It can't be hampered or pigeonholed; it is never dependent on doctrine, philosophical concepts, or whatever happens to be in style.

Starting out with materials broken down into their innermost elements, I try to record a question, not to paint a message. I don't want the picture to be merely an optical delight but to embrace the intellect of the viewer, for I feel that mankind, glutted as it is with facts and certainties, yearns for the mysterious in life and longs to delve more and more into the world of the mind. Wide-eyed, men await the dreams that are truer than what they know. They want painting to be a springboard for their imaginations, an assistant in transcending reality, a tool to strangle the commonplace. In his heart of hearts the true art lover knows that the painting is also looking at him. He is only really happy when they can talk together.

We live in a time in which men are trying to break free from certain immutable laws, like those of time and gravity. Science has served to make this possible. Why not then admit that art also seeks to escape the slavery of certain classical canons in perpetually exploring all possible liberties of expression? In an era in which the unit of measure in time has become the nanosecond—the one-billionth part of a second—it would be indecent of art not to get into step.

Like the atom we are constantly being subjected to the bombardment of shocks and sensations without being able to locate their source, as if they were purely due to chance. In the field of art I am one of those who are determined to hold on to their senses, their self-control. Like Reverdy, I believe that "art begins where chance ends." I am for thinking things out but, paradoxically enough, also for giving the mind a rest. Only the end result counts. Painting as I see it is neither an exercise in virtuosity nor a pastime. Painting is a secret language that opens all the doors that neither philosophy nor music can unlock. But the mystery of this penetration works only in a certain climate, that of veritable art, and only on a certain level, among the mountain peaks. Michel Tapie defined it perfectly: "Art is the phenomenology of the masterpiece." And this only goes to show what I think of what's facile.

To me, painting is neither a profession nor a game. It's a mistress. I mold her with my hands. I speak to her. She answers me. We have our secrets, our joys, our sorrows. Her whims are my pleasure, since I owe her everything. I've lived with her a long time. Yes, I love her.

PIAUBERT

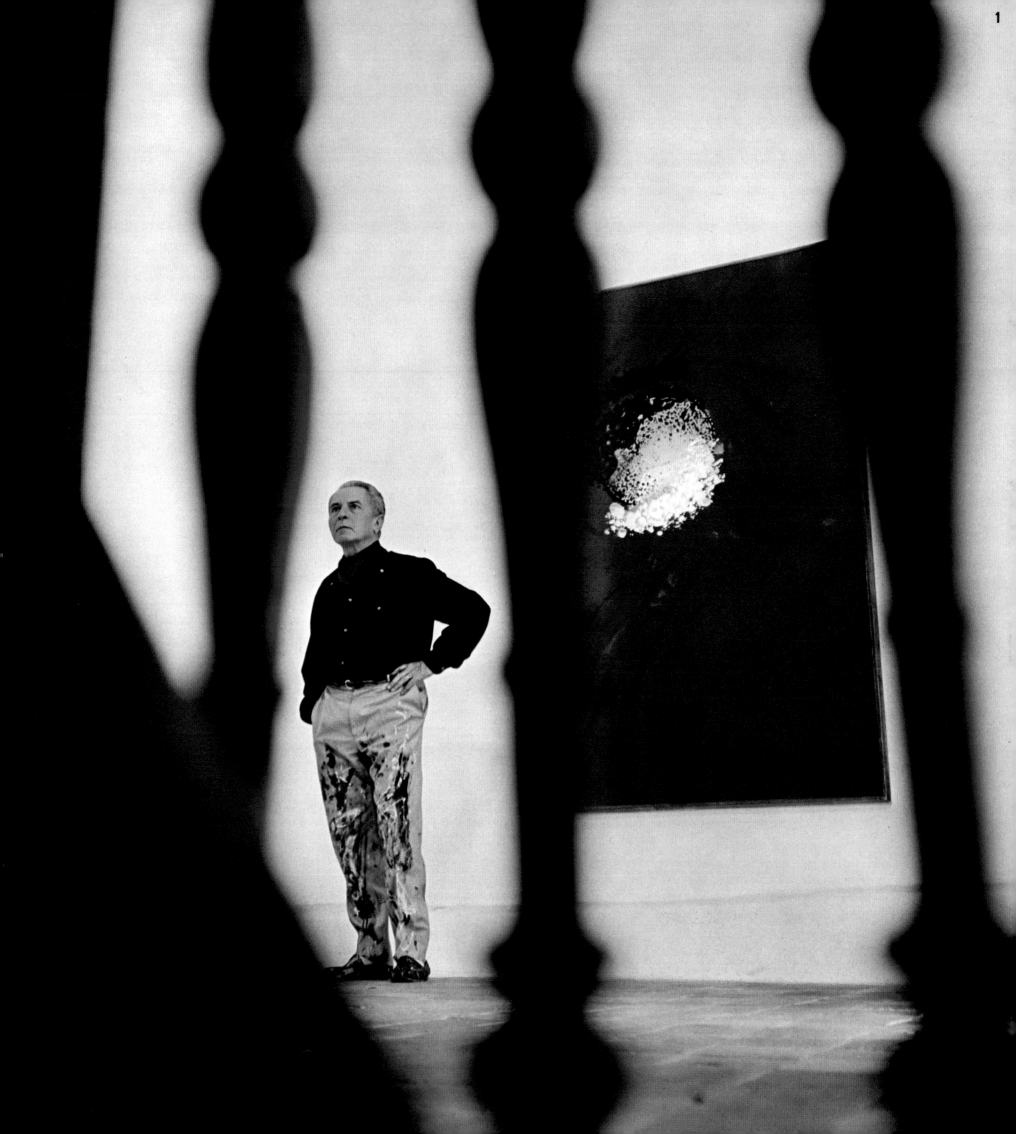

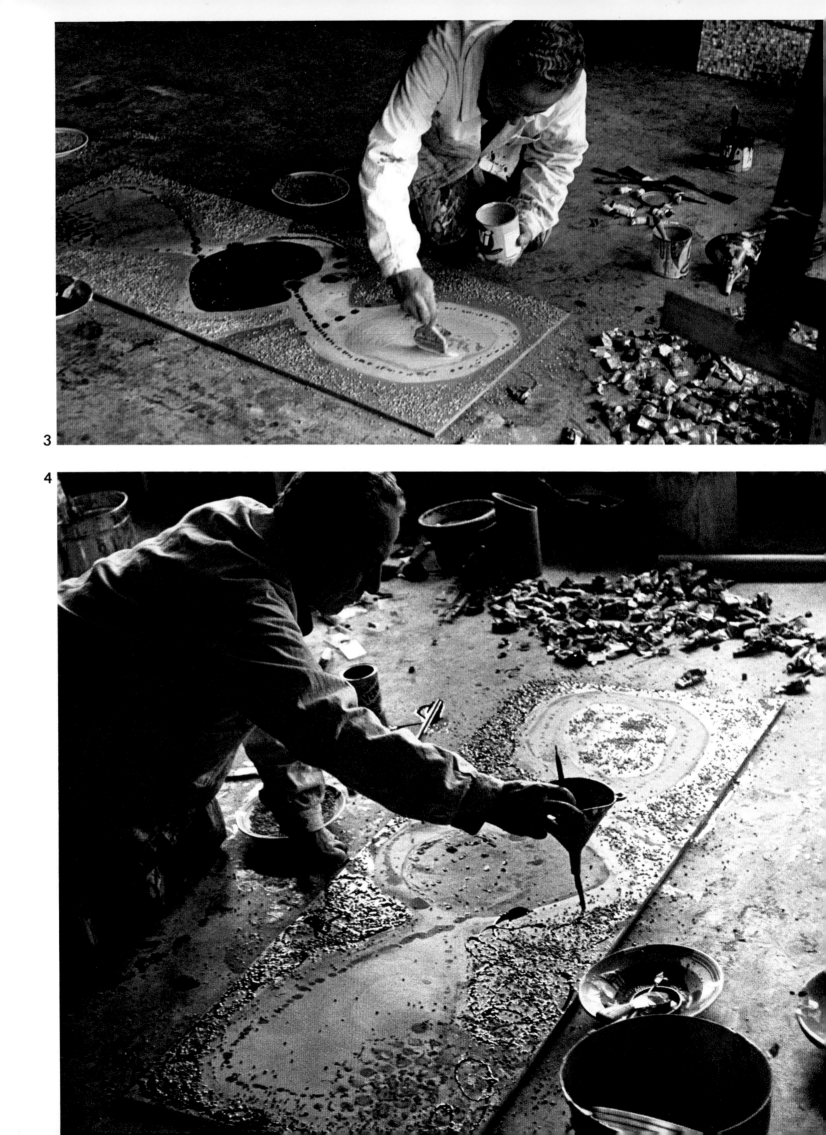

3

4

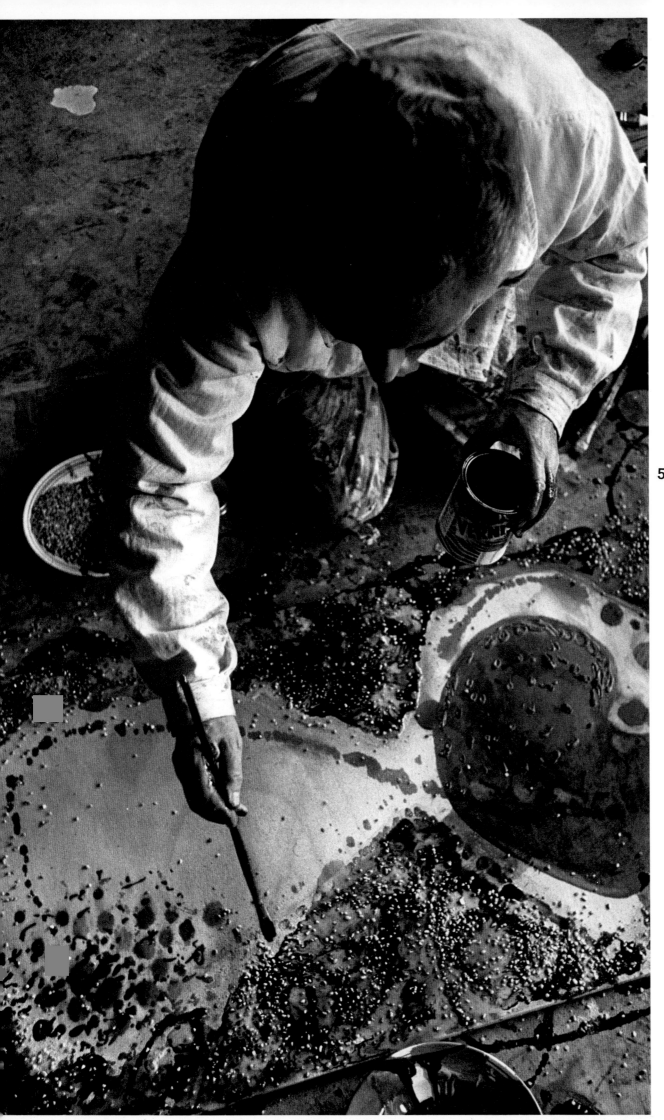

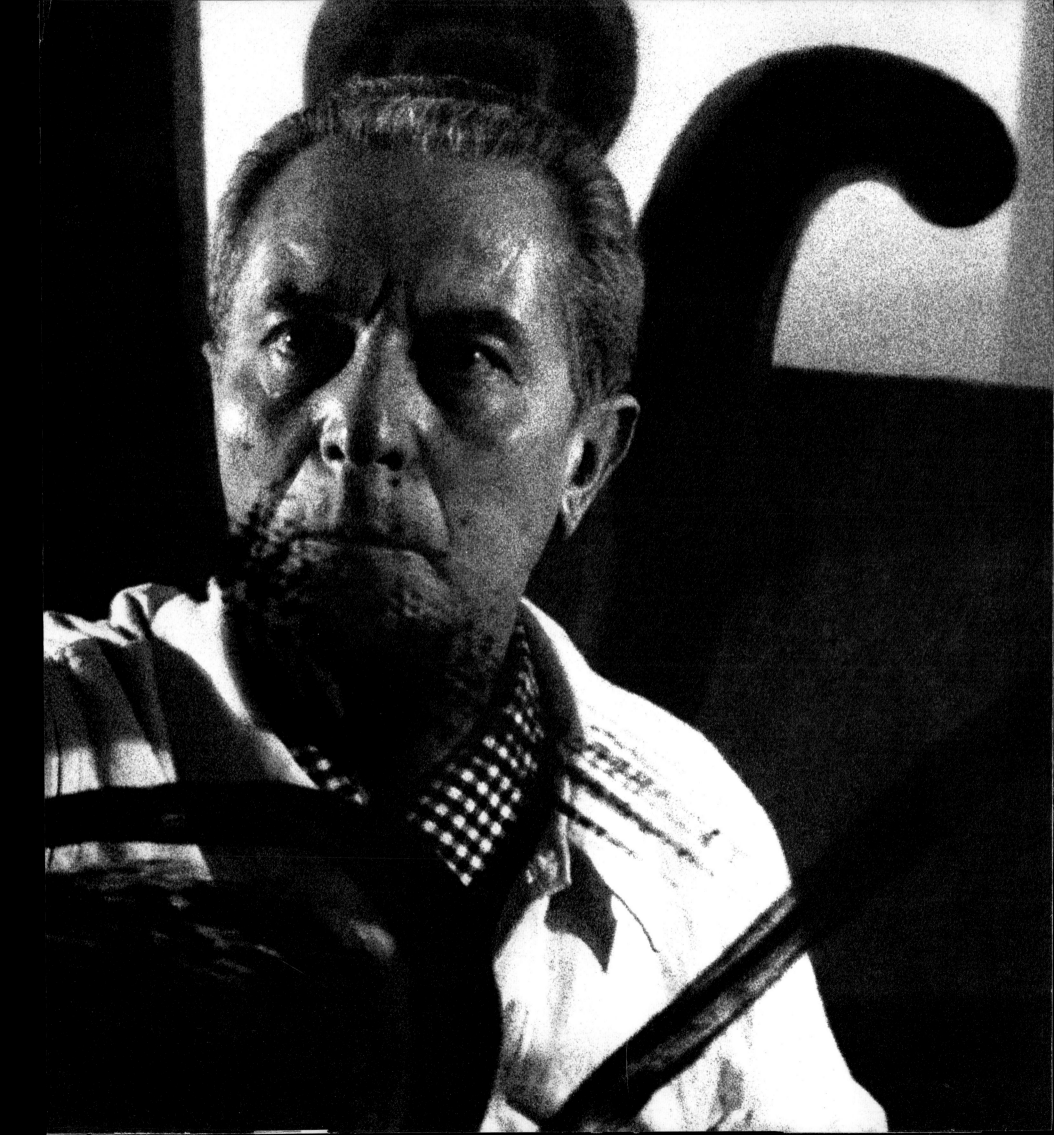

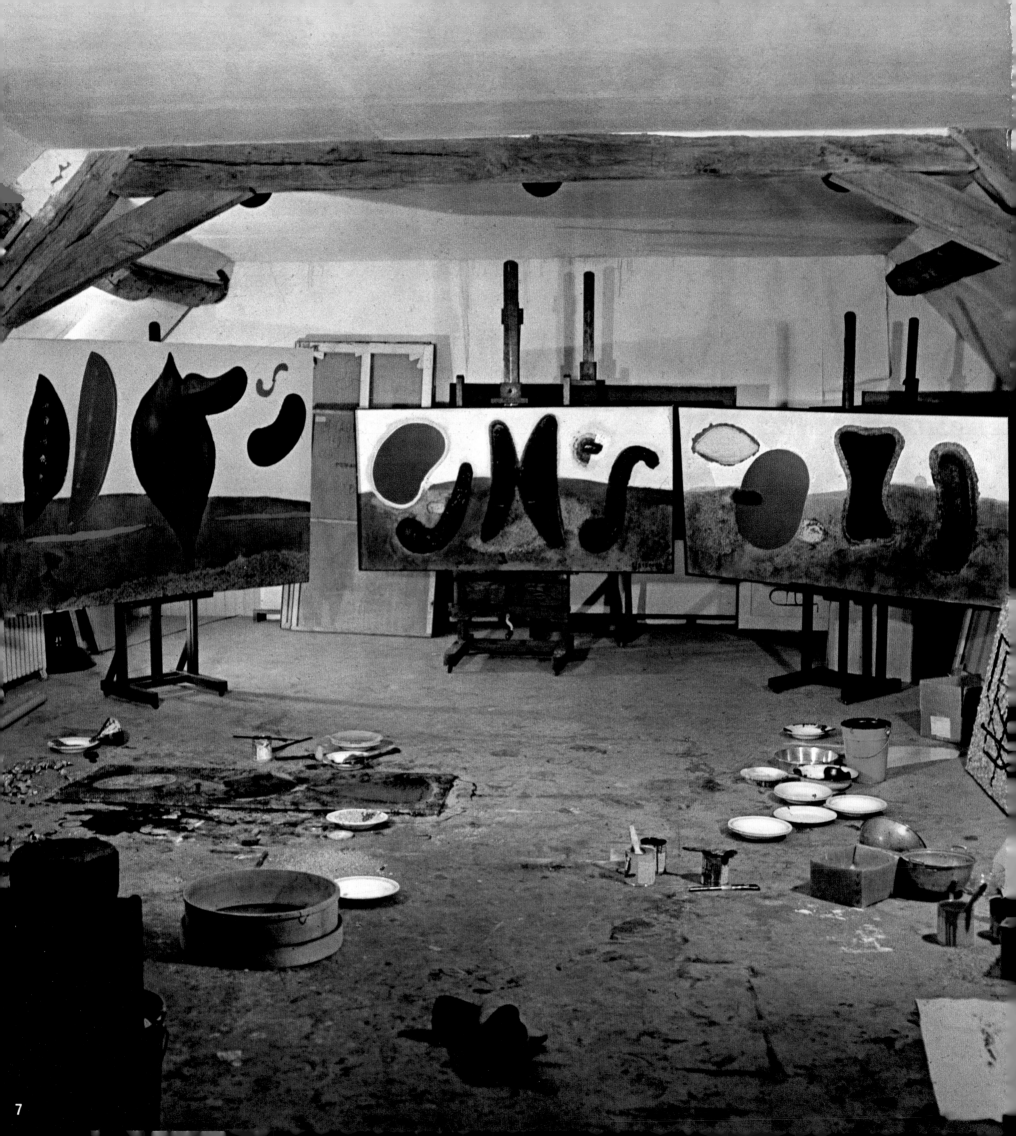

jean piaubert

1. ... "I am for careful consideration" : Piaubert.

2. Detail.

3-4-5. The painter at his work.

6. Piaubert paints with the help of a transparent support : "... my painting is a confrontation between the innate and the metaphysical."

7. After the artist has left it, the studio seems like a suspended journey.

1900　Born January 27 at Feydieu, in the Gironde.

1917-1920　Engaged in classical studies at the École des Beaux-Arts in Bordeaux and worked on stage settings.

1925　Designed sets for Paul Poiret, who bought his first canvases.

1932　First show, Galerie Zak at Saint-Germain-des-Prés, where Kandinsky was also exhibiting.

1936　Collaborated with Draeger, the printer.

1939　Drafted by the army.

1944　Made his first abstract painting, La Mer Méditée. Afterward he painted a large-size canvas entitled Barbara.

1946　Joined the New Realities group with Arp and Pevsner and exhibited with them for the first time.

1947　One-man show, at Galerie Denise René. Paris. Preface to catalogue by Estienne.

1948-1949　Participated in many group exhibitions abroad.

1950　Salon de Mai. Illustrated the Trente-trois Sonnets of Jean Cassou. Received Gold Medal at Milan Triennial.

1951　Held a one-man show at the Galerie Bing, Paris.
Monograph on his work by Jean Cassou published.

1952-1954　Traveled in Greece, Turkey, Asia Minor.

1955　Three one-man shows : at the Galerie Bing in Paris, the Birch in Copenhagen, and the Kunst in Odeuse.

1956　One-man show at the Obelisco Gallery, Rome.
J. C. Sorenson published his Voyage en Grèce and L'Univers Prophétique de Piaubert, by Frank Elgar.

1957-1958　One-man shows at the Galerie Bing and Galerie Creuzevault, Paris ; the Palais des Beaux-Arts, Brussels ; the P. B. A. Charleroi ; the Raaklin in Bruges and at the Kunstforeningen, Copenhagen.

1959　Illustrated Bahia by Pierre Seghers.
Received the Prix Paul Cézanne, Brussels.

1960　Eight retrospective exhibitions of his work held in German museums and art galleries : Mannheim, Düsseldorf, Hamburg, Dortmund, Wuppertal, Münster, Lubeck, Bremen.
At the Heidelberg Theater, designed scenery for a revival of Darius Milhaud's ballet La Création du Monde, with a libretto by D. H. Fuchs illustrated with his eight stage settings for the ballet.

1961　Twenty-five Piaubert paintings from South American collections shown at the Caracas Museum. Preface to the catalogue by J. Palacios.
Exhibitions in Paris and at the Galerie Argos, Nantes.

1962　Showed ten canvases at the Sixth Sao Paulo Biennial. Illustrated three poems by St.-John Perse, published in Réalités.

1963　Several large canvases exhibited at the Palais des Beaux-Arts, Brussels, and at Charleroi.

1964　Received the Gold Seal of the S.E.A.I., Paris. At the Menton Fifth Biennial, which payed homage to Braque, received the International Grand Prix.
At the Turin International Center, Michel Tapié showed a group of his paintings, drawings, engravings, and tapestries under the title Le Triptyque Pérennité in a general exhibition called "Metaphysics of Matter," at the Galerie Stadler.

1965　Second exhibition of his work at the Galerie Argos, Nantes. Invited to take part in an exhibition of modern tapestries at Baylor University in Texas.
One-man show at the Metras gallery, Barcelona.
Retrospective exhibition at Musée du Havre, presented by Reynold Arnould. Preface to the catalogue by Frank Elgar.

1966　One-man show, "Painting and Matter," at the Galerie Stadler, Paris.
Monograph on his work by F. Pluchard issued in the Collection Musée de Poche, under the editorship of G. Fall.
Retrospective exhibition at the Cologne Kunstverein, organized by Dr. Becker, then again at the Europa-Center, West Berlin. The Japanese Government invited him (and also Louise Nevelson and Giuseppi Capogrossi) to pursue his studies in Japan.
Exhibition at the Nippon gallery.
Visited California and New York.
Ten of his canvases shown at the exposition "Foreign Art in Danish Collections" at the Louisiana gallery, Copenhagen.

1967　Retrospective exhibition at the Maison de la Culture, Caen.
Victor Beyer, in partnership with Alexandre Iolas, showed forty of Piaubert's large canvases at the Musée de l'Ancienne Douane, Strasbourg.

1968　One-man show at the Alexandre Iolas gallery, Milan.

moore

Henry Moore, one of the titans of the art world, lives and works in the country, an hour's ride from London.

Behind his residence, an old farmhouse in Anglo-Norman style, the grassy turf stretches parklike to the studios. Looking like soft, sensual fleece modeled in all the varying tones of green, the lawn serves as the temporary repository for the vigorous forms of Moore's statues of motherhood.

These are the work of a man who sets his hand, his eye, on a human body, a pebble, a bone, a shell, with equal kindness. The demands of his poetic nature transfigure the shapes or forms he examines.

The masses of his sculpture, even to the hollows carved into them, are vibrant with the vitality that is their proper due, a vigor in harmony with the occult powers found in our deepest selves, reflecting both the peaceful rhythms and the convulsions of Mother Nature.

Does his outstretched hand or his optical mouth offer open sesame? Perhaps it is the way Moore carries his shoulders. His friendship opens up the refuge of his studios, the refuge of his garden, the refuge of his sculpture.

Mountain-women of undulating flesh,
sentinels draped in their original clay,
disturbing standing figures, exacting tribute,
recumbent figures with their gaping voids
mothers, pregnant majesties
shapes, fœtuses in the act of evolution
helmets that are tabernacle-heads
totems that are person-objects.

Moore's effigies explore themselves outward
each one finds shelter there.
Seeded with emotion
they have the dimensions of the earth.
Mankind can find room there
they give the man-child
the desire to live.

The sculptures invented by Henry Moore
represent pain, actual, potential, imagined :
the black barge,
the mother's belly,
pain the belly hasn't had,
of which she knows nothing;
belly that she would have liked to rip open
that it might remember.

For me, sculpture is an art for the Open-Air.

DAYLIGHT — (on dull days or bright days, — in sunshine or rain) ~~nothing~~, reveals, shows shape better than the smartest, cleverest special lighting of any museum

Henry Moore

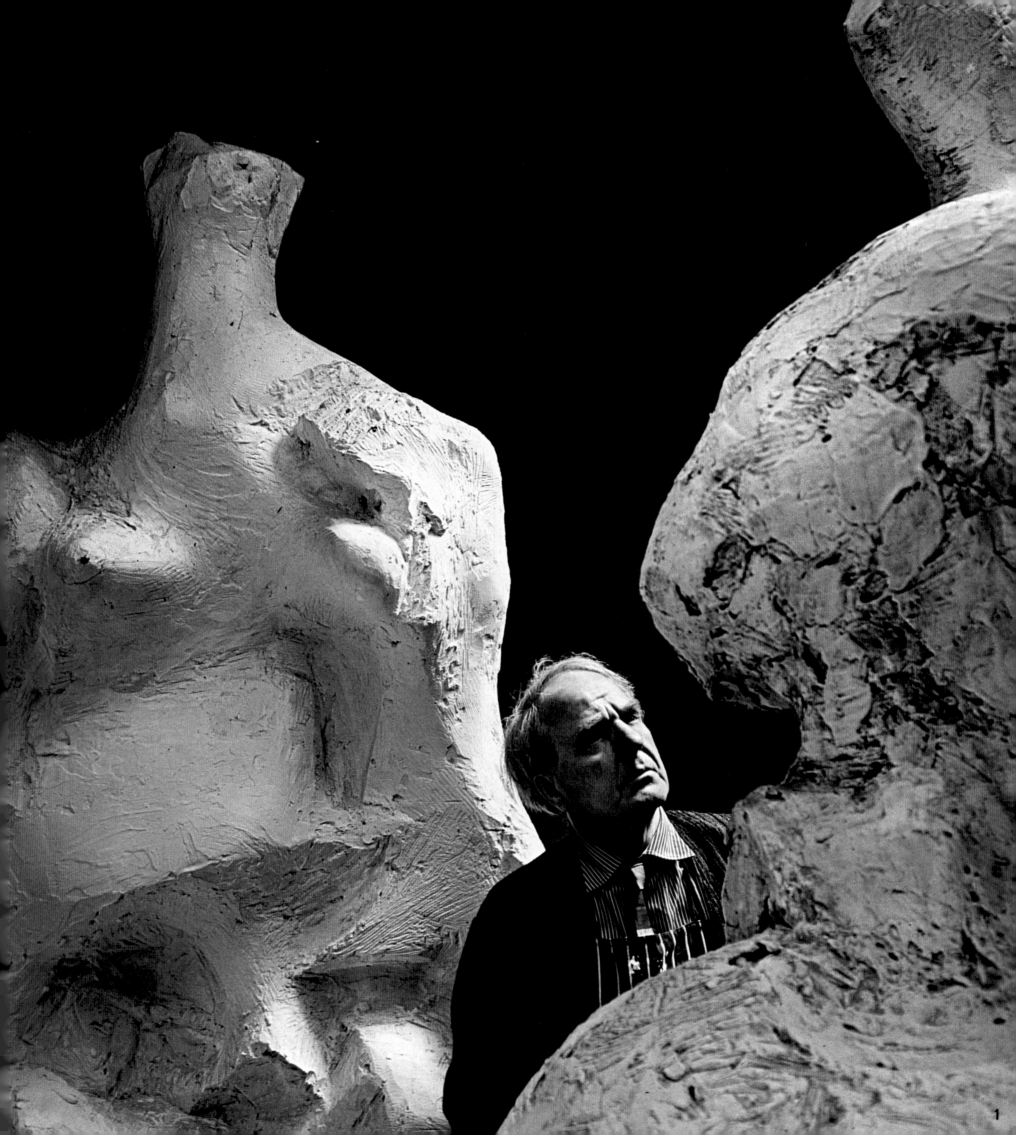

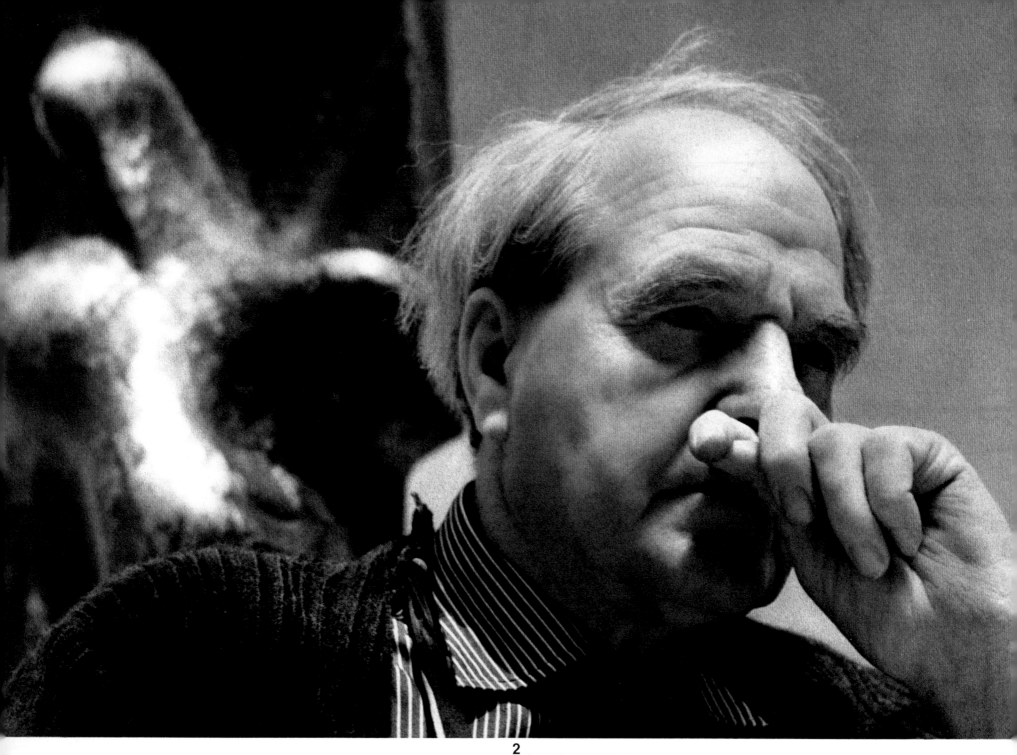

2

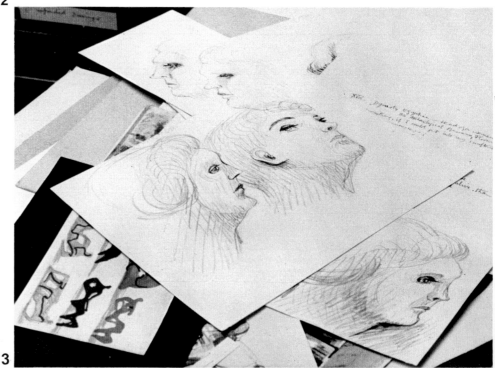

3

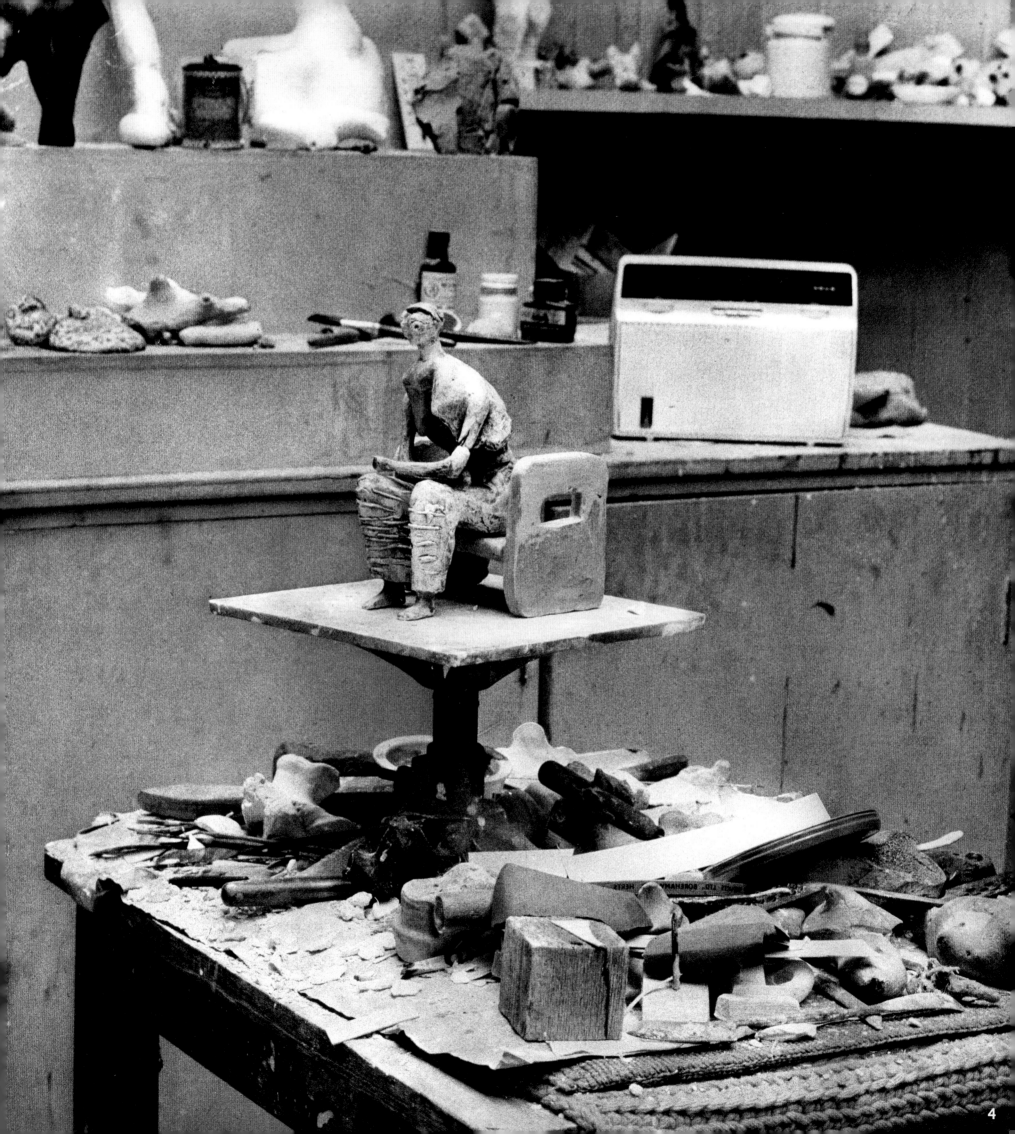

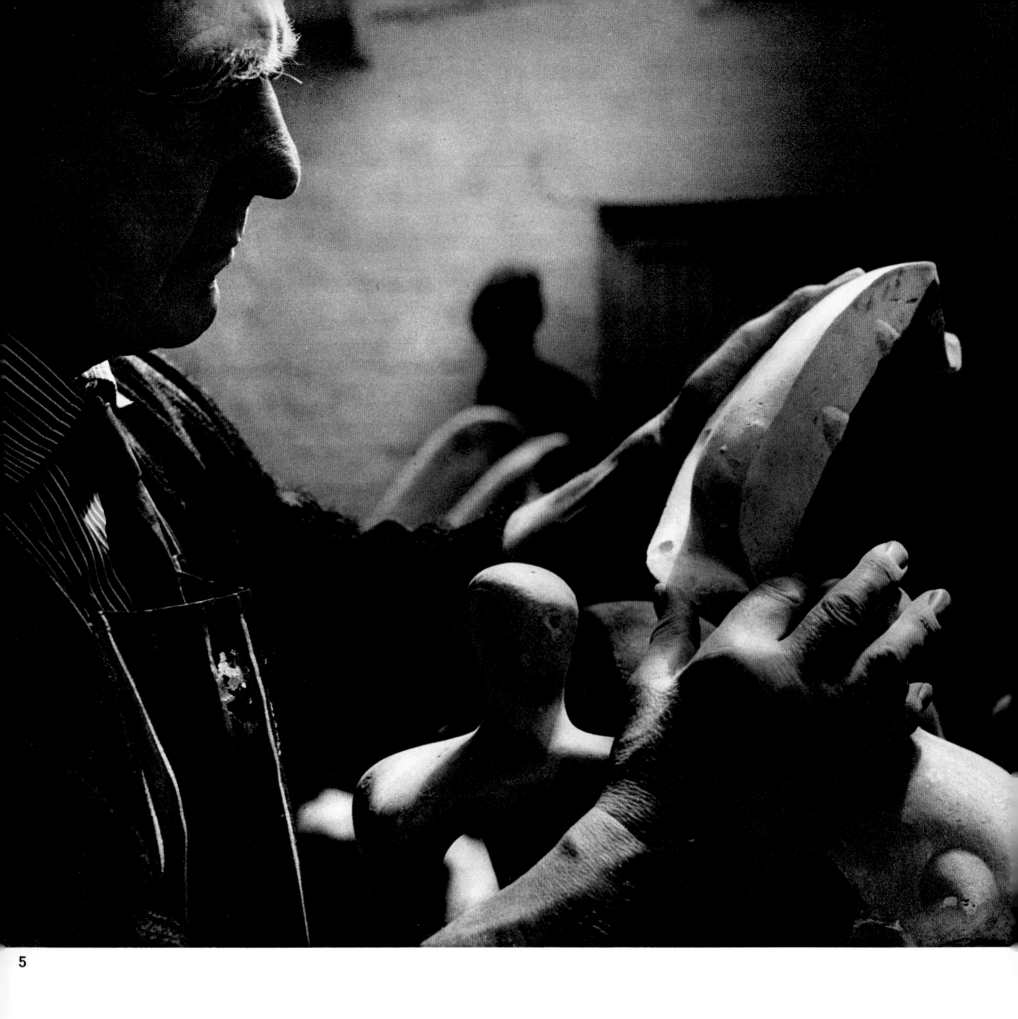

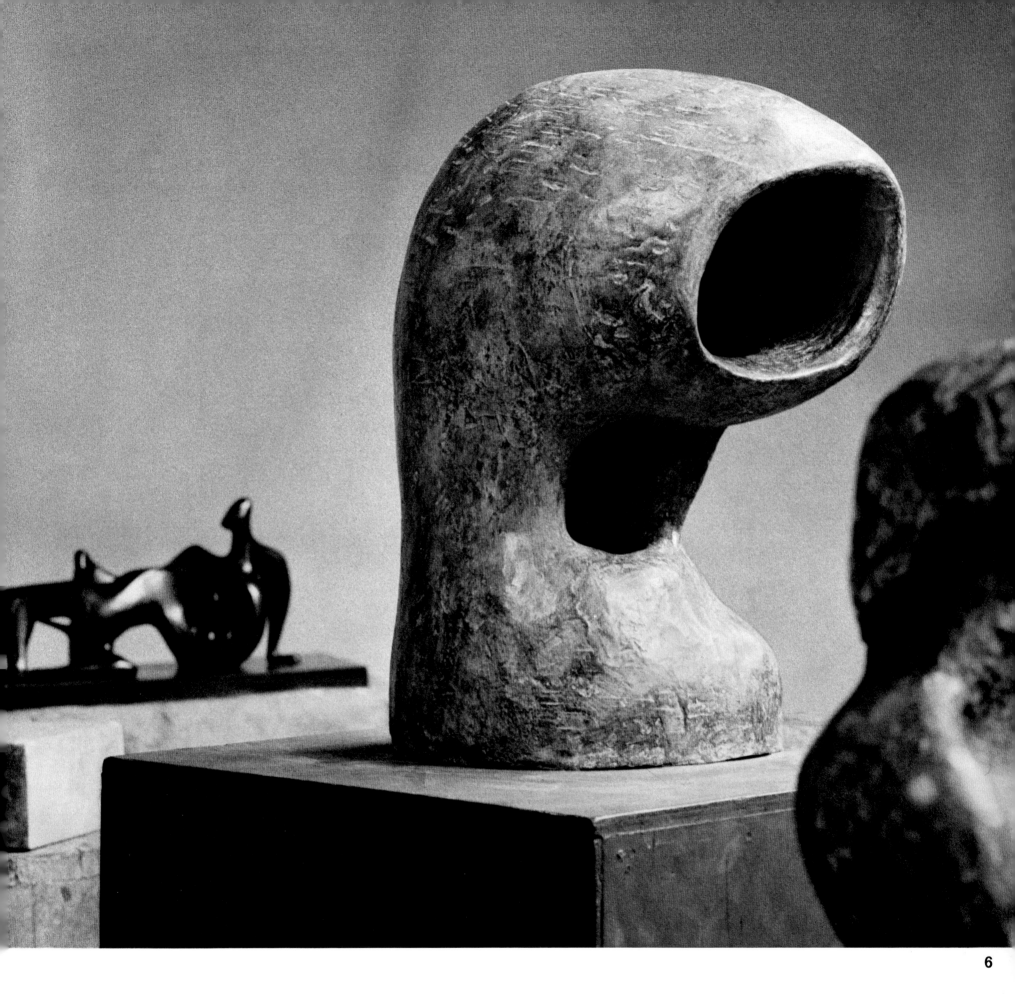

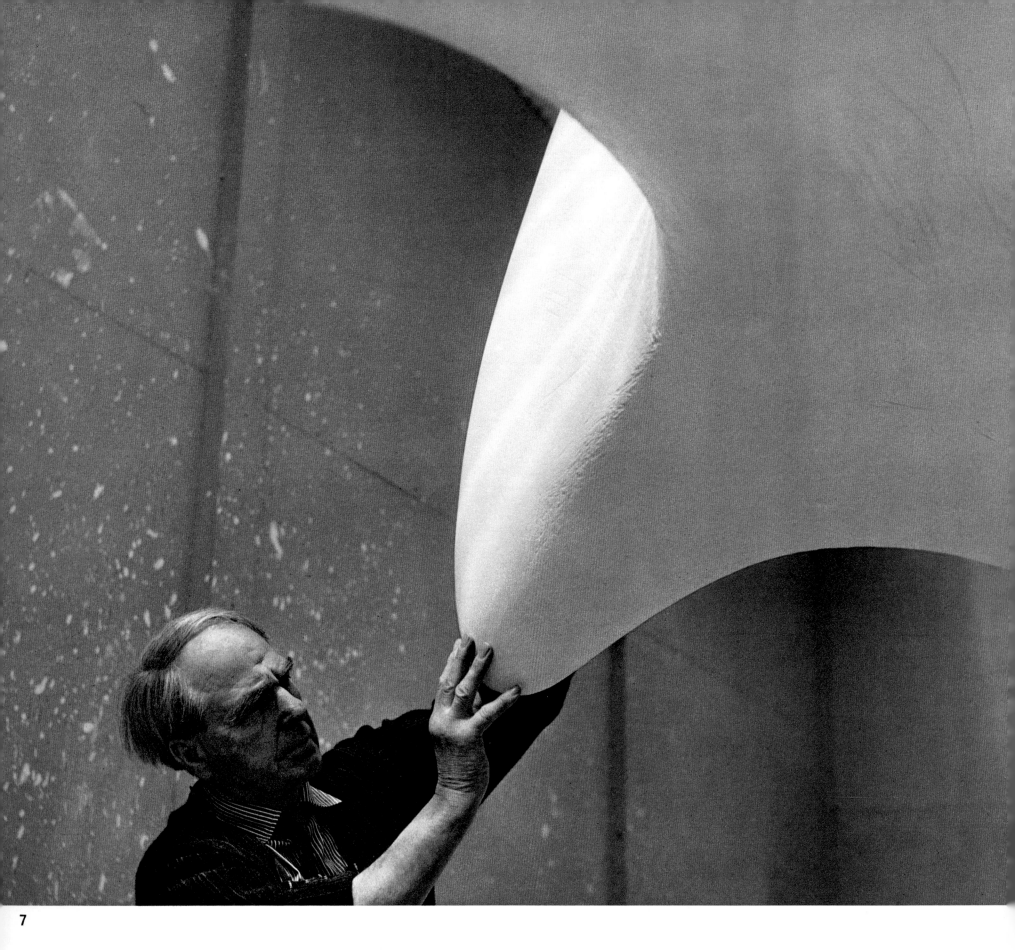

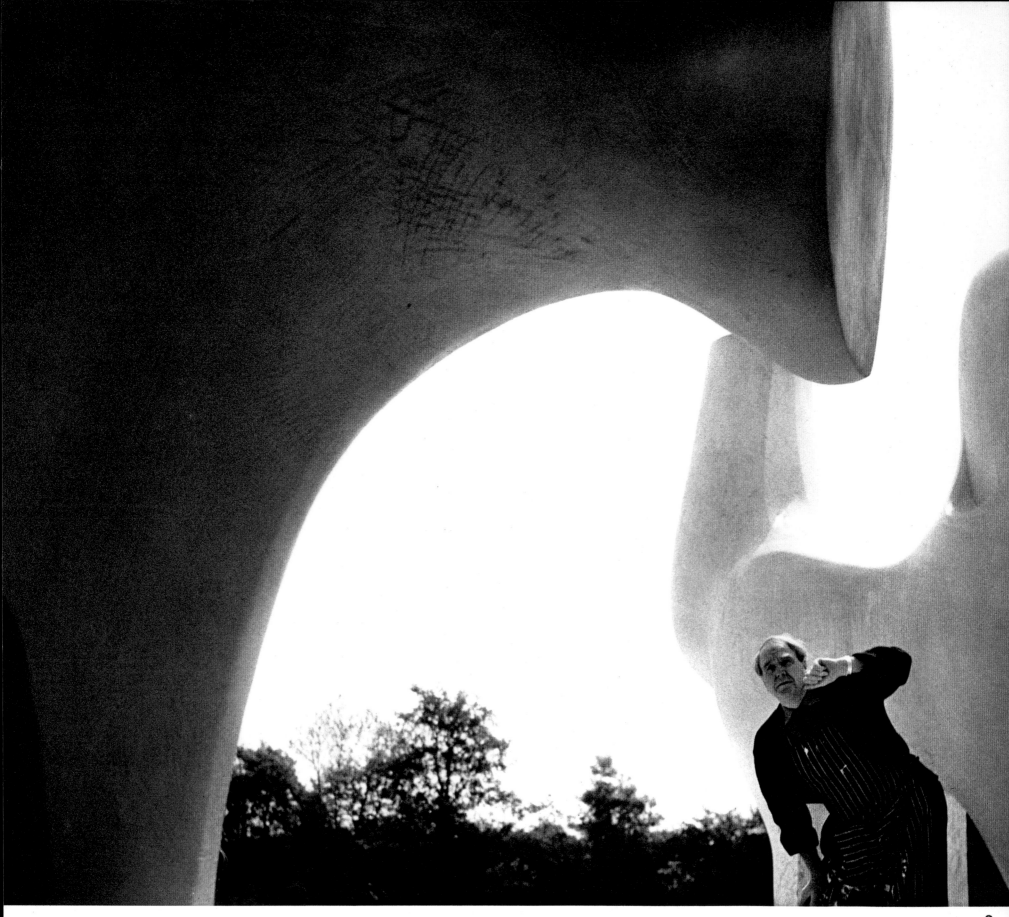

8

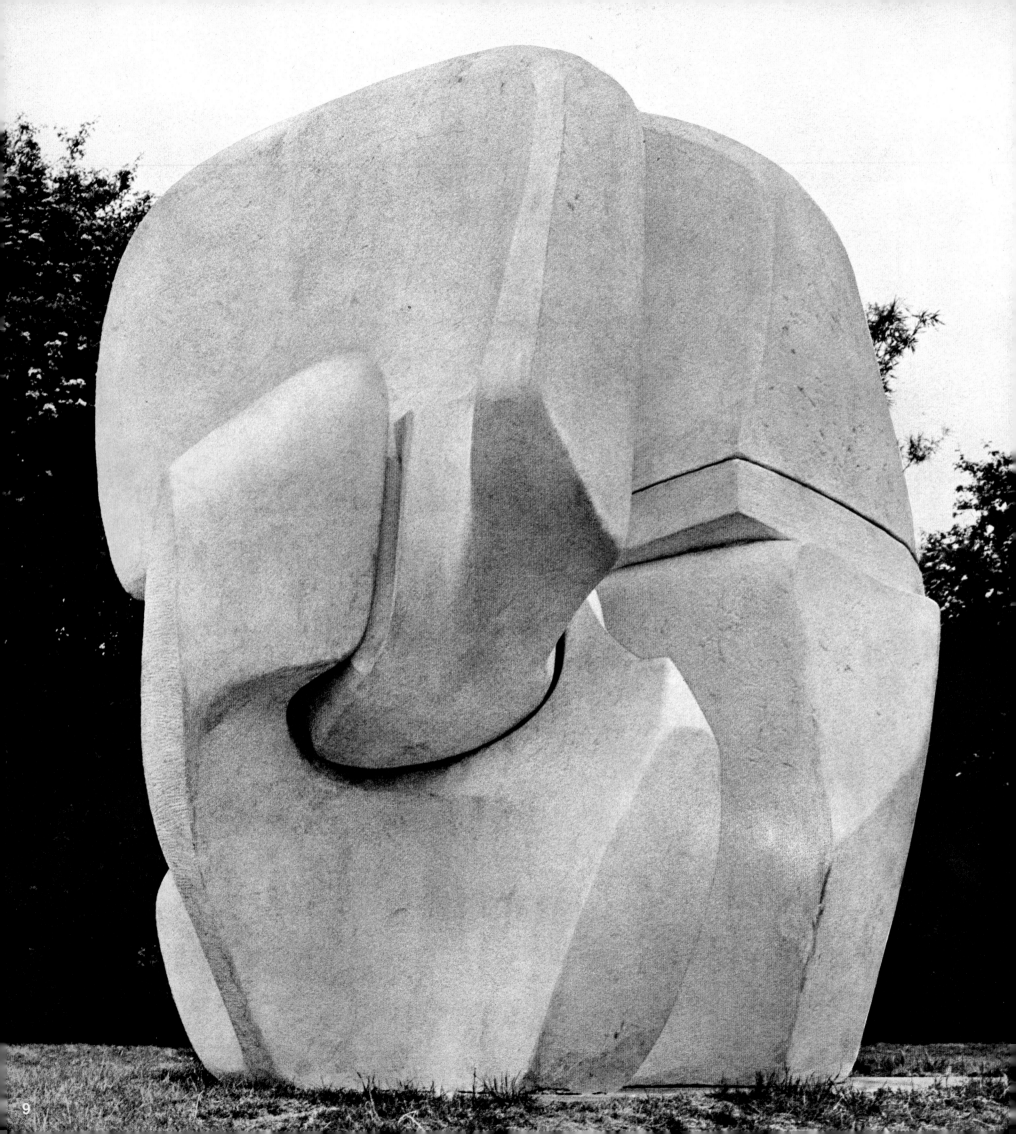

9

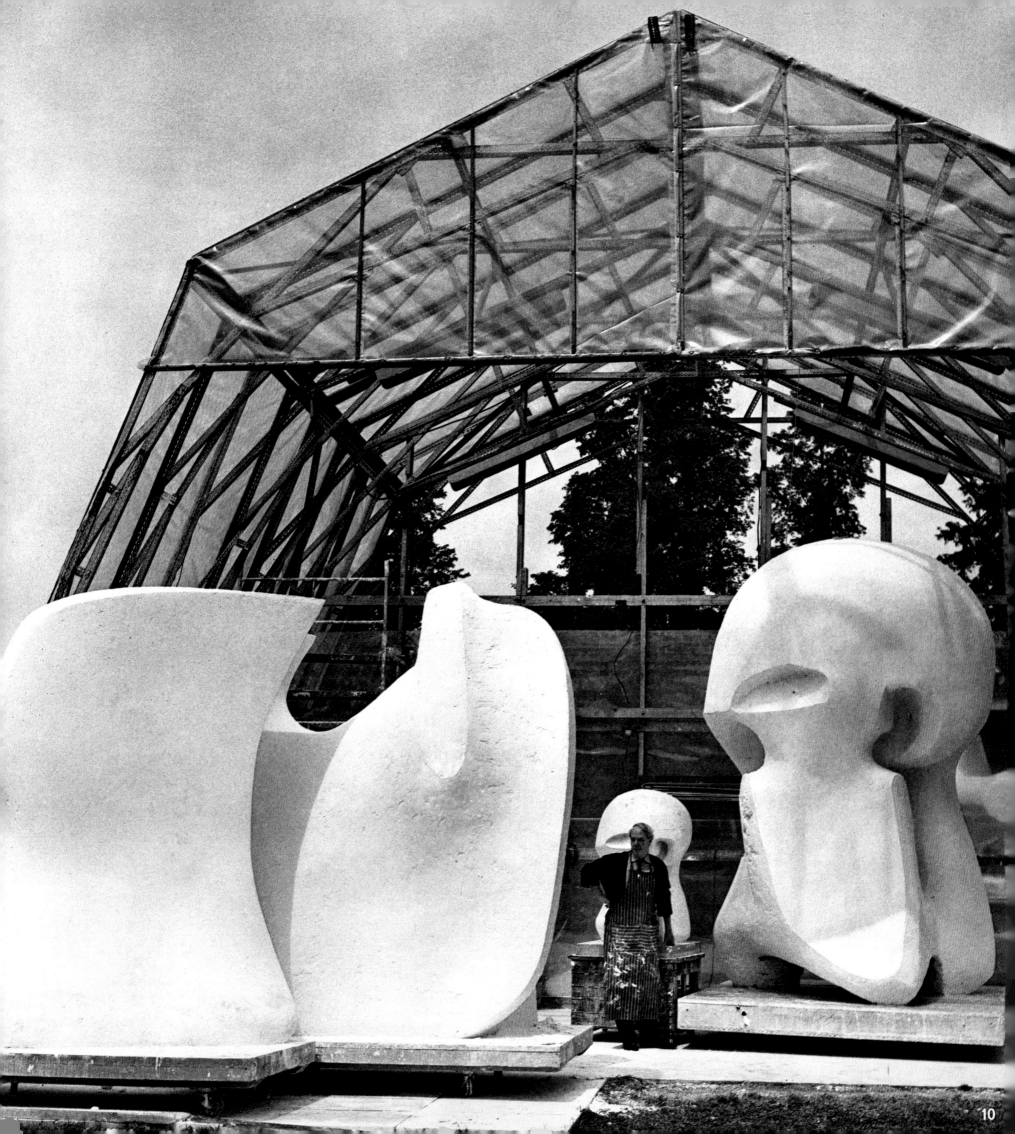

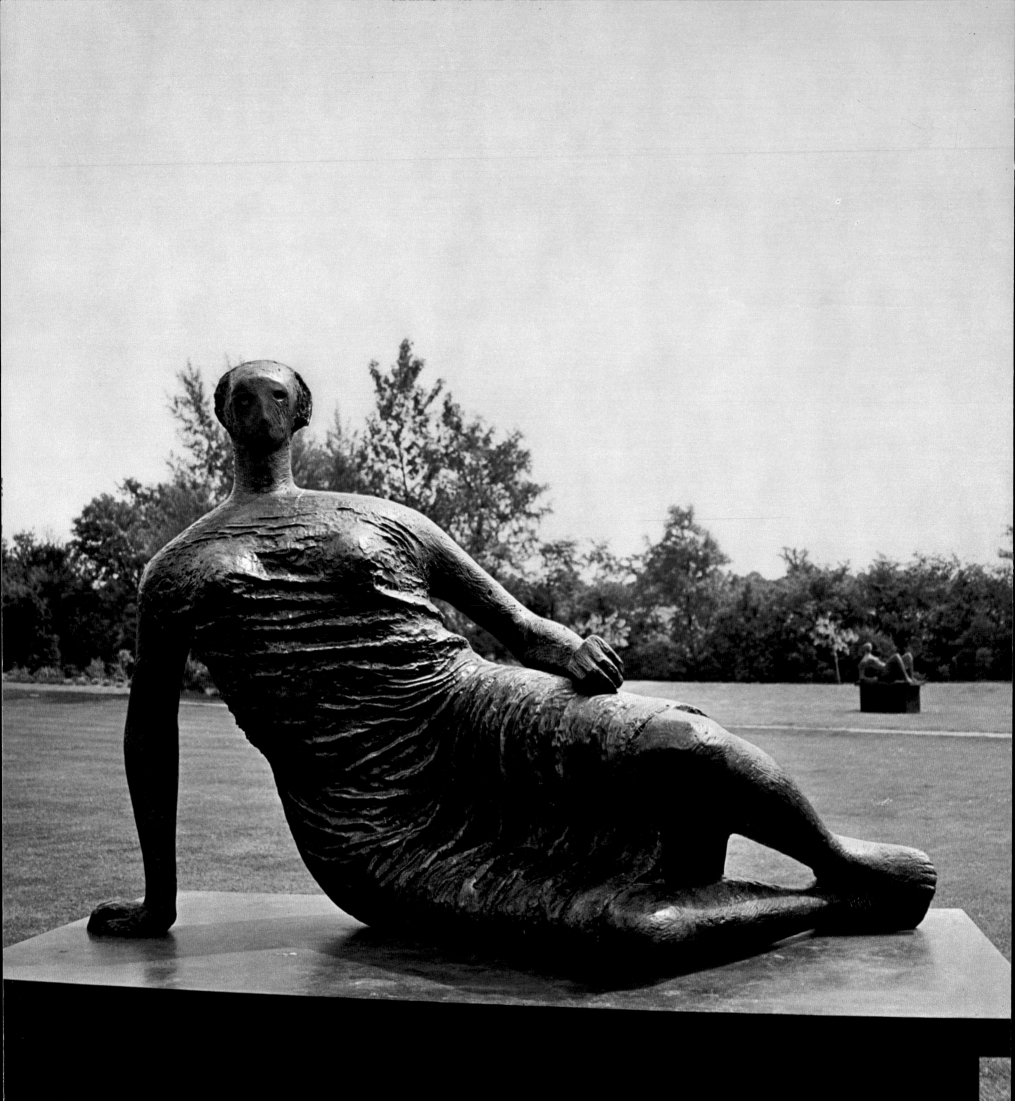

henry moore

1. Henry Moore between two original plaster casts.
Left, *Relief No. 2*, 1959.
Right, *Seated Woman*, 1959.

2. Moore in the little studio where he makes his scale models. ". . . Every sculpture I produce assumes a certain character, a certain human personality, sometimes an animal personality, within me, and it is this personality that determines its structure and formal qualities and that makes me satisfied or dissatisfied with the work as it progresses."

3. Sketches.

4. A corner of the studio devoted to scale models.
". . . to communicate one's feelings and one's hopes to all humanity."

5. The artist in his studio.

6. *Helmet-head No. 4*. Bronze, 1963.

7. Moore examining a detail of *Archer*. Plaster, 1964.

8. The sculptor with another view of the same work.
". . . Sculpture must express a sense of life and arouse a greater desire to live."

9. *Locking-piece*, 1963-1964.

10. Moore in his outdoor studio.
To the left are his *Knife Edge Two Piece* and *Nuclear Energy*, 1965-1966.

11. *Draped Reclining Woman*, 1957-1958.

1898	Born at Castleford, Yorkshire, England, on July 30.
1910	Obtained scholarship at school in Castleford. Art teacher, Alicia Gostick, noticed budding talent and encouraged him.
1917	Enlisted in army as a private. Gassed at battle of Cambrai. Returned to England in December.
1919	Demobilized in February. Entitled, as a war veteran, to a course of study at government expense, chose Leeds Art School.
1921	In September, attended the Royal College of Art.
1922	On holiday in Norfolk, started habit of sculpturing outdoors.
1923	First visit to Paris. Saw Pellerin Collection.
1924	Awarded travel scholarship by Royal College of Art. Applied for a professorship there and obtained a seven-year contract, teaching twice a week.
1925	Spent summer holidays in France, Italy.
1928	First one-man show at Warren Gallery. Received first commission for a public building. Created sculptured relief for façade of new "Underground Building" in St. James's quarter of London.
1929	Married Irina Radesky.
1931	Purchased house at Barfreston, Kent, for holidays.
1932	After contract with Royal College of Art expired, organized sculpture department at Chelsea School of Art. Taught twice a week.
1933	Became member of Unit One.
1934	Left Barfreston to take house (with extensive grounds) at Kingston, near Canterbury.
1940	In August, set up a studio in London. Made series of drawings in air-raid shelters. Appointed official war artist (until 1942). In October, studio destroyed during air raid. Bought house at Much Hadham, Hertfordshire (still his home).
1941	Received seven-year appointment to Tate Gallery Committee.
1943	Awarded commission to carve Virgin with Child for St. Matthew's Church, Northampton.
1949	Reappointed member of Tate Gallery Committee for further seven years.
1953	Awarded International Sculpture Prize at second São Paulo Biennial. Traveled in Brazil, Mexico.
1955	Elected member of the Order of the Companions of Honour.
1956	Received sculpture commission for esplanade at UNESCO complex in Paris.
1958	Awarded second prize for sculpture at Carnegie International, Pittsburgh.
1959	Awarded International Sculpture Prize at Tokyo Biennial.
1962	Received commission for large bronze sculpture for Lincoln Center of the Performing Arts, New York.
1963	Awarded Order of Merit.
1966	Became member of British Academy.
1967	Already Doctor honoris causa of the Universities of Harvard, Cambridge, Oxford, and Yale, received a similar doctorate from the London Royal College of Arts.
1968	Received Erasmus Prize in Holland.

delvaux

Paul Delvaux was given the keys to the city in 1936.
Magritte, who for ten years had conspired for the suppression of concessions to the established rationale, showed him the way to the breaches that had already been made in the defenses of fidelity to reality.
At first Delvaux approached this revelation with misgivings. But then, believing he could perceive, in the triumphal arches raised by Chirico's metaphysical perspective, the shadows of the phantoms he had himself been pursuing, he entered the city.
He entered the city and built his own house, and a single woman lived in it, in all her multiplicities. . . .
What sensual echo, forever reverberating, does Delvaux hear?
I doubt that a systematic count of all the mirrors mottled by the imprint of a body with impassioned breasts, or even an attentive surveillance of the waiting rooms in railroad stations, the rendezvous of infatuated adolescents and their impatient virgins, would yield the kind of beauty with unknowing eyes we find in Delvaux's works.

Delvaux lives on the outskirts of Brussels among substantial residences and long rows of brick houses rising in tiers above the rich loam of the countryside, parading outward to the detriment of the dark woods that thin out more and more. Not far from his house, right in the middle of the road, there is a powerful statue of a pregnant peasant woman, the work of the Flemish painter Rik Wouters (1882-1916), that reminds Delvaux of his early attachment to the Expressionist painting of Gustave de Smet and Perméke.
His home, standing like a thin slice of architecture in a row of squat little buildings, is distinguished from the others by a big bay window resembling a gaping wound just below the roof.
Stretched out to its full length, bordering on a tiny garden, the house is a place to explore, a commingling of model boats, Greek pottery, and all kinds of statuettes, with a grand piano like an anchored ship extending its golden sides.

The studio itself, situated on the second floor, holds the froth of Delvaux's unique universe, replete with selected fetishes, collections of all kinds of objects, and the artist's own work. Everything fights for room and yet remains quite still, giving the impression of joining in a silent, stately dance. To the right of the window, three skeletons gathered in a corner appear to be engaged in criminal conversation. Propped up against the opposite wall is a painting : two women with naked breasts wandering through some suburban Roman landscape studded with lampposts, trying to mouth a prayer taught them by a thin red-headed woman. . . .

Delvaux surveys the scene from afar, gazing into a tilted mirror. Smiling, he leans against a wooden easel that fills the room like a bed set up for the everlasting couplings of newlyweds.

A mute bird in a large cage keeps jumping around, grasping at the bars, then at the roosts on which it perches, repeating the action endlessly, as if it were pursued by some hand visible only to itself.

Like a blind watchman, a plaster head gleams against the mist covering a window bordered with colored balls, dried flowers, little statues, and a rosary of glass insulators that would ordinarily serve to crown telephone poles or power transmitters.
Long lines of model railroad cars attached to little steam locomotives stand on shelves around the walls, awaiting a miraculous whistle that might start them off on a journey ending in the warm bowels of some unknown station.

The music of a Beethoven quartet played by invisible musicians weaves the invisible thread that binds the artist to the canvases and to everything else around him.
Delvaux picks up a fresh canvas and sets it on the easel.
His brush, with the same purity of color, the same graphic discipline of Ingres, is about to choreograph a dream ballet of real skeletons, of sirens clothed in tenderness and crowned with green hair like leaves that never die. . . .
Clasping his palette, he seems to be dipping his brush in the genitals of the roses, strangled by a knotted black stocking, lying on the floor beside the easel.

Woman is clearly one of my favorite subjects, not that I haven't painted pictures without her, but on the whole she always forms part of my compositions.

To me she is a kind of illumination in a chosen theme. First for her contours and coloring, for the charm she exudes and also for her erotic potential.

She contributes a very special atmosphere to a picture. Even when reduced to a walk-on appearance, and playing a plastic role in the composition like that of the other elements of the canvas, she draws every eye to herself, she focuses the composition around her, all the while integrating herself into the architecture of the painting. As an expression "the eternal feminine" is always true. Ever since man first discovered his ability to create, he has tirelessly reproduced the image of woman in all her possible variations, from the worn Venus of the Magdalenians to the blonde beauties of the Venetians, the beautiful Infantas of Velasquez, so sumptuous yet fragile, down to her modern likenesses and caricatures, portrayed in different guises according to the tendencies of the time, always subscribing to a changing norm of beauty.

Which is to say that "the eternal feminine" continues to remain a part of our time as well. How many artists have attempted to portray her mystery and charm!

I've always tried to paint lovely women that are a pleasure to contemplate, for I have found that the spirit of a picture is very favorably controlled by such an ideal. I believe that the artist who paints a woman is responding to a natural instinct and that he will unconsciously bend every effort to make her as beautiful as possible.

I find it normal that she should light up a painting.

P. Delvaux

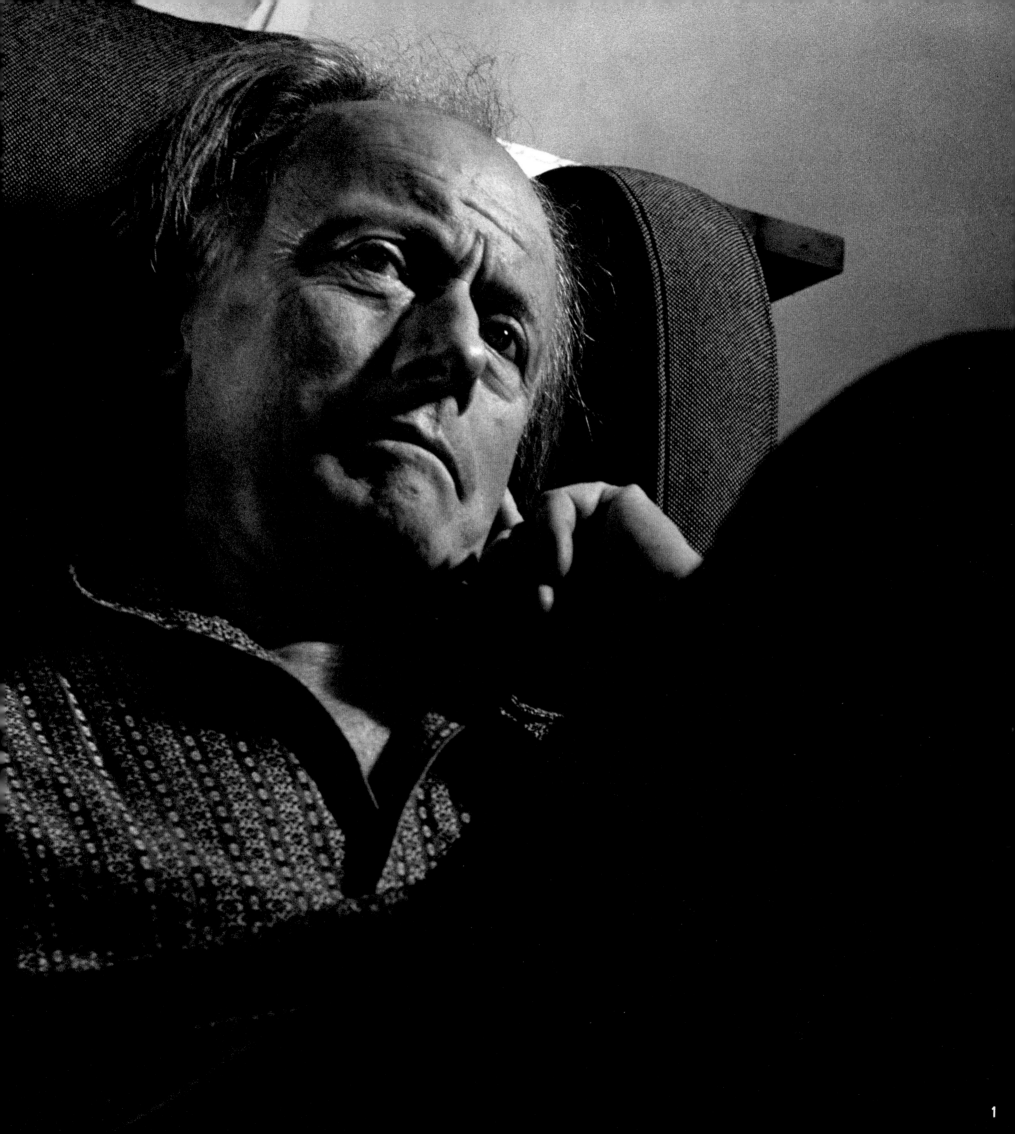

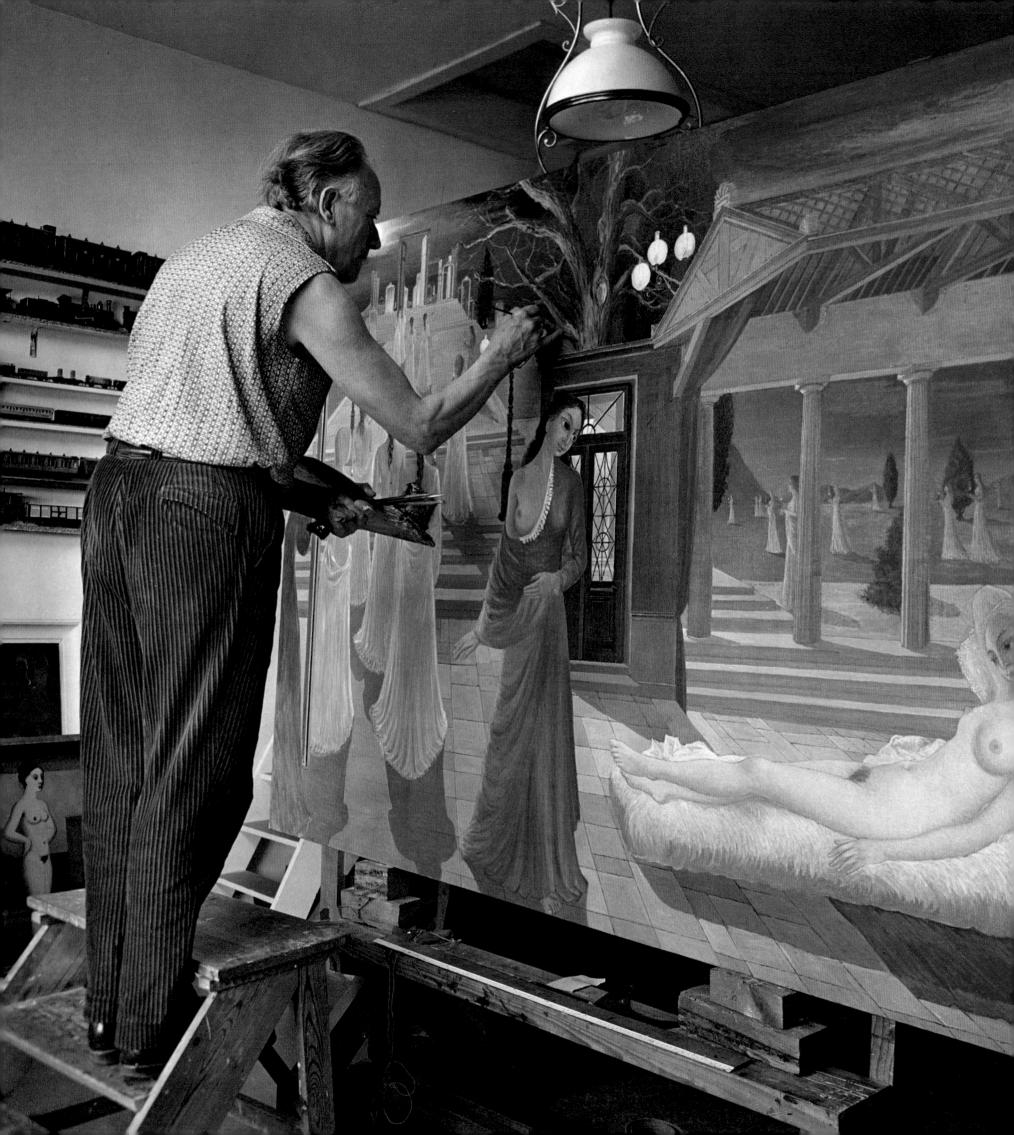

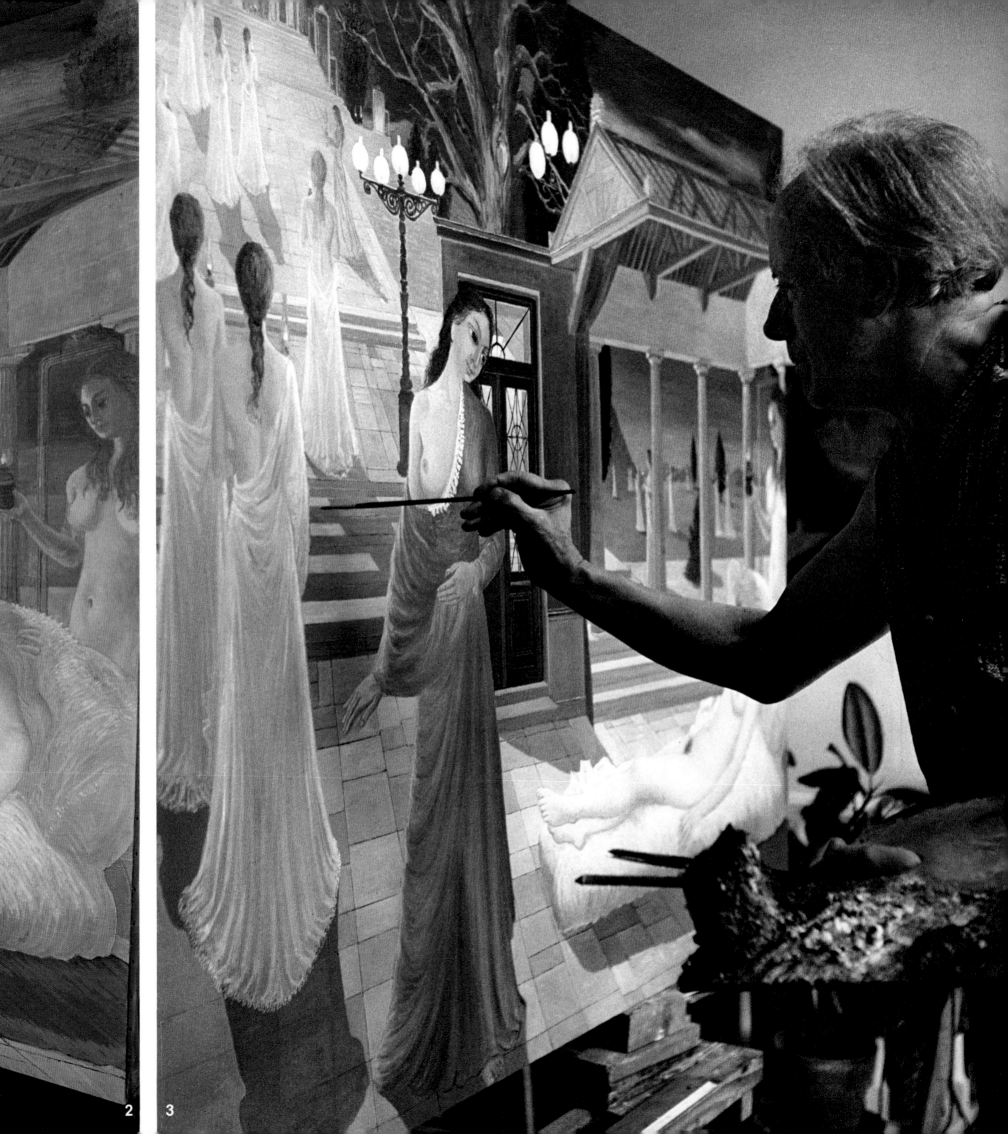

2 3

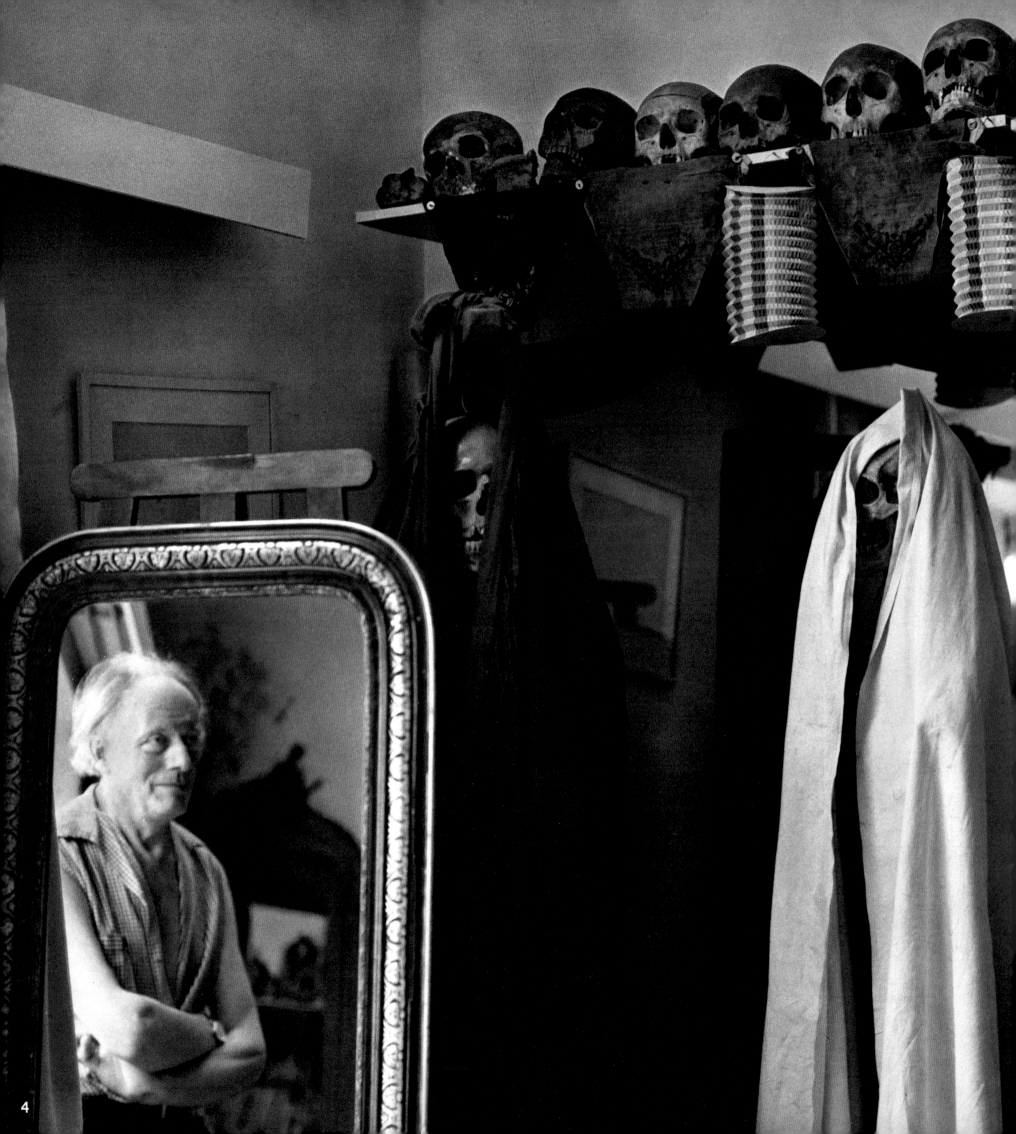

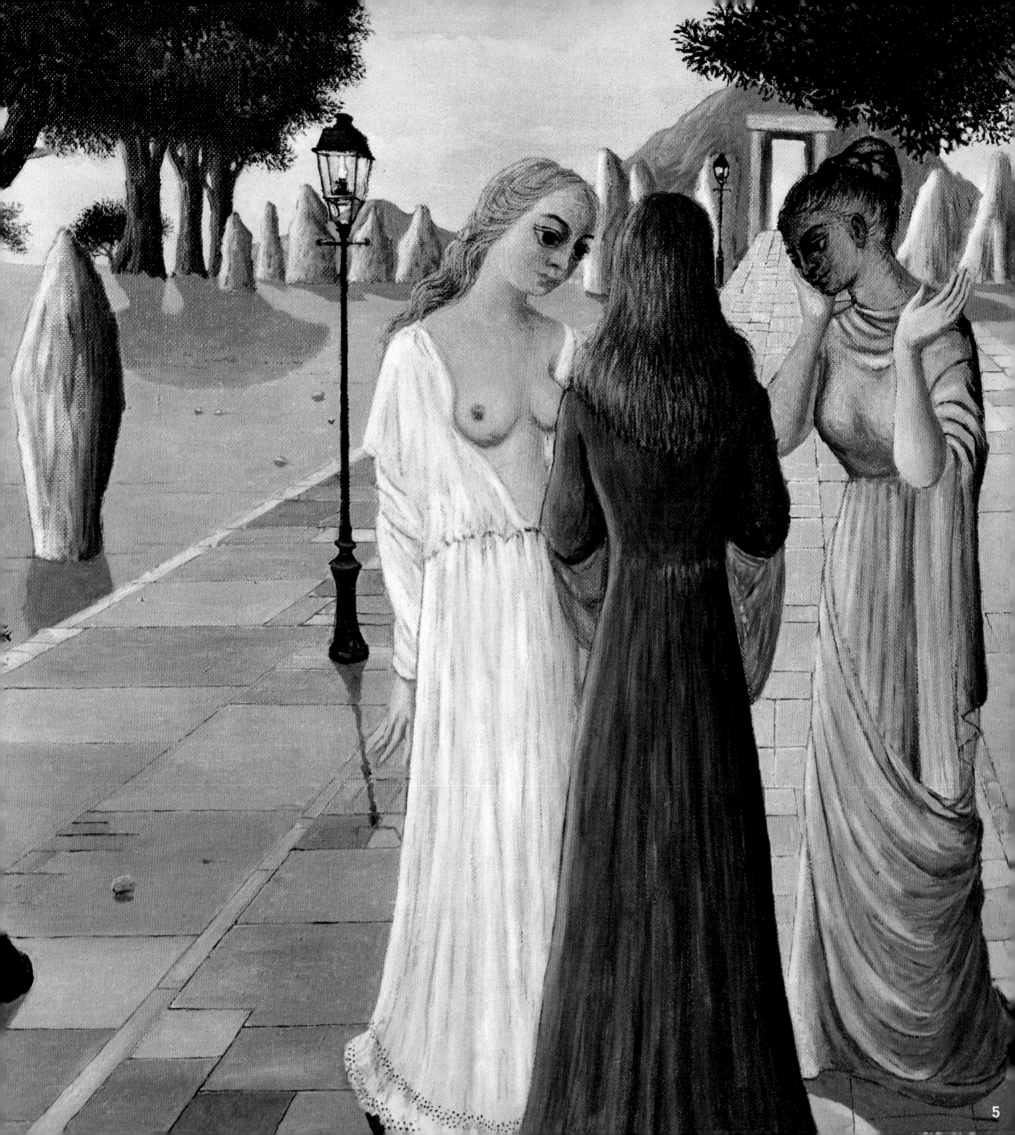

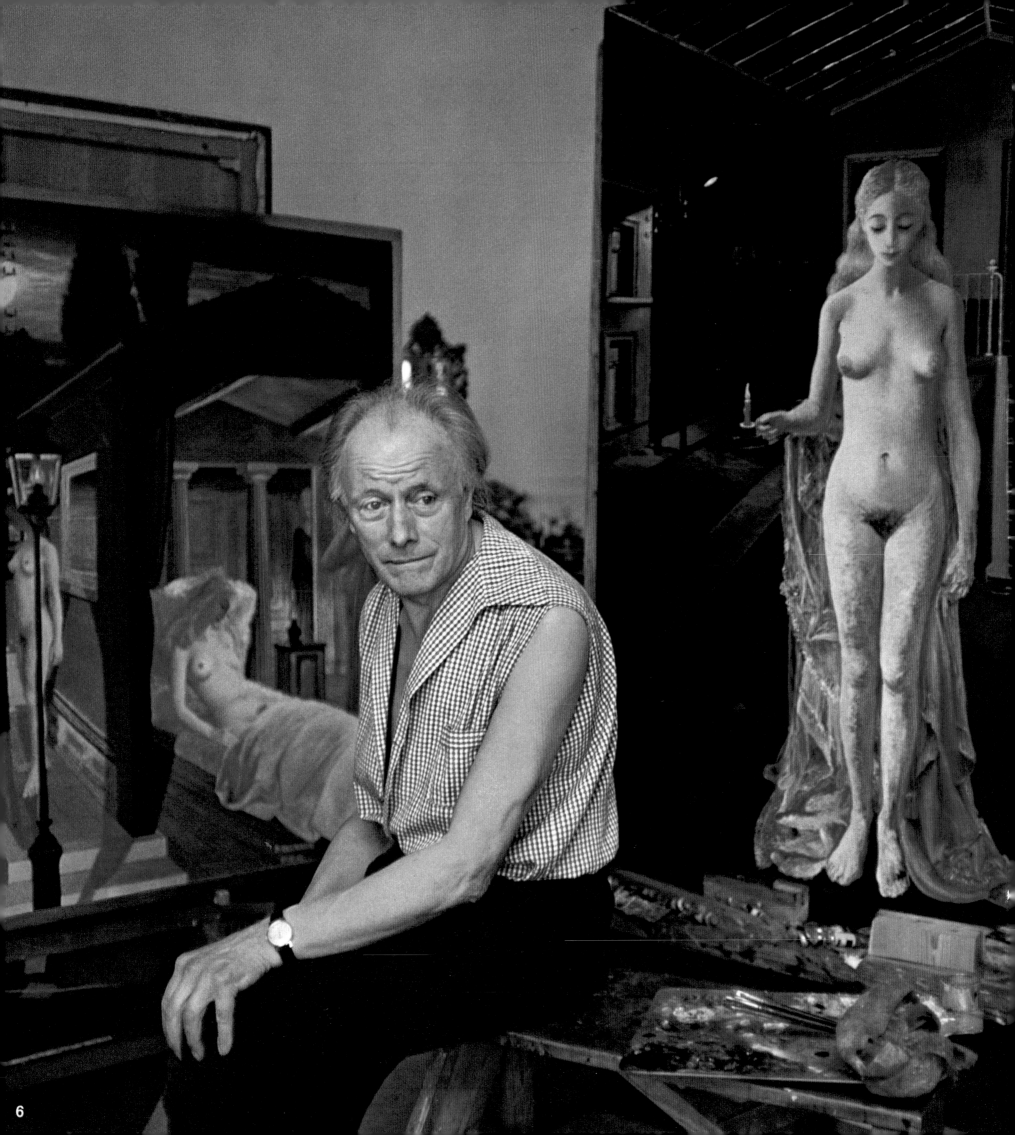

paul delvaux

1. ". . . to express the eternal feminine" : Delvaux.

2-3. The artist painting *L'Acropole* (1/1966).

4. View of the mysterious universe within the studio.

5. *La Prière du Soir* (7/1966).

6. At the end of a day after working on *Chrysis* (5/1967).

1897	*Born at Antheit near Huy, Belgium, September 23.*
	Became student of classical painting in Brussels.
	Pupil of Montald at the Brussels Académie des Beaux-Arts.
1938	*Awarded prize by: Académie Picard, Belgium.*
1947	*Designed stage settings of ballet by Jean Genêt for Roland Petit.*
1952	*Executed mural paintings at Ostend Kursaal.*
1955	*Awarded Reggio-Emilia prize, Italy.*
1957	*Made drawings for* Films Scandaleux *at the Écran du Séminaire des Arts.*
1958	*Medalist at Brussels Universal Exposition and Brussels Press Association.*
1959	*Painted large mural for the Palais des Congrès, Brussels.*
1960	*Awarded prize for painting by Province of Liège.*
	Executed mural for Liège Institut de Zoologie.
1965	*Won Prix de Consécration de Carrière.*
1965-1966	*Became President and Director of Académie Royale des Beaux-Arts, Belgium.*
	Member of Thérésienne Académie Royale des Beaux-Arts, Belgium.

Various films about Paul Delvaux have been produced, in particular one by Henry Storck with a script by Paul Éluard (1947). Other films include one by Blankaert made in 1960, and another, by Max-Pol Fouchet, in 1967.

giacometti

Star fallen from a mardigras of worshipers
surviving in Montparnasse,
Giacometti loved to capsize
in the nocturnal foam of its bohemian Mass.

Jester-king of Brotherhood, Alberto Giacometti would extend his arms like the skeleton work of his poetic soul to diminish the void that separated him from humanity.

One night I ran into the cortege of votaries carrying the corpse of Alberto Giacometti toward the heart of the distant Pyramids where he, in reality Pharaoh, might transmute gold into clay and himself erect the naked idols which would serve as the guardians of his tomb.

In the morning I entered Giacometti's studio.
The light falling through dirty broken glass partly patched with sackcloth showed me the walls of some ancient cemetery, gray as lava beds, and the sculptor's last works loomed from the shadows, the damp rough plaster still exhibiting his fingerprints. Everything hung between heaven and earth at a level determined by the light. Erect, keeping watch in the middle of the studio like a royal sphinx suffering in silence, a bust of Elie Lothar in clay looked as if it had been clawed together by some animal's paws.

The last portrait of Caroline, the model who posed for Giacometti every night, stood between a sofa littered with scraps of paper and an unlit stove, opposite the entrance door.

All around was a small world of statuettes that had been allowed to stay there, as well as everyday things like stools, flat stones, an easel, the artist's chair, an ashtray. Everything was gray. On the table minute traces of a shade of blue were visible on his palette. Nearby, his touch was clearly written in the clay, the plaster, the bronzes, painted on the canvases, scratched on the walls.

In his life of voluntary servitude he sought his freedom in the materials of his choice, endlessly scraping out the same hole and endlessly encountering the same obstacles.

He spelled living with the letters of reality.

His hand had long since learned to tear away appearances and scatter the features that make a face recognizable or permit a body to be measured by the masses.

Dissolving the specific into the unknown, he employed his research to give permanence to what is alive, to what fades away, and to write the moment, the flash of his discovery in space.
Dawn saw him victorious; at night he disowned what he had done. Using the same model year after year, Giacometti was tireless in his explorations, attempting to curtail the difference between what he saw and what he was doing. He would strangle the clay, causing threadlike asexual beings, seemingly drawn toward the cosmos, to spurt from his hands, but he would implant them in heavy pedestals set in enormous bases to prevent them from ever escaping him completely.

Obsessed by a face, turning his pencil or his brush into a dagger, he would attack his paper, his canvas, like a murderer. Again and again combining one short stroke of his pencil with another stormy one, he would evoke the symbols of some predicted truth that seemed ever farther off as it was daily better understood.

As though pursued by the blunted orgasm of a sexual nightmare, his dissatisfaction with his art forced him to go on, to redouble the same dream, to re-create the hopelessness of his winning out and to die, his heart aglaze.

CHARBON D'HERBE

I revolve in the void staring at space, at the noonday stars racing through the liquid silver that surrounds me, at Bianca's head looking lightly over her shoulder in the echo of her voice and her feathery footprints near the crumbling red wall.

I come back to the constructions that amuse me and live in their surreality—a beautiful palace, a floor of white dice spotted with red and black, columns that look like rockets, the ceiling in the laughing air and the nice precise mechanical devices that serve no purpose.

I grope in space for the vibrating invisible white thread of the magical that lets fall facts and fancies like the music of a stream singing its way through pebbles, quick and precious.

It brings life alive and the glistening games of needles and thimbles take place and connect successively. A drop of blood on milk-white skin, and a piercing cry breaks out suddenly, making the air quiver and the white earth tremble.

All life in the marvelous globe that surrounds us shines in the corner near the fountain.

I look for women with light steps and burnished faces who sing in silence, their heads somewhat inclined—the same ones who existed in the little boy wearing his new suit who crossed a meadow in time or space, forgetting the hour; he stopped short and looked inward and outward at all the wonders. Oh palaces, palaces!

Alberto Giacometti

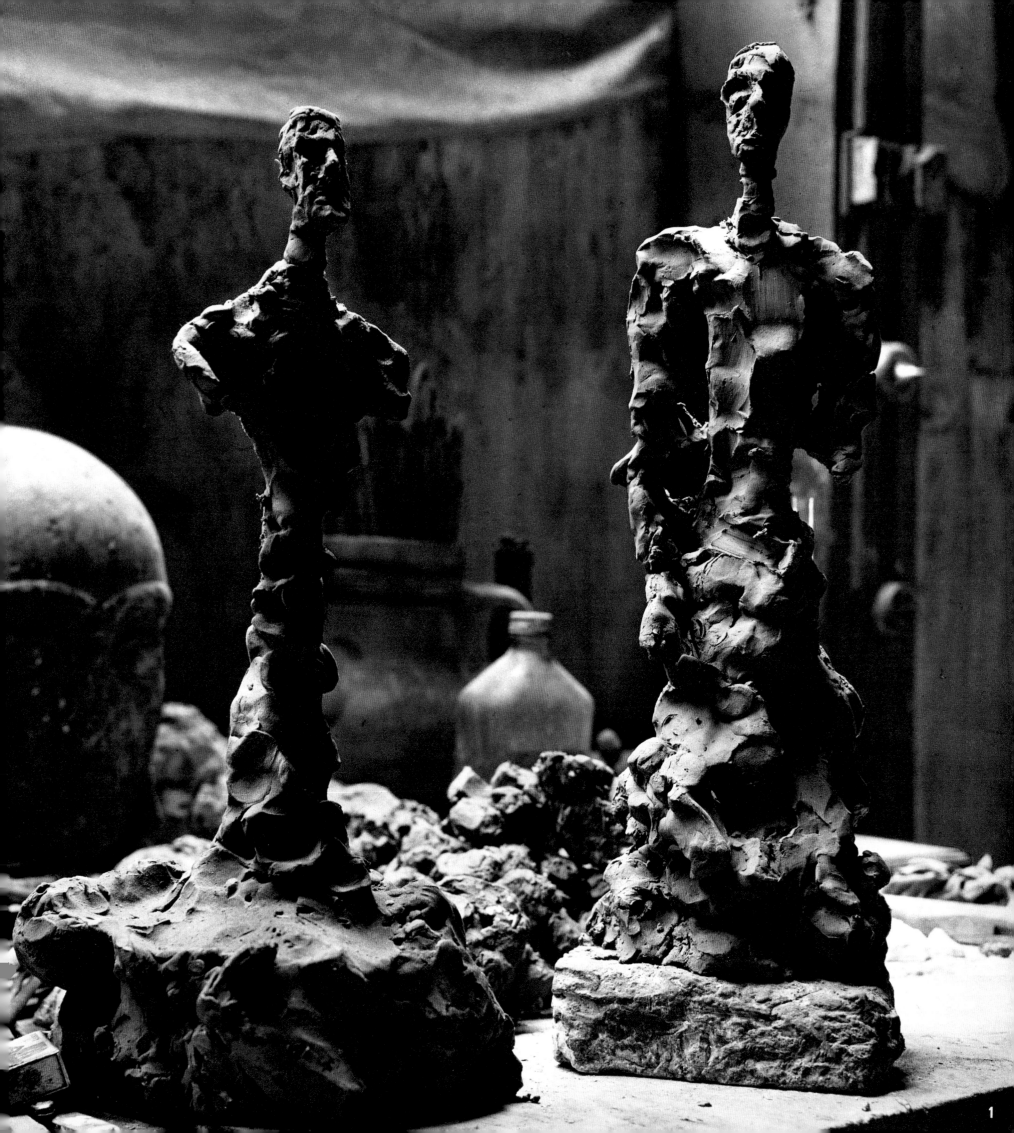

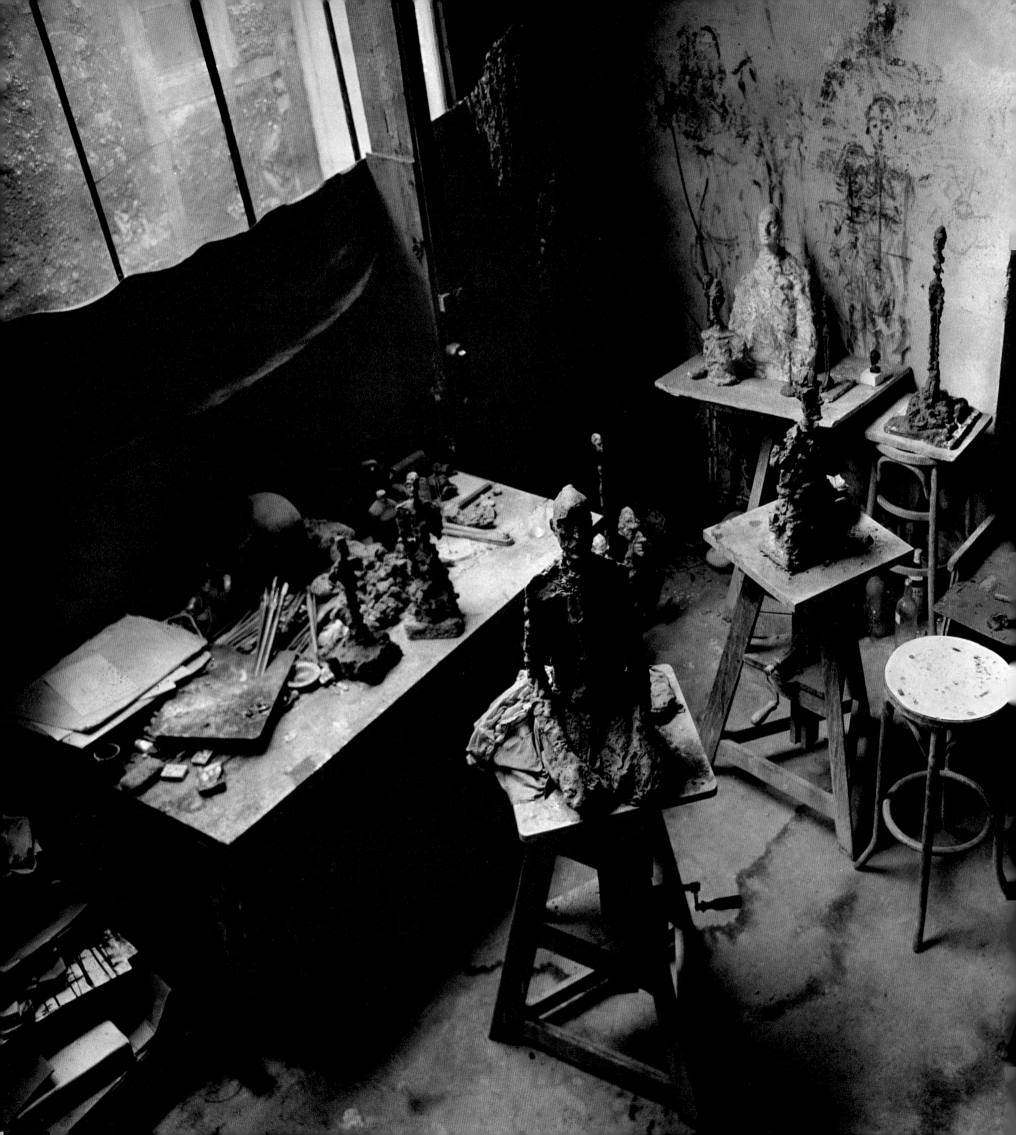

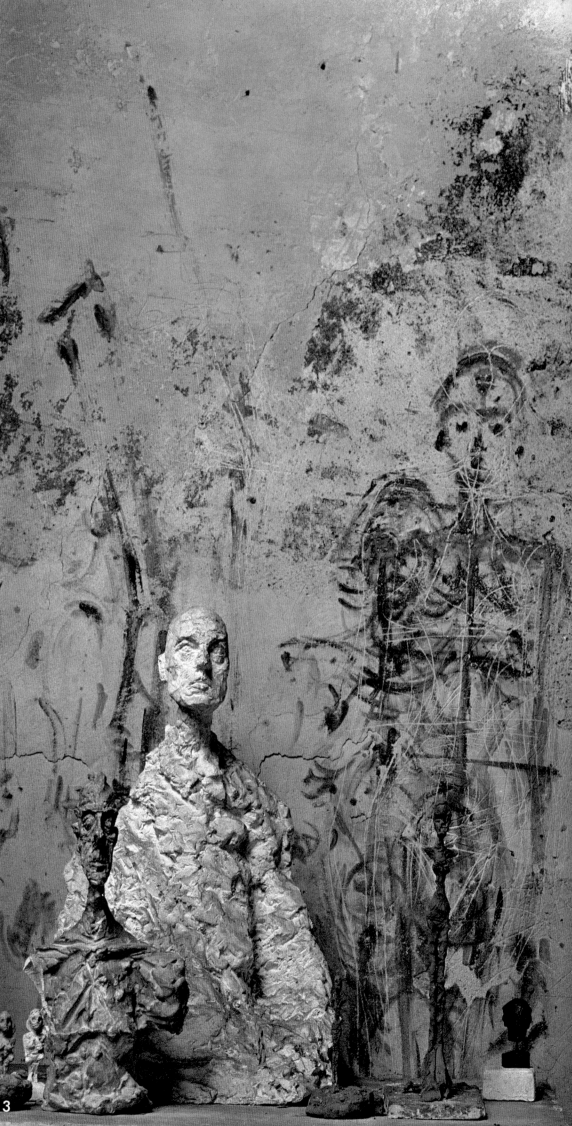

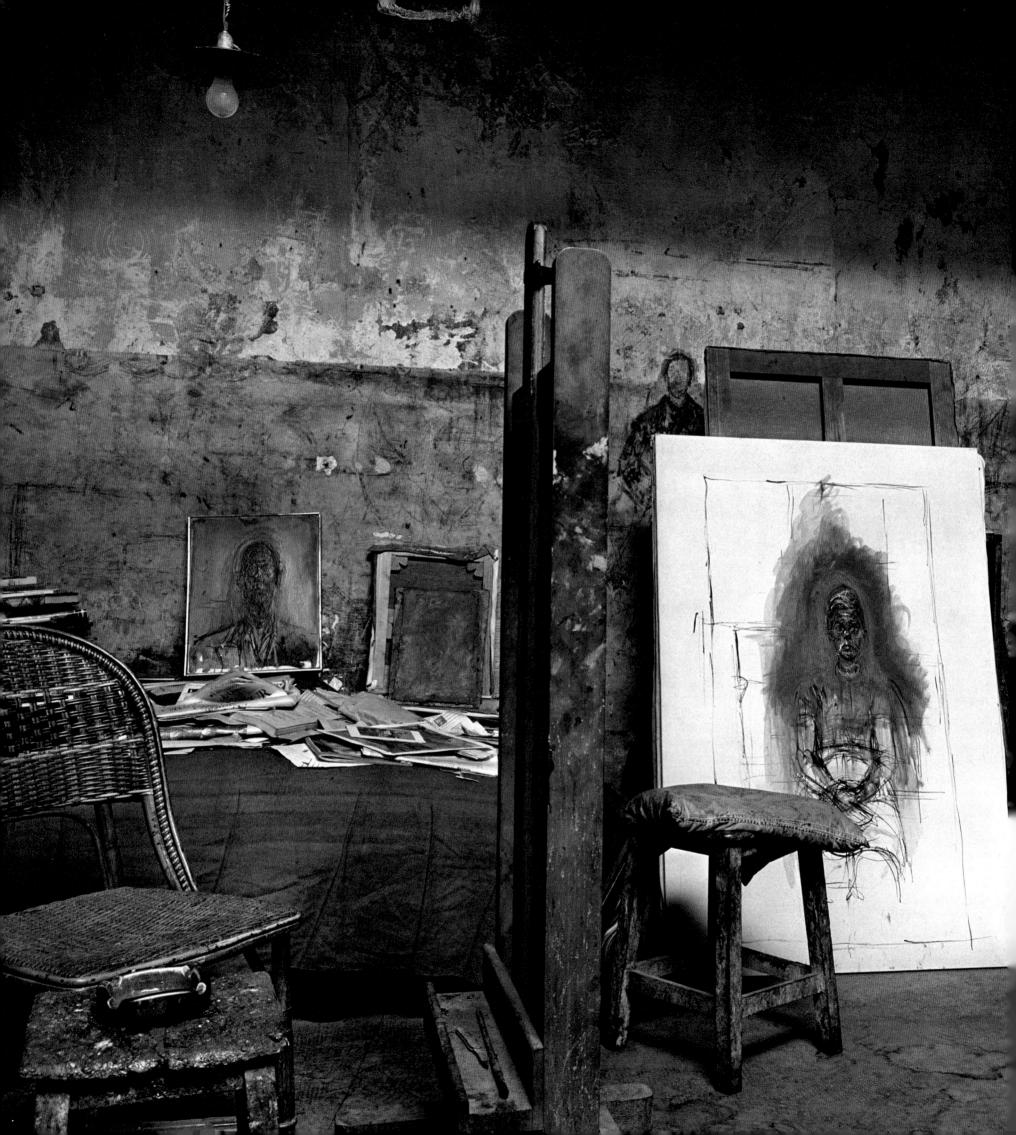

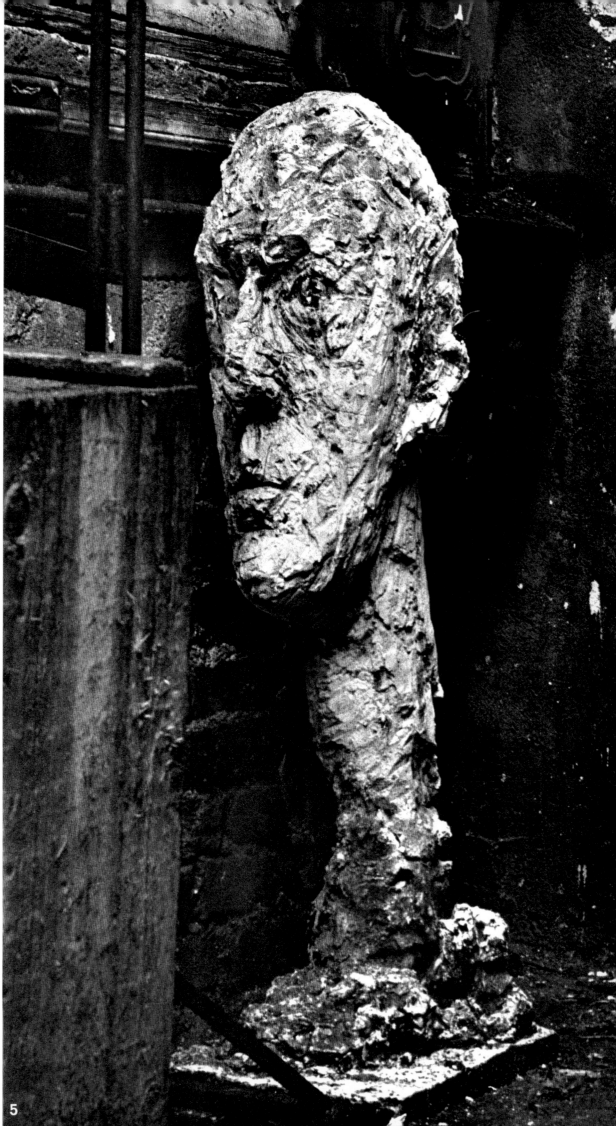

4 5

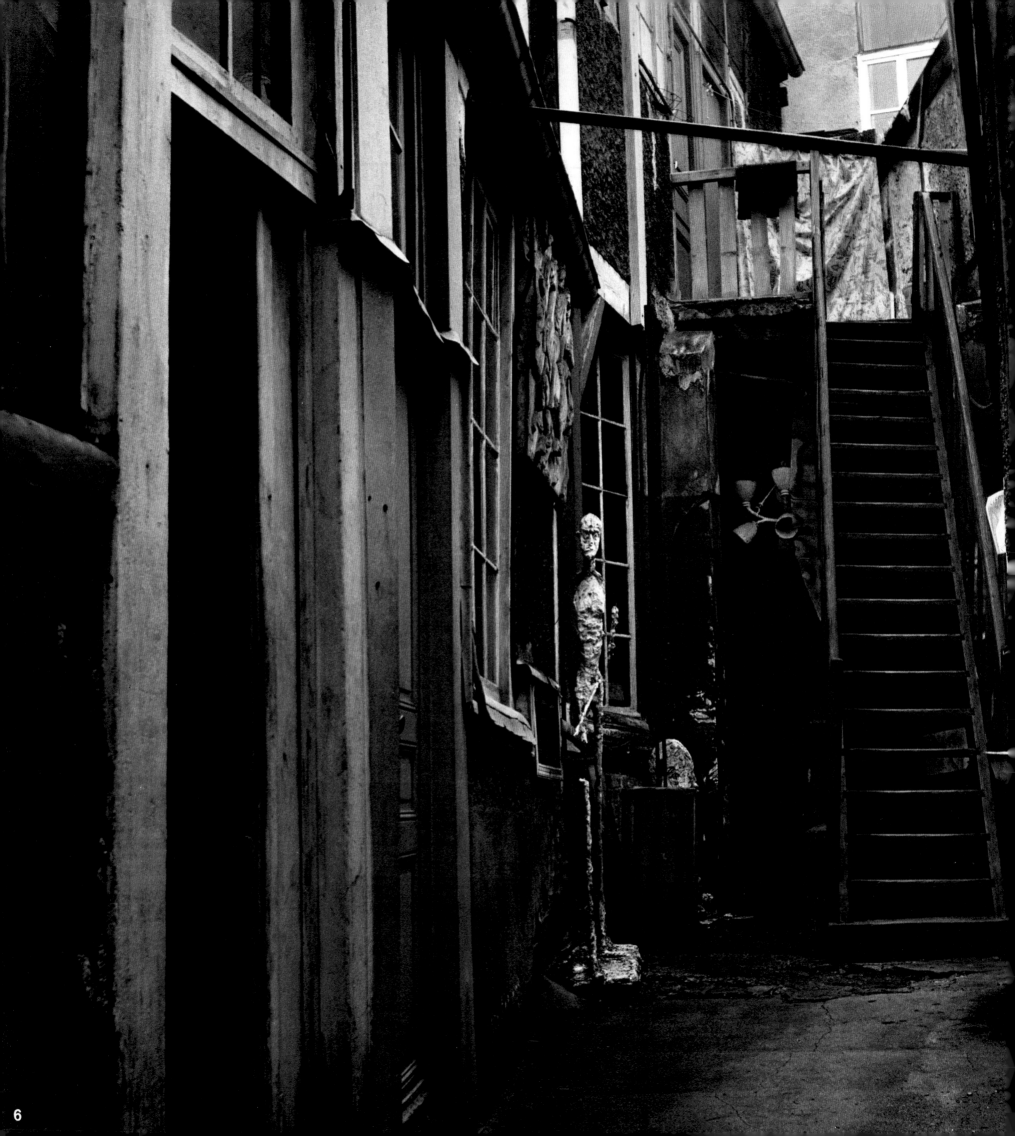

alberto giacometti

1. ". . . if I knew how to make sculptures they would have been made long ago" : Giacometti.

2-3. The sculptor's studio a few hours after his death. In the center, his last unfinished work : the bust of Lothar.

4. The easel, and the portrait of Caroline.

5. The eye listens. . . .

6. A narrow courtyard, left of studio entrance, and the broken plaster of an *Homme en Marche*.

1901 Born October 10 in Stampa, Switzerland. His father was Giovanni Giacometti, the Impressionist painter. As a child, he drew, painted, and created sculpture. The bust of Diego, his brother, was dated about 1914.

1915 Boarded at the Schiers high school. Special interests were literature, history.

1919 Joined sculpture class at Geneva École des Arts et Métiers.

1920 First voyage to Italy, with his father. Affected by Tintoretto's works in Venice, and Giotto's at Padua. A longer visit in the spring: Florence, then Rome. Baroque art and Byzantine mosaics became special interest. Worked at copying and painting from life.

1922 Arrived in Paris. Became student at Académie de la Grande-Chaumière, in studio of Bourdelle.

1925 Set up his first studio, on the Rue Froidevaux. Gave up painting and sculpture from life. Under influence of Laurens, Arp, Lipchitz, and the primitive arts, took refuge in the imaginary (Le Couple).

1926 Period of "flat sculpture."

1927 Moved to studio in the Rue Hippolyte Maindron.

1928 Exhibited at Salon des Tuileries. Became intimate with Tériade, met André Masson and Michel Leiris (who remained his best friend). Became friendly with dissident Surrealists, including Queneau and Prévert. Became associated with Calder, Miró. Period of "open sculpture."

1930 Exhibited at Galerie Pierre (Object Sculpture) with Miró, Arp. With his brother Diego, began to produce practical objects for decorator Jean-Michel Franck. After meeting Aragon, Dali, and Breton, joined Surrealist group and activities.

1932 First one-man show at Galerie Pierre Colle, Paris.

1934 Exhibition at Julien Levy Gallery, New York.

Tentative experiments with "affective sculpture" lead to abstractions.

1935 Attempted to work from life and was rejected by Surrealists. Associated with Balthus, Gruber, and Tal Coat. Work diminishes in size and thickness, to near vanishing point. No further exhibitions until 1947.

1940 Stopped working from life. Mostly from memory, began to create his famous threadlike creatures in ever-diminishing dimensions.

1942 Geneva. Met Annette Arm (to become his wife and very often his model as well as inspiration).

1945 Returned to Paris studio. Despite himself, kept whittling down sculptured heads and nudes he tried to produce.

1946 Tried painting from life once more, using those nearest him as models : his mother, wife, brother.

1948 Exhibited at Pierre Matisse Gallery, New York (where later—in 1950, 1955, and 1961—he had other shows).

1949 Began creating groups of tiny flowers, stationary or in motion (Place, Basel Museum).

1950 Exhibition at the Basel Kunsthalle.

1951 Exhibited in Paris, at the Galerie Maeght (again in 1954, 1957, and 1961).

1955 Exhibited at the Guggenheim Museum, New York.

1956 Took part in Venice Biennial (French Pavilion) and Kunsthalle exhibition, Berne. Seldom finished his work, though it appeared to be shrinking into itself less than before.

1962 Awarded Grand Prize for sculpture at Venice Biennial. Zurich Kunstmuseum organized retrospective exhibition of his work.

1966 Died January 11.

pignon

He's a red man
blood on him
blood in him—
red revitalized by forty years of pigment
blue holds his eye
captive balloon evading the battles
of furies flooded by red....

Pignon is the war correspondent,
permanent envoy extraordinary
on the high bluffs of reality.

For example,
Pignon wants to paint
hard and black
the artery that shakes the sea
the wake of the ship under stress
that widens and stretches, the better to disappear
swallowing up the first-class passengers' sunshine,
the migratory rubbish in the hold, all that's due for shipwreck
after the ship's passage....

To be nearer the water,
Pignon shovels coal.
He is where the ship's heart beats loudest,
stuffing the boilers full,
lungs and pistons breathing red oil.
Time off he spends
on deck,
perched on the curving anchor, dangling hands,
swinging legs, his feet walking the waters.
The waves spit at him out of the great thrusts of their flanks.

After the ship, the sea, everything has exerted its pressure
on his mind and body,
Pignon, ashore, sets up his easel
and, reaching inside himself,
brings forth the rainbow of pulsations
and convulsions seething,
palpitating, gushing from disemboweled memories :
Pignon dips his brush in the red furnace of his images,
his canvas is the log book
where he sets down the dark architecture of the here-and-now,
the legend of forms,
the truth of colors,
plumbed from the blue depths of his own eyes.

In his Paris studio, on the Rue des Plantes, Édouard Pignon, seated with his back against the wall, showed me all the sketches, drawings, and scale models he was using for the creation of an enormous ceramic mural which would soon brighten the courtyard of a school in Marseilles.

The project was different from anything he had attempted before, and, as Pignon told me of the problems he had encountered, his voice was quiet and earnest.
Even at ease Pignon's voice is that of a man of action. It was not long before he was on his feet again, moving about. Preoccupied, he drew closer and closer to the walls, then moved away again, scrutinizing his work, reviewing the subject matter, immersing himself in a particular problem, then telling, quietly, intensely, how he intended to articulate and develop it.
Analogies of style can be distinguished in many of Pignon's works. For instance, in his paintings of bloody cockfights, impressions that had once spattered his childhood, he brings to life in the participants the same kind of grandeur displayed in his pictures of knights in combat. And, again, the flying thrusts of the cocks' razor-sharp claws seem to provoke a turbulence in the air around them as far-reaching as the waves set in motion by his famous "red divers," whose bodies, after cleaving the seas, straighten out for a moment to look like the trunks of the olive trees he has so often drawn reaching, thirstily, for the sky.
Again, in Pignon's paintings of threshers and wheat growers, executed in the torrid heat of Italian summers, the pitchforks of the men come to a long point like the steel spurs of the cocks and the lances of the knights in his battle scenes. You seem to hear the same curses, the same cries, the same howls. Like small suns fallen from the sky, the fireworks of the glinting wheat match the yellow swirling of the cocks' flying feathers, the fire of the lightning which flashes from the armorplate. On Pignon's canvases :

The same red drips
from armed combat,
from everyday occupations.
He seems to catch the blood
in the hollow of his hand.
His brush becomes the spur,
the pitchfork, the lance
with which on a clean fresh canvas,
he implants an anguished world,
his world,
A WORLD IN SEARCH OF REALITY.

Je rêvais, je griffonnais sur mes carnets.
Des grands coqs de combat aux pattes
armées d'ergots d'acier qui sont de
petites épées ficelées avec des lanières
de cuir, paraissaient d'énormes
guerriers au niveau de ma tête.
Quand ils se rapprochaient du grillage
ils devenaient à mes yeux gigantesques.

Pignon

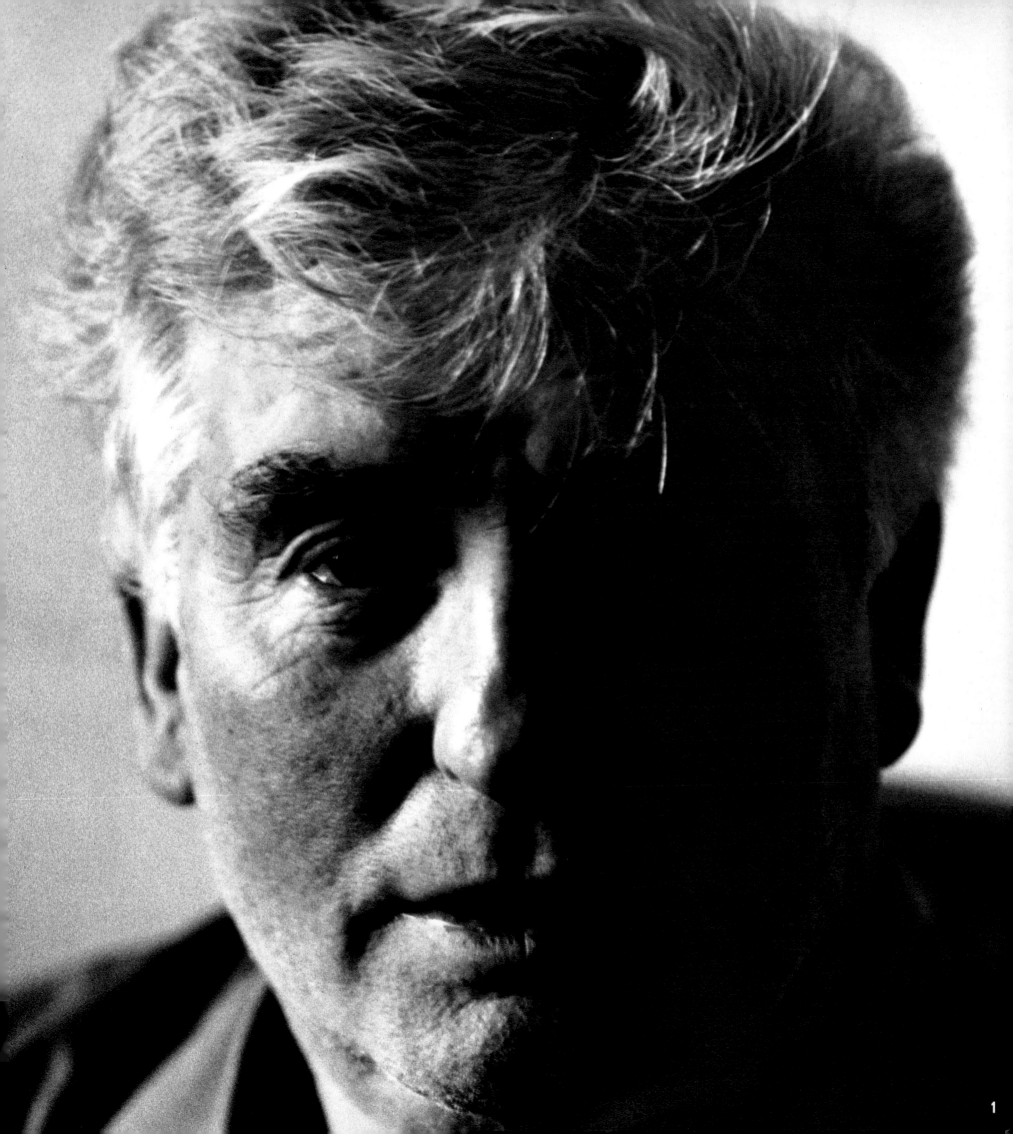

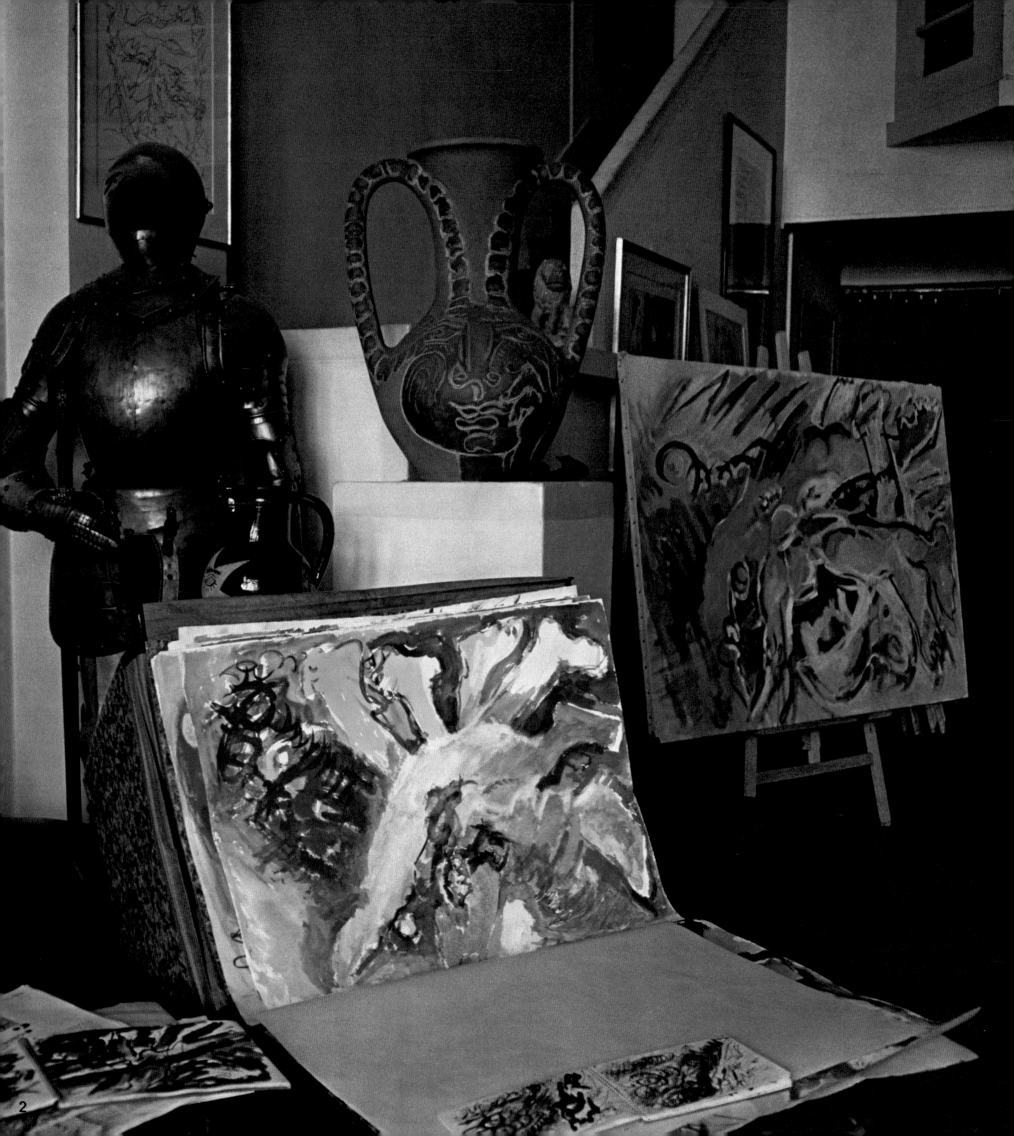

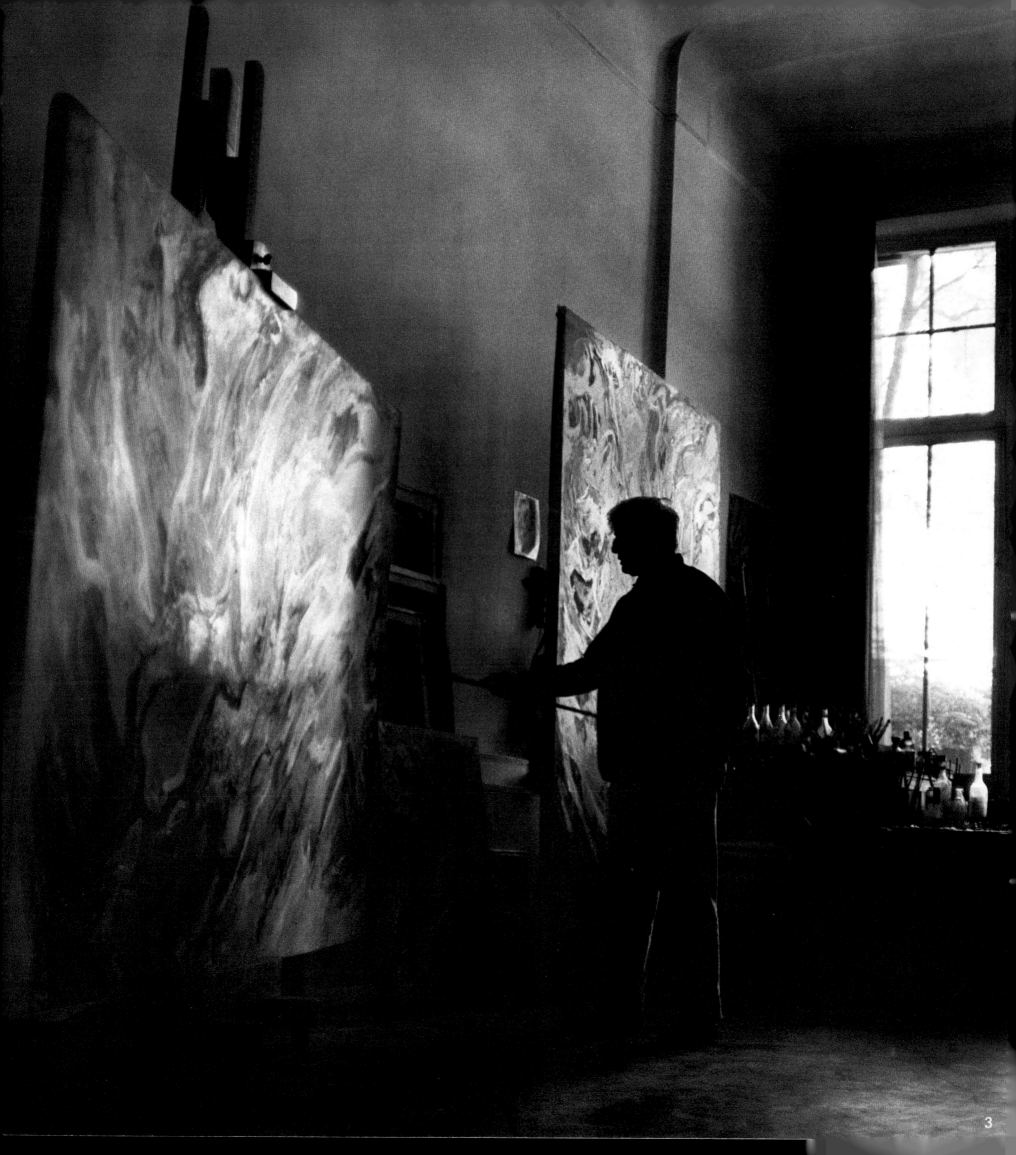

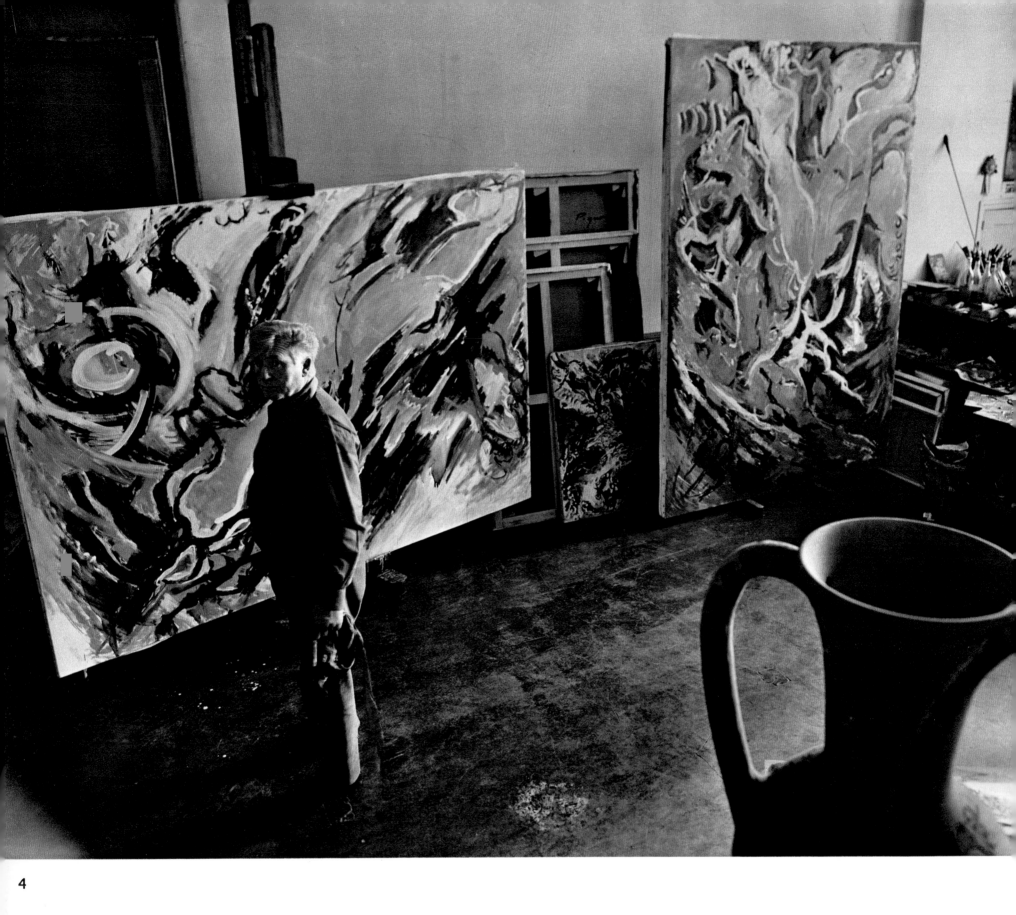

4

édouard pignon

1. "... I set myself right up against it, a yard away" : Pignon.

2. Sketches for *Les Plongeurs* tumble from their portfolios in the Montparnasse studio. On the easel : *Les Plongeurs*. Large ceramic vase and the armor of a knight used for *Batailles*.

3. "... the ceaseless motion of waves taught me a certain rhythm and, likewise, a certain way of writing" : Pignon.

4. "... when I say 'being of the action' I mean being as near as possible to the subject, and even inside it."

1905　Born of a family of miners in Bully (Pas-de-Calais), February 12.

1920-1925　After receiving grade school diploma, took job in a mine, then went to work in a cement plant. Read a great deal and began to draw and paint.

1925-1927　Military service in Syria.

1927-1932　Worked in a factory in Paris and attended evening courses in painting and sculpture.

1932　Exhibited for first time at Salon des Indépendants, Paris.

1933　Turned from factory work and earned living at various other trades. Exhibited at Salon des Artistes du Travail.

1934　With Léger and Lhote, exhibited with Association of Revolutionary Artists and Writers. Took up acting with Raymond Rouleau's theater company (with Dullin, later with Antonin Artaud).

1935　Illness prevented him from working. Penniless, he later managed to find work as lithographer.

1936　Managed to devote four days a week to painting.

1937　Exhibited at Durand-Ruel's Salon du Temps Présent, Paris, and in foyer of the Alhambra with Picasso, Matisse, Léger, Braque.

1938　Exhibited at Salon des Surindépendants, Paris.

1939　First one-man exhibition, at Galerie d'Anjou, Paris.

1940　Demobilized, returned to Paris and participated in the Resistance movement.

1941　Showed work at "Young Painters in the French Tradition" exhibition, and, later, with Bazaine and the sculptor Chauvin at Jeanne Bucher's, Paris.

1942　Exhibited at Galerie Friedland with Gruber, Bazaine, Tal Coat, Estève, and others.

1943　Exhibition, "Twelve Painters of Today" at Galerie de France, included his work. Showed large-size decoration, executed for a school at Creil, at Salon d'Automne, Paris.

1944　His Maternité hung at Salon d'Automne of the Liberation.

1945　Founding of Salon de Mai. Stayed at Collioure, where he began work on the paintings called Catalanes, then at Ostend.

1946　First one-man show at Galerie de France.

1947　Salon d'Automne hung his Remailleuses de Filets.

1948　Painted canvases using miners for subjects. Designed costumes and stage sets for Supervielle's Scheherazade at Avignon Festival.

1949　Showed Ostende et les Mineurs at Galerie de France; also La Voile Rose (now at Musée d'Art Moderne, Paris). Painted Le Mineur à la Cigarette (now at Tate Gallery, London). Exhibited with Atlan in Copenhagen. Visited Italy and made hundreds of drawings from Giotto and Piero della Francesca.

1950　Visited London and showed at the Leicester Gallery. On trip to the Var, became particularly interested in olive trees as subject matter for pictures.

1951　Worked with Picasso at Vallauris. Received prize at São Paulo Biennial. Designed sets and costumes for Brecht's Mother Courage (Vilar's production).

1952　Showed at Salon de Mai and at Galerie de France (using a dead workman as subject of paintings).

1953　Showed Nu à l'Olivier at Galerie de France. Made ceramics at Vallauris.

1954　Continued ceramics work and watercolor in Paris.

1955　Devoted time to oils and watercolors, in Paris.

1956　Designed settings and costumes for the T.N.P. (Théâtre National Populaire).

1958　Executed large ceramic work for Paris Pavilion at the Brussels Universal Exposition (also shown at Galerie de France and at Perls Gallery, New York). Room at Venice Biennial was devoted to his work.

1959　In Italy, worked on Pousseurs de Blé. Designed stage settings for the T.N.P. Exhibited in Poland.

1960　Showed large paintings of "Cockfights" and his first "Divers." Retrospective exhibitions are held at Metz and Musée de Luxembourg.

1961　Exhibitions in Nantes and Moscow.

1962　Showed "50 Paintings from 1936 to 1962" at Galerie de France, and drawings for Battages and Pousseurs de Blé at Galerie du Passeur, Paris. One-man show at Lefèvre Gallery, New York.

1963　Exhibitions in Amsterdam, Sète, and Le Havre.

1964　Showed seventy "battles" in Lucerne. Retrospective exhibitions in Milan and Geneva.

1965　Showed seventy-three paintings at Namur, Lille, and Charleroi.

1966　His Quête de la Vérité published.

1968　Rotating exhibition of his work held in Maisons de la Culture. Created two large ceramic works: one for the Nouvelle École des Beaux-Arts, Marseilles (Lumini), the other for the Université de Lille.

de kooning

As soon as the wind dropped, all became flat, gray, calm, almost stifling. A cargo boat passing out at sea restored the elements to their rightful order : sky, water, earth. Standing on the thin strip of sand between sky and ocean, Willem de Kooning's upright figure loomed so large that I began to understand the importance assumed by the human form in his latest canvases : reflected, distorted, constantly reconstructed by the water until it was right side up which — ever way you look at it !

Immediately inland from the beach, marshes alive with bullrushes bordered a forest of pine trees. Beside the road the broad sails of a windmill begged for a passing breeze.

As we passed the paddock of a riding school, he stopped. Shading his eyes with his hand, he pointed out his daughter in the distance, a young Amazon with blond hair and chubby cheeks.

At home, before his easel, he began to explain the vision glimpsed upon the beach :
I try to free myself from the notion of top and bottom, left and right, from realism ! Everything should float. When I go down to the water's edge on my daily bicycle ride I see the clam diggers bending over, up to their ankles in the surf, their shadows quite unreal, as if floating. This is what gave me the idea.

He had observed the same phenomenon in Italy.

I remember everything half-suspended or projected into space; the paintings look right from whatever angle you choose to look at them. The whole secret is to free yourself of gravity !
Yes, his memories of Italy were happy ones. In 1959 he had met an interesting painter who had become his friend. He had not been able to travel further afield. France, Holland seemed very far away. No, he had never been to Paris, *and to go there now....*

Dressed in a faded, half-unbuttoned blue shirt over dark-gray trousers, the artist seemed weary...

Hands folded across his stomach, he looked for a long time at the canvas before him. Some slow chemical reaction seemed to be taking place in his mind. Raising his brush, he added a few touches of color. A pale, sickly pink emerged, but already the artist had let his hand fall. He turned his head, seemed to waken from a dream, smiled softly and said apologetically, *I am not sure of what I'm doing right now. Who can tell when a picture is really finished?*

His gray hair framed a long, pale face, and his deep-set blues eyes seemed to look far beyond, at things visible only to himself.

A little while ago on the beach, hair flying in the breeze, his square chin emphasizing strength and energy, he had been speaking of the neighbors who had helped him build his house :
I made all the plans myself with the help of local workmen : carpenters, brickmakers, masons, all men who, like me, work with their arms and hands.

He preferred to live on the "workers" side of the island, rather than in the residential quarter among other painters and the snobs they attracted. He was proud of his house.

No, it isn't finished.

Will it be one day? He did not seem in any hurry.

Elongated and solid, the house resembled a long, stocky barge, stranded in the sand of the newly cleared forest. Propped against the doorpost stood the artist's bicycle, his traveling companion. He looked at me :
I don't think I shall go back.

Jumping astride the bicycle like a young man, he rode, around for a moment, pedaling rapidly. When he came back he was happy. He spoke of his childhood : of winters when a dozen youngsters used to skate together for miles along the frozen canals, alongside lines of barges locked in the ice like great whales.

Later, as an art student, he spent his evenings at the Royal Academy, his days painting shop signs for a livelihood.

In his twenties, somewhat apprehensive of the obscure future his country seemed to offer him, he boarded a Dutch steamer headed for New York. In order to paint the way he wanted to and at the same time earn his daily bread, he became successively a house painter and then a designer of stage scenery. After ten years, he became a citizen of the United States.

In 1964, in recognition of his artistic fame, he was awarded the Presidential Medal of Freedom.
I don't really know why I was decorated, but the reception at the White House was most enjoyable !
With this, he went into the kitchen, offering to make coffee, but finally deciding to pour out generous doses of whisky in tall red metal tumblers.

He came back slowly into the long white studio. Metal girders support the roof and a uniform light poured in through the large windows

lining both sides of the room. The nearby woods accentuated the impression of a boat dragging its anchor.

The paintings stacked against the walls were all of women. I seemed to see hazily a troop of elderly chorus girls, dancing and fluttering in place. Done in pastel tones of yellow, pink, and blue, their ugly nakedness was merely indicated by a few black lines.

Hemingway specifies, Faulkner suggests. I am more inclined to Faulkner's side.

Breaking the straight lines of the studio, a staircase leads to the living quarters on an upper story. At the top is a landing like the poop deck of a ship, from which the whole studio can be surveyed. A gangway, with wooden walls, divides rooms separated by glass partitions. *I like to see inside people's houses. Have you ever noticed the way house wreckers always knock down a piece of wall and leave the rooms open for everyone to look at?*

Hanging on the corridor walls, a number of figurative pictures: a still life, portraits of his former wife, Elaine. On the walls of the sparsely furnished rooms are sketches in color, studies in texture, symbols and "effects" painted on sheets of newspaper. The faded blue of an old-fashioned color print, fixed above a door, remind one of the blues of certain of his pictures. Laughing aloud, he showed me a magnificently calligraphed and framed diploma. Signed Saul Steinberg, it has neither meaning nor validity, but is so majestic in appearance as to seem the ultimate in officialdom.

I am far removed from my Tenth Street studio and life here is so comfortable, I have no desire to go back to the city. Hurry and crowds are not for me!

Leaning out of the window, he showed me the enormous piles of stone at the edge of the forest :

There is my Montagne Sainte-Victoire!

The road narrowed behind me. One more turning and the house was hidden by the trees. The doubled-hung gate stood open : on the letter box a name in white paint :

de Koonins

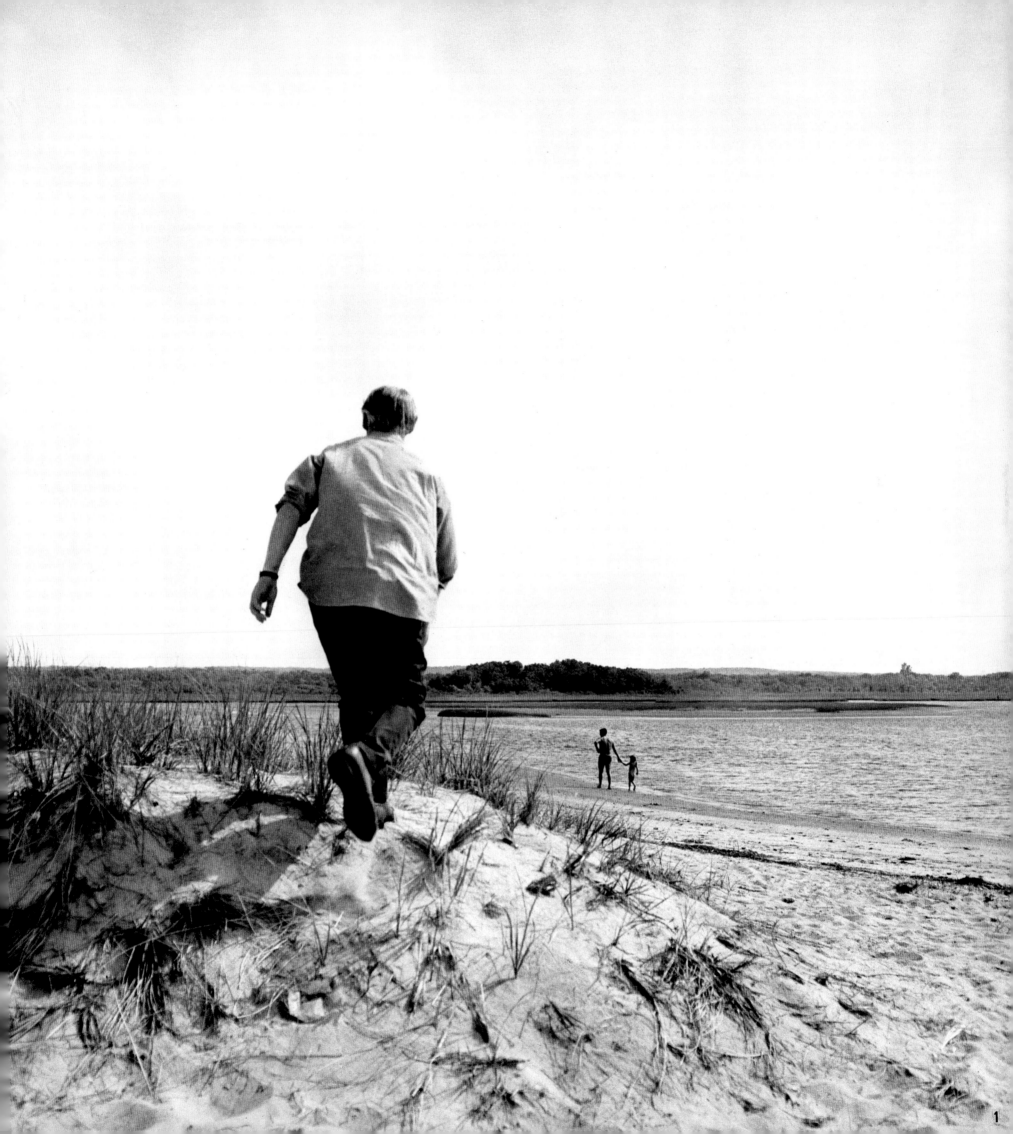

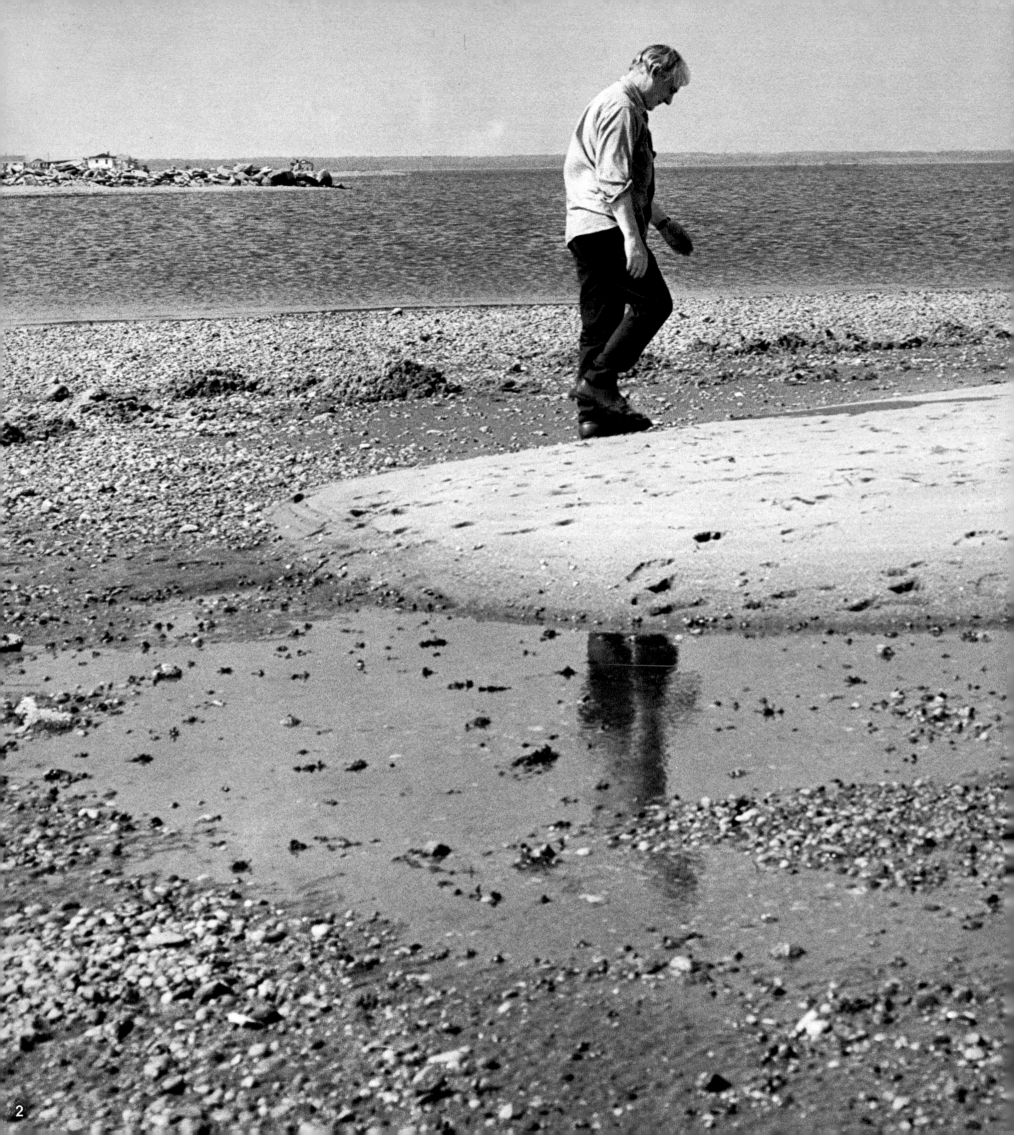

2

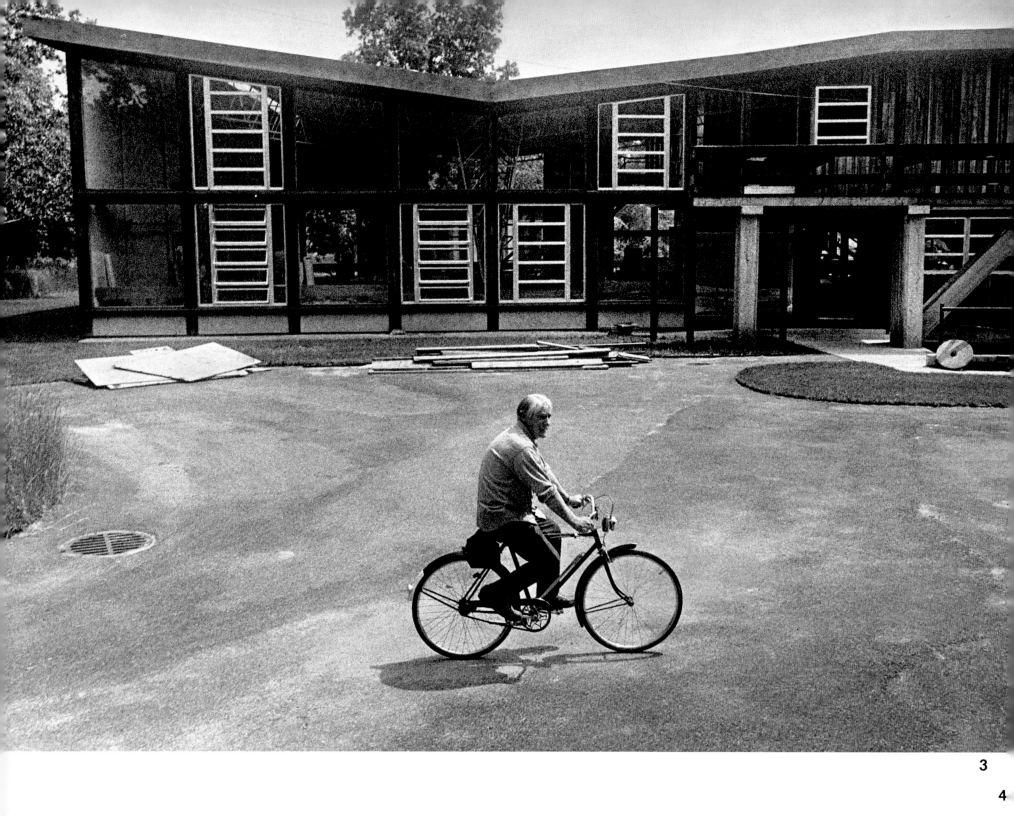

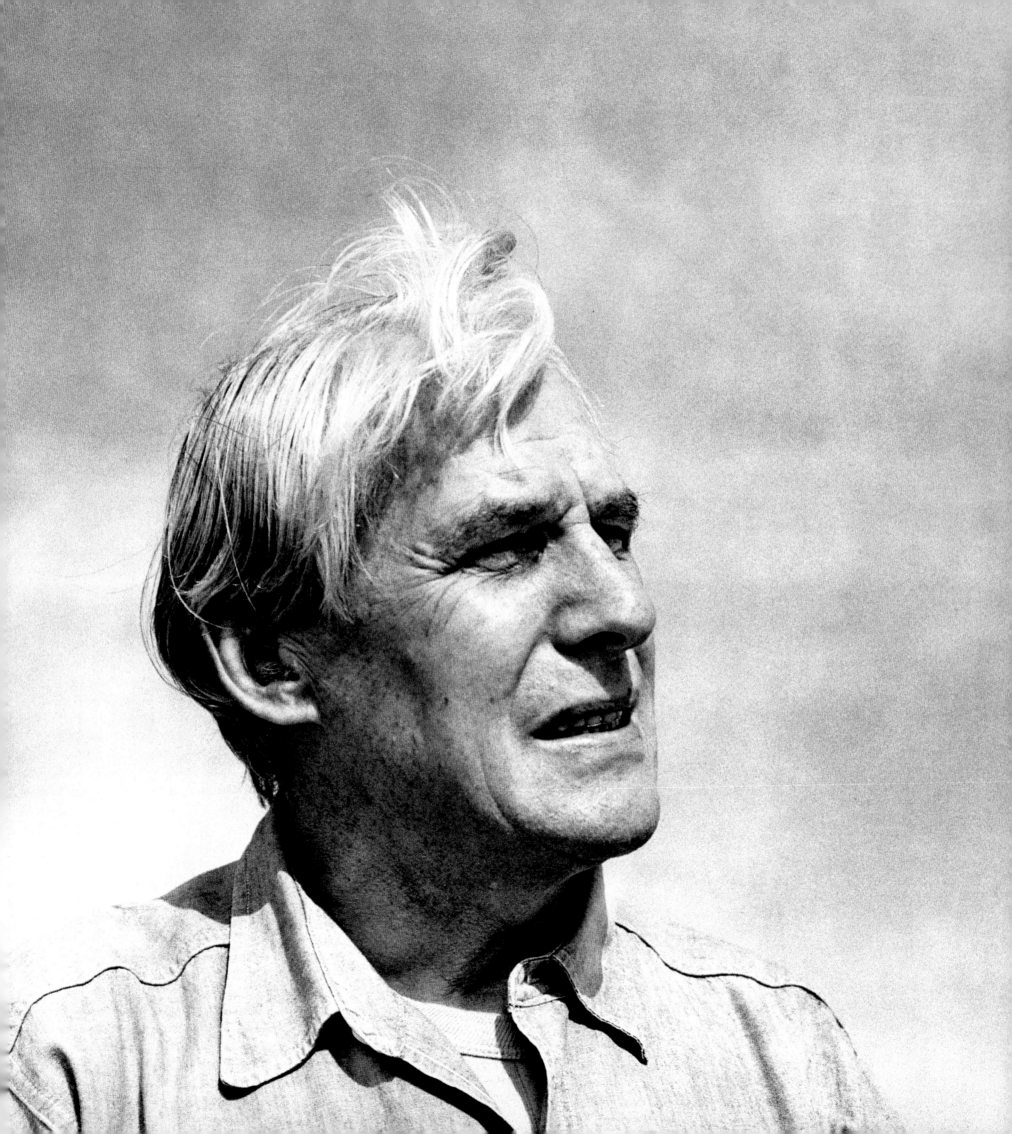

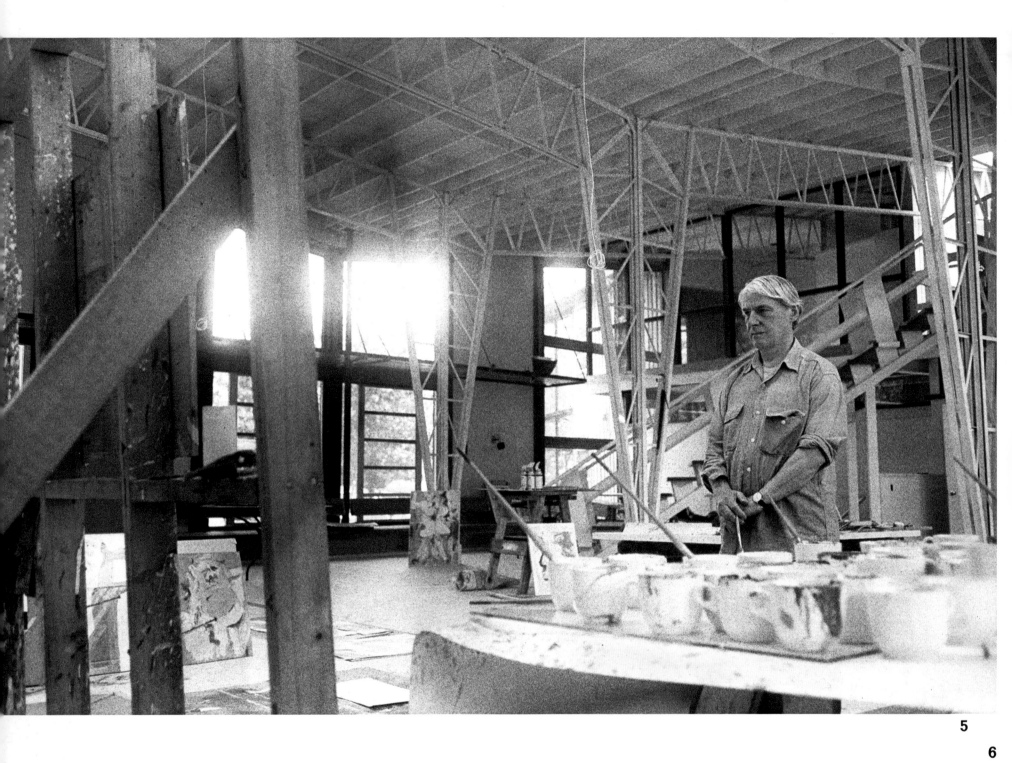

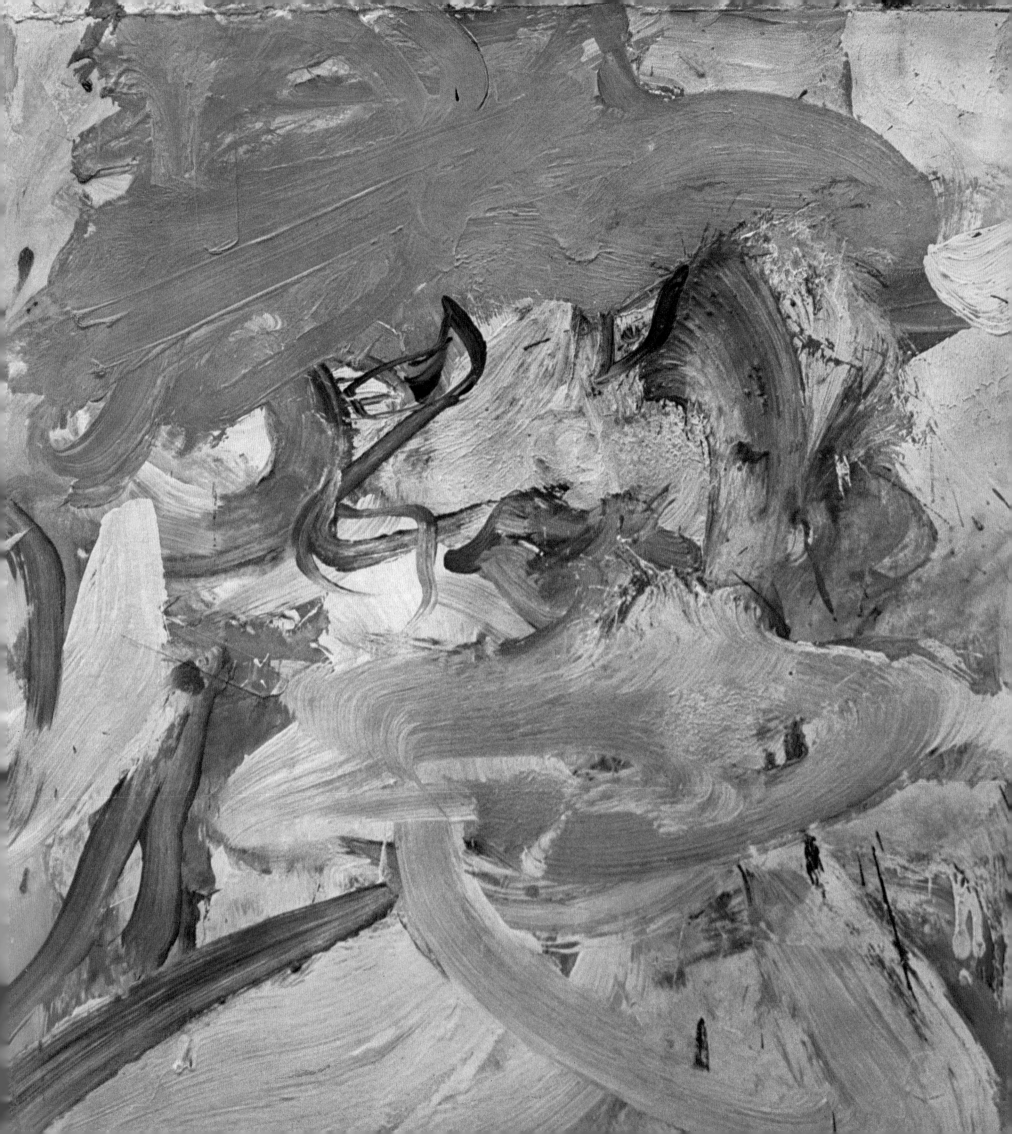

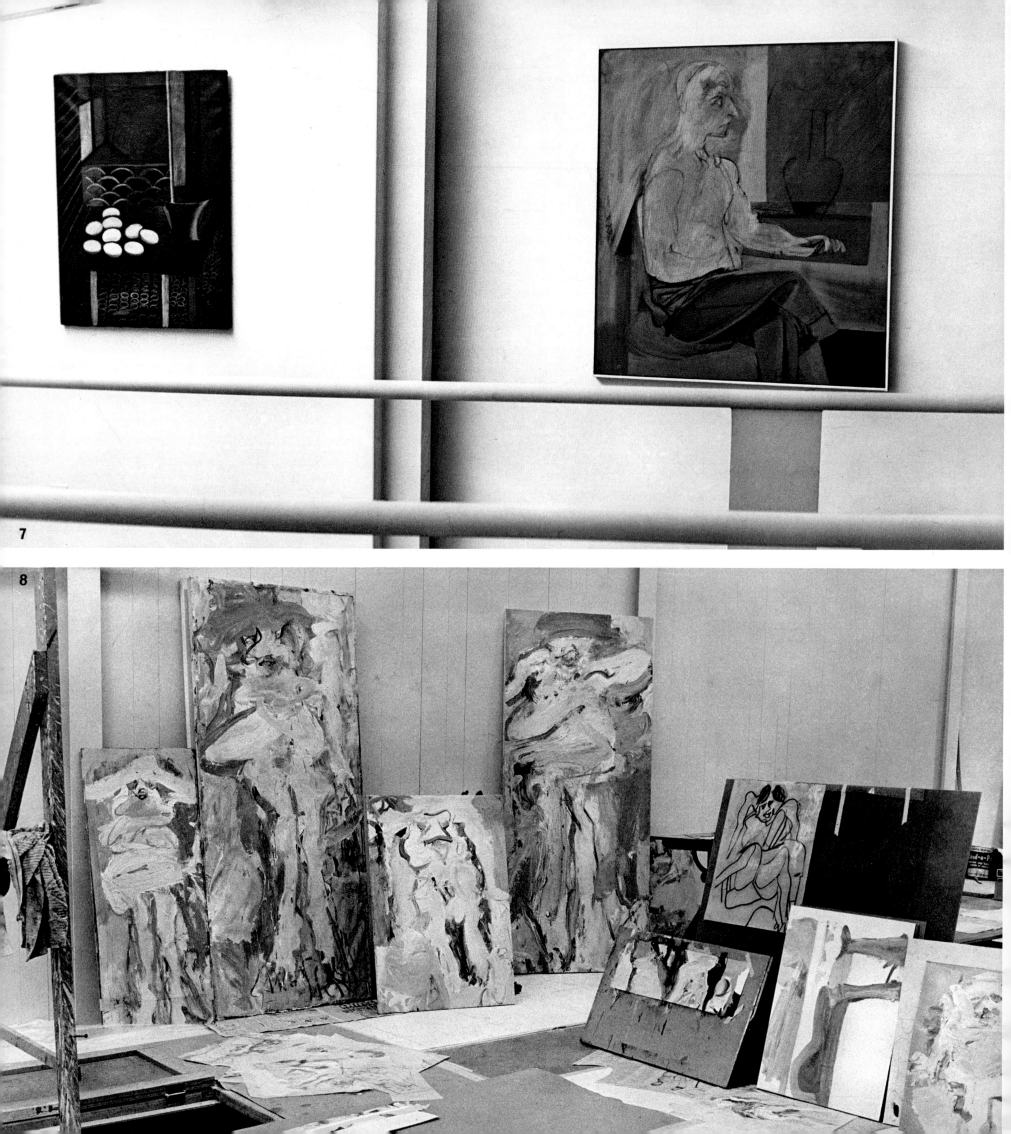

7

8

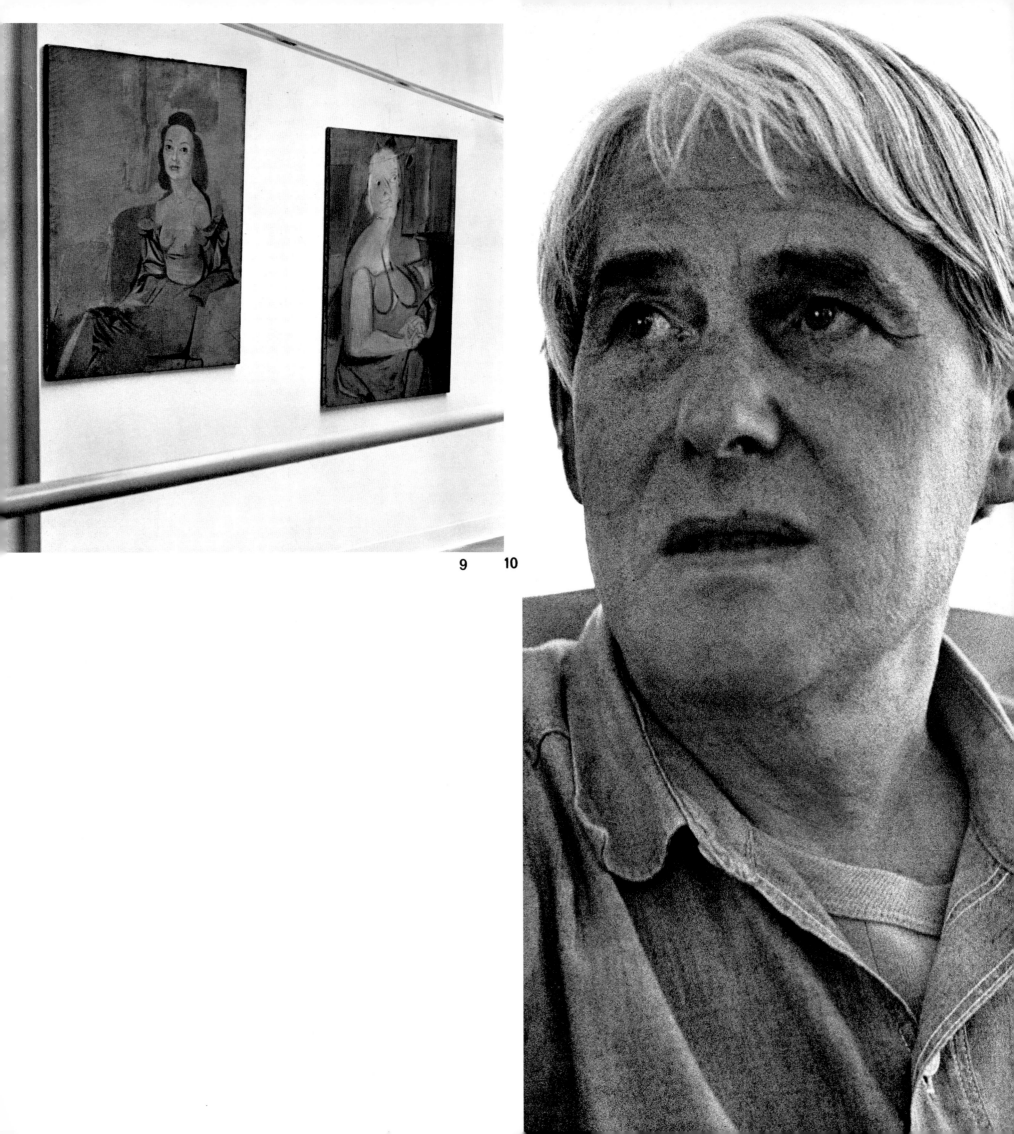

9 10

11

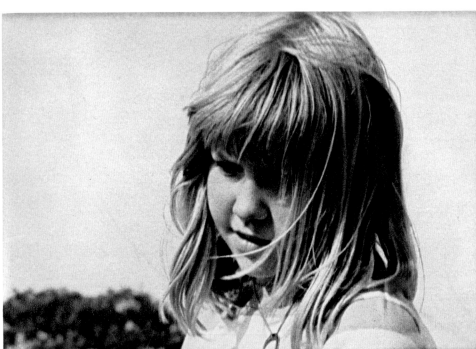

12

willem de kooning

1. In quest of a certain vision.

2. The distorted image. . . .

3. The house on Long Island. The artist on a bicycle, back from an outing.

4. In the wind, the mask blows aside, revealing the artist's contained suffering in the harsh lines etched on his face.

5. Facing the easel, de Kooning seeks escape from "the melodrama of vulgarity."

6. *Study*, 1966.

7. *Still Life*, 1929.
Seated Man, 1939.

8. Studies and paintings photographed in the studio, June 1966.

9. Portrait of Elaine de Kooning, 1940.
Seated Woman, 1942.

10. "Art never seems to make me peaceful or pure. . . ."

11-12. With his daughter.

1904 *Born in Rotterdam, Holland, April 24.*

1916 *Left school to enter the decorating house of Jan and Joap Gidding as apprentice. Attended night classes to get a solid grounding as an interior decorator, and also as a painter: drawing, anatomy, perspective.*

1920 *Left the Gidding to work with Bernard Romein (signs, window displays), who interested him in modern-art movements. Became acquainted with the de Stijl group and discovered the work of younger painters.*

1924 *Went to Belgium. Earned living as interior decorator. Continued painting, influenced by Expressionism.*

1925 *Returned to Rotterdam. Studied at his former art school.*

1926 *Left for the United States and again earned living as a decorator. Visited art galleries and museums.*

1927 *Made acquaintance of John Graham, who recognized his gift for painting. Through Mischa Resnikoff, met Arshile Gorky, who became a friend and co-worker.*

1928 *Spent summer in artists' colony at Woodstock, New York.*

1934 *Met the poet Edwin Denby, first collector of his works. Through Denby, met painter-photographer Rudolph Burckhardt and artists in the world of music.*

1935 *Employed in federal arts projects; devoted all his time to painting.*

1936 *At Museum of Modern Art exhibited sketches (for a large-sized decoration for the Williamsburg Federal Housing Project). Became closely allied with Abstract painters Browne, Criss, Balcomb Greene, Matulka, and worked for a time with Fernand Léger.*

1937 *Received mural commission for the Hall of Pharmacy, New York, in association with Michael Loew and Stuyvesant van Veen.*

1938 *Devoted time to classical painting.*

1943 *Married Elaine Fried, painter and writer.*

1946 *Worked in black and white—like many artists, he was poor and paints were expensive.*

1948 *Black-and-white works shown at Egan Gallery, New York. This first exhibition was successful. Became one of the leaders of the postwar generation of dynamic artists including Pollock, Rothko, Gottlieb, Hofmann, Still. Gorky died, and in an open letter de Kooning acknowledged his indebtedness to him. During summer taught at Black Mountain College.*

1950 *Returned to New York, taught at Yale Art School. Exhibited at Venice Biennial. Began work on large canvas, Woman I.*

1951 *Second one-man show at Egan Gallery, hailed by critics, but no pictures sold.*

1952 *Spent months on Long Island. Began making pastel pictures of women.*

1953 *Exhibition at the Sidney Janis Gallery, New York.*

1955 *Martha Jackson bought group of oils and pastels and exhibited them in New York.*

1959 *Shows of new, large abstractions at Sidney Janis Gallery.*

1961 *Exhibition at Paul Kantor Gallery, Beverly Hills, California.*

1962 *Shows at Sidney Janis Gallery and, with Barnett Newman, at the Allan Stone Gallery, New York.*

1964 *Awarded Presidential Medal of Freedom. Drawings 1936-1963 presented at Allan Stone Gallery. Exhibition at James Goodman Gallery, Buffalo, New York.*

1965 *Smith College Museum of Art, Northampton, Massachusetts, and the Hayden Gallery of Massachusetts Institute of Technology in Cambridge both presented exhibition "Willem de Kooning." Exhibitions at Paul Kantor Gallery and, with Joseph Cornell, at the Allan Stone Gallery.*

1967-1968 *Knoedler Galleries in New York and Paris presented major exhibition of works since 1963.*

1968 *Visited Netherlands; was warmly welcomed in Amsterdam for opening at Stedelijk Museum of first retrospective exhibition of his works. Won Talens International Prize.*

1968-1969 *Retrospective exhibition traveled to Tate Gallery, London, then to Museum of Modern Art, New York; the Art Institute of Chicago; and Los Angeles County Museum of Art.*

FIRE EXIT FIRE EXIT

These words, in flaming red letters, at the end of the hotel corridors, brought back memories of fast-paced movies full of men fighting, feverish crowds, a world of clamor, of human emotions felt and shared in common.

I stood leaning against a window, looking beyond the little brick houses on 22nd Street to the tall impenetrable walls of the buildings in Lower Manhattan standing like concrete sentinels over New York.

I had come to photograph several American Abstract artists, among them Norman Bluhm, Adolph Gottlieb, James Brooks, and Salvatore Scarpitta, and was staying in the Chelsea Hotel.

Norman Bluhm's paintings are filled with large colorful kaleidoscopic signs turning, crossing over each other, and disappearing into the surface of the canvases, like the fiery tails that unbridled shooting stars might leave behind them in a silent cosmos. Bluhm conceals his sensitivity with his favorite weapon, the palette knife, spreading his pictorial matter in great sweeping lyrical gestures which encompass the heavens and earth.

Salvatore Scarpitta works in a nearby studio in a welter of confusion and disorder that reminds you of the frantic Ford and Ferrari pits during the twenty-four-hour endurance race at Le Mans. This is perfectly natural, since Scarpitta, a happy giant of a man, is himself a racing enthusiast. Working directly from the model, the artist achieves abstract gouaches that evoke the hallucinatory fairyland of the racing world.

To his large canvases Scarpitta affixes mechanical and plastic parts of cars retrieved from the racing pits. He was one of the first artists in the United States to do combine painting.

Adolph Gottlieb's world is quite different. He is a master of pure abstract painting, peaceful and thought-provoking canvases whose inner poetry lends their color range forms of the highest spirituality.

During my stay in New York I met the young Dutch sculptor Mark Brusse. It was at Max's Kansas City, a restaurant on Park Avenue South. An apostle of object sculpture, Brusse creates wooden constructions that seem to stir in an archaic fashion : fetish sculptures, often erotic, painted in many-colored hues. One Sunday, I left with him for the sandy beaches of Long Island. We had been invited to East Hampton by Carlos Basq, an Argentinian artist who makes pictures with pasted fabrics that give his work a touching, sensual dimension, the secret banners of lovers.

East Hampton is a mixture of Barbizon and St. Tropez—on the American scale ! Writers, painters, and sculptors live there, intermingling with millionaires and the Madison Avenue set.

Pollock, archangel of action painting, used to work there. De Kooning, prince-regnant of Abstract Expressionism, found the land-and seascapes of his native Holland there. Other exalted exponents of Abstract Expressionism, such as James Brooks and Conrad Marca-Relli, have houses there. Among neighbors and friends are Herman Cherry, Ludwig Sander, Bluhm, Syd Solomon, and John Little, as well as Ibram Lassaw, who chisels the architecture of his labyrinths in space, weaving welded ribbons into the framework of airy constructions that are cathedrals in the Milky Way.

gottlieb

In my studio I am in a non-verbal world. Surrounded by my materials, canvas, paints, oils, brushes etc. I feel like a relic of the past because paintings are still among the few things made by hand.

Yet with these crude implements it seems possible to convey something of a spirit that transcends our mundane and often brutal environment. Perhaps even the emanation of a divine spark may become manifest.

Adolph Gottlieb
Feb 14, 1968

236

James Brooks

Painting remains for me the process
of starting a canvas with as little
memory, or even intention, as
is possible — so that it represents
at that beginning stage a thing
foreign to my habits and clichés.

The painting of it from then on
is a dialogue, an argument, a
conflict at times—which in the
end changes both the painting
and the painter.

August 21 1967

scarpitta, brusse, little, basq

The choice of art in the life of man is, without a doubt, the choice of loneliness in the motion of time, in so far as loneliness or remoteness is but the effort of man to touch that which is beyond the reach of his fingers. His life in relationship to his family, friends, etc. is a key to a different door than that of his studio. How many nights do I, upon returning home in the evening, try to open the door of the apartment with the studio key! How many hours are spent like a strange lion in a cage, marching up and down in silence only to find my own reach limited to my outstretched arms! Nevertheless, there are no tears: even though one lives on the edge of the glass, joy is forever the unknown.

I found it necessary to bind the fractures and sores inflicted on my work. I bandaged my canvases together, trying to stanch the loss of color. I showed this work for the first time in New York at the Leo Castelli Gallery in 1959. It had already been seen in Europe in 1957. Curved and shaped canvases are intermingled here. The three dimensions on a painter's stretcher caused confusion at that time. I have never liked "either/or" definitions. Was it sculpture or painting? I consider this to be prototype work. Others must have gotten the message because in the meantime a whole school of shaped canvas developed here in the United States. Let's leave this. I'm working on racing cars now.

Salvatore Scarpitta

As a sculptor I like to know what I'm doing.
So far as I'm concerned I've lost faith in the automatic gesture. Before I begin anything I know the how and the why of it exactly. I believe that an artist today should be a technician, or better yet a specialist in his own field, a field which paradoxically often combines the worlds of the mathematician and the physician. We must employ all the means at our disposal to herald the life of tomorrow and enjoy a better life today.

mark brusse

In the problem of formal painting the prime factors are:
A. The color-light-life forces.
B. The counterforce of form and space.
C. The dynamic rhythm, the tensions and discovery in the magnetic field (the picture plane).
I feel that the multiplicity and vitality of color-light is the side-by-sideness in painting.
The movement, countermovement of form is the inside and outside of space.
Opposition and tension is the up and down and the out and in, in the magnetic field.
The oneness and endlessness of expansion on the two-dimensional pictorial surface is the totality of totality of totality.

John Little

Art is one of the human pursuits I know least about but which interests me most. This combination makes me wonder about a mystery which always seems to be within my grasp and yet invariably eludes me like a ghost. I also love to cook, to drink, and to make love because I can never know enough about them. Like art, they are different every time, always puzzling, always painjoyful and unresolved.
I am an artist because art is the best way to express man without defining him. Art like man is never bad or good, it exists or doesn't exist. This is more than enough for me. When I think I have finished a painting I feel as if I have conquered the world. I go out to buy cigarettes. When I come back the illusion has already vanished. I am left at the beginning of a new battle to be fought in which I can never hurt anybody but myself.

Carlos Basq

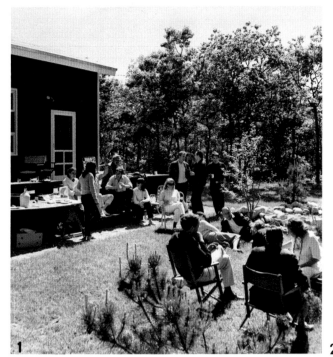

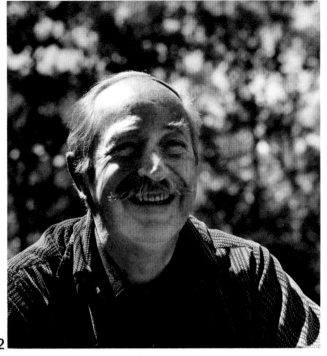

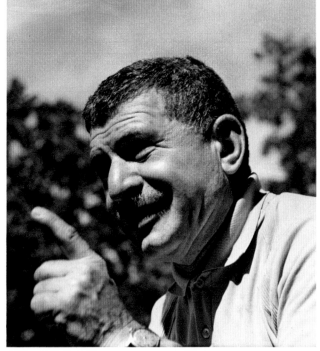

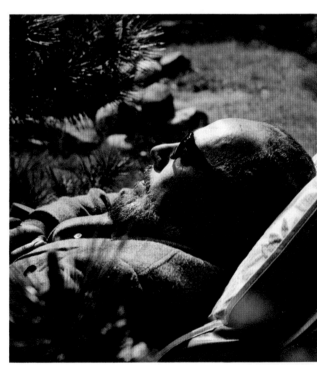

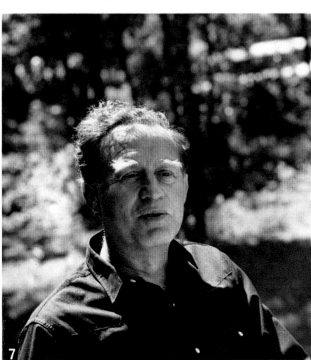

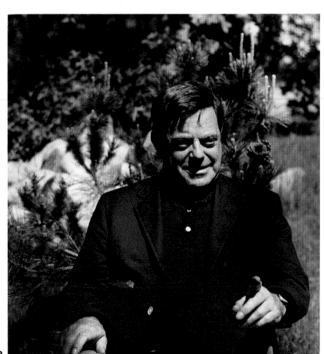

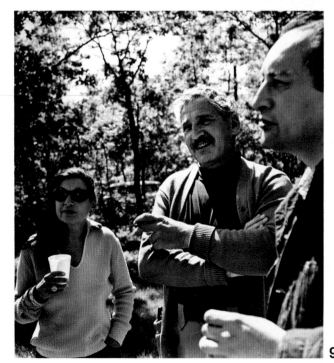

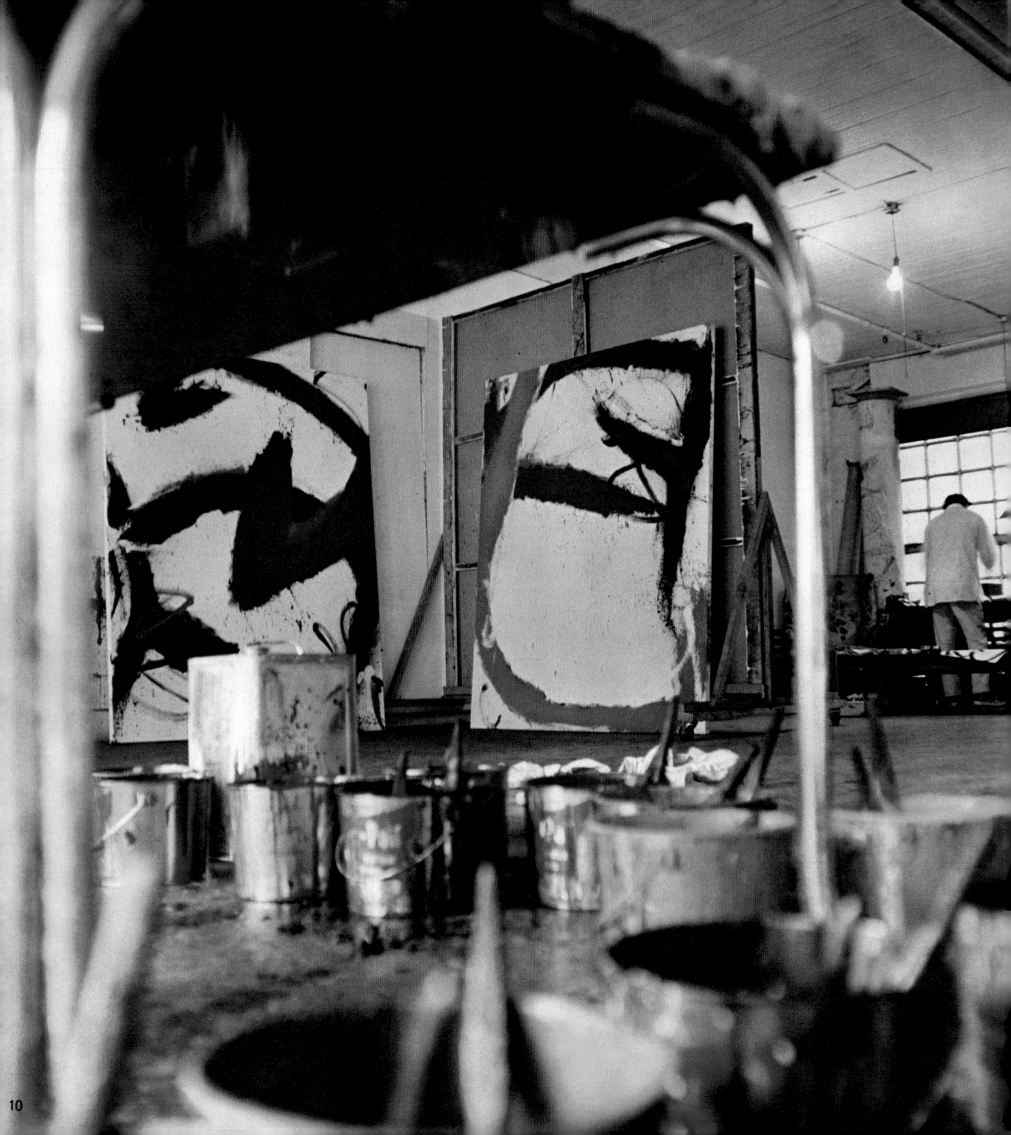

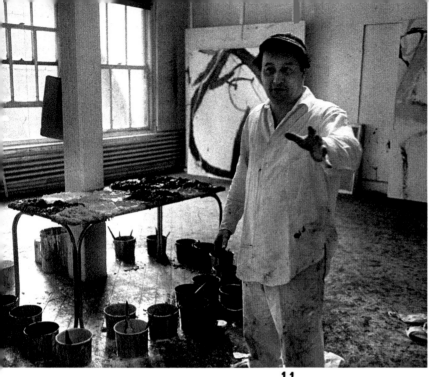

11

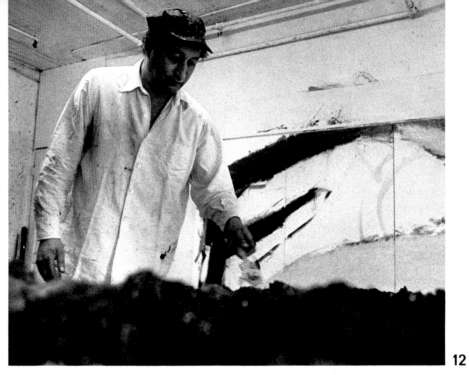

12

13

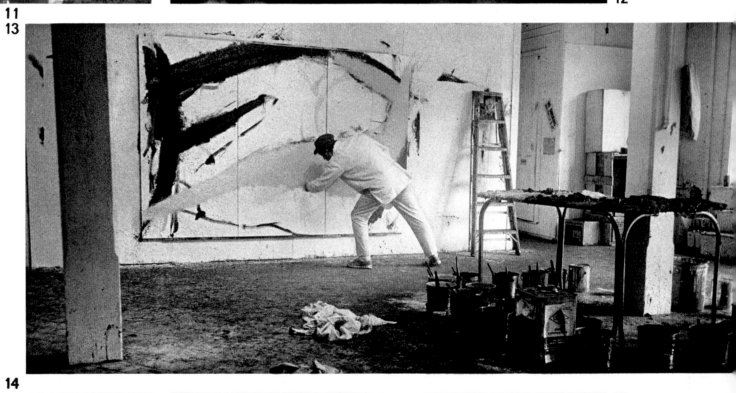

14

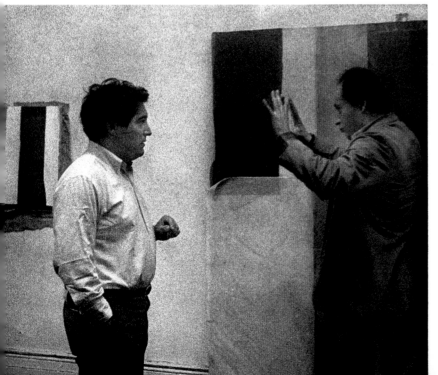

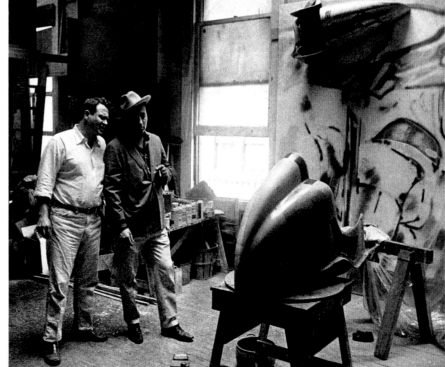

15

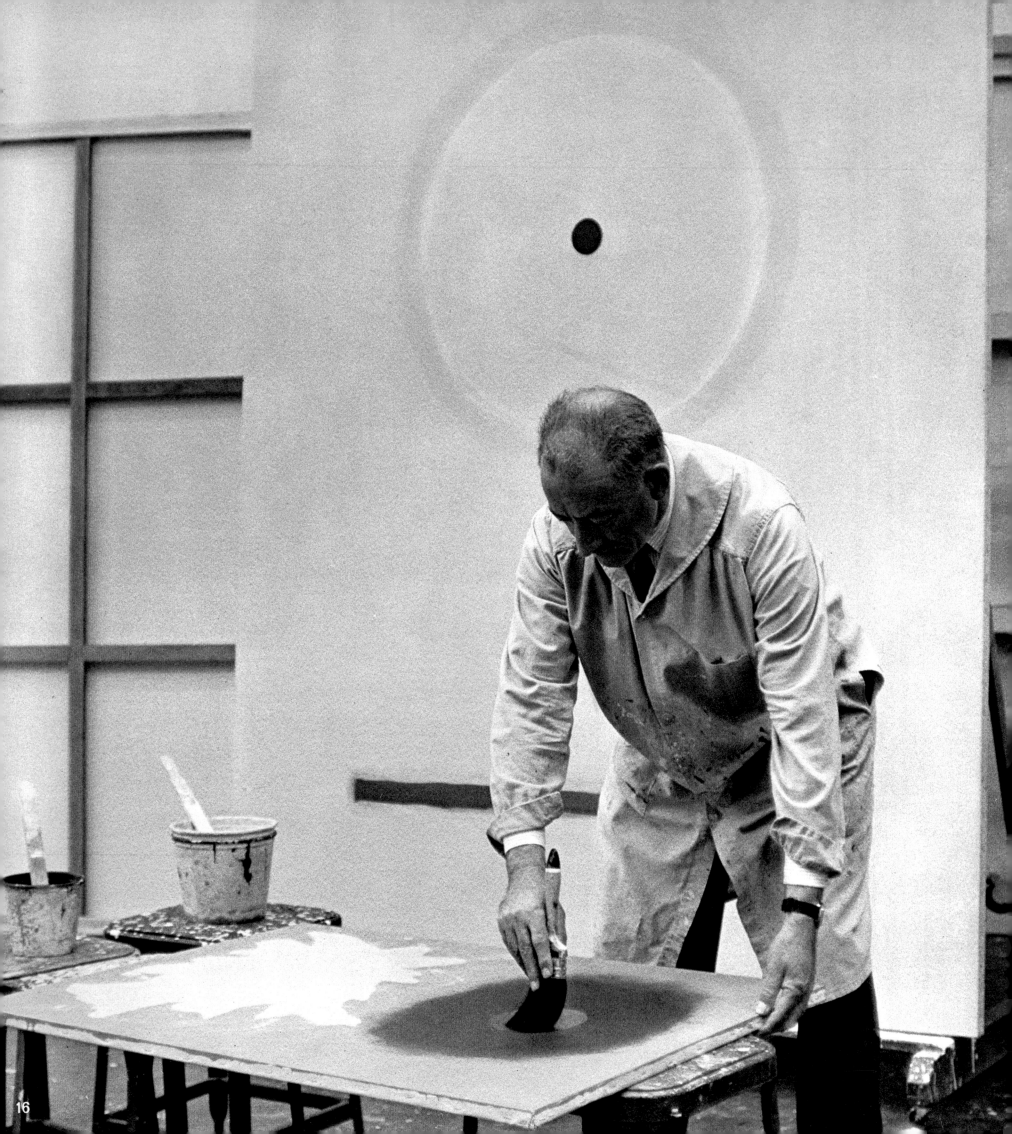

new york

NEW YORK......

1. Barbecue at the home of Carlos Basq. John Little lies stretched out in the middle ground.

2. John Ferren.

3. Herman Cherry.

4. James Brooks and the young sculptor Mark Brusse.

5. Carlos Basq, chef.

6. Conrad Marca-Relli.

7. Ibram Lassaw, sculptor.

8. Ludwig Sander.

9. Syd Solomon and his wife and the profile of Norman Bluhm.

10. In Norman Bluhm's studio, New York.

11-13. Bluhm painting *Just West*.

14. Bluhm at the home of Carlos Basq. Pictures made of pasted fabrics hang on the studio walls.

15. On a visit to the studio of Salvatore Scarpitta.
The artist points out the plastic molding of a racing car component he plans to incorporate in a picture.

16. Adolph Gottlieb in his New York studio.

CARLOS BASQ

1929 Born in Argentina of American parents. Studied law in Argentina, Spain, France, Belgium, and the United States. Lived in New York and in East Hampton after 1954. Following a year spent at Mariano's studio in Havana, he studied with Theodoros Stamos at the Art Students' League, New York.

1960 First one-man show, at the RJ Gallery, New York.

1964 One-man show at Bodino gallery, Buenos Aires.

1966 Exhibition at Westerly Gallery, New York. Represented in numerous exhibitions in the United States and Latin America.

LUDWIG SANDER

1906 Born in New York.

1931-1932 Studied painting in Paris, then in Munich with Hans Hofmann. Has exhibited since 1961 with the Abstract Expressionists.

IBRAM LASSAW

1913 Born in Alexandria, Egypt.

1926-1930 Studied at the New York Sculpture Center with Dorothea H. Denslow.

1931 Attended Beaux-Arts Institute of Design, New York.

1962-1963 After professorship at University of Washington, taught at Duke University, Durham, North Carolina. Lives in New York.

SYD SOLOMON

1917 Born in Uniontown, Pennsylvania. Studied at École des Beaux-Arts, Paris, then at Chicago School of Art.

1947 Became professor at Pittsburgh Institute of Art.

1954-1965 Director of the Famous Artist Schools Inc.

HERMAN CHERRY

1909 Was born in Atlantic City New Jersey. One April 10, after living in Californiav (Los Angeles primarily) from 1924, he moved in 1945 to New York, first to Woodstock and to then to New York City, where he has been closely associated with the leading painters and sculptors of the "New York School."

JOHN FERREN

1905 Born in Pendleton, Oregon.

1936-1965 One-man shows at Matisse Gallery, Minneapolis Institute of Art, Putzel Gallery, Hollywood (1936), San Francisco Museum of Art (1937), Willard Gallery (1941), Iolas Gallery (1952), Stable Gallery (1954, 1955, 1957, 1958), Pasadena Museum of Art (1955).

1958 Provinceton Art Festival Prize.

1963-1964 " Artist-in-residence, " Beirut, Lebanon (U.S. State Department grant).

CONRAD MARCA-RELLI

1913 Born in Boston, Massachusetts.

1953-1963 One-man shows at Stable Gallery, New York (1953-1958) Perls Gallery, Hollywood (1956), Kootz Gallery (1959-1963), Bolles Gallery, San Francisco (1961), Joan Peterson Gallery, Boston (1961). Other exhibitions 1957-1963 in Rome, Milan, Düsseldorf, Lima, Zurich, Tokyo.

1954 Logan Medal and Purchase Prize.

1959 Ford Foundation Award.

1960 Detroit Institute of Art Purchase Prize.

NORMAN BLUHM

1920 Born in Chicago.

1936 Studied architecture with Mies Van der Rohe.

1941-1945 Served in the United States Air Force.

1947-1956 Lived and painted in Paris.

1956-1964 New York. First one-man show at the Leo Castelli Gallery, 1957 (another in 1960). Exhibited with De Kooning at Anderson Gallery.

1964 Worked in Paris. Exhibited at the Galerie David Anderson. One-man shows in Turin, Zurich, Brussels, Paris, New York. Represented in several international exhibitions.

ADOLPH GOTTLIEB

1903 Born in New York.

1919 Studied with John Sloan and Robert Henri at the Art Students' League.

1920 In Paris, worked at the Académie de la Grande Chaumière.

1923 Returned to the United States. Student at the Parsons School of Design, New York.

1929 First one-man show in New York (Dusending Galleries).

1935-1940 Annual exhibitions with avante garde group, The Ten.

1941 Made first pictographs.

1944 Received first prize at annual exhibition of Brooklyn Society of Artists. Made President of the Federation of Modern Artists.

1949 One-man show at Jacques Seligmann Gallery, New York.

1957 Exhibition at Martha Jackson Gallery, New York.

1958 Professor at Pratt Institute, New York, and University of California, Los Angeles.

1959 Exhibition at Galerie Rive Droite, Paris.

1960 One-man show at Sidney Janis Gallery, New York. (Again in 1961.)

1961 Third prize at Carnegie International, Pittsburgh. Show at Ariete gallery, Milan, and Handschin gallery, Basel.

1963 First prize at São Paulo Biennial.

JAMES BROOKS

1906 Born in St. Louis, Missouri. Studied with Nicolaides and Robinson at the Arts Students' League, New York, and with Wallace Harrison.

1938-1942 Interested in mural decoration. (Federal Arts Project.)

1946-1966 Taught in several American universities.

1961 Awarded Silver Medal, Chicago Art Institute.

SALVATORE SCARPITTA

1919 Born in New York.

1936 Studied painting in Rome and exhibited in Italy.

1959 Returned to the United States. Settled in New York.

JOHN LITTLE

1907 Born in Sandford, Alabama. Studied drawing and painting at Buffalo Academy of Fine Arts, then at Art Students' League, New York.

1946 First one-man show, in San Francisco (Palace of the Legion of Honor). Held several exhibitions in New York galleries and at universities.

MARK BRUSSE

1937 Born in Alkmaar, in Holland.

1956 Studied at school of fine arts for sculpture, in Arnheim.

1959 First one-man shows at Nijmegen and The Hague.

1960 Showed with the Nada group in Holland and Germany. Settled in Paris.

1960-1965 Several one-man shows, including exhibition at Galerie Mathias Fels, Paris. Exhibited at Paris Biennials.

1965-1967 Worked and exhibited in New York.

1968 Returned to Paris. One-man show at Stedelijk Museum, Amsterdam.

He chose the sun, or rather, the sunny side of the arena—for at five in the afternoon there's also a shady side.

But Bernard Lorjou never moves out of the sun.

He sees the bull attack and maneuver, indeed he is the whole bull-fight himself. He sees the bull through the blinded eyes of the picador's horse, the goad through the retracted pupils of the English tourists, the bull's blood through the ten thousand razor-sharp eyes of the bloodthirsty public, the matador through the bulging eye of the sun that turns his shadow purple and lengthens it sufficiently to receive the horn's deadly thrust. Perhaps he even sees himself through the perforated eye of the trumpet that sounds the kill.

When I sat next to Lorjou in the arena at Palma de Mallorca, the *corrida* enabled him to live through and to experience all the secret passions of mankind, which is what he paints.

The struggle between man and beast furnishes Lorjou with an excuse to re-create a plot on a violent theme which in turn reveals the personality of the painter. An example is his *Le Sang de Grimau*, which is set up like a billboard in the middle of the new city of Sarcelles. Painted on a background of funereal white, the assassin with a bull's head wears the dazzling ceremonial robes of an Infanta. In his right hand he holds a revolver from which the smoke of the last shot blows away, veiling a distant cathedral. With his other arm he brandishes aloft the body of an executed Spanish patriot in the sort of ridiculous gesture a minotaur might use to flaunt his victory. Sharing life together, Bernard Lorjou and Yvonne Mottet, also a painter, live and work in Saint-Denis-sur-Loire, a quiet little village in the Touraine.

Their home was once the farm property of a buccaneer who operated out of the port of Saint-Malo.

The ground floor comprises a living room, a dining room, and another enormous room with windows facing the Loire where Lorjou paints his easel pictures. This studio is littered with work in progress. A long table holds a medley of charcoal sticks, tubes of color, flower pots, loads of correspondence, and a tough old leather boot which he often uses as a model. A small portrait of Lorjou's mother elbows a trumpet on the mantelpiece. It was the first painting he ever did, aged sixteen. His completed canvases hang on the walls, glowing, shining with health. A *Bouquet de Soleils* tries to cover up the nakedness of a plucked chicken while an immodest goat mocks a dreamy-eyed harlequin.

Yvonne Mottet's studio and rooms are on the floor above.

You have to cross the yard to get to the large barn swollen with movable scaffolding that looms like engines of destruction and bristles with brushes awaiting the new frescoes they'll be used for. The day I visited Lorjou, he was dressed in a dark-gray sweater and around his waist was tied a paint-splashed gardener's apron. He was busy painting *La Guerre du Vietnam*. It was an immense canvas. "Painting this isn't all," he said, climbing down from the scaffold, "you still have to find a place to hang it, show it."

Looking at him, I saw an ironical blue eye shielded by the brim of a battered old hat, a hat probably knocked about in one or another of his fits of anger. Lorjou encourages you to think that he lives on a diet of sparks and conflagrations.

His gaze drills through his glasses, laying bare the intensity of his life and something of the feverish exaltation he discharges upon his canvas while he paints.

He was born the son of peasants and struggles against any form of restraint. His colossal works, pure and vibrant in color, created out of an embittered sensibility, glow with lyrical expressionism.

Founder in 1948 with Mottet, Minaux, and other young painters of the group known as "L'Homme Témoin," it is now twenty years since Lorjou began turning the art establishment upside down with his polemical action and with canvases that are manifestoes in themselves.

A picture by Lorjou is the eyeball-to-eyeball confrontation of two adversaries—one, the man who remembers the hard times of his youth, of his struggles in behalf of figurative painting, of a man imprisoned by an idea—the other, the artist who has inherited the skill of the old masters but uses the colors dictated by his heart-beat.

Lorjou's art was born of the equilibrium achieved between the clash of the idea and the clear shaping of its expression.

Thus he painted the pinkish scourge of bacteriological warfare in *La Peste en Beauce* (1953), revealed the whole world's anguish in *L'Age Atomique* (1958), showed the bellies disemboweled by *La Force de Frappe* (1962), and laid bare in *Blancs et Noirs* (1964) the character of men haunted by racial injustice.

As a spectator bearing witness to the times he invited Paris society to a private view of his *Bal des Fols* (1958), and the general public to a showing of his *Massacres de Rambouillet* (1957) during a street fair held on the esplanade of the Hôtel des Invalides, the great military museum containing the tomb of Napoleon.

In 1968, he exhibited four of his immense canvases : *La Force de Frappe*, *La Mort de Jean XXIII*, *Grimau*, and *14 Juillet* on a canal boat cruising up and down the Seine, enabling all of Paris to see his work. Along with his paintings, Lorjou has produced a large body of lithographic work that places him at the head of the group of artists using this means of expression.

Lorjou, the anarchist, has a town house in Paris. It is right at the very top of Montmartre. To get there his Rolls-Royce travels through the plains of the Beauce and brushes the outskirts of Chartres. Wearing a red scarf around his neck, he likes to go back to the Mourlot Studios where he prepares the stones he uses for his lithographs, later dropping in at the Italian restaurant in the Rue Chabrol. The easel picture in his Paris studio, all sand, sun, and blood, depicts a *corrida* with an unhorsed picador. Red, yellow, and green, the magical apparition of a cathedral arching its rooftree lifts into the skies.

Lorjou's painting, mighty as an overflowing river washing up gold and mud, overturning monuments, splitting beds and tabernacles, catching all the reflected fire of a world in convulsion in its angry waters, is intended to extract whatever fraternal love we possess out of our egotism, so that the hearts of men may be immersed in it.

1 éil

clic
le
petit
oi
SEAU

SORT

LORjou

3 pieds

c'est
1
Chef d'ŒUUr
signé
FRASNAY

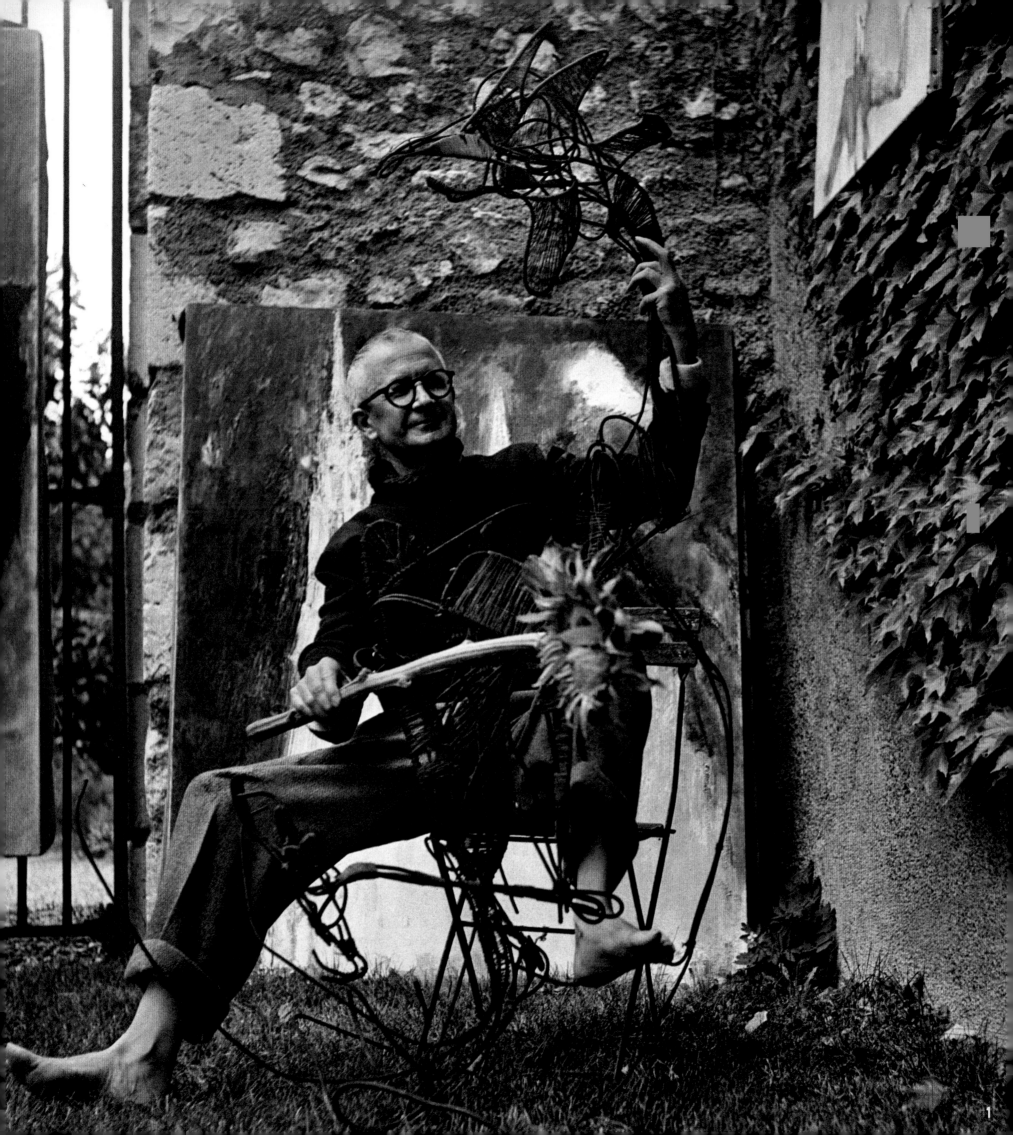

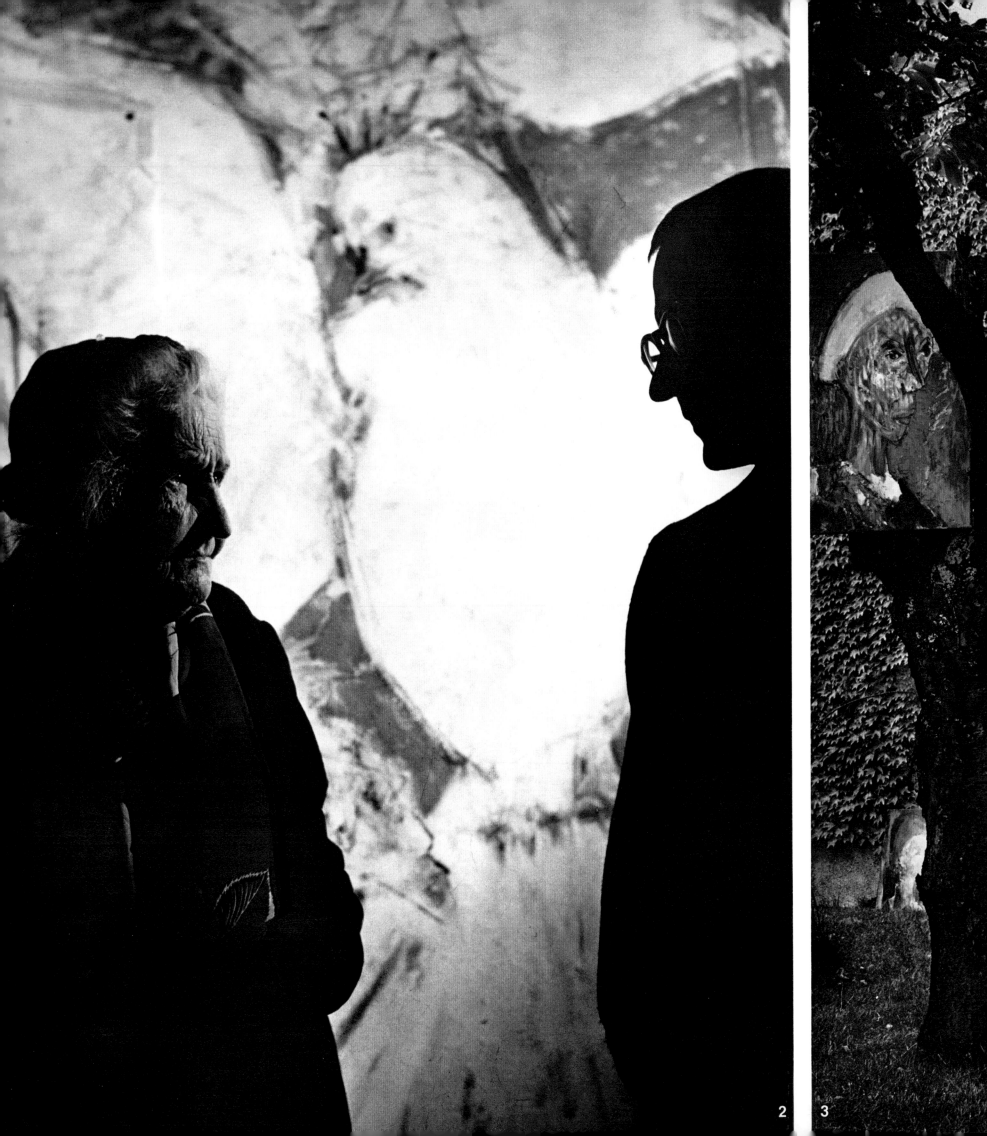

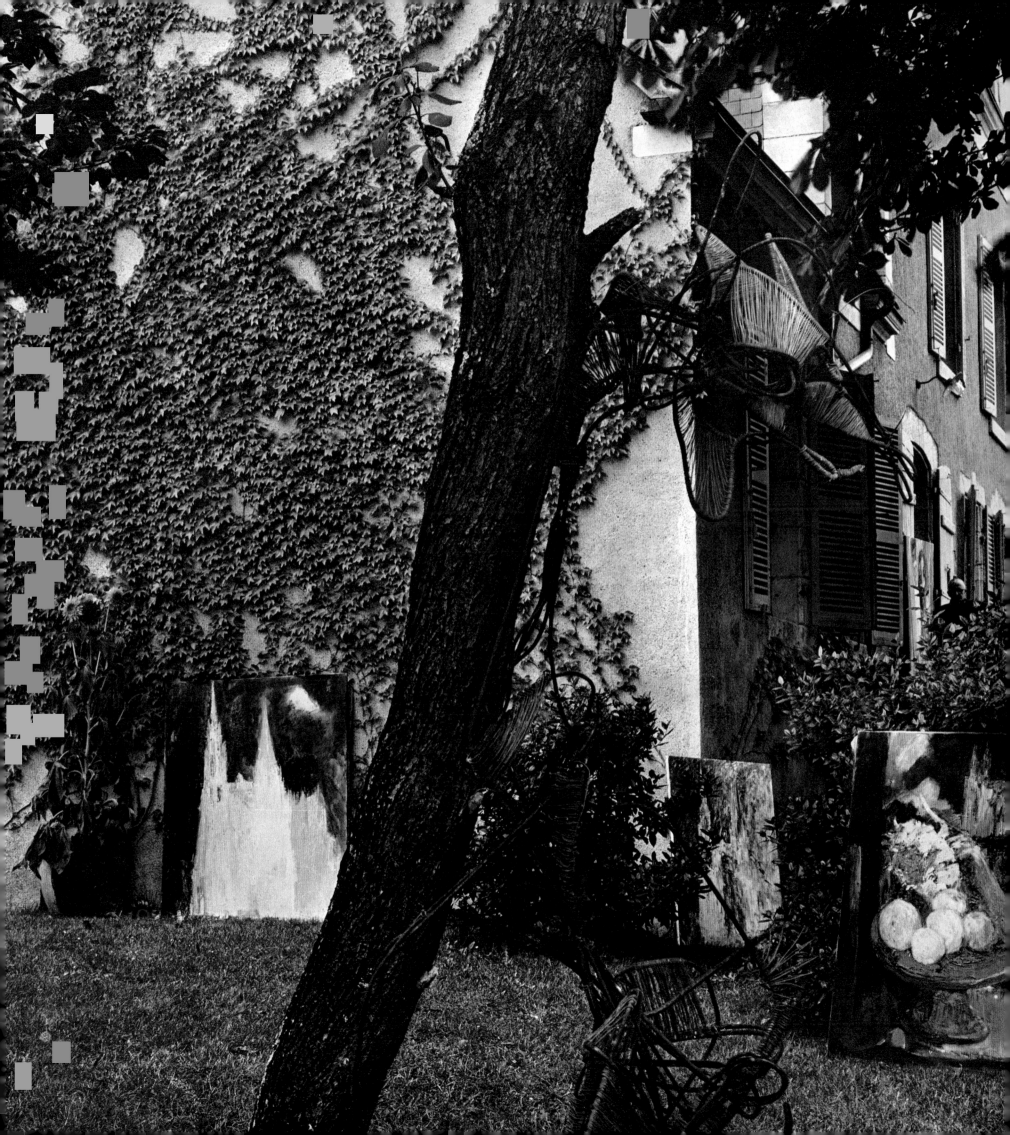

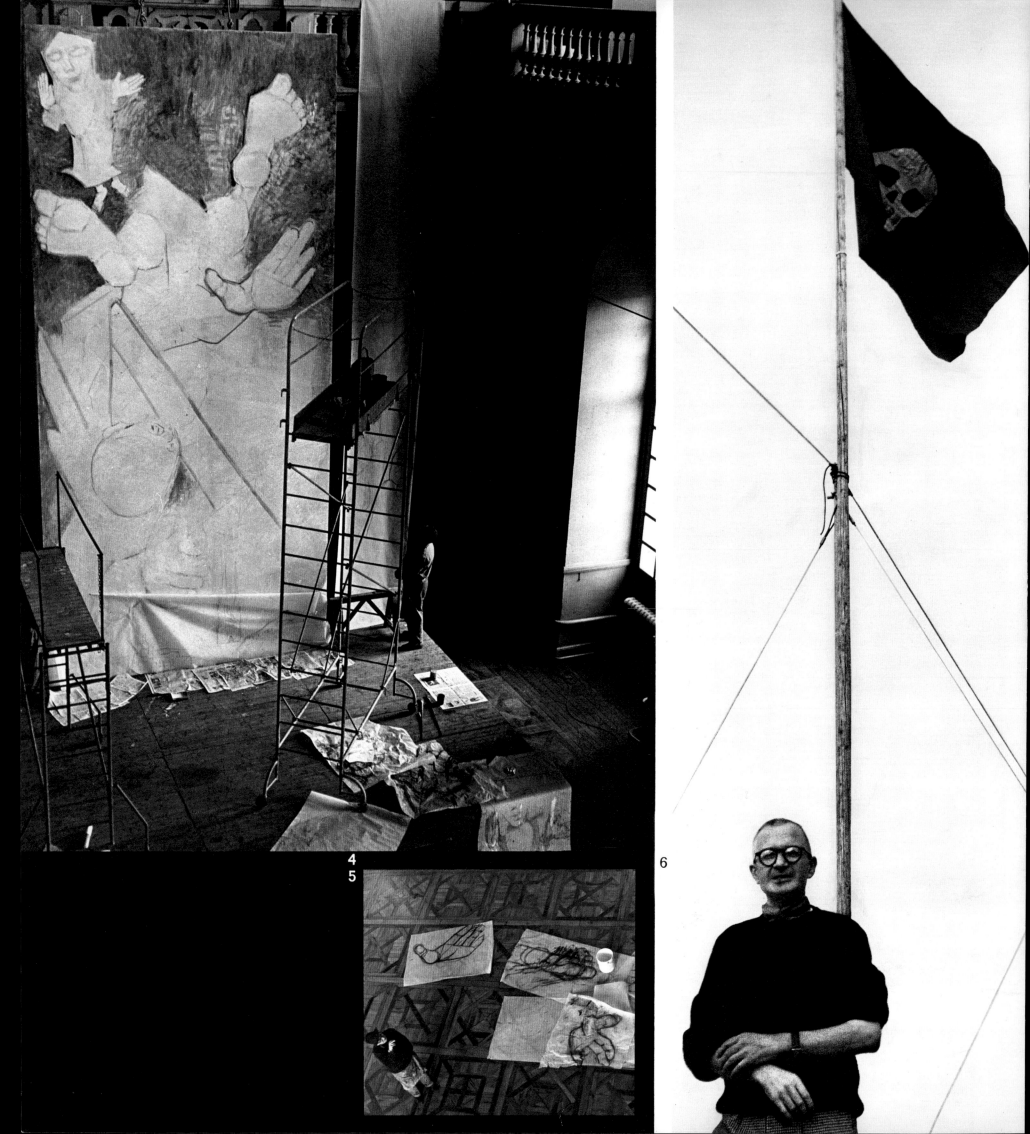

4
5
6

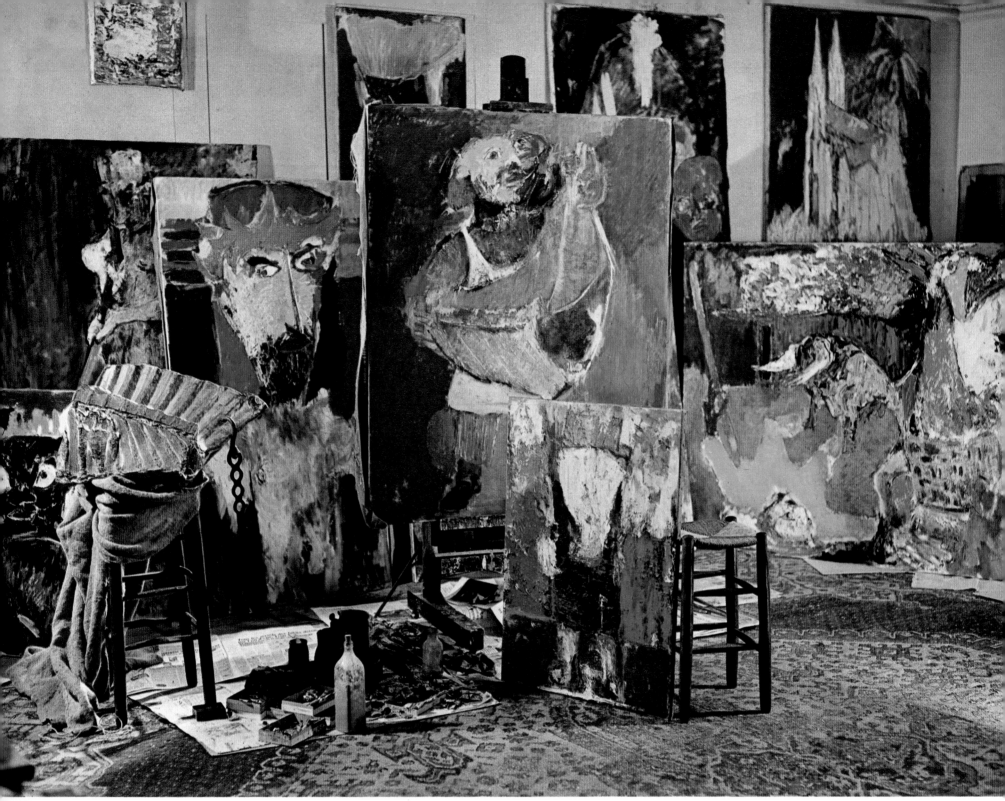

9

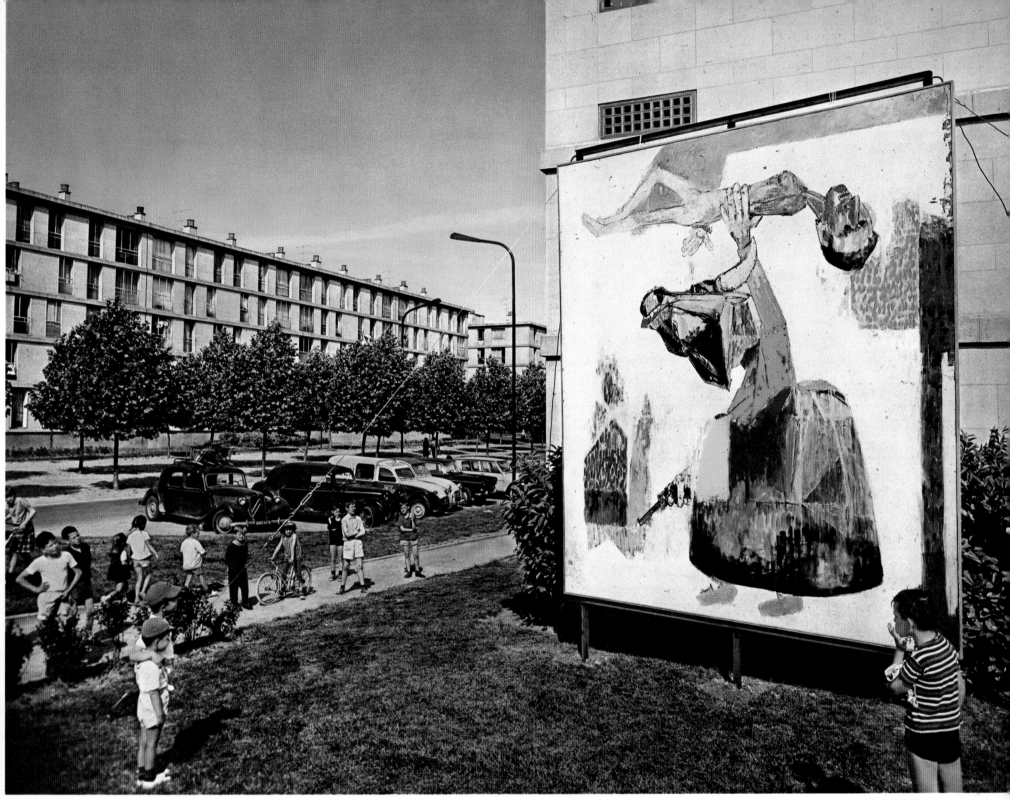

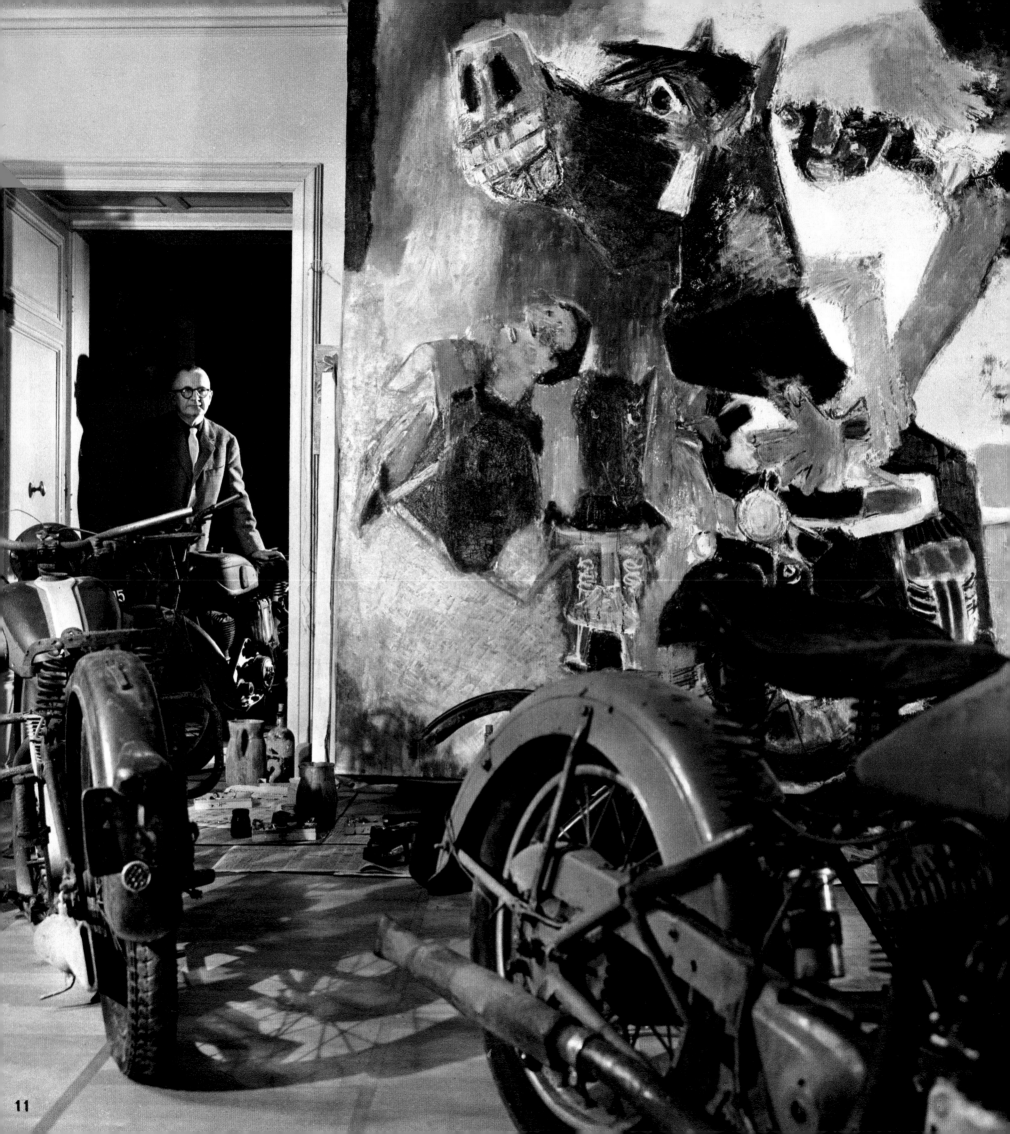

11

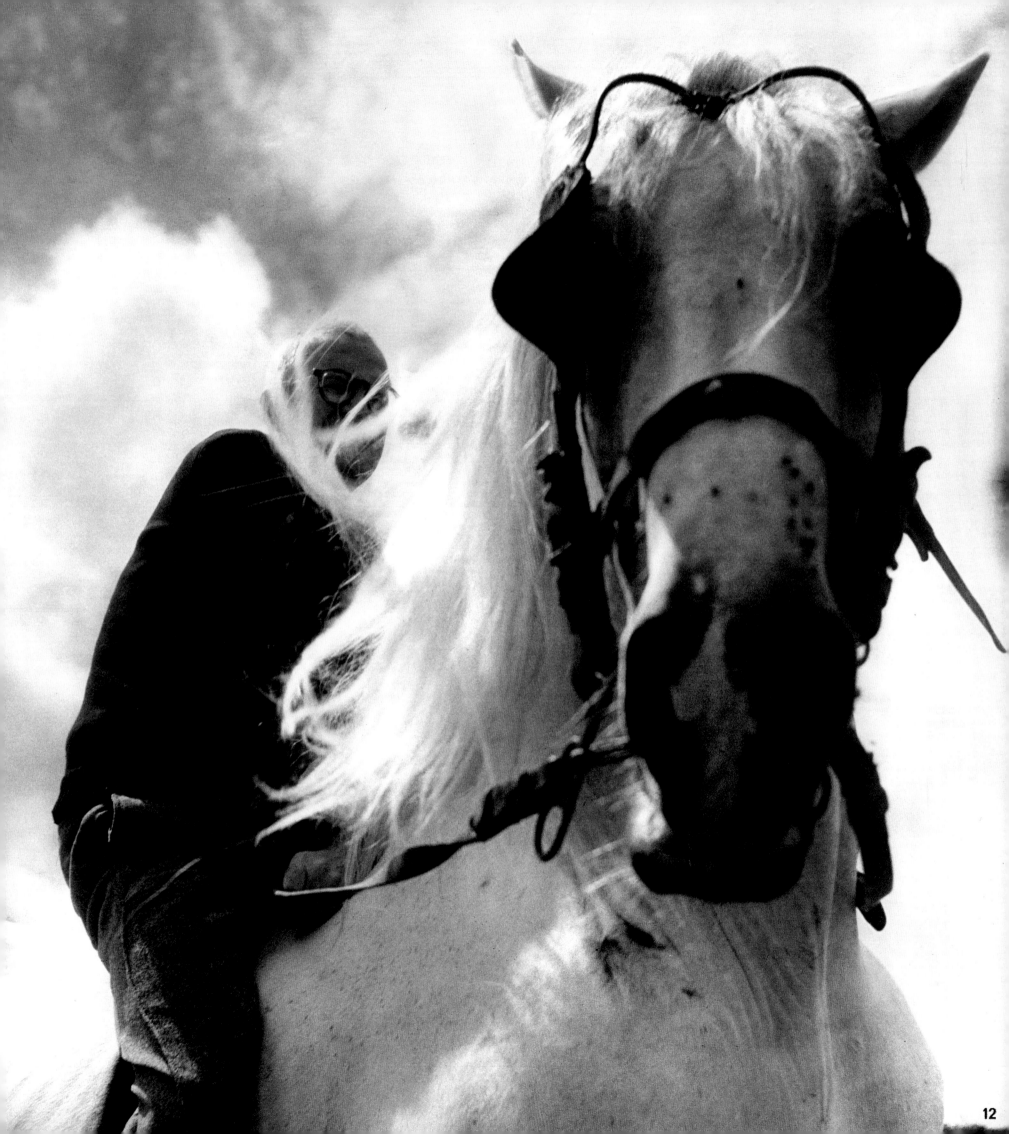

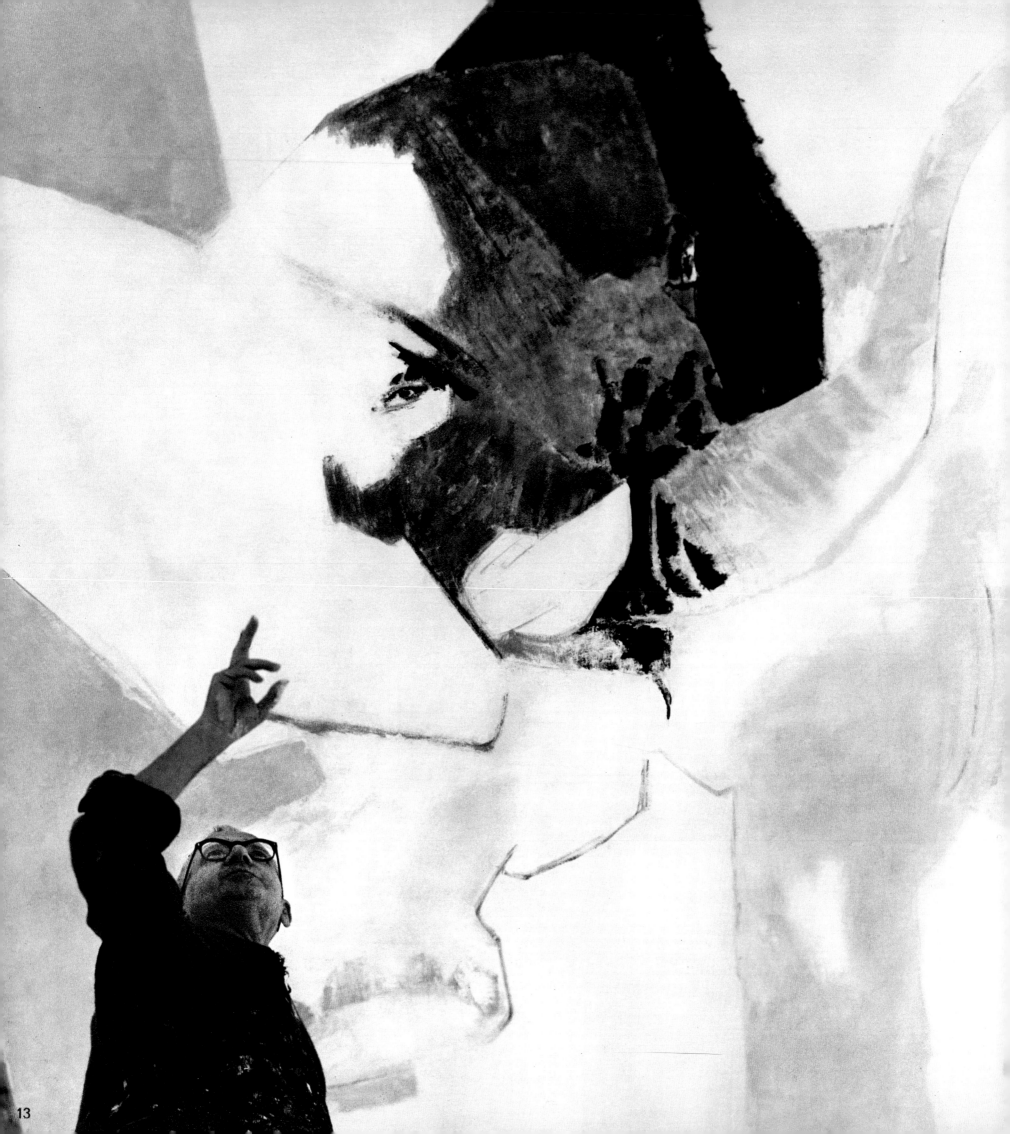

13

bernard lorjou

1. Lorjou playing a rooster-cello with a sunbow. In the background, the spire of a cathedral painting.

2. The mother of Lorjou, the son, and the *Dove of the Holy Ghost.*

3. In the garden of his house at Saint-Denis-sur-Loire.

4-5. Sketches for a new monumental work.

6-7-8. Lorjou with his canvases, cruising up and down the Seine like the captain of a pirate ship.

9. The studio, with canvas entitled *Rois.* On the easel is *Le Roi de l'Entrecôte.* Below it, *Roi Mage.*

10. *Hommage à Grimau* as shown at Sarcelles.

11. The new generation : *Centaures et Motocyclettes.*

12. Lorjou, a horse, nature.

13. The painter has made an elephant fly up to the ceiling of the African Gallery at the Hunting Museum (Sommer Foundation).

1908	*Born at Blois, September 9.*
	He taught himself painting.
1921	*Errand boy at a printer's.*
1925	*Worked in design department of Francis Ducharme, a Lyons silk manufacturer.*
1928-1930	*Visited Vienna and Madrid museums, where he discovered El Greco and Goya.*
1930	*Worked at various trades.*
1948	*Received Prix de la Critique.*
	Founding of the group called "L'Homme Témoin."
1963	*Exhibition on board the canal boat on the Seine.*
1968	*Exhibition, Le Camion Rouge (in association with Mottet).*

MAJOR WORKS

1934	Le 6 Février.
	La Conquête de l'Abyssinie par les Italiens.
1935	Le Cirque.
1940	La Brasserie.
1945	Le Miracle de Lourdes *(Vienna Museum),* Les Déportés, Le Métro, La Chasse aux Fauves.
1949	L'Age Atomique.
1950	La Bataille d'Abadan.
1951	La Conférence *(Warsaw Museum).*
1953	Matin de Couronnement, La Peste en Beauce.
1956	Le Bouc et l'Arlequin.
1957	Les Massacres de Rambouillet *(shown in a shed on the esplanade of the Invalides).*
1958	Le Roman de Renard.
1959	Le Bal des Fols.
1960	Les Cathédrales.
1961	La Crécelle.
1962	Les Rois.
1964	Blancs et Noirs, Dallas Murder Show.
1965	Centaures et Motocyclettes.
	Drawings for Apollinaire's Le Bestiaire. Idoles 65.
1966	*Ceiling for the African Gallery at the Hunting Museum in the Hotel Guenegaud (Sommer Foundation).*
1967	*At request of the Centre d'Information Civique, executed a poster,* Votez *(aimed at nonvoters).*
	Le Trophée du Civisme (a terra-cotta ceramic in color).
	La Famine aux Indes. A Komarov.
	Colored ceramics representing large totem figures : Ethistra, Notre-Dame-des-Radars, Octobre.
	Sketches for a large totemistic figure, in Paris.
	Portraits Antipsychédéliques.
	Les Paraboles and Christ en Gloire *for the chapel of the home for priests in the Blois Diocese.*
	Curtain for the Théâtre du Centre Culturel at La Courneuve.

matta

The thrust our best-known energy provokes
out of its unpredictable power
opens the way to the inchoate kingdom
painted by Matta.

ENERGY out of ERECTION

The mental vehicle thus created stirs with the chain reaction
of exquisite neutrons in constant reproduction.
It allows one to discover galaxies
the color of industrial eruptions
and the attainment of stellar constructions
MONUMENTAL
in their equatorial sensitivity.

Membership in the sway of this fantastic cosmos requires initiation.
It is simple —
contained in a single word — REVOLUTION
hurl down your gods — your civilizations,
create a vacuum...
you must be spotless
virginal.
Then only, profiting from your new-found freedom,
total in scope,
will you find it possible to take part in the civic festivals
invented and organized by Matta.

New Eden, the picture is the holy space
defined by the instinctive choice
that is the ancestral legacy of the artist,
that sorcerer portraying the signs
that are LOVE... and INHUMANITY
according to the lips that utter the words,
the fingers that trace them.

Each sign possesses its own sexuality
its behavior determines its commitment,
the character of the total effort.

Eyes smitten by the flinty dialogue of our times,
temples throbbing to the torture of the loyal symphonies
orchestrated and enacted by our timidities and passions.

With poetry his crowbar,
on the blue beaches of his planetary polemics
he raises the cathedral of a new era
illuminated, walled in by mirrors of transparent steel
magical aery places
orbiting in brain-determined paths.

Images of images
space is inside
space is outside
space is elsewhere
the actor is the spectator
peeper becomes seer
in a dynamic miracle of floating mirrors!

Matta's art reveals the irreversible invasion
of creatures born of forbidden morphogeneses,
operating through totems
secreted by the revolutionary womb
of universal urgencies.
On the canvas, his personal battlefield
Matta paints the thieves' market of to-morrow.

A careful visual perceptivity
divulges the disintegration
the ceaseless renewal
of beings, elements,
matter, sustaining the picture :
the energy of a thousand suns breaks loose
and joins our own.

The picture would be agony but is rebirth —
if it says delirium... it may be SELF.

I doubt that one can "see" life optically, but since time immemorial people have taken pains to master that "technique" called painting, which is supposed to give us the feeling that we are worldmen.

To grasp the world is to grasp the conflicts that surround us and decide our fate.

To "see" these conflicts you need more than pictures, you have to stir up that subversive imagination that shatters the accepted formulas and ideas we're imbued with and unleashes the poetic states. That exists in all of us and propels us toward the unforeseeable.

YOU'VE JUST GOT TO GET TO THAT INNERMOST CORE!

Art is the discharge of reality you obtain when you want what doesn't exist. But so that there may be art, there must also be an ART-ER and an ARTEE. In both cases, it's the profundity of the understanding that matters.

What is taken for "art" is often but a shot in the dark, a shot that misses the target and merely brushes the heart or the head, thereby stirring up nothing but a quiver, a surprise.

Everything depends on the profundity;
THE EYE AND THE TARGET ARE ONE.

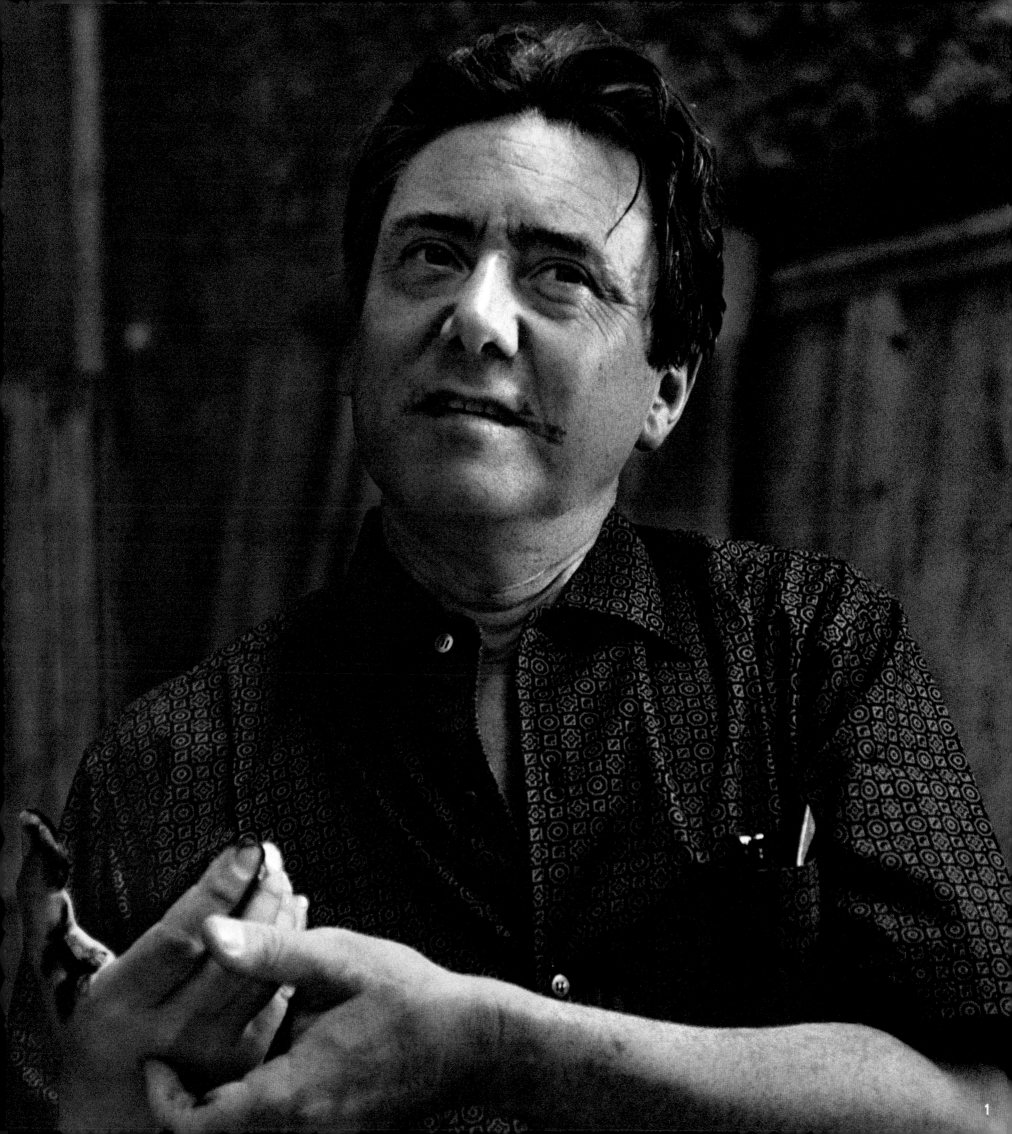

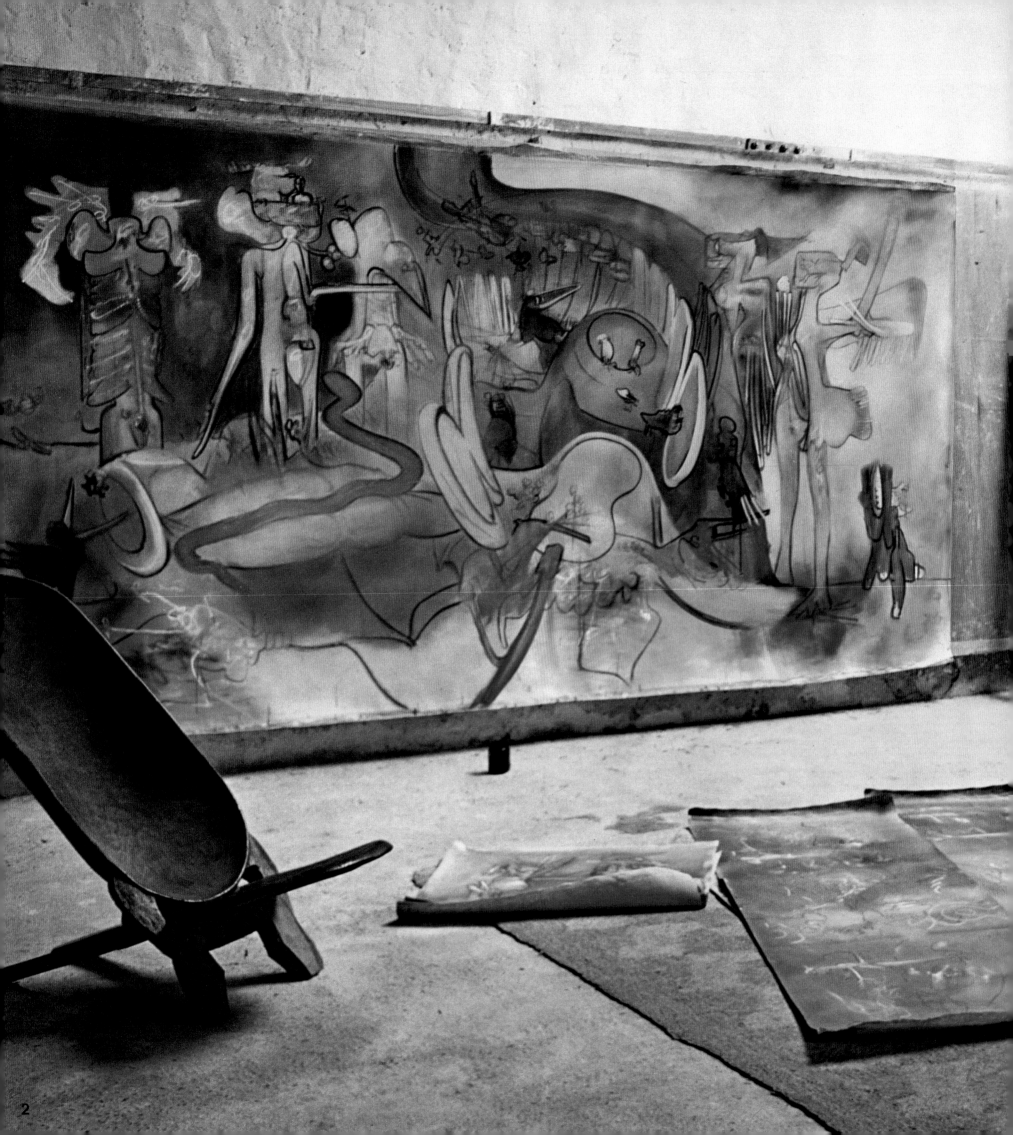

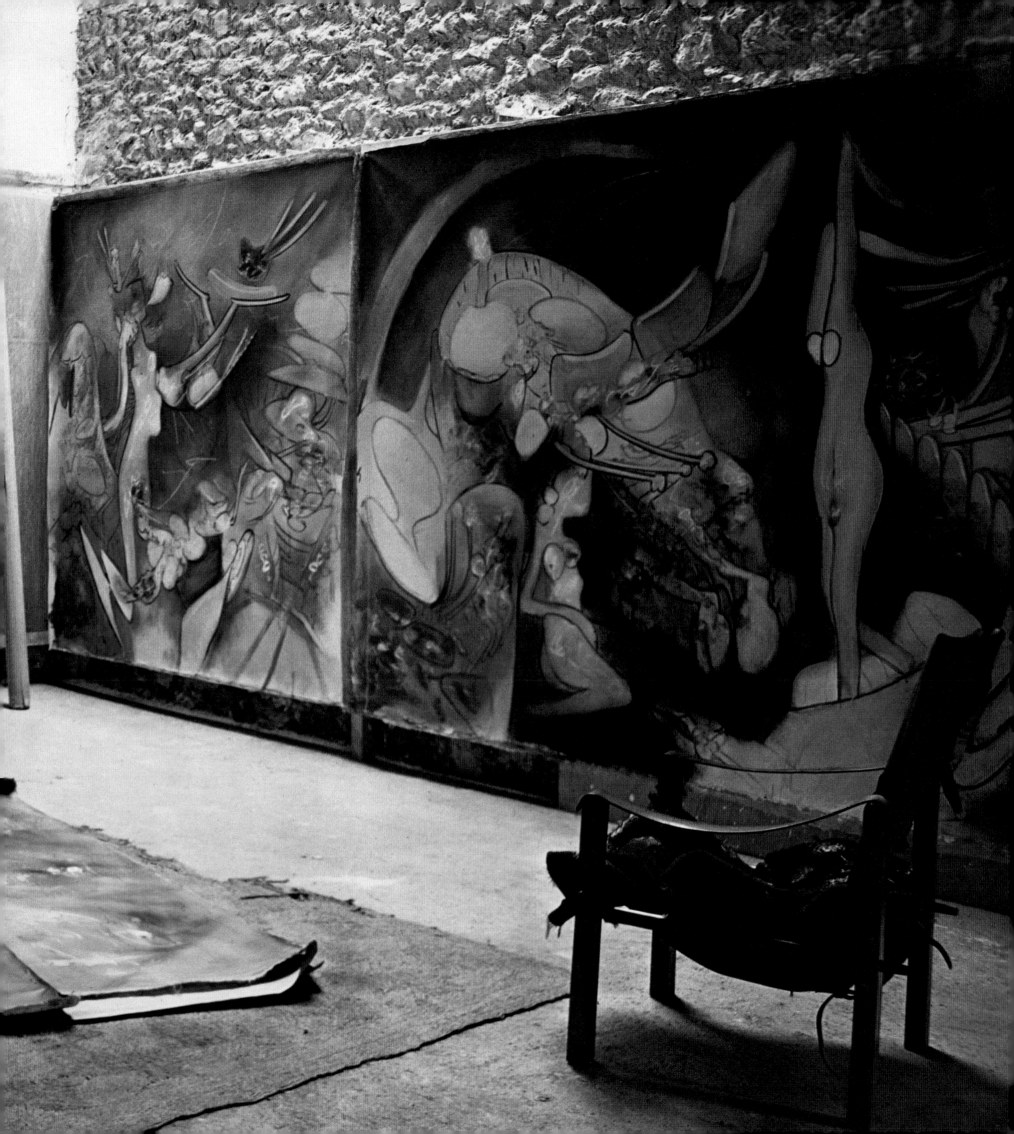

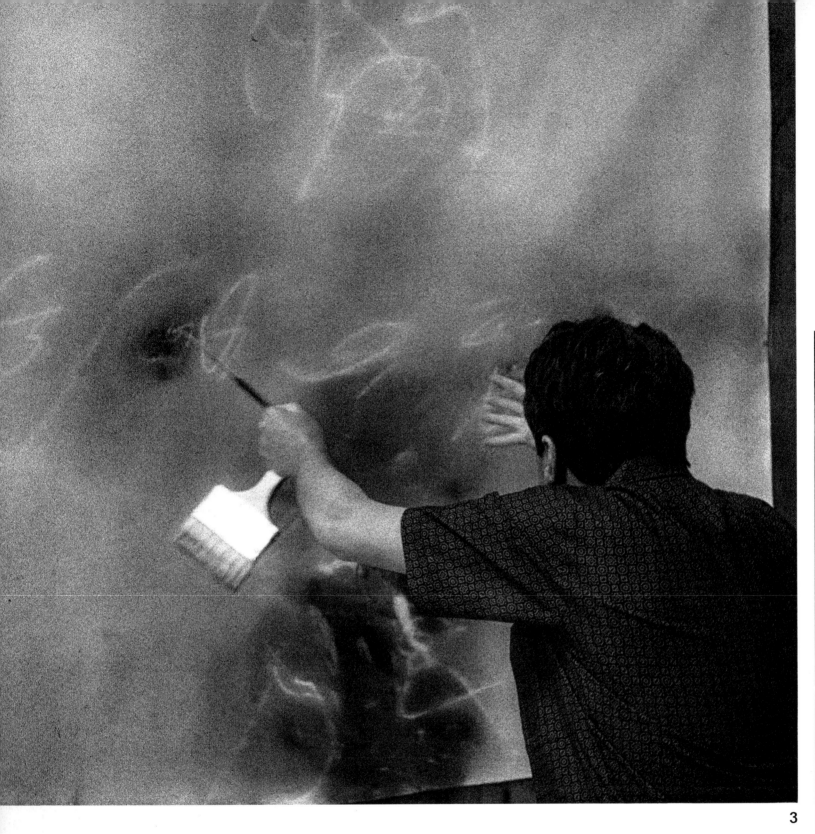

3

4

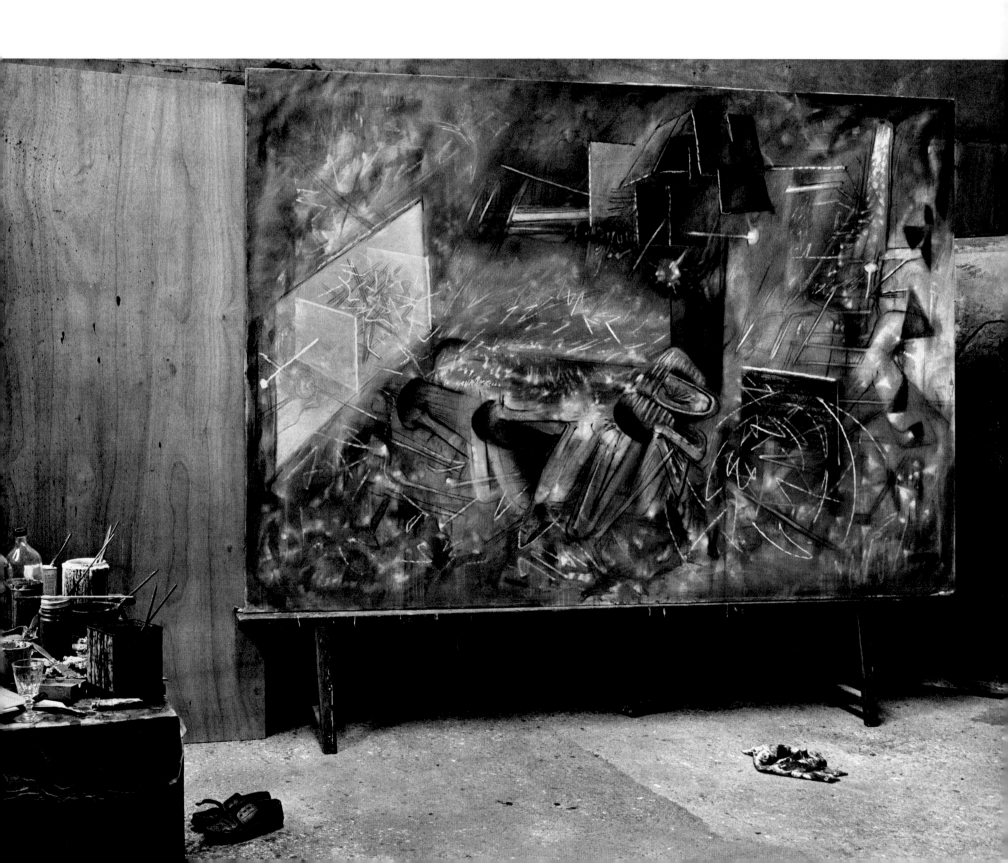

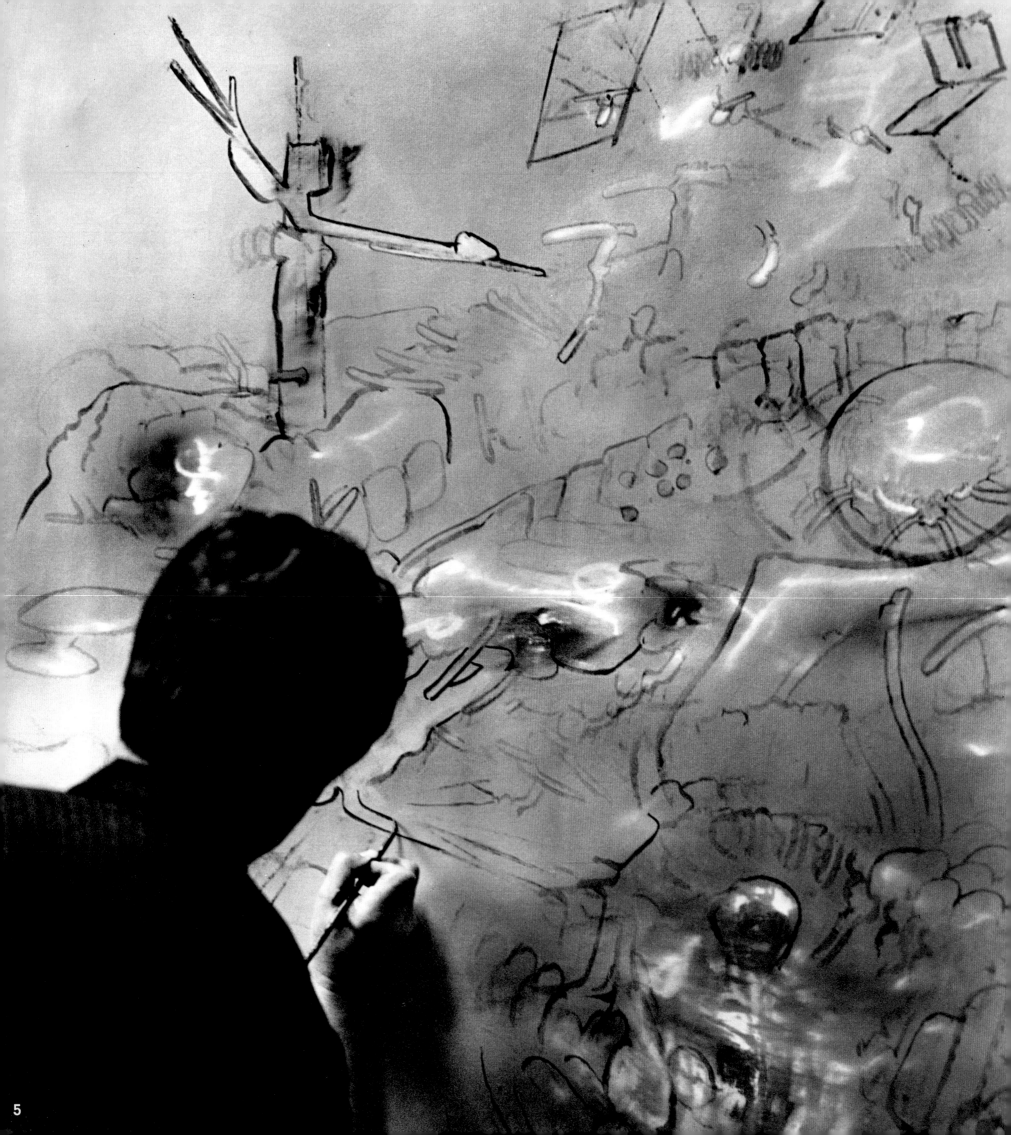

roberto sebastian matta

1. "All the morphologies I use in place of the purely anatomical morphology create other anatomies, but not those employing the biological functions. So, what happens? Imagination wakes up" : Matta.

2. In his studio at Boissy-sans-Avoir. Pictures executed in 1966 under the collective title *La Honni Aveuglant*. They were shown at the Galerie Alexandre Iolas, Paris.

3. Matta paints.... "Recognition of the nonexistent, recognition of the coming event obtained through the imagination."

4. *La Question Djamila*, 1957.

5. "Man is not necessarily the anthropomorphic image seen in a mirror, he may very well be the sum total of his energies, of his hopes and desires.... Desire and energy are also the creature, man" : Matta.

1911 Born November 11 in Santiago, Chile. After early studies at Santiago's College of the Sacred Heart, matriculated at the Catholic University there.

1931 Received architect's diploma.

1933 Left for Europe and worked for Le Corbusier in Paris.

1936 Met Garcia Lorca.

1937 Met André Breton, introduced by Dali. Joined Surrealists and showed his first drawings at the 1937 Surrealist exhibition.

1938 Painted his first canvas, in Trevignon, Brittany.

1939 Made his first trip to the United States where he remained until 1948, working for a time under the influence of Marcel Duchamp.

1950 Returned to Europe and lived in Rome (1950-1954).

1952 Painted large canvas for EUR.

1955 Now lived in Paris (making numerous trips from then on to Latin America, especially to Cuba).

1956 Executed mural painting, Les Doutes des Trois Mondes, for UNESCO Palace, Paris.

1961 Executed mural for University of Santiago, Chile.

1962 Received Prix Marzotto for his canvas La Question Djamila. Remained faithful to tenets of Surrealism. As well as one-man shows throughout world, retrospective exhibitions have been held in New York, Stockholm, Bologna, Vienna, Düsseldorf, Brussels, Amsterdam, and Mannheim. He has illustrated work of poets, including Lautréamont, Benjamin Peret, Joyce Mansour, Michel Butor, Henri Michaux, André Breton, and A. Jouffroy.

A man's life isn't measured by dates, like history, but from battle to battle, battles to be approached not in relation to the names of generals, but in relation to the struggles that took place. I believe that a man spends his private life in passing from one situation to the next in search of emancipation.

I was born in a place where men used the language of exploitation. I was educated to collaborate with the various forms of colonialism to which Chile was condemned and in the process of learning it I vaguely began to understand that I was fated to practice oppression. It was to escape that despotic destiny that I went into exile.

I found myself in Paris leading the life of an immigrant. Gradually, a new consciousness developed in me wherein the need to work, to be a workingman, took root, replacing the humiliations I'd suffered and my own revolutionary instincts, propelling me to seek fulfillment in creation. After a period of withdrawal, working with Le Corbusier, I began to discover Surrealism. To my mind, the surrealists have always been artists of revolution, though I was never to be found in the camp of fractious, worldly and hysterical subdivisions who also called themselves surrealists.

Then there was the Spanish Civil War, the coming to grips with my conscience on discovering what the Dachaus and Buchenwalds had been—and I may say that that was the most traumatic experience I ever lived through; also the great monstrosities perpetrated in our epoch, the great holes opened up through which one can see all the lack of perceptivity, the irresponsibility, the distrust, the resentments there are on earth, all the things one has to blow up to be " with " and effect a creative and revolutionary expression—those are things that made me.

Chinatown.
From New York's Chinatown,
a pagoda with ten thousand eyes,
strangled between Brooklyn Bridge and Manhattan Bridge,
I went uptown through the Bowery
—the Carnegie Hall of hoboes.
Here every shadow foretells a body—flat on its back.
Crucified, tumbling down the steps of brick buildings,
dressed in cast-off clothing threadbare with repeated use
by too many others,
men, women lie broken in the gutters,
struck down in their tracks,
fallen like Dali's soft watches
across parked cars.
The Bowery—the rotting barracks of thirst's hirelings,
army of twisted men wrapped around public benches
stretched out on pavements
guzzling, belching, singing, weeping,
crumbling in shameless, shackling sleep
vomiting its guts,
garbage can of Chinatown's restaurants.
Thus the Bowery is edged with the most human of flowers
blooming in New York,
clutching in their fetid hues
the surplus of all the hopes
of those who grew dizzy with Manhattan's sky
and never attained it.
At the end of this rotting garden,
I pushed through the door of a house in Spring Street.
The street of springtime. Was I in the rediscovered Palace of Antinea?
Or in the whale's belly... like Jonah?
This house is the focus of a world
halfway between light and shadow,
created out of gold, out of ashes
the gold of time... of space...
Entering Louise Nevelson's house
is like breaching a dike cradling the lunar tides :
on each floor, from top to bottom,

the harvest of her work, rises in layered bowels...
harvest of a modern age with stratified entrails...
virginity... silence... death...
to give tangible expression to this other self,
Nevelson became a scavenger
poaching on the city.
Around her house, which looks like others in the neighborhood,
she has gathered worn, discarded boards,
beams recovered from the wreckage of old buildings,
second-hand chairs, tables, legs,
the carved decorations of disemboweled wardrobes,
anything made of wood, and rejected by man.
Nevelson rearranges this debris into the art of her own invention.
Surrealist humor vies with nostalgic piety;
crates that once held spices, raisins, liquor,
and discarded packing boxes
become the baroque sanctuaries of her spiritual authority
according to the rules of some poetic scripture.
She makes these things the foundations of cinerary monuments;
in their careful assemblage they most often appear as high walls
stern, mute, monochromatic—columns that could be gods...
or edifices. The structures in black, white, gold, or purple
create a magical architecture that arouses a feeling of anxiety.
They form a closed, stifling world where Nevelson lives...
and dreams. At the foot of the stairs two shapes in combination
make a map from some golden Babylon
leading to the cathedrals
in the shadowy territory of the skies.
Then come the white chapels edged with ruins
placed together to make a new wall,
its gaps encased in the stiff protective fencing of an alien forest.
The cloister chambers are peopled by totems
like a throng of dignitaries in distress.
The work of Louise Nevelson
establishes the presence of elsewhere,
a world bewitched.
Whosoever finds sustainment in it
will never seek to hasten his departure from it.

Shadow & I have a
long long love affair.
Now I have encompass-
ed reflection,

Louise Nevelson

February 16 · 1968.

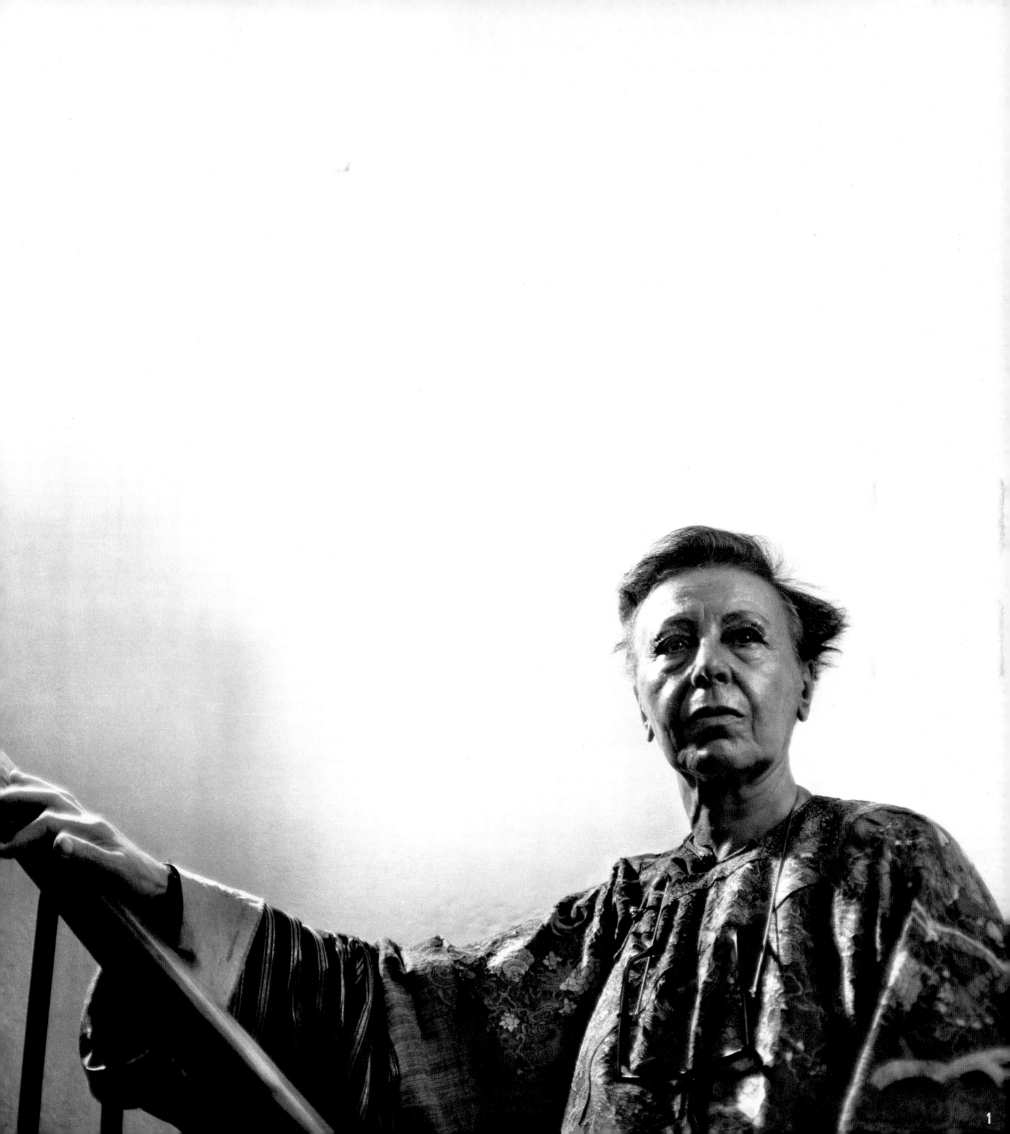

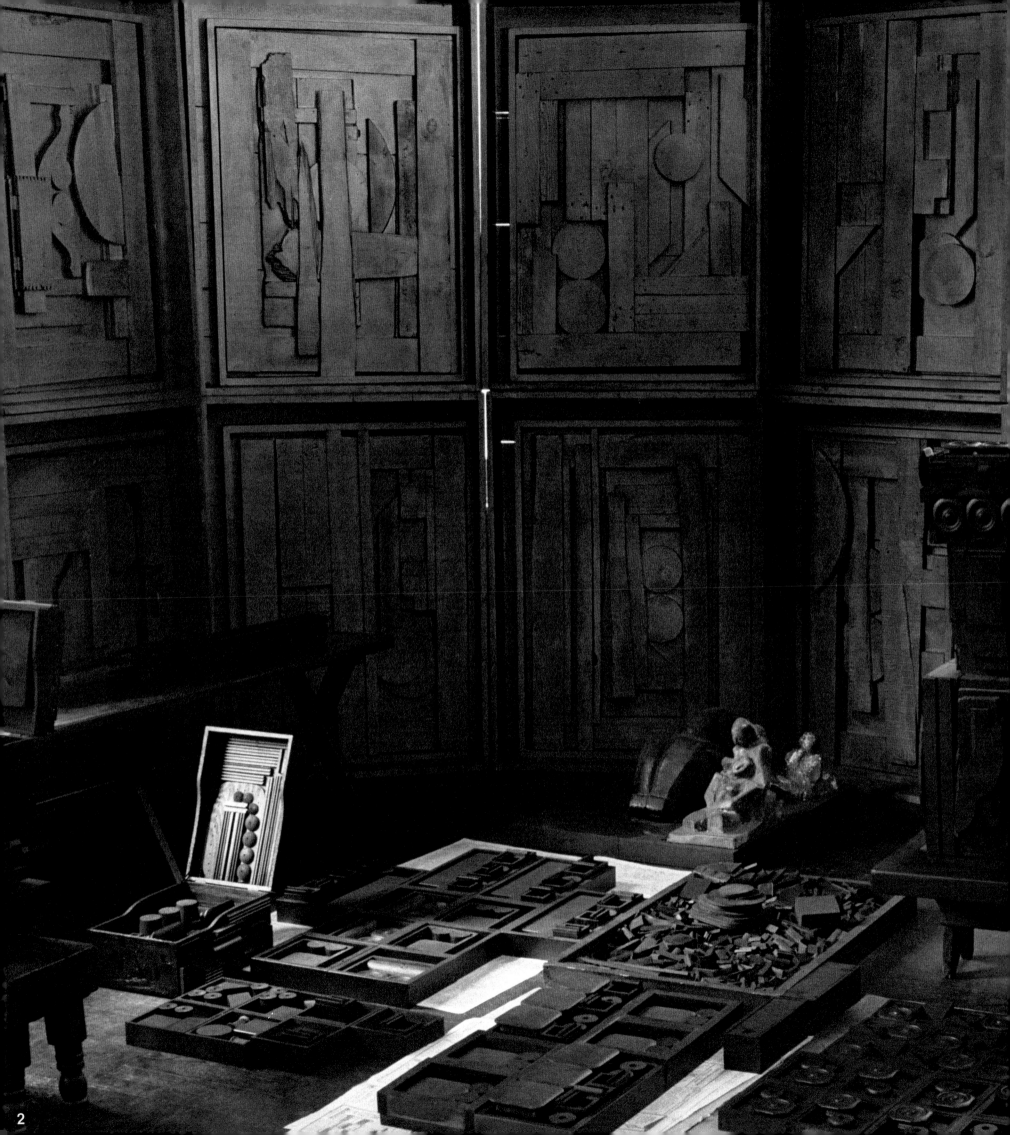

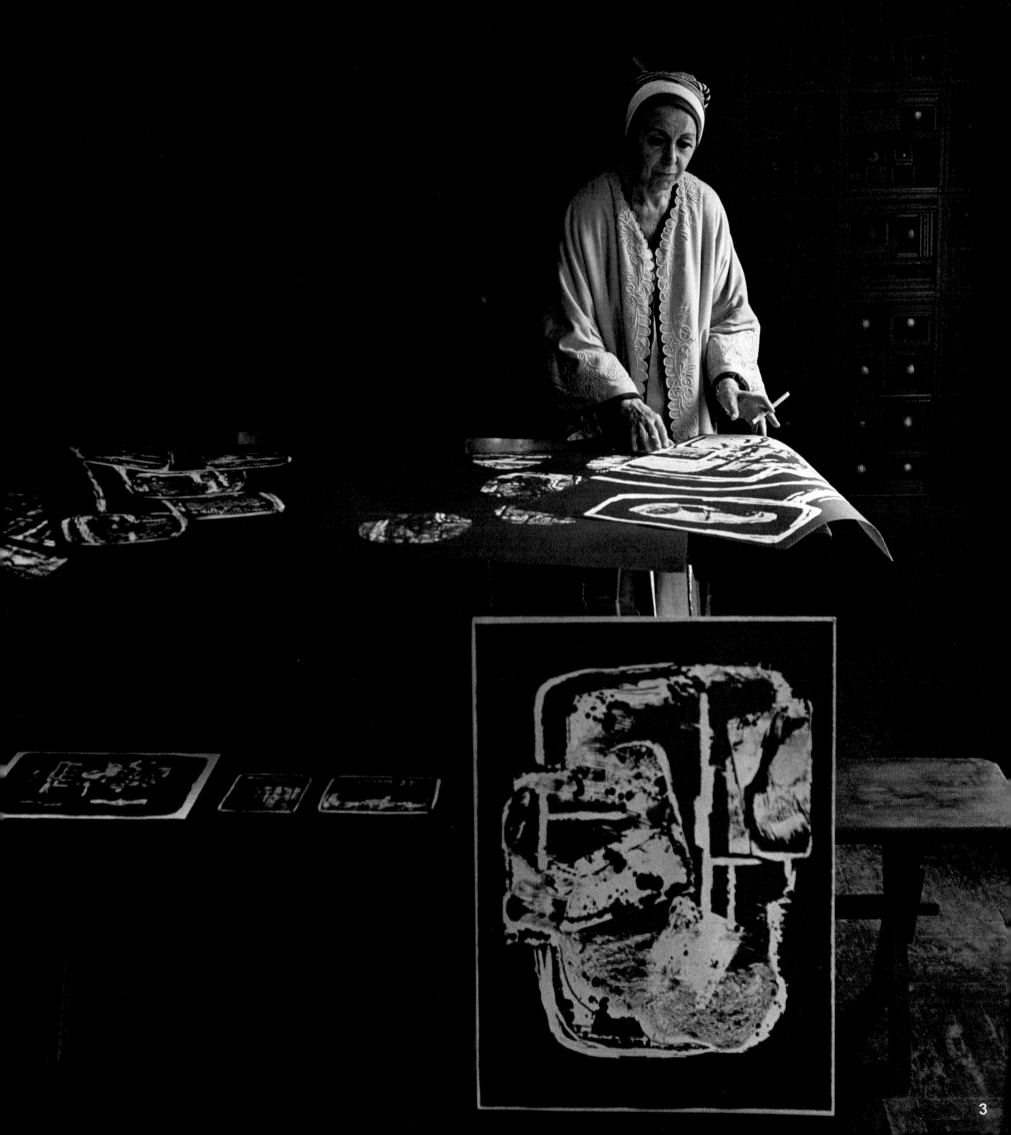

4

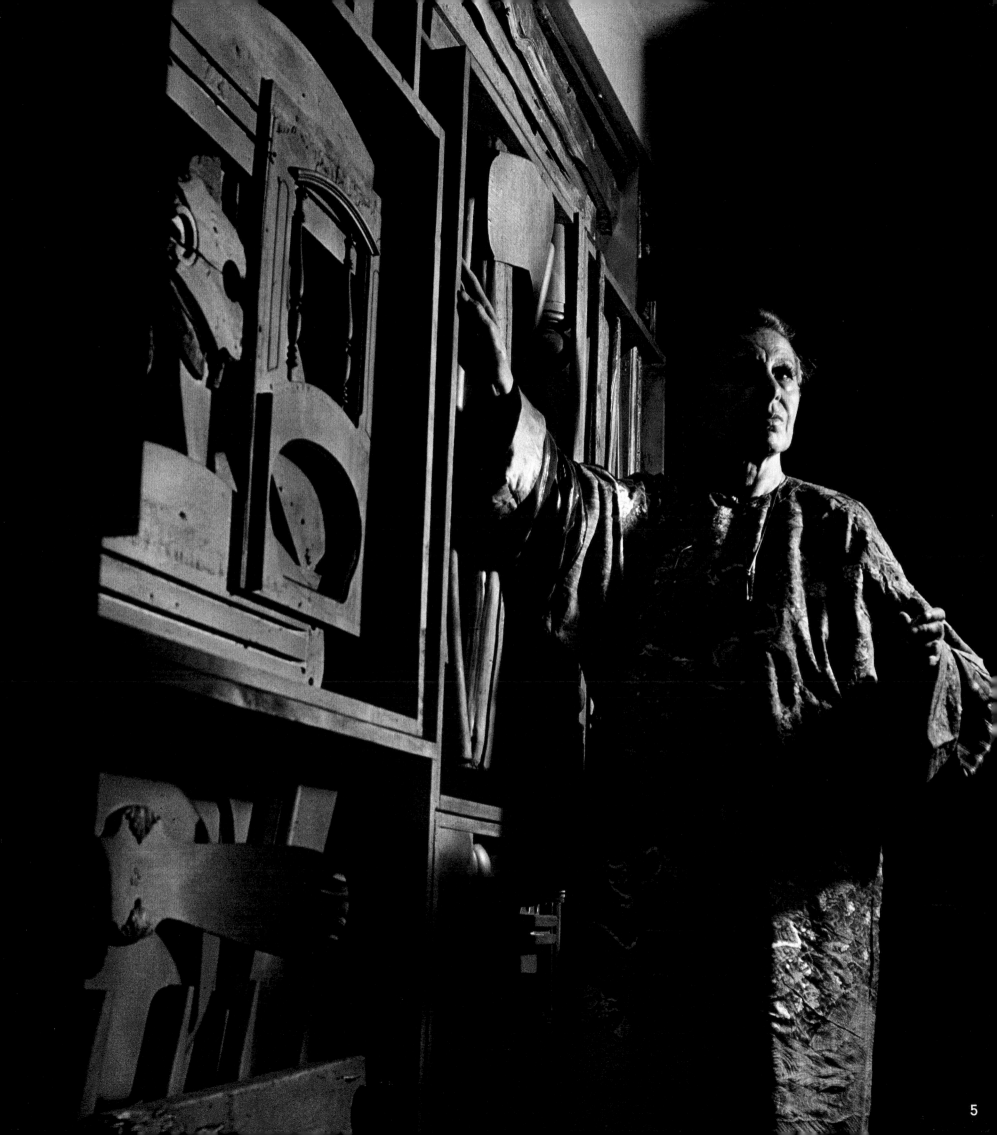

louise nevelson

1. Louise Nevelson.

2. A disencumbered corner of the studio.

3. Lithographs.

4. The basic materials for her sculptural or architectural creations.

5. A Queen in her funerary palace. . . .

6. The Hanging Garden—The walled refuge of Louise Nevelson's New York house.

1900	*Born at Kiev, Russia.*
1905	*The family emigrated to the United States and settled in Rockland, Maine.*
1918	*Won a diploma at Rockland High School.*
1920	*Married Charles Nevelson and moved to New York. Studied painting and drawing with Theresa Bernstein and William Meyerowitz. Studied singing and acting with a view to making these a career.*
1922	*Birth of son, Myron (Mike).*
1931	*Studied with Hans Hofmann in Munich.*
1932	*Assisted Diego Rivera during execution of mural at New Workers' School, New York. Studied dancing with Ellen Kearns.*
1933	*Work shown in several New York galleries.*
1935	*Exhibited with group of young sculptors in exposition organized by Secession Gallery at Brooklyn Museum.*
1941	*First one-man show, at Nierendorf Gallery.*
1948	*Visited England, France, Italy.*
1949-1950	*Worked at Sculpture Center, New York (baked clay, aluminum, and bronze). Attended classes at Studio 17 with Stanley Hayter. Two trips to Mexico. Influenced by Mexican art and archeology.*
1953-1955	*Studied at Studio 17 with Peter Grippi and Leo Katz.*
1956	*Whitney Museum purchased* Black Majesty.
1957	*Brooklyn Museum purchased* First Personage.
1958	*Museum of Modern Art purchased* Sky Cathedral.
1962	*Exhibited in American Pavilion at Venice Biennial. Whitney Museum purchased* Young Shadows.
1963	*Became president of Artists' Equity.*
1965	Homage to Six Millions II *given to Israel Museum, Jerusalem.* An American Tribute to the British People *given the Tate Gallery, London.*
1966	*Became Vice President of International Association of Artists. Made Doctor* honoris causa *in Fine Arts by Western College for Women, Oxford, Ohio.*

Louise Nevelson's work has been exhibited at the Whitney Museum of American Art and the Nierendorf, Lotte Jacobi, Marcia Clapp, Grand Central Moderns, Esther Stuttean, Martha Jackson, Tanager, and Sidney Janis galleries in New York; Daniel Cordier gallery in Paris and in Frankfurt; Staatliche Kunsthalle, Baden-Baden; Hanover Gallery, London; Place Gallery, New York and Boston; Gimpel and Hanover Gallery, Zurich; Kunsthalle, Berne; Galeria d'Arte Contemporanea, Turin; David Mervish Gallery, Toronto; Schmela Gallery, Düsseldorf; Ferus-Pace Gallery, Los Angeles; Galerie Daniel Gervis, Paris.

bacon

When I photographed Francis Bacon I was aware that the man I was facing on the other side of the camera had a reputation for being indifferent to recognition or wealth and yet had achieved the pinnacle of fame in his own country and abroad, a man who would keep destroying his pictures because they did not satisfy him—and yet went on painting. The temptation was there to try to catch Bacon unawares, as he in his painting catches his fellow beings unawares, in the middle of—it is often said—some revealing act, or shouting, laughing, or grimacing. A painting by Bacon is, in a sense, a reflection of some human affliction or tragedy that holds the viewer spellbound, sometimes revolted, by what is said and how it has been said.

Bacon is almost as much of an enigma to us as it appears he is most of the time to himself. He has, perhaps, destroyed more of his own canvases than any other artist has, and in those he has chosen to leave to posterity are the transitory images, the distortions of form, the images of motion, violence, or shock that stare out of the canvas like the blurred reflection of a candid photograph held up in front of a distressed mirror. Bacon says that he does not always intend that his paintings have a precise meaning, but to make a certain type of feeling visual. What he tries to give us is "the grin without the cat, the sensation without the boredom of conveyance."

. .

Every time, when, during the course of my work, something begins to take form, it occurs just at the moment when I cease being aware of what I am doing. I have often noticed, for instance, that if I try to force the image I have in mind to the point where it becomes illustrative and extremely banal, and then, if through nervous irritation or despair I completely destroy it by riddling the canvas with unconsciously applied brush strokes, suddenly without my knowing just how it happens an image emerges which is closer to the instinctive vision of the subject I had in the first place. It is as if I had to lay a trap to surprise, to snare the object in its sharpest, most living aspect. . . .

. .

What I want to do, in distorting the object, is to carry it beyond actual appearance, and then, at the end of the deformation, bring it back to a reduced or lifelike statement.

. .

I believe that art is an obsession of existence and, when all is said and done, since we are human beings, our most lasting obsession centers on ourselves.

. .

FRANCIS BACON.

280

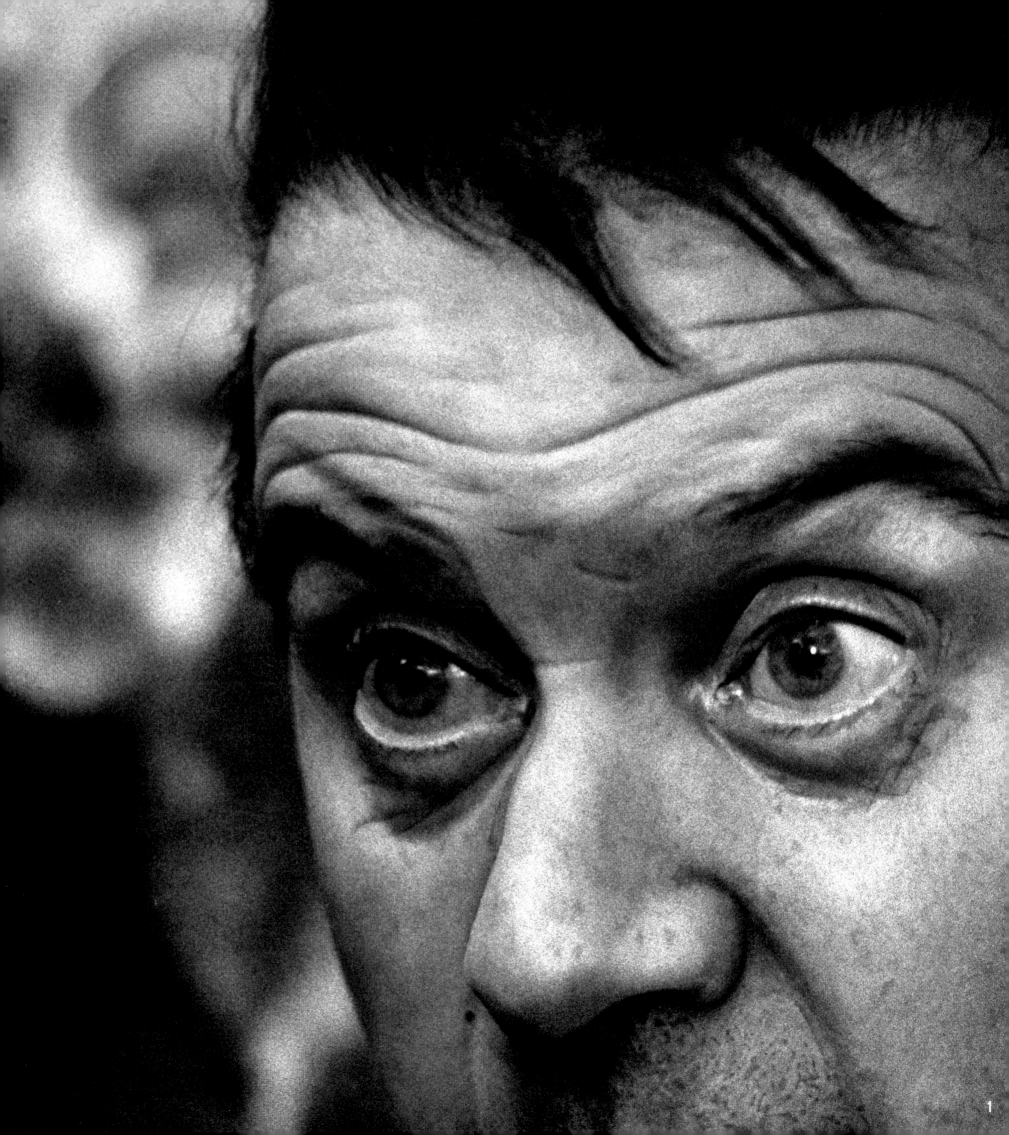

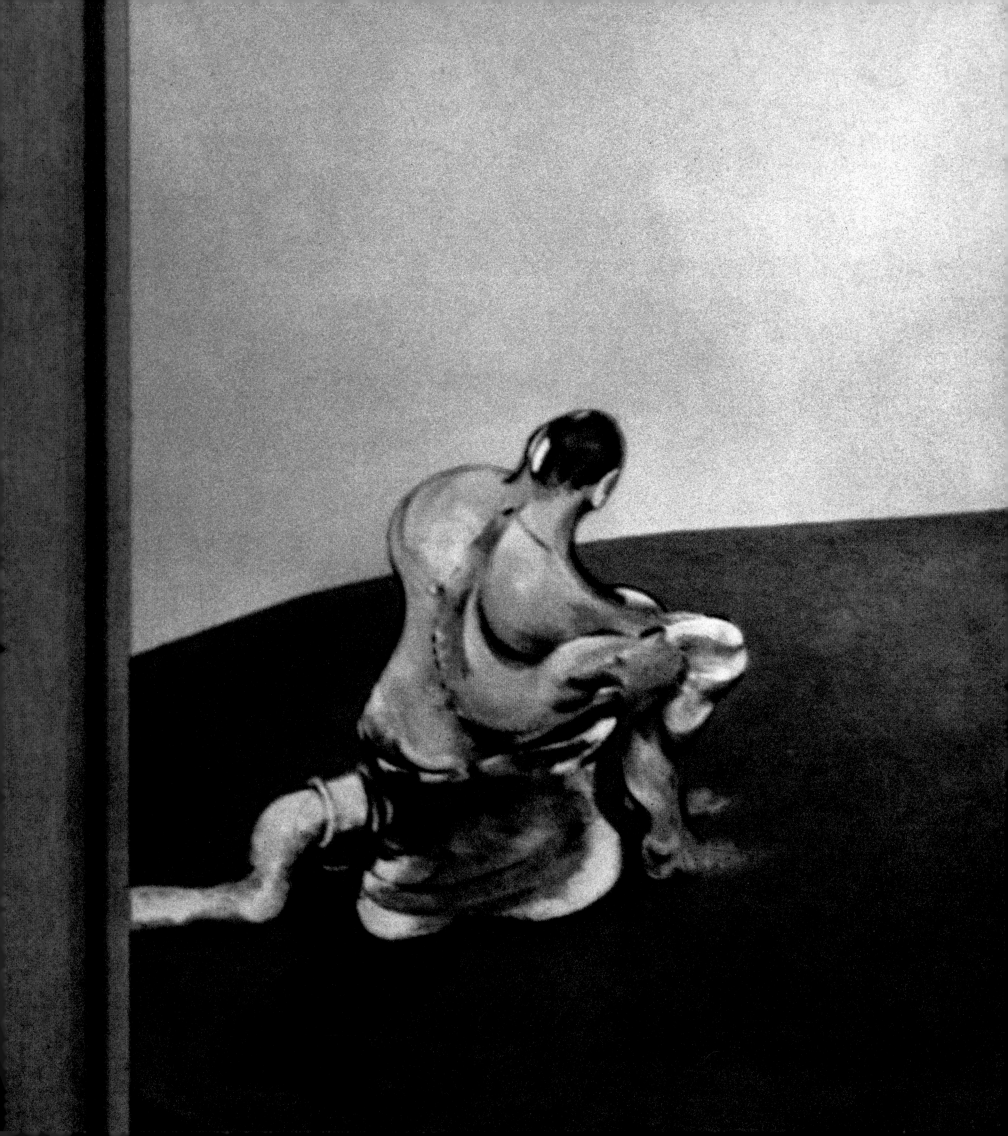

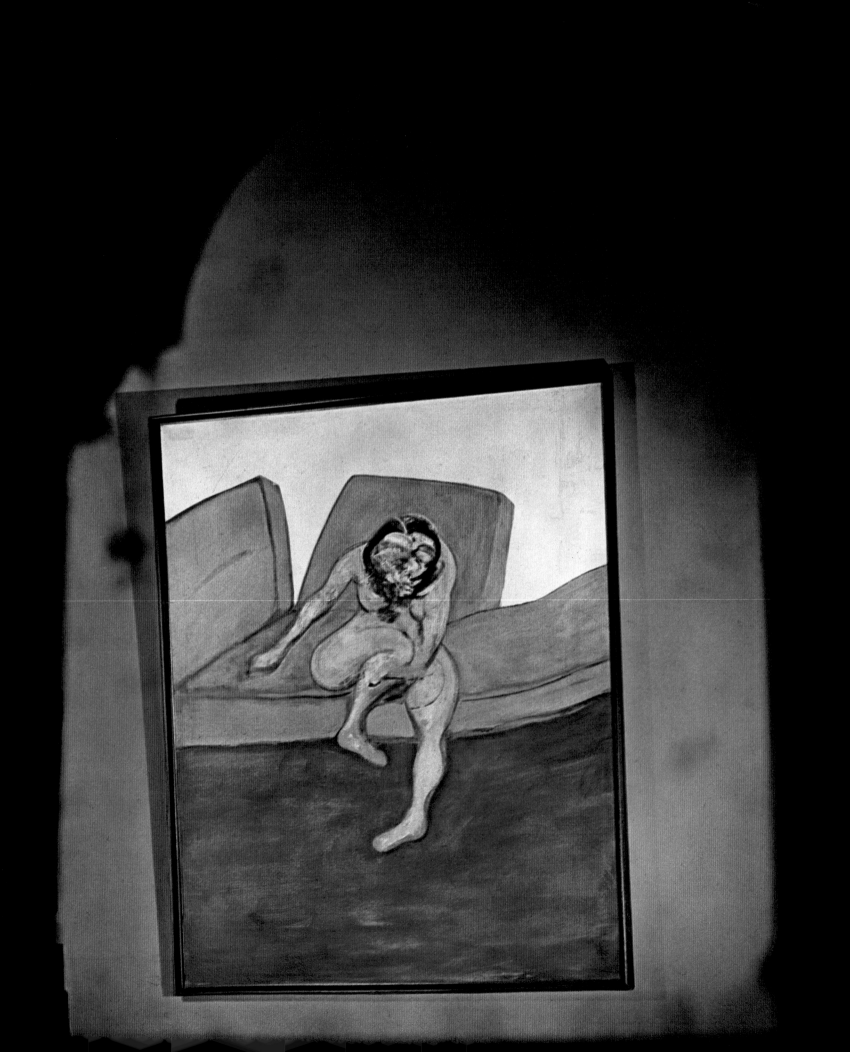

francis bacon

1. Francis Bacon talking to David Sylvester.

2. The shadow of Bacon's profile as he studies his *Character in a Play*, 1964.

3. Photographed in a mirror: *Seated Nude*, 1961. Jacques Damase Collection.

1909 Born in Dublin.
Received little regular schooling and worked on father's farm.

1927-1930 Left family; spent two years in Berlin and Paris. Began to paint but received no formal training. Worked slowly under the guidance of Roy le Maistre, but was never satisfied with his paintings and kept destroying them (a bare dozen of Bacon's pre-1944 paintings remain).

1932-1933 Made the acquaintance of Max Ernst and Picasso. Abandoned geometric, abstract style.

1939-1944 Acted as civil-defense volunteer in London, and stopped painting. Horrors of war affected him deeply.

1944 Resumed painting, and the three studies made for Figures at the Foot of a Crucifixion (he called them the Eumenides, or Greek Furies), became, for him, the real starting point of his art.

1945 Started using photography as aid, inserting fragments of "objective reality" as in his Figure in a Landscape.

1946 Painted The Magdalen and explained aggressiveness of this painting as "the projection of my own nervous system onto the canvas."
Participated in UNESCO International Exposition of Contemporary Painting, Paris.

1949 One-man show at Hanover Gallery.

1951 Made increasing use of photographs with emotional impact. Discovered work of Victorian photographer Muybridge, whose fragmentation of motion interested him.
Exhibited in "Ten Decades: a Review of British Taste, 1851-1951" at Institute of Contemporary Art, London; and in exhibition of British Council at Vancouver: "Twenty-one Modern British Painters."

1953 Began series of canvases portraying a pope, influenced by Velasquez Innocent III. Other recognizable influences in Bacon's work are Grünewald, Rembrandt, Goya, Daumier, each of whom has expressed, individually, effects of drama and violence. Exhibition, "Wonder and Horror of the Human Head" at Institute of Contemporary Art, London.

1954 One-man show in a British Pavilion gallery at Venice Biennial.

1955 "A Francis Bacon Exhibition" at Institute of Contemporary Art, London. Participated in "The New Decade" exhibition at Museum of Modern Art, New York.

1956 Interest in Van Gogh led to a series of five interpretive studies.
Participated in exhibition "British Art 1900-1955," at Kunstforeningen, Copenhagen.

1958 One-man show at Galatea Gallery, Turin.

1959 Took part in the São Paulo Biennial.

1960 "Francis Bacon Paintings 1959-1960" exhibition at Marlborough Fine Art, London.

1962 Returned to Crucifixion theme in "Three Studies," a show organized at Tate Gallery, London.
One-man shows at Galleria Civico d'Arte Moderna, Turin, and at Kunsthalle, Mannheim.

1963 Retrospective exhibition of important canvases including The Eumenides, Figure in a Landscape, The Magdalen, at Guggenheim Museum, New York.

appel

I left Paris by car and, after swallowing up the long stretch of highway leading south through the suburbs of Auxerre, I swerved the car to the right on the Nevers road and followed the road markers pointing to Molesmes.

Naked guts of scores of trees lay on either side of the road, as if some Cyclopean tornado had swept by, uprooting them. I brought the car to a standstill before the gate to "Bluebeard's" Castle, where, as if straight out of that strange fairy tale, Karel Appel appeared before me like a lord, hand outstretched.

Genial squire of this small village of the Yonne, Appel guided my steps across a vast courtyard peopled with tortured shapes of his creation. In passing, he introduced them: *Hibou*, *Femme*, *Nain Rouge*, *Oiseau Blessé*, and *Homme de la Terre*, all ax-hewn out of olive wood, a labor of Hercules executed on the Riviera in 1962.

Inside the house, stark, staring colors blazed from the walls. A trail of Appel's works led us up, and up again to his studio, perched high under the eaves. I looked around and gasped—was this his studio, a magic circle where the painter could express himself, or a hell where easels served as scaffolds?

In the center of the studio, around a great paint-smeared palette, lay strangled, twisted, dribbling tubes; on the floor random smears of vivid color suggested a barbaric rape of virgins.

Everywhere, propped against walls or hanging from them, were Appel's pictures, vibrant, shocking, mysterious.

Red celestial vaults
and
splashes of stars;
a blue torso,
mouth slit like a sex
blushing with agonized desire.
An idol, yellow,
flayed, expiating eccentric passions.
Masks of howling men
goat-men bristling with great erections.
Explosions of thick paint,
architecture
scattered on canvas with palette knife.
Virgins
and
victórious Kings
dancing to the rhythm of a trembling earth.

Awesome forms, these and others, inspired by a fierce love of life, a gigantic carnal passion for mankind, take shape and life from the hands of Appel, the merry-bellied artist with colossal Rabelaisian Flemish humor.

*I make myself free, I stand aside, I squeeze myself dry.
Then I am ready to begin painting. It's the start of a new world.*

*I begin with signs. I stand empty before an empty canvas, full
of idealism and ideas, as one might contemplate a battlefield.
I make no prior plans, no arrangements. I chance on some color,
a touch of red, perhaps ; red is a delicious color (who said that?
It doesn't matter, it's merely a technical detail). I was waiting
for red, the canvas was waiting for red, and I feel myself redden-
ing as I cover the canvas with color. The second try may be blue ;
this color now enters into me. Whether working with red or blue
or with black, white, yellow I feel myself fill up wholly, bodily,
with the color. When the canvas is full, so am I. Having given
of myself totally, I move away from what I have done. Therein
lies the difference between man and beast. The beast will copy
the monkey that was allowed to paint, dip a brush in the pigments
and daub the canvas. This cannot be painting because the core
of the beasts's experience, his intellect, or his lack of it, is
precisely what differentiates him from man.*

*Man passes beyond the monkey stage while still a child. His
intellect develops. The monkey remains the same ; he continues
to break his brush, eat the canvas, chew the tubes of paint. He
climbs back into his tree. I stop at a certain point. But I too can
destroy. My work may very well develop out of destruction. My
temperament is aggressive. I destroy the first stages of my work.
Sometimes I act like an action-painter, but I grow with the
canvas ; the monkey, on the other hand, can only remain an
action-painter.*

*I find liberty in the act of combat which is painting. Artists,
many of them, are knocked about by a primitive force and cannot
shake it off. A muddled roaring torrent sweeps them along
through blood, sweat, and tears pouring through the great inner
arteries of joy, sensuality and death.*

*The whole earth is a sowing of seeds that springs up in the field
of my spirit. Everything that from time immemorial has struggled
in the dark womb of matter to ripen and bear its fruits explodes
and blossoms in my head like swift, silent lightning. In capturing
the instant when matter becomes spirit, the moments of ecstasy
that occur in creation are like received gifts, similar to those
enjoyed by a medium, a seer. I feel like a medium exploring
the world with radar, not reason.*

*As early as 1950 I turned away from conscious configurations.
I start painting without a single idea, a single thought. I never
know in advance what I will do. It might all miscarry. I paint
to see what I can revolutionize through color. As a result, each
canvas becomes a thing in itself, a unique entity, different each
time, autonomous. My first series of nudes, for instance, came
out of inspiration and memories ; I let them sink into me for
a few moments until I was no longer part of the atmosphere
around me.*
*Aloof, and without the slightest trace of tension, I have to allow
all sensation to sink into me, deeper and deeper. Work begun
with emotion shatters into bits and pieces.*

*But I can stop. Then I start again. My eyes fill up deliciously,
for all matter suggests an image, a statement. Suddenly, in the
chaos, I distinguish the image I could not at first see. So I go
on until I perceive heads, beasts, winds, or whatever other image
emerges. I continue, and I develop the vision ; I am submerged,
subordinated to it. Sometimes it vanishes only to reappear
vaguely, dimly. Then I say to myself "Ah, that was it !" and
make the vision burst forth again, full-blown. And there it is,
before me. A trying moment, really, as when the bull in the arena
faces the matador head-on. Action fully embodied. Then I
examine the various possibilities open to me, a show of intellect,
for example. There are painters and stylists, and there are others
who merely express themselves in paint. None of this has anything
to do with painting, except to give it birth. And this is so
important.*

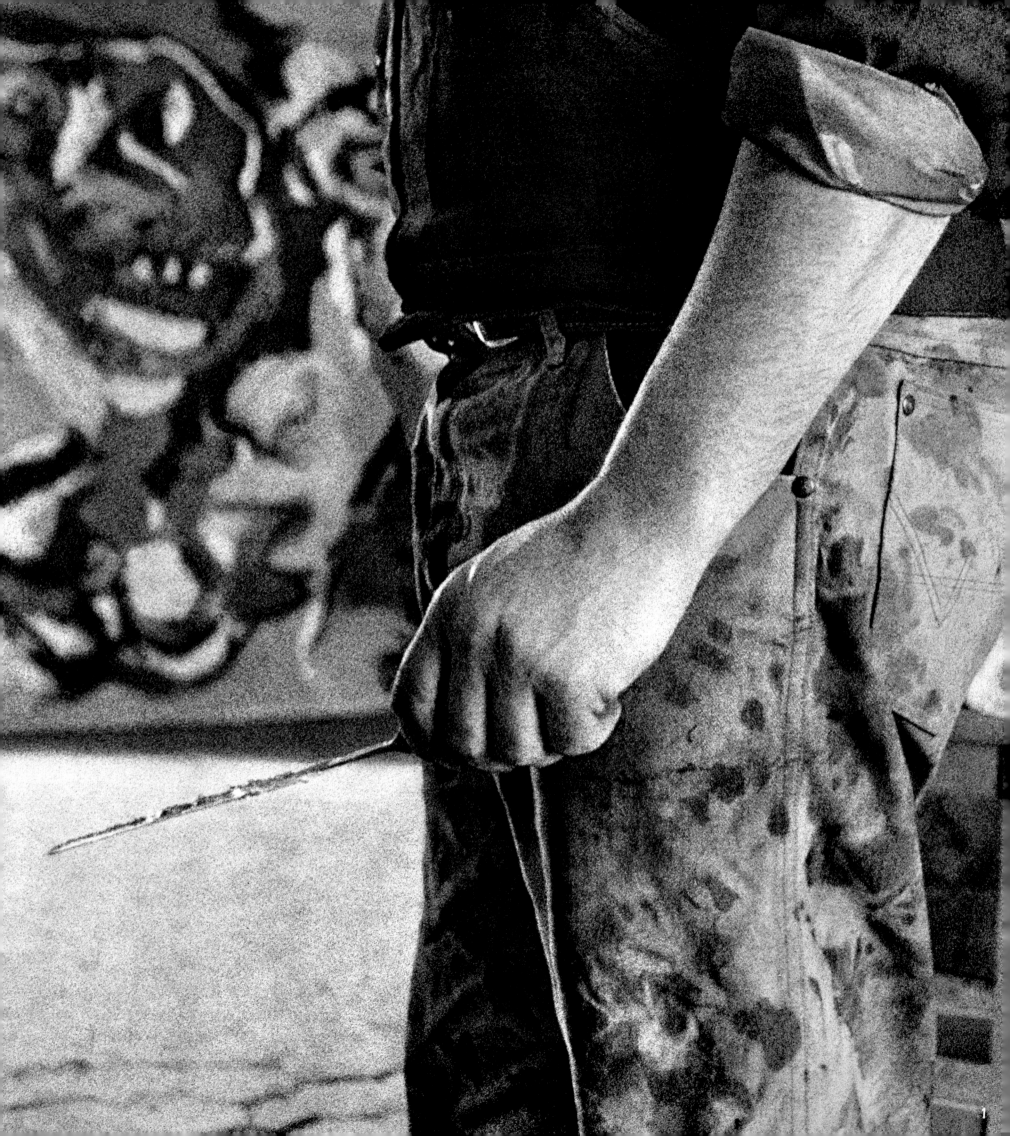

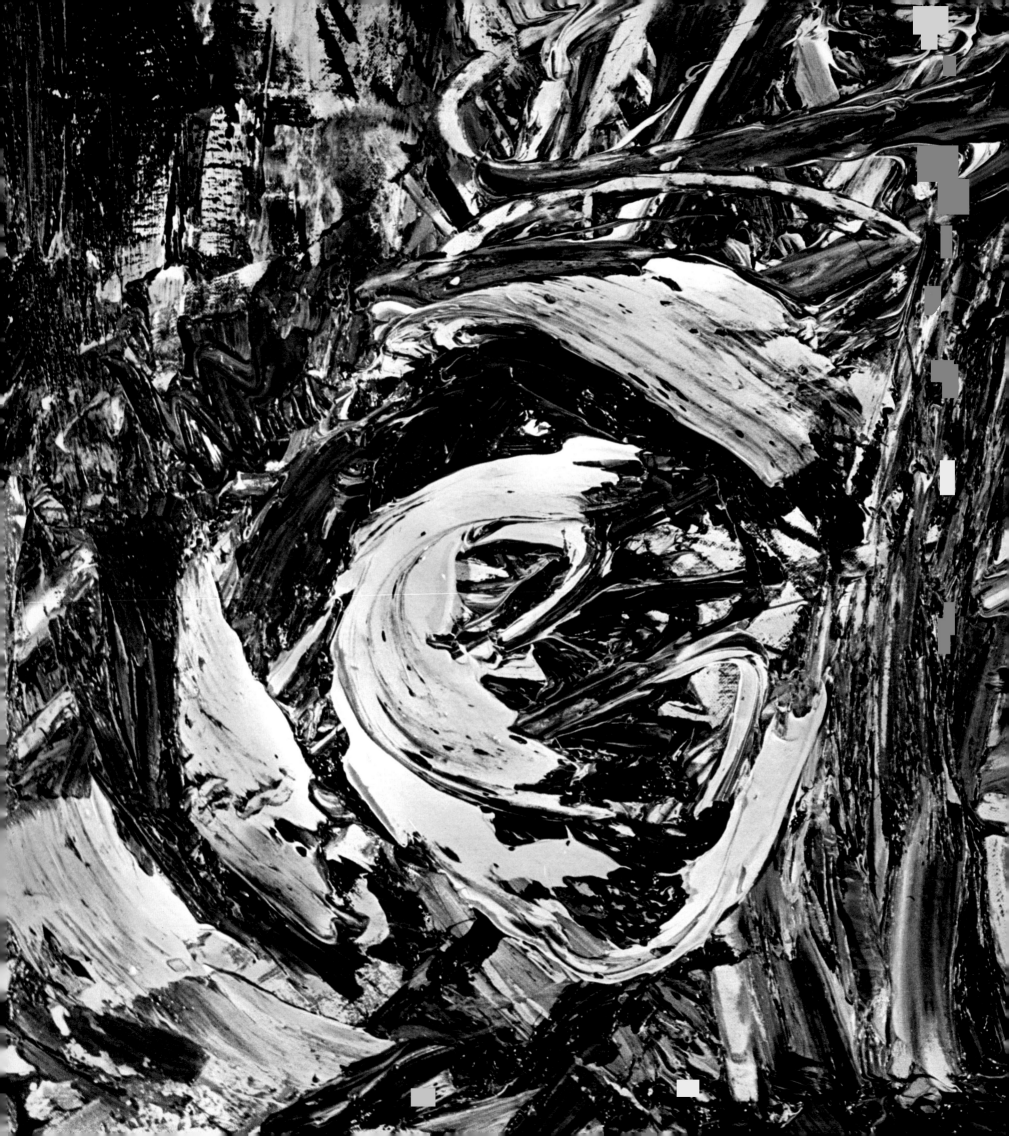

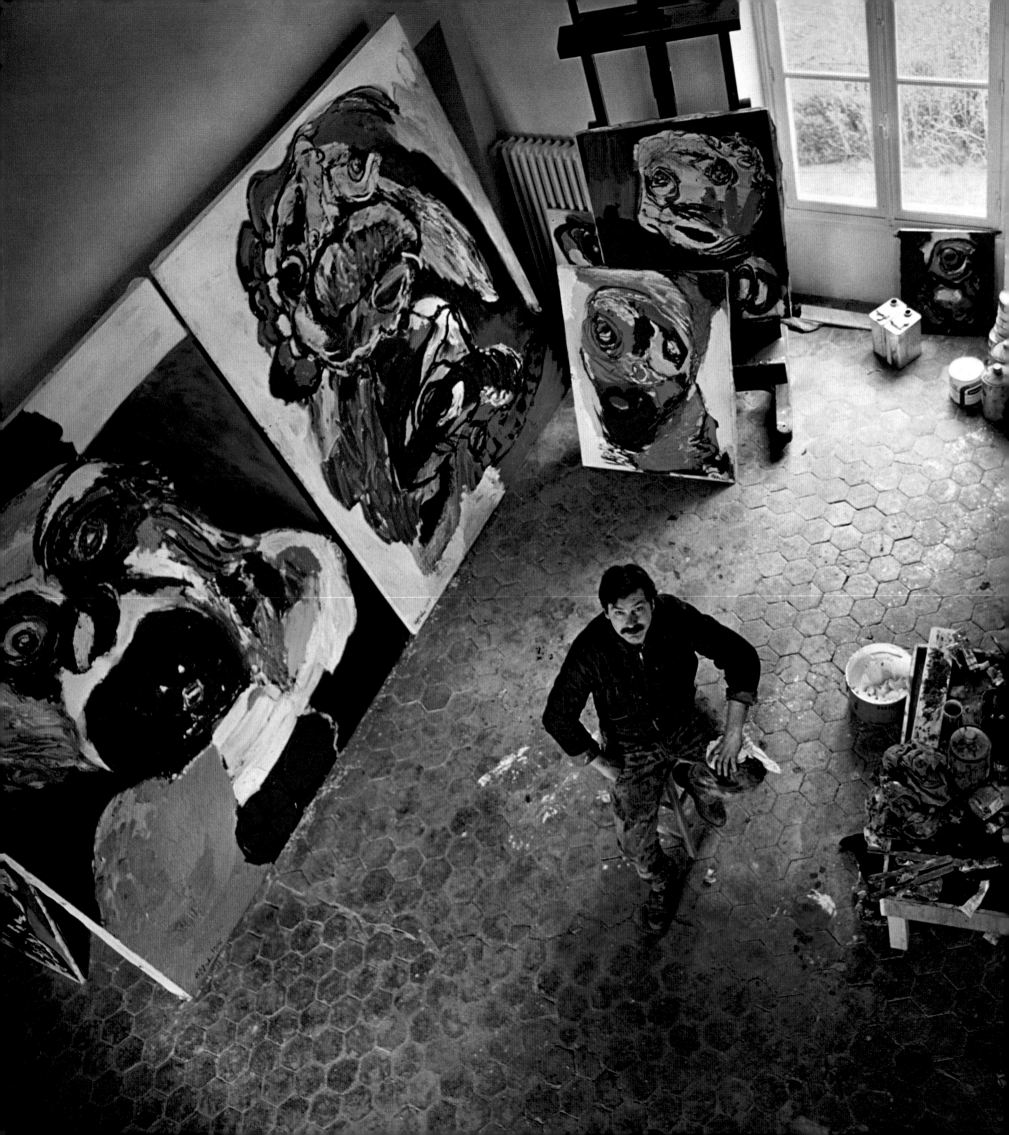

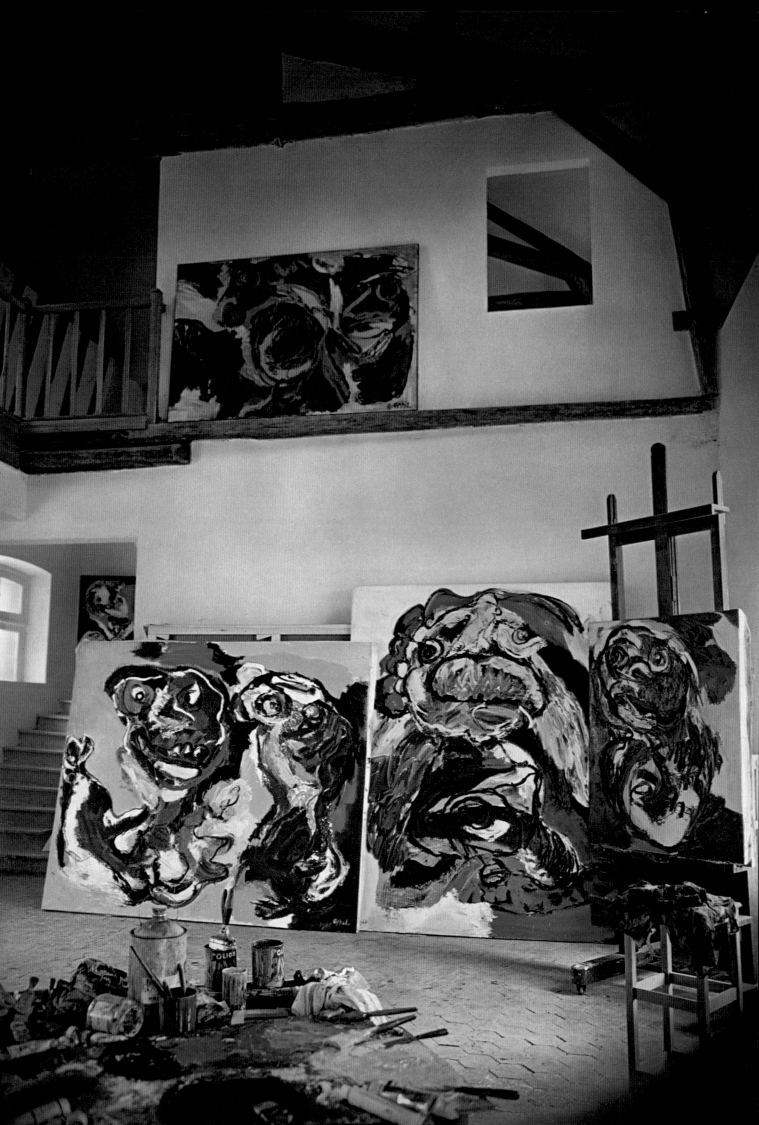

3

4

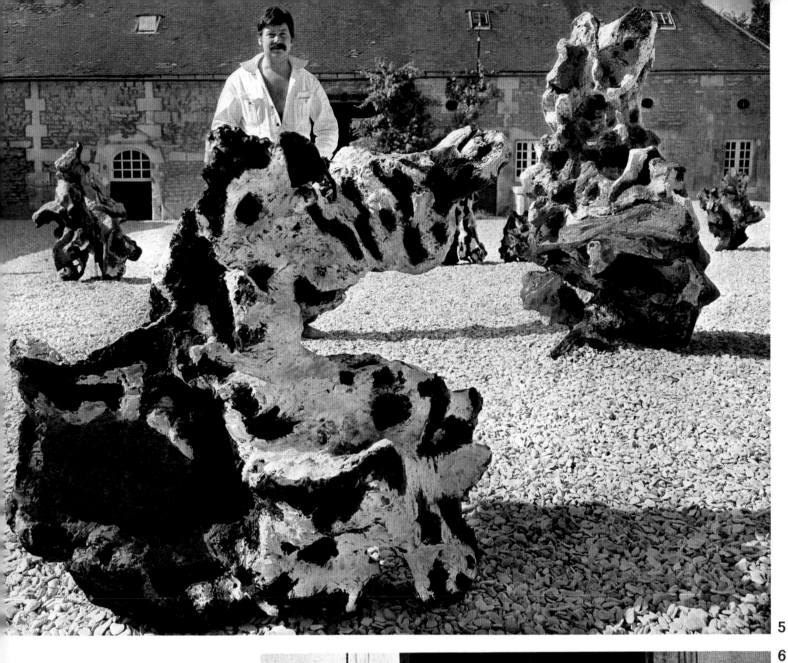

5

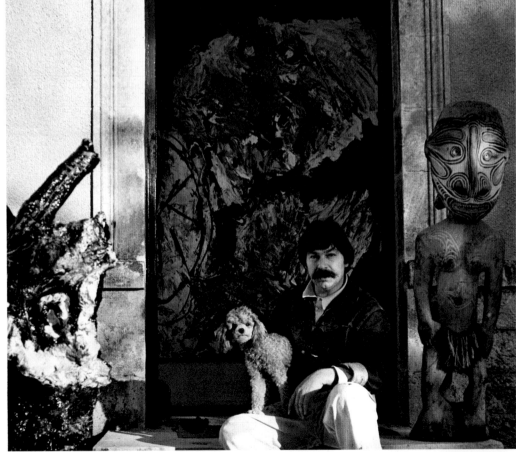

6

7

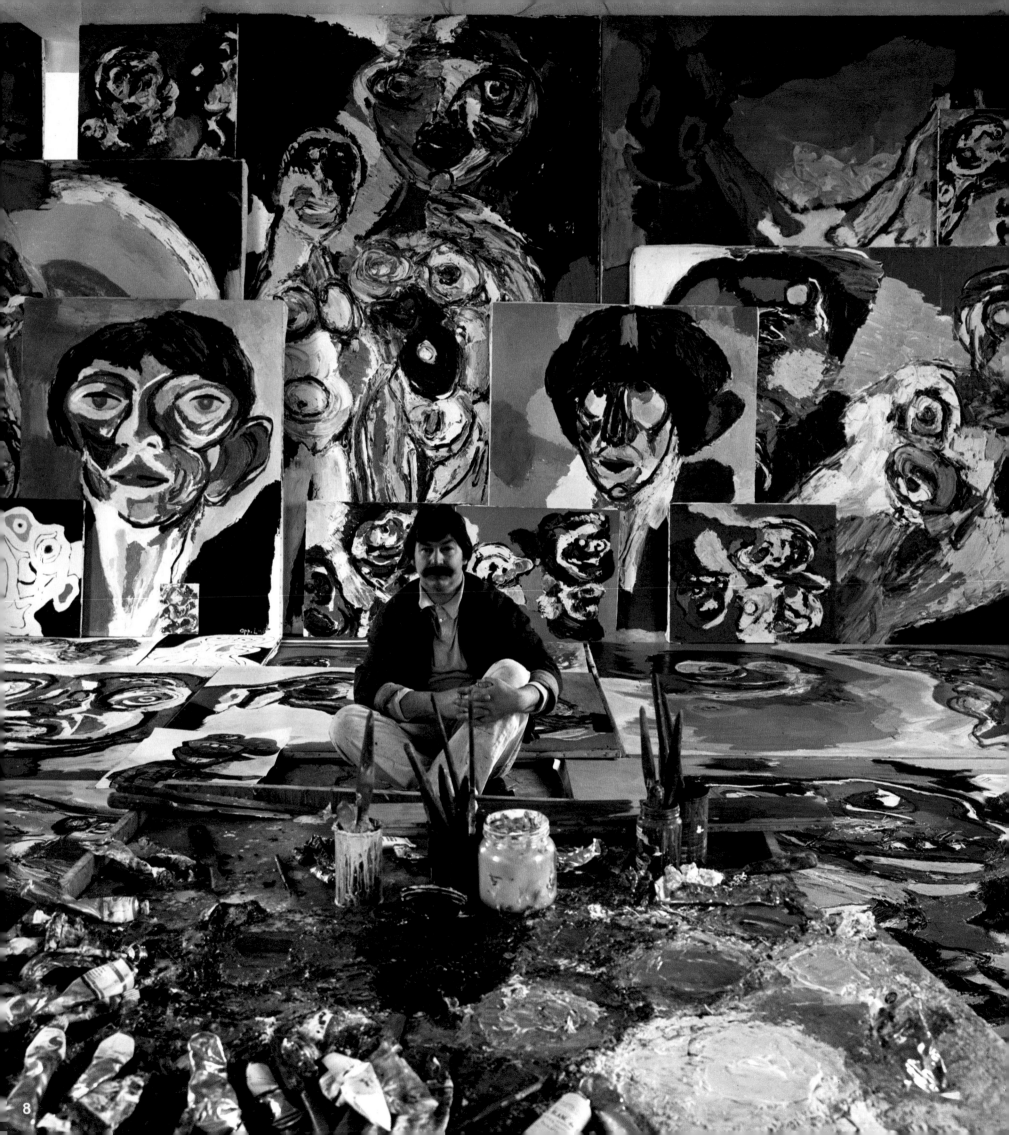

karel appel

1. "Thus you stand, one hand ready, laden with paint, arm outstretched as the canvas waits, immaculate. The canvas knows what it wants, yes, but what does it want?" : Appel.

2. "My hand approaches, my eyes transform the waiting canvas. As the color touches the canvas, it vibrates. The consecration begins, the struggle to harmonize hand and form, eye and canvas. Out of this the beast springs forth."

3-4. In the studio of the château at Molesmes.
"I paint like a barbarian in these barbaric times."

5. Convulsive forms sculptured in olive wood and painted.

6. Photograph for Appel's album.

7. "I stand facing my canvas and I paint. I never attempt to make a *painting*; it is a cry or a child, or a tiger behind bars."

8. "My tube of paint is like a rocket tracing its own movement. I attempt to make the impossible possible. I never try to make a picture, only a fragment of life."

1921 Born at Amsterdam, Holland.
1940 Student at Amsterdam Academy of Fine Arts.
(Remained there for three years.)
1946 First one-man show at Groningen. Took part in group exhibition at the Stedelijk Museum.
1947 One-man show at Amsterdam Guildhall.
1948 Organized international association of experimental painters, the Cobra Group, with several friends.
1949 With Cobra Group, exhibited at the Stedelijk Museum.
Executed mural for the Amsterdam Town Hall.
Colette Allendy became his Paris dealer.
1950 Settled in Paris.
Publication of Michel Ragon's treatise Expression and Nonfiguration, Problems and Trends in Present-Day Art, which prompted him and Cobra Group to hold exhibition at Librairie 72.
Showed work at the Salon de Mai (and continued to do so annually until 1957).
1951 Exhibited in group show, "Five Painters" at Galerie Pierre, Paris.
Cobra International Exhibition held at the Liège Palais des Beaux-Arts.
One-man show at the Van Lier gallery, Amsterdam.
Painted mural for foyer of Stedelijk Museum, Amsterdam.
In Paris group exhibition, "Significance of the Informal," organized by Michel Tapié.
1953 One-man show at Palais des Beaux-Arts, Brussels.
Participated in second São Paulo Biennial.
1954 Received UNESCO Prize at Venice Biennial.
First one-man show in New York, at Martha Jackson Gallery.
1955 Painted large decorative panel for "E 55" exposition, Rotterdam.

1956 Exhibited canvases and ceramics at Ariette gallery, Milan.
Painted mural for dining hall in Stedelijk Museum garden. Made stained-glass window for Kruiskerk church, Geleen. Executed two murals for high school in The Hague.
1957 Received Lissone Prize, Italy.
Executed six stained-glass windows for Paaskerk church, Zaandam. Retrospective exhibition of his work at the London Institute of Contemporary Art.
1958 Executed large decoration for Dutch Pavilion at Brussels Universal Exposition.
Painting commission for UNESCO, Paris.
1959 Received painting prize at São Paulo Biennial.
1960 Exhibited with Mathieu, Moreni, and Riopelle at Kunsthalle, Basel.
1962 Took part in "Art Since 1950" exhibition, Seattle.
1963 Show at Martha Jackson Gallery, New York.
Participated in "Vision and Color" exposition, Palazzo Grazzi, Venice.
Painted window for Amsterdam Savings Bank.
1964 Exhibited at Gimpel Fils Gallery, London, and Martha Jackson Gallery, New York.
1965 Executed large ceramic wall for University of Economic Science, Rotterdam. Made decorative mural for Royal Dutch Shell, The Hague.
1966 Retrospective exhibition (129 canvases and sculptures covering the years 1947-1966) at Stedelijk Museum.
1967 Continued to exhibit internationally; showed at Martha Jackson Gallery, New York; Redfern Gallery, London; and Galerie Lefort, Montreal.

buffet

In the middle ages Bernard Buffet might well have been burned at the stake in the course of a miracle play. As it is Buffet has been crucified by the press for twenty years. With his devil-inspired brush he bestows upon his human images the identity of clown or matador, slaying them, as it were, with his sword. Each of his shows turns into a sort of funeral parlor. The canvases glow and redden with tongues of fire, and the mourning pilgrims that crowd silently around them refuse to recognize these mirrors of themselves.

Bernard Buffet doesn't play the devil with impunity... but solitude protects him. Some nine miles from Aix-en-Provence, you have to stumble along a scarred and broken path before you see the stiff silhouette of his château, squared off by four towers that rise dark against the sky.

The ground-floor rooms of Château-l'Arc include an enormous entrance hall, a large red drawing room, and another, friendlier living room for informal guests, all filled with beautiful period furniture. Antique tables display collections of ivory carvings, wood polychrome statues, and rare porcelains. Behind the tables, hanging on the old walls, are large compositions done in the stiff kind of drawing that characterizes the work of the master of the house. One of these, *Horreurs de la Guerre* (1955), shows an exterminating angel, in the form of an immense nude, drawing away from the spectator after accomplishing its evil task; another canvas, *Les Oiseaux* (1960), shows enormous cocks plowing consenting women, and in *Corrida* (1965), bouquets of black flowers are spread against a pale background like souvenirs of a fatal wedding feast.

The artist's own room is cluttered with mineral fossils, and the twisted wooden carving of a Christ shares the pain of two crucified fish in canvases Buffet painted in 1963. In the middle of the adjoining room a giant sculptured and painted ray (1963) aims its pointed nose at a 1964 portrait of a matador painted in blood-red and gold.

On the floor above, which serves as one of Buffet's four studios, a paint-encrusted easel holds the picture of a bunch of yellow tulips dropping from a vase. The usual painter's tools and materials lie all around, amidst innumerable books, in a sort of deliberately organized tornado—paintboxes filled with oozing tubes of color, household plates frequently used as palettes, and ladders loaded with paint-stained rags. From across the studio, the devastated turmoil of Bernard Buffet's world, a pendant skeleton stares mutely out of empty sockets, watching the artist's ever-renewed struggles with fresh canvases.

To approach and win (or think you've won) Buffet's friendship is a test of anyone's patience, for he is as moderate in showing his feelings as he is in his movements.

To get any reasonable idea of how he works means spending about ten hours in his studio. Dressed in paint-stained corduroys, Buffet smokes ceaselessly, and he is silent most of the time. Painting, one is reminded, is done with colors, not words.

Night... day... to live with Buffet is to succumb to the multitude of lights that unmask the night, to have one's eyes seared by the cold steel of dawn, and to join in grudgingly, in the measured satisfaction of the corpses on the walls as they await the next victims of his brush.

A handful of little houses make up a hamlet around the chapel, which shelters canvases consecrated to Buffet's encounters with the Man of Sorrows. Done in a pale, wan expressionistic fashion highlighted with rich reds and golds, these great representations of the life of Christ are the summit of Bernard Buffet's art.

Savagely individualistic, Buffet remains "outside and unique." He describes himself as "*absolutely to one side; sometimes I am not even conceded to be an artist; others say I am the dregs of society; still others that I am the best there is! The others walk on the pavement while I live in the gutter... well, I prefer the gutter to the pavement!*"

Perhaps in order to be closer to us.

In a time when everyone knows so many things, when genius abounds and intelligence is common property, I must admit that I know nothing. Genius must have passed me by, since I have to work so hard; and intelligence cannot have come my way either for in all the time I've been painting, I've never yet begun to understand what most people seem to find quite evident.

Do you know a single doctor, politician, financier, statesman, or society woman who hasn't passed a final judgment on painting? Of course not. They protest, asseverate, judge, eliminate. You interest them only in so far as you concur in their opinion at that moment!

Lack of culture in painting is so deep-rooted that the less culture you have, the more "avant-garde" you're considered.

Painting and politeness must not be confused.

Neither the atomic era nor the exploration of the moon, nor abstract art, will ever make the slightest difference to what I call "painting." "Painting" is not to be discussed, or analyzed, it is to be felt. A hundredth part of a second is enough to judge a picture.

Rembrandt is beautiful, but sad. Boucher is gay but bad. "Great Painting" has never made anyone laugh.

The face of the earth may well change but no one has yet improved on Rembrandt, Delacroix, and Courbet.

I do not believe in inspiration, I'm only a worker.

No storm of insults will ever stop me from painting. I have the blind faith of fools and I'm proud of it. The hatred that surrounds me is the most cherished gift I've ever received.

I DON'T HAVE TO SPARE ANYONE OR ANYTHING. *Few people can say as much.*

Bernard Buffet

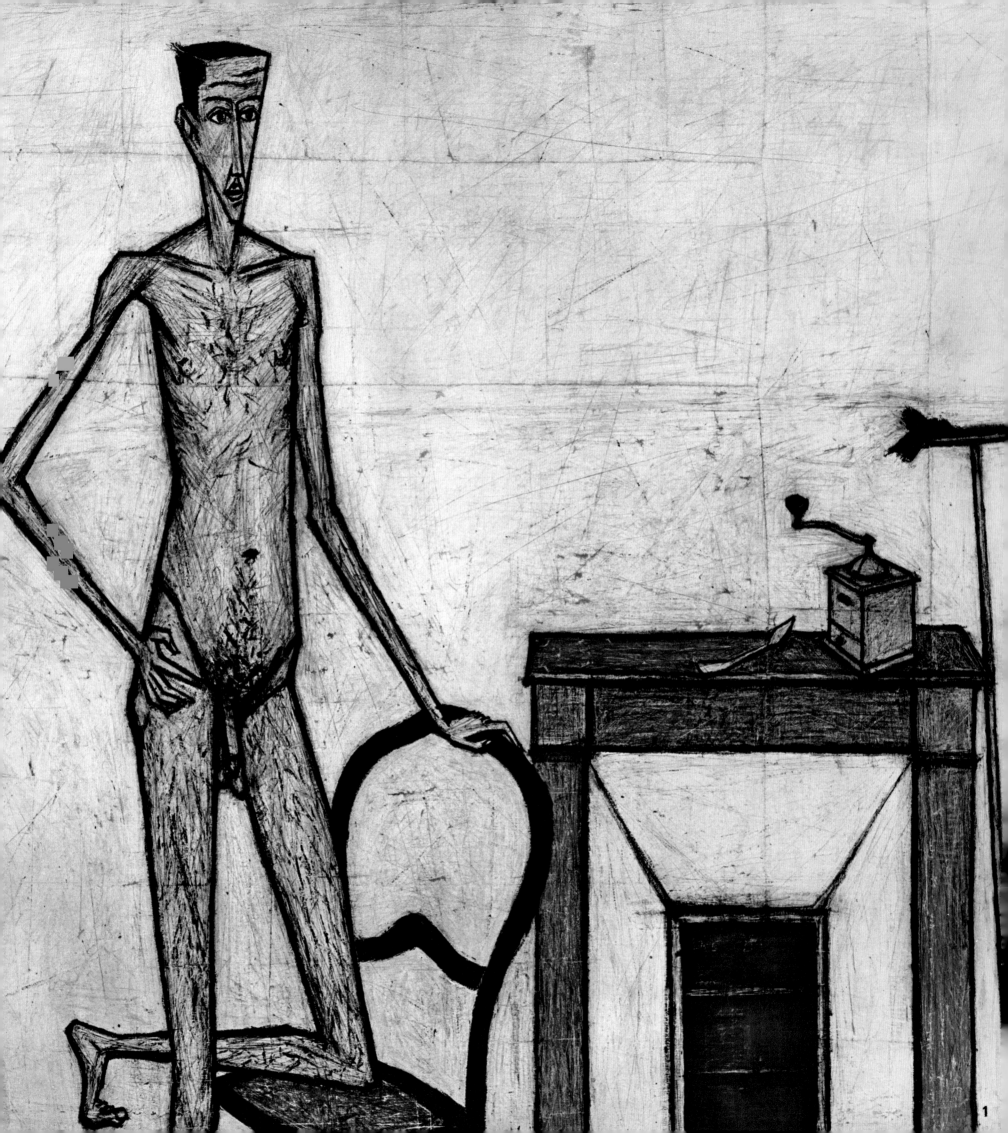

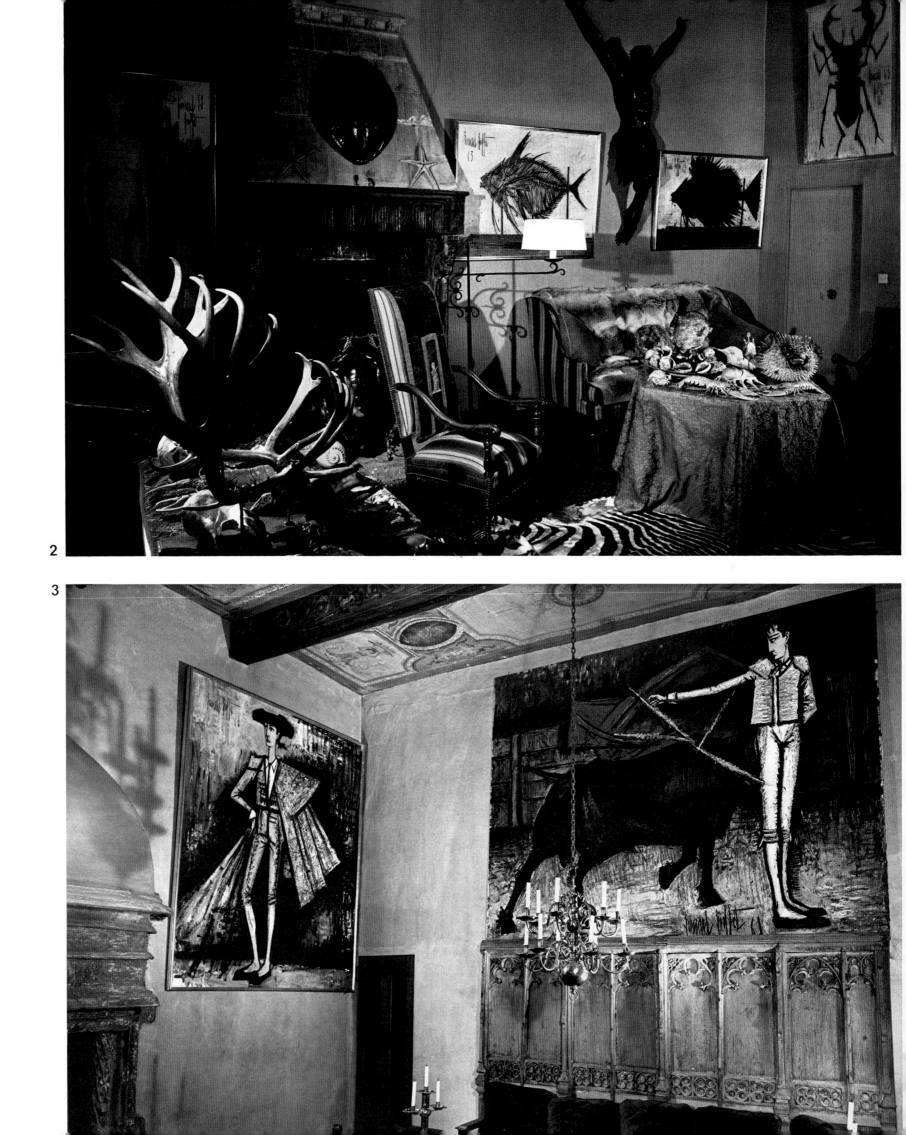

2

3

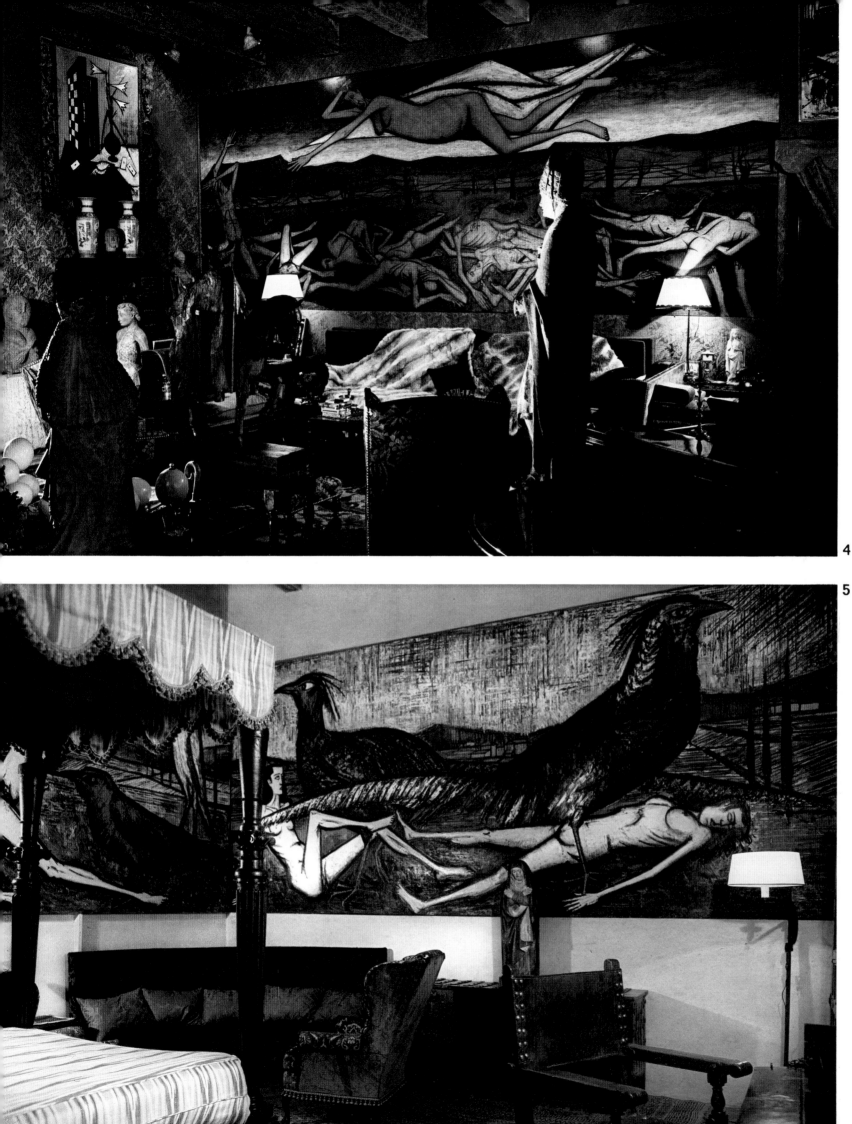

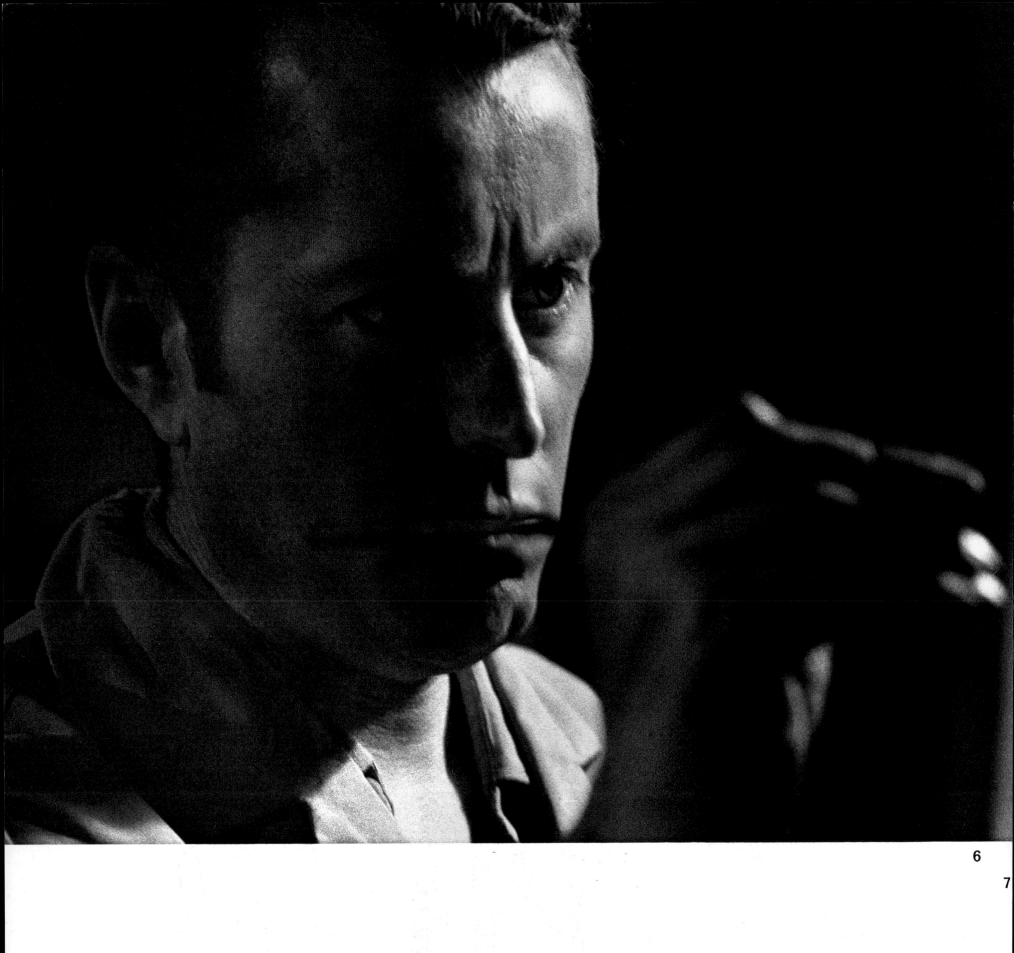

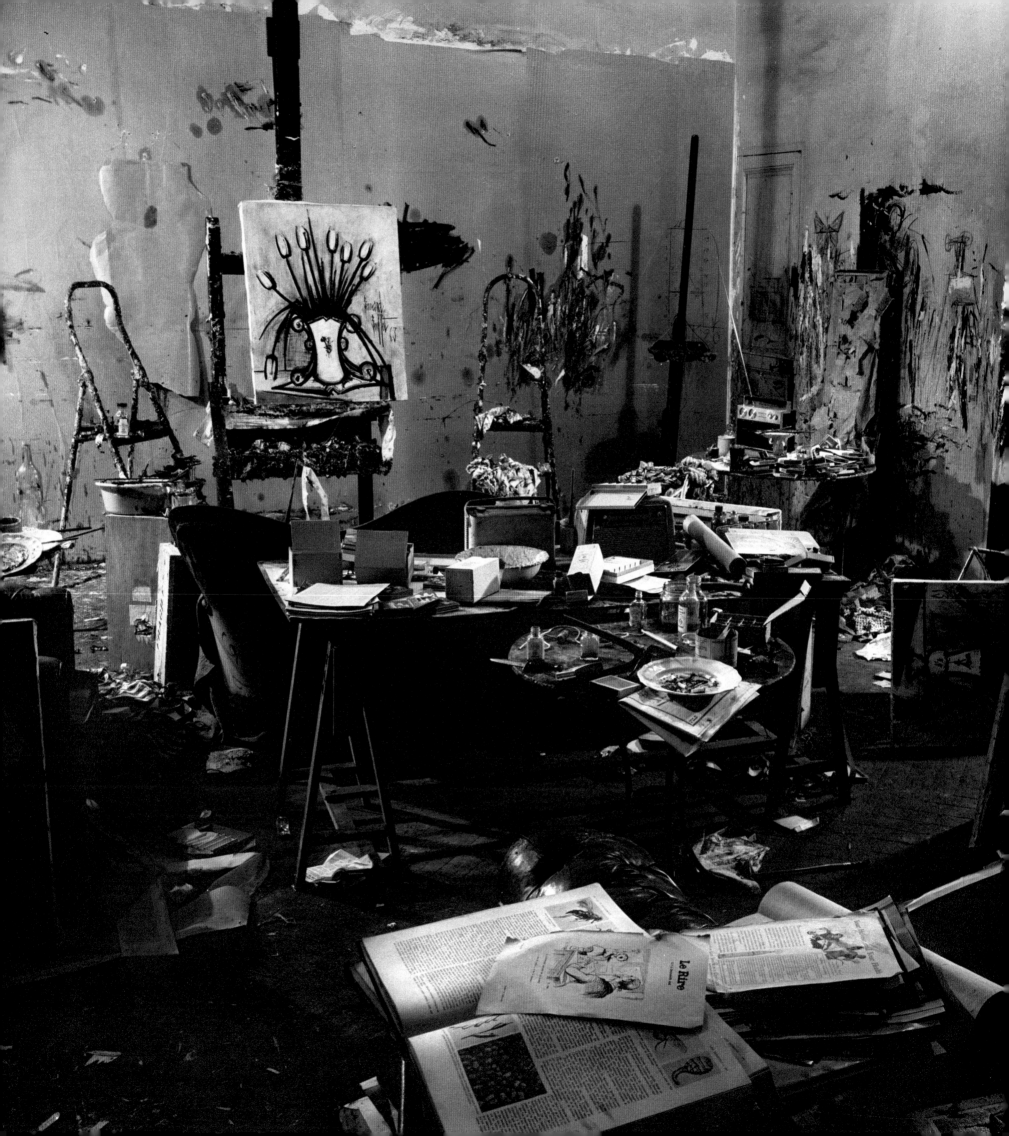

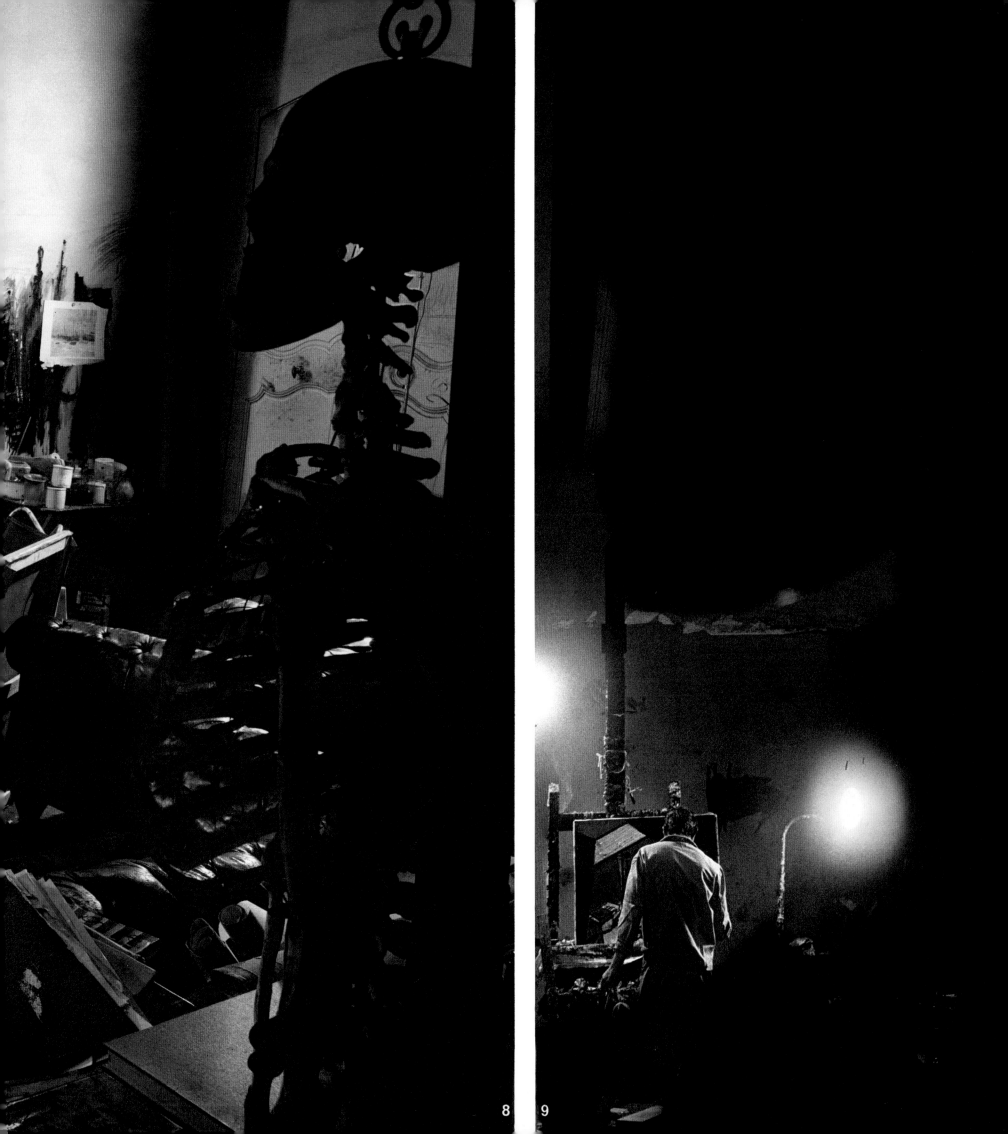

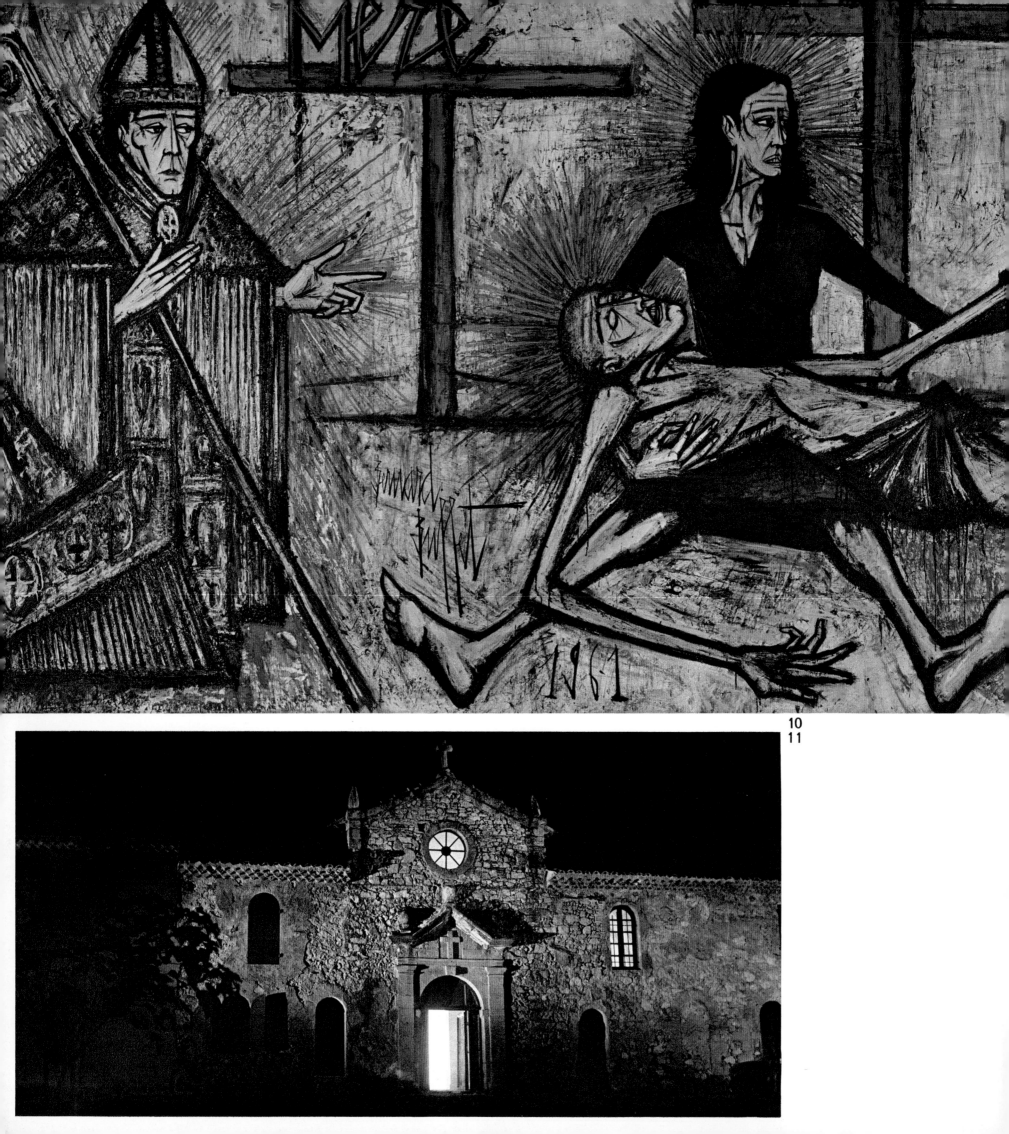

12　13

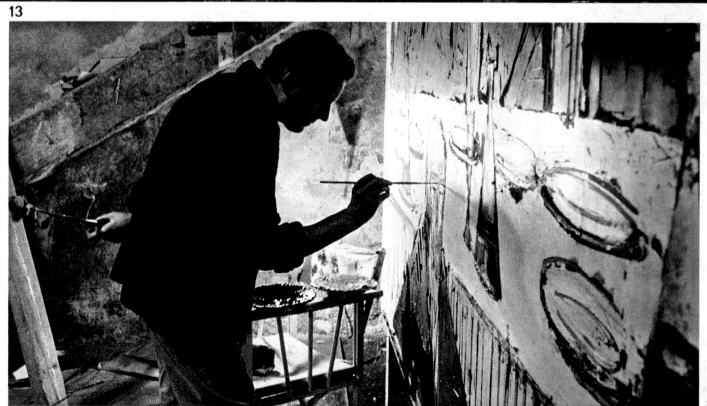

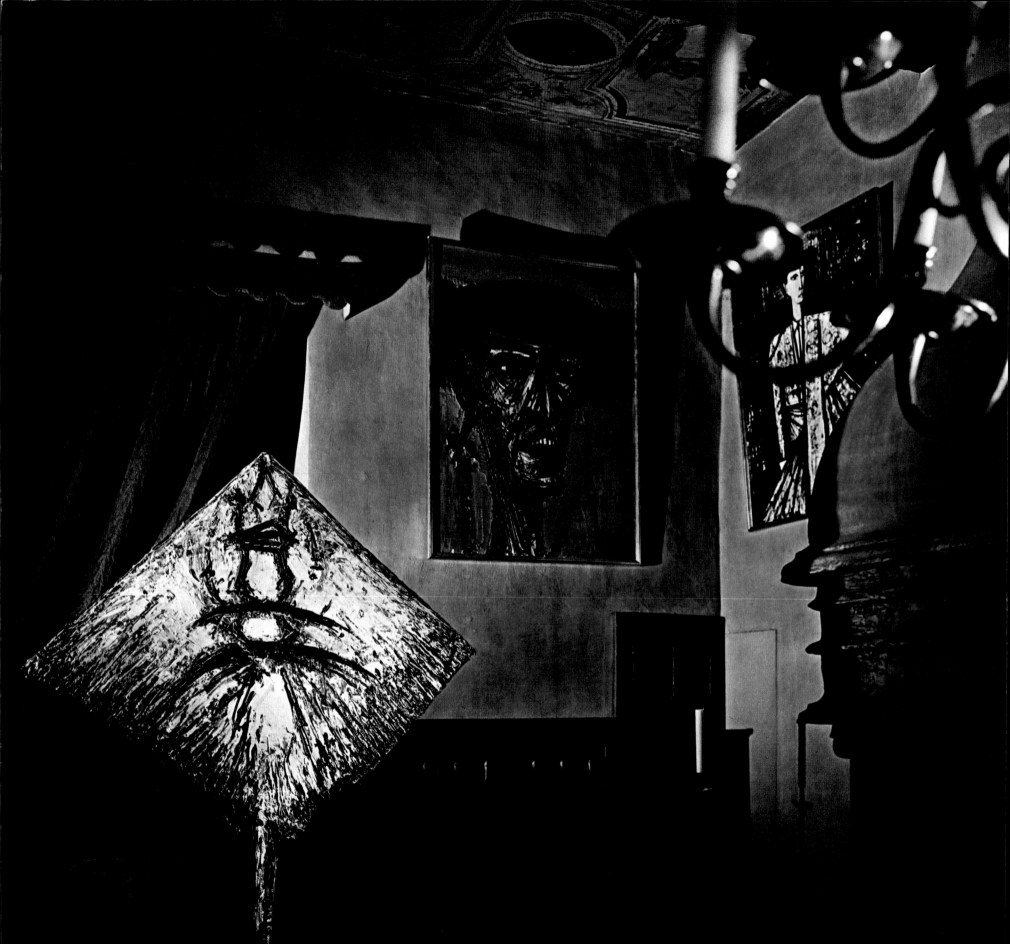

bernard buffet

1. Self-portrait, 1947.

2-3-4-5. The artist's world at Château-l'Arc.

6-7. The flayed man will appear on the mirror-picture out of the night.

8. A few tulips bloom on the easel amid the chaos of the studio....

9. Bernard Buffet, at night.

10. *Descente de la Croix*, 1961.

11. Chapel of the Château-l'Arc.

12. Buffet painting *Sainte Face*.

13. At work on *La Cène*, 1961. Buffet is painting the face of Judas.

14. In the château :
A ray, molded in painted plaster, and the *Toréros*.

1928	*Born on July 10 in Paris.*
1944	*Became a student at École des Beaux-Arts, Paris, remaining there only a few months. Subsequently worked alone.*
1947	*First show.*
1948	*Shared Prix de la Critique with Lorjou.*
	First place in referendum organized by Connaissance des Arts *magazine to select the ten best postwar painters.*

Exhibited yearly in Paris on various subjects :

1952	La Passion.
1953	Paysages.
1954	Nus.
1955	Horreurs de la Guerre.
1956	Le Cirque.
1957	Paysages de Paris.
1958	Jeanne d'Arc.
1959	Paysages de New York.
1960	Les Oiseaux.
1961	Portraits d'Annabel.
1962	La Chapelle de Château-l'Arc.
1963	Paysages de Venise.
1964	Le Muséum de Bernard Buffet.
1965	Les Ecorchés.
1966	Nus.
1967	La Corrida.
1968	Les Plages.

From 1953 to 1968 he also had numerous one-man shows : in London, New York, Chicago, Palm Beach, Montreal, Rome, Venice, Brussels, Basel, Geneva, and Berlin.

Retrospective exhibitions of his works :

1958	*At Galerie Charpentier, Paris, and at the French Institute, Berlin.*
1959	*At Knokke-le-Zoute.*
1963	*At Museum of Modern Art, Tokyo, and Museum of Modern Art, Kyoto.*

Books illustrated with his work :
Les Chants de Maldoror *by Lautréamont.*
Recherche de la Pureté, *by Jean Giono.*
La Passion du Christ.
La Voix Humaine, *by Jean Cocteau.*
Les Voyages Fantastiques, *by Cyrano de Bergerac.*
Saint-Cast.

Stage sets :
La Chambre, *by Georges Simenon, for Roland Petit Ballet.*
Le Rendez-vous Manqué, *by Françoise Sagan.*
Patron, *by Marcel Aymé.*
Carmen, *by Bizet, for Marseilles Opera House.*

mathieu

Georges Mathieu has probably succeeded in borrowing more energy—lyrical energy one might say—from his contacts with the common people than has any other creative artist, ably transferring it into the slashes of color that adorn his canvases.

For example, there was that extraordinary demonstration at the Sarah Bernhardt Theatre, Paris, in May 1956, called "A Night of Poetry." Long before Mathieu's appearance the audience was subjected to the spectacle of a talented robot, a small metal monster with square shoulders and backside stuffed with machinery, dancing a few waltz steps. The robot was surrounded by a crowd of people who had been brought on stage to tease the circuits of the electric eye inside him, all under the careful observation of the machine's "father," Nicolas Schœffler, inventor of space-dynamics.

Then came poets—from all over the world—who murmured verses into the microphone. While all this was going on Mathieu, sheltered by an enormous stretch of white canvas and watching his assistants reel toward him under the weight of oil and gasoline cans filled with paint and forests of long brushes, was consumed with impatience to get on with his act. There was that forty-foot canvas to paint in front of two thousand people.

At last, and for the next hour, the audience was to watch Mathieu, ten feet off the ground, perched on a sliding ladder, shooting eight hundred tubes of color over the giant canvas while the microphones continued to spout poetry.

The crowd yelled, "Madman! Money back!" and "Throw him out!" Apparently unperturbed, Mathieu continued to jab long spears of color at the canvas. The white surface quivered under a hail of blue. Next Mathieu struck it a sledge-hammer blow... with red. Then came a volley of green, followed by black, ejected from the tube like a grenade... and yellow. The audience screamed "Agincourt," but Mathieu was Bayard at Marignan.

Emptied at last of all his strength and out of paint, Mathieu, standing in front of the canvas (which he had signed!), bowed to the spectators. The brawling crowd, suddenly aware of the epic quality of his finished poetry, began to applaud.

There have been other contests since then, other canvases, other battles. Several dozen Mathieu exhibitions throughout the world have assailed a public stupefied by the fireworks of Mathieu's calligraphy, his splattering, his thermonuclear explosions.

Mathieu's refuge from the uproar created by his exhibitions is his town house in Paris. Here he lords it grandly over representatives of the press and delights in arguing with the world's philosophers. Mathieu's kingdom has been adapted to serve two purposes, two ways of living—the formal and the agreeable. Three styles of decoration, or themes, are intermingled in his house—Roman, Gothic, and Louis XIV. Some find the setting too baroque, incoherent, heteroclite, yet it came about as a result of the strictest, most faultless sort of accounting possible in the mind of a man devoted both to the mathematics of the past and the myths he entertains as one of art's most revolutionary painters. It is part of his milieu.

It was just after reading one of Edward Crankshaw's books in 1944, while I was quite alone in northern France, that I suddenly understood that painting need not be representational in order to have value. This meditation on aesthetics led me to the decision to devote myself to nonfigurative work—not along the usual channels, but in spiritual fashion.

After Alaska and Japan my search led me from San Francisco to New York, from Milan to Brussels, from Rome to Düsseldorf, then to Stockholm, Zurich, Basel, Liège, Cologne, Krefeld, Vienna, from Geneva to Venice, from Rio de Janeiro to Buenos Aires, from São Paulo to London, to Madrid, from Beirut to Munich to Jerusalem. Wherever I went I found the same Westernization, or, rather, the same thirst for Western materialism. In addition, I found that my searching invariably seemed to change into giving, as if Buddha's words were ringing in my ears: "Once across the river, help the others over."

In my promotion of free abstraction I would like to reaffirm that after sweeping out the whole Graeco-Latin tradition, lyrical abstraction affords one the means of progressing beyond the world's old classical lexicon.

In a transdialectic in which signs precede their meaning it would be out of the question to look into or try to analyze the components as one does in established styles, such as the Greek, for instance in the examination of a carving from the Cyclades, or in studying one of Raphael's virgins or even a picture by Mondrian. The cosmic dynamism that holds sway over the new relationship between human beings and their world feeds on its own future. Wouldn't it therefore be useless to illustrate the semantics of a language still in formation, or which at least doesn't yet have to worry over the make-up of its parts? All the classical misunderstandings in this modern world can be traced back to the refusal to abandon devices in reasoning which from Aristotle to Heidegger retain a fixed notion of the idealistic and middle-class world without perceiving that the limits of matter, of gravity and of conscience have been split.

The history of our civilization begins with the emancipation of humanistic thought. It is incarnated in a free aesthetic after the manner of God's, maintaining itself before him. It comes out of forty thousand years of artistic activity spent on abstracting reality and after seven centuries of a mistaken idealism founded on anthropomorphism. Its dialogue with men has only begun.

Desperately, if necessary, I'll employ all my powers to reverse the direction of our relationship with the universe; giving before accepting; revising our idea of words like holiday, play, holy, and such; laying the foundations of a metaphysics of the empty, the perilous, of detachment; re-creating a faith, a confidence, a spirit of sacrifice whose absence is the origin of the malaise in our culture, based as it is on getting ahead and making profits. I'll do my best to re-establish order between humans and things, duties and rights; I'll fight to restore the idea of individuality. As for you who uphold the establishment—be it temporal or spiritual—I want you to know that I do not fear God and that if you have lost the gift of love, I shall inexorably continue to tell a little of my pain and of that of other men, just as St. Grignion of Montfort did.

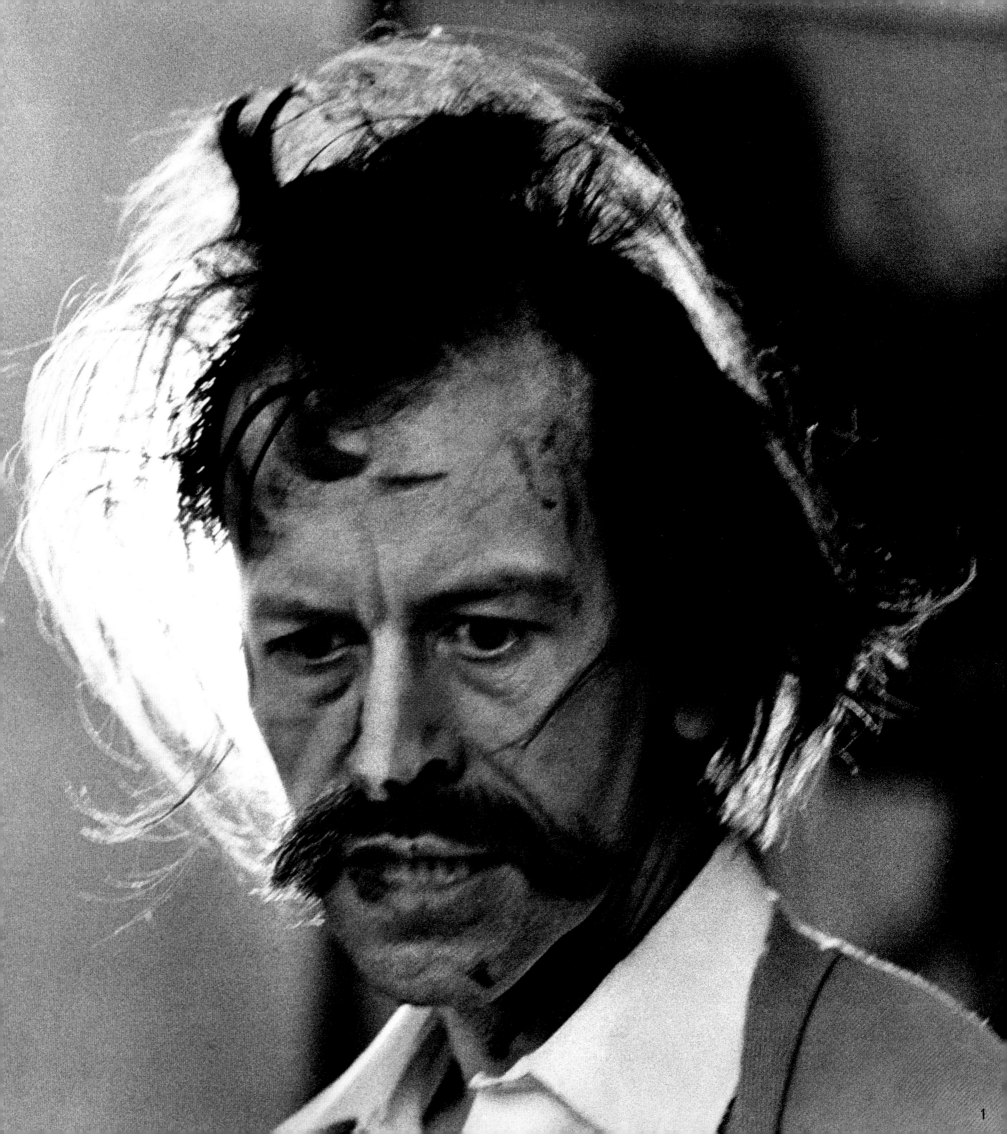

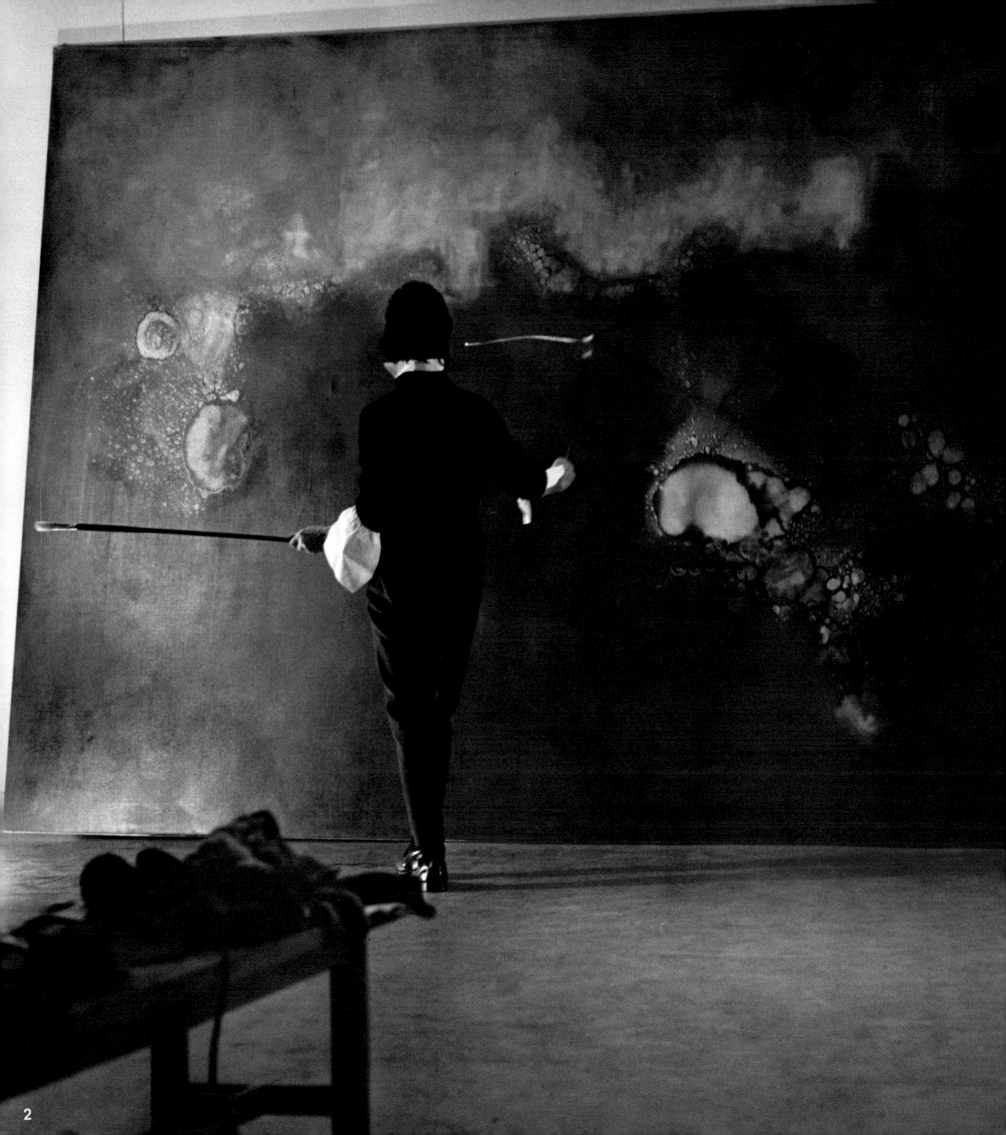

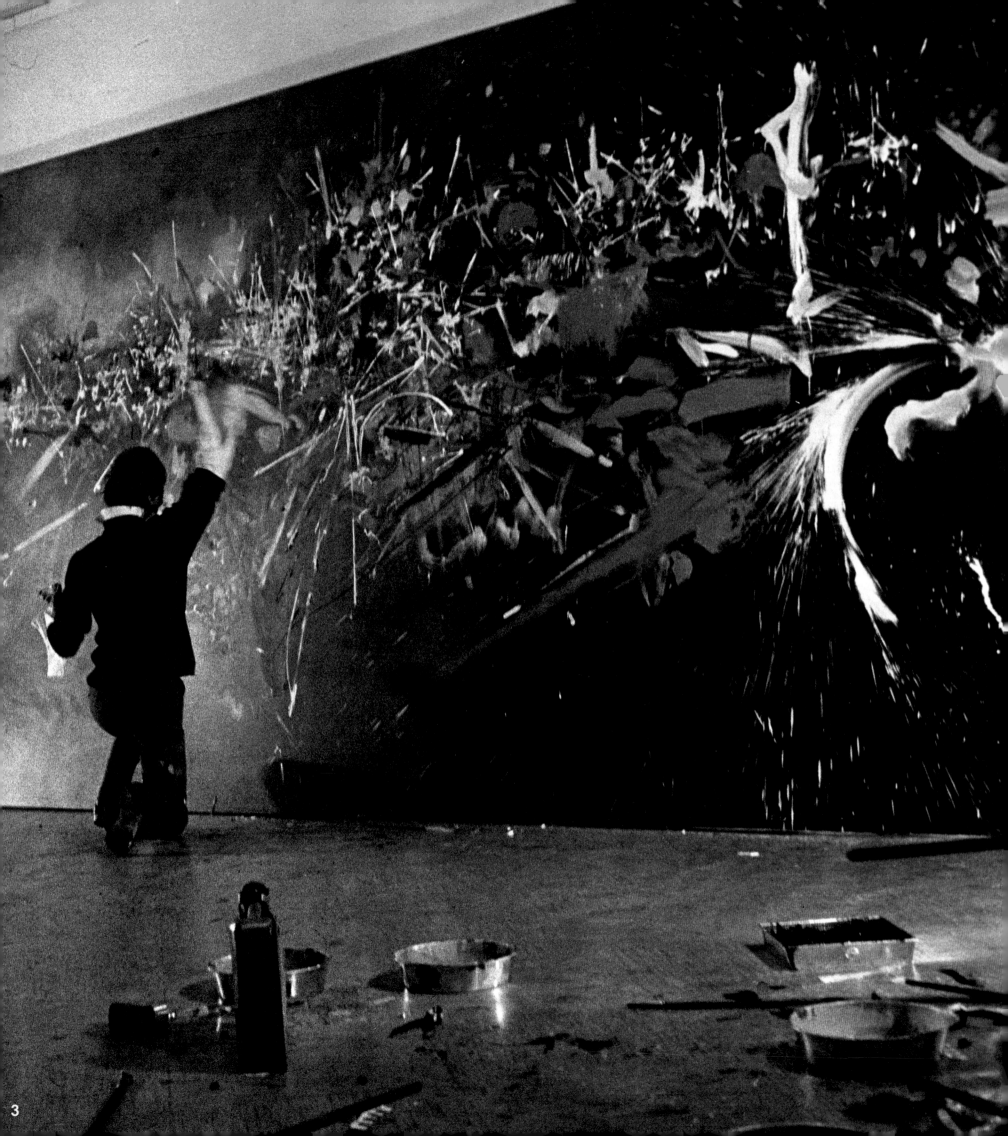

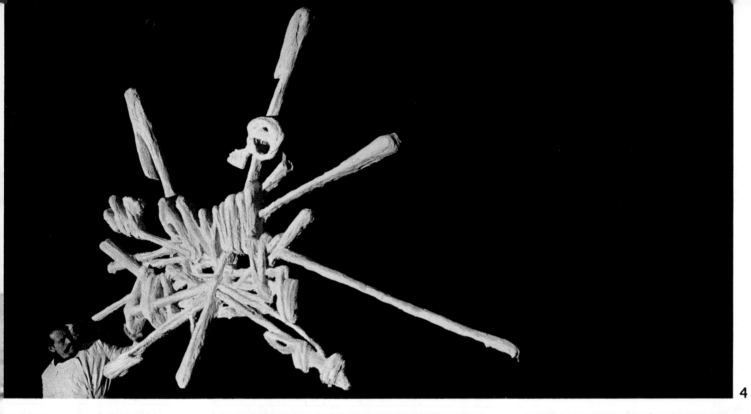

4

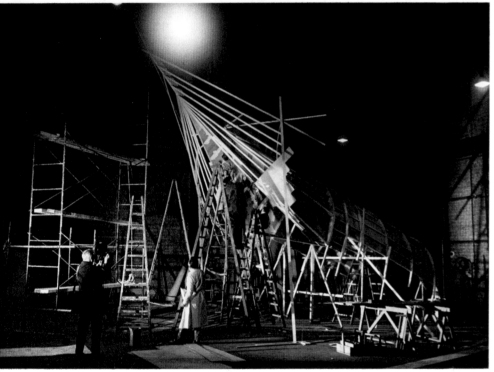

5 6

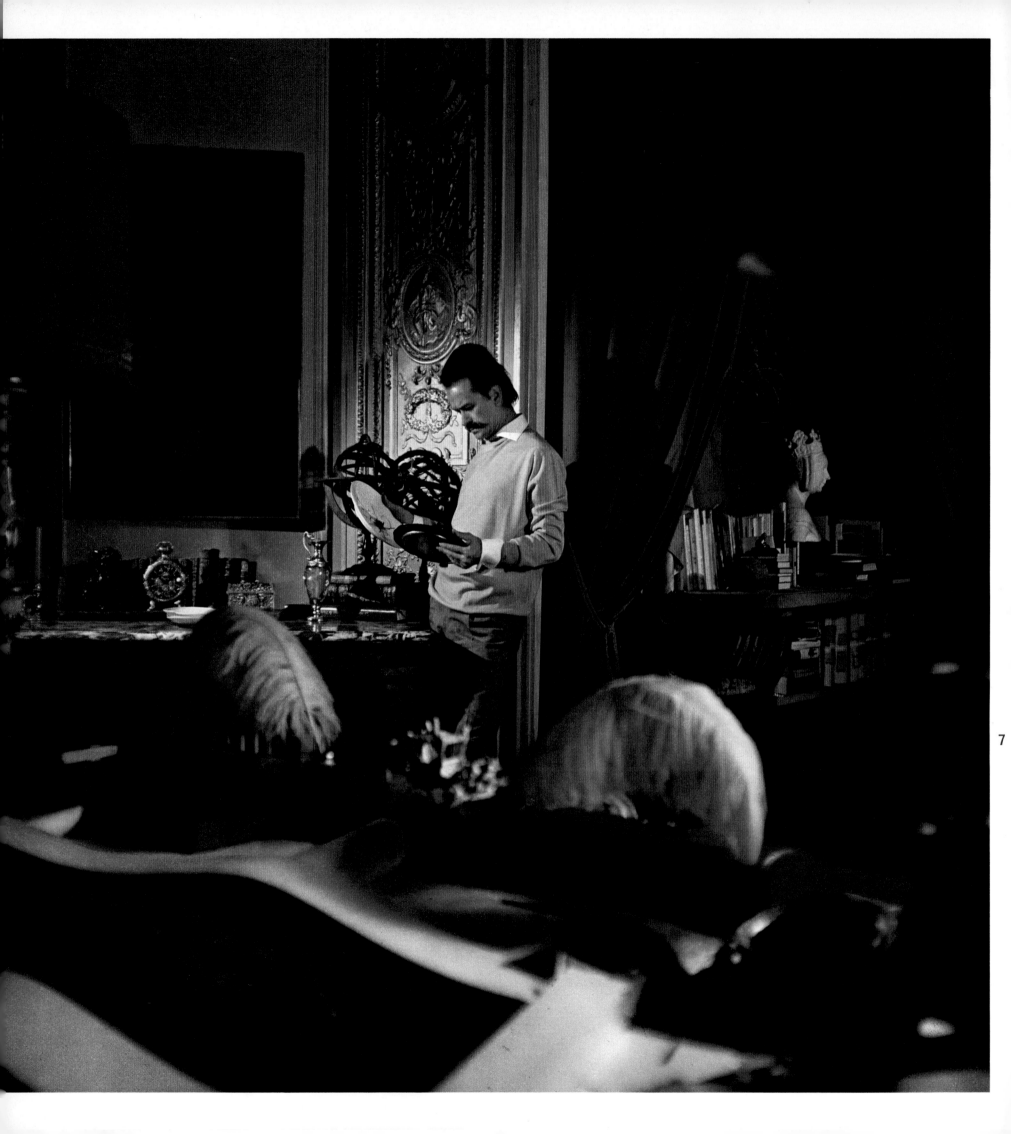

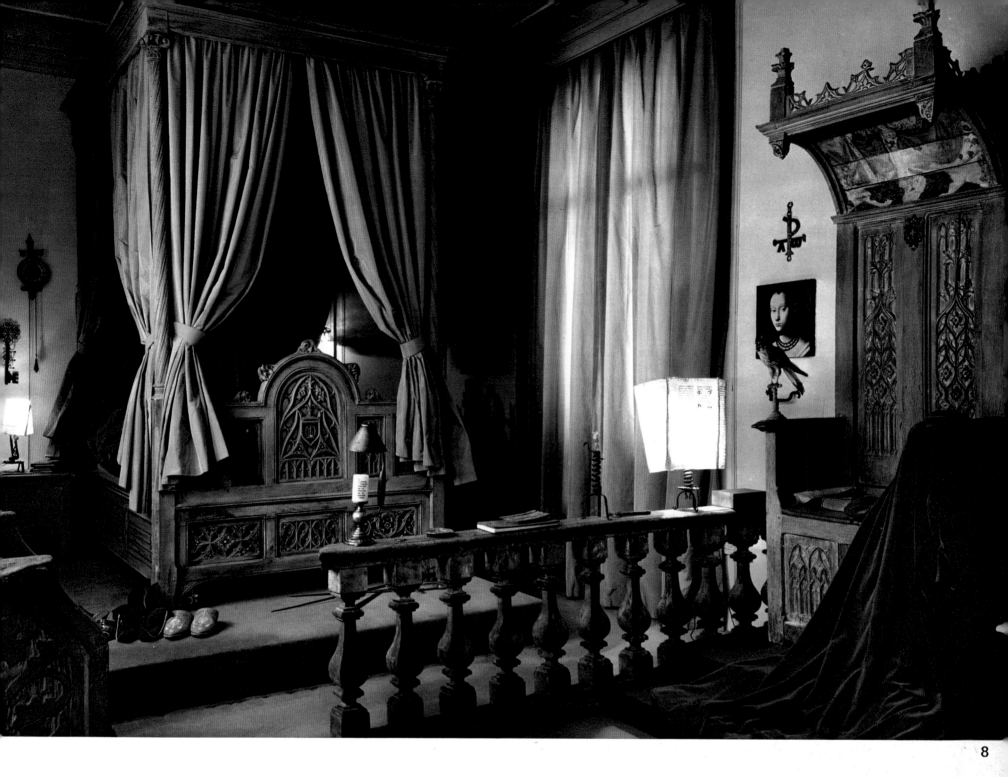

9
10

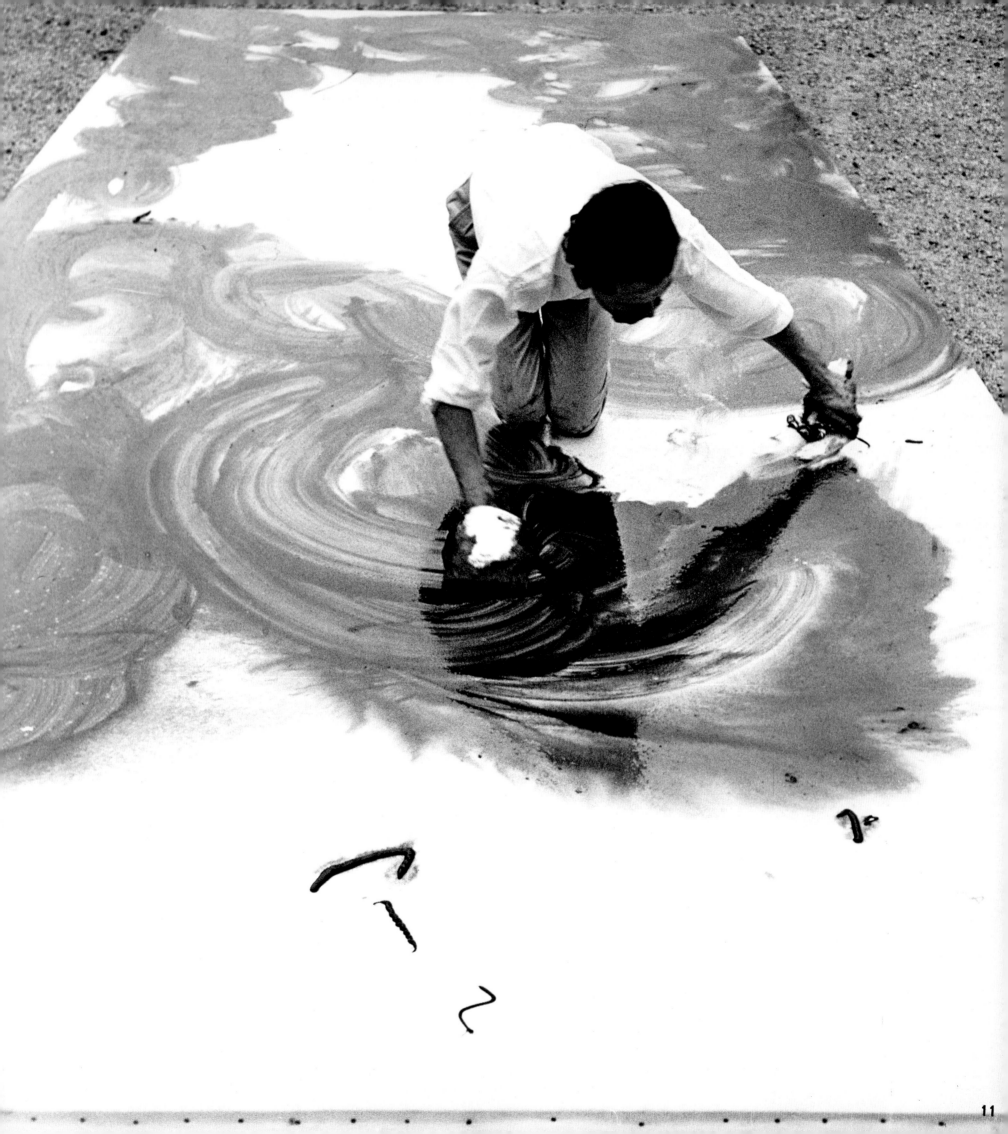

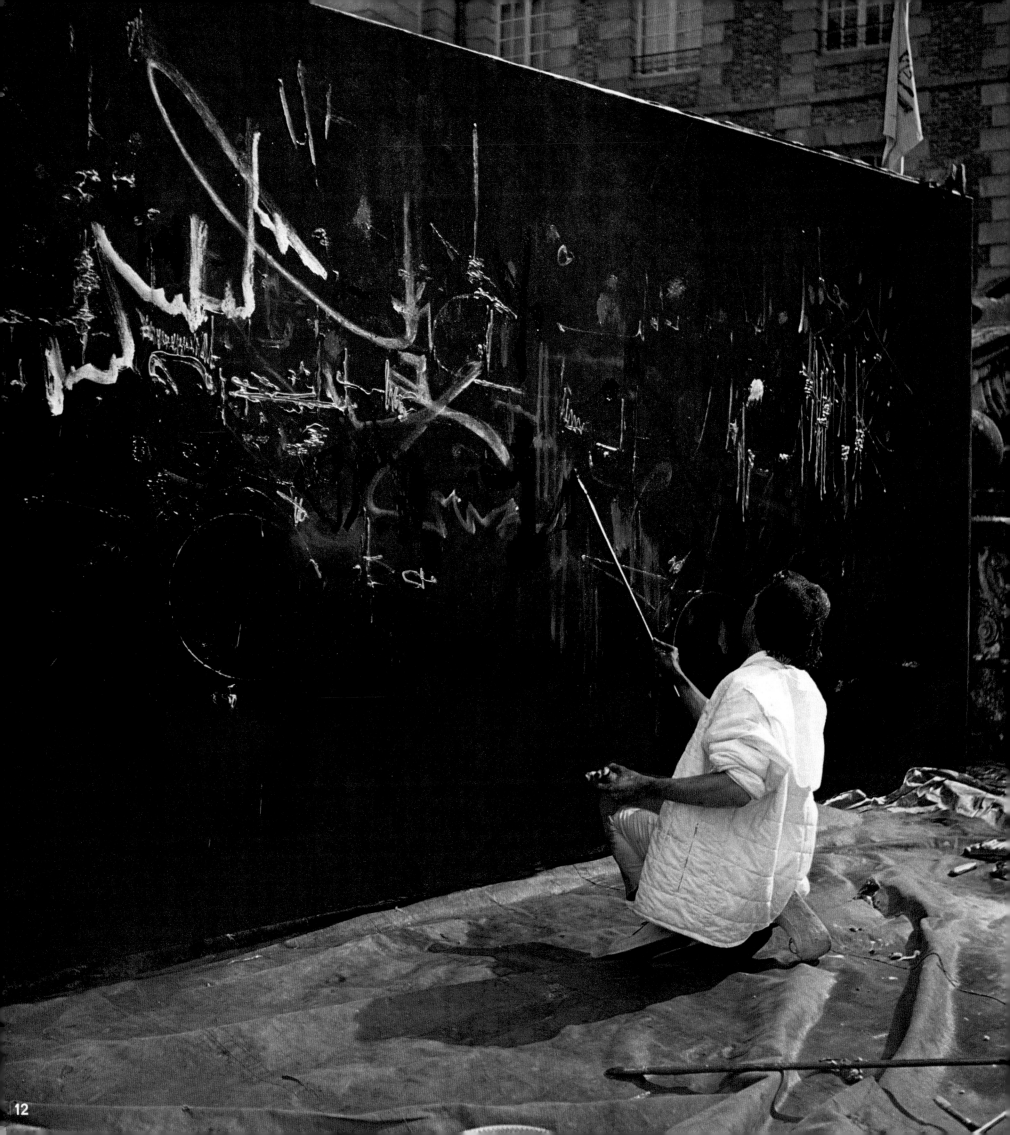

georges mathieu

1. "The artist is the elect, chosen to incarnate the sensibility and suffering of the world" : Mathieu.

2. Mathieu at the Musée d'Art Moderne, Paris, painting the first brush strokes of *La Bataille de Denain* (1963) on a background as mysterious as the cosmos.

3. The last touch of the brush, bringing the picture to life.

4. Sign sculpture.

5. Building a triumphal arch for the entrance to the "Antagonisms" exhibition at the Musée des Arts Décoratifs, Paris.

6. Creating a bed for *L'Objet 2*, 1962 (Musée des Arts Décoratifs.)

7. In his Paris residence.

8. The Gothic room.

9. Arriving at Courances in his 1927 Mercedes.

10. The painter superintending the arrival of the canvas he is to paint in the courtyard of the Château of Courances.

11. Preparing a "foundation."

12. Painting *L'Entrée de Louis XIII et d'Anne d'Autriche dans Paris.*

1921 Born January 27 in Boulogne-sur-Mer.

1942 After schooling and study of literature and philosophy, he took up painting as a career.

1947-1948 Became the first person in France to react violently against geometrical abstractions in painting. Organized first demonstrations in favor of an art freed from all classical constraints. (L'Imaginaire, 1947, H.W.P.S.M.T.B., 1948, White & Black, 1948.)
Defined his new concept, Lyrical Abstraction, and named himself its high priest.

1950 One-man show, Paris.

1952 One-man show, New York.

1954 Began painting large canvases.

1957 Traveled to Japan and met triumphal welcome.

1959 Retrospective exhibitions held at the Kunstverein, Cologne ; Kunsthalle, Basel ; Krefeld Museum ; and Musée de l'Athénée, Geneva. (In following years his paintings were exhibited in Brazil, the Argentine, Lebanon, Israel, Canada, and most European countries.)
As the originator of "Tachisme," he introduced notion of speed into Occidental art.

1963 Musée d'Art Moderne, Paris, held retrospective exhibition of 120 of his works. This honor and publication of

his book Au-delà du Tachisme *(by Éditions Julliard)* established him as one of the most important artists of our times.

1964 Began paintings small canvases. Exhibition at Gimpel Gallery, London, demonstrated a turning point toward austerity and severity in his work.

1965 Exhibitions of paintings held at Zurich, Düsseldorf, Copenhagen, Stockholm, Oslo, Montreal, Milan, Gstaad.
One hundred canvases shown at Galerie Charpentier, Paris.

1966 Gobelin commissioned tapestry for main hall of the French Pavilion at "Expo" in Montreal.
Drew up blueprints for large factory covering at Fontenay-le-Comte.
Painted series of plates for Sèvres factory—one set intended for Presidency of French Republic.
Exhibitions held at Bologna, Brescia, Brussels, Luxembourg, and Copenhagen and elsewhere.

1967 Second book, Le Privilège d'Être, published by Éditions Morel. Designed tapestry to decorate Faculty of Science, Grenoble. Exhibition at the Kunstverein, Cologne.
Created series of fifteen posters for Air-France.
His work is now on view in forty-eight of the world's leading museums.

Step up, step up
ladies and gentlemen
children soldiers
brides-to-be merry widows
come on it's a marvelous world
it will enrich your
eye
with a million's worth of colors
there's no charge
for this magical jazz
where your ear can breathe
air ringing with impish flutes
plant your feet on the wizard's shoulders
sitting
on his flying guitar
raise your hands
you can grab
bagpipe elephants,
pink parrots,
tubular bats,
harmonica fish,
you'll be able to hear
a ballad
plucked from the peacock's lyre
examine the butterfly blossoms
blooming on the zebra keyboard
follow a fleeting echo
riding the crest
of a rainbow athwart the firmament.
God's pledge to Noah
has been taken up by Alan Davie
who, with brush dipped in a rainbow,
traces the Ark,
a flood of color,
the moving parade of
a whole new posterity of designs
bright Bengal tigers
painted
so that canvas may retain
the world
of an eternal circus.

Alan Davie lives in a glass house pleasantly concealed in a stretch of Cornwall's green and cosy countryside. There is green all around the house, and green predominates indoors too. You walk through the rooms and your eyes are attracted here then there, in quick succession, by the appealing confusion of flowers, a guitar, dogs, cats, parrots, a flute, paintpots, parakeets, spreading ivy, fish, a piano. Twining tropical plants extend the impression of greenery; they climb toward or work down from the many Davie paintings on the walls.

The painter, his wife Janet, and their daughter Jane live in the shade of this lush and vital world.

Davie is a musician as well as a painter and seems to be preoccupied with sounds everywhere he paints. Another of his favorite pastimes is flying. On a fine day you may arrive at the house to find him up in the sky gliding over the beautiful countryside in his winged ark, his red beard gleaming in the sun.

The impressions Davie gains from aloft, as well as from the earth, from his music, from his live animals all contribute their share to the liveliness and originality that have brought his painting such renown.

Dear Daniel,

Please don't forget the sounds — the sound of
the sunshine and the yellow sound of yesterday;
the sound of hips, thighs, breasts and toes and fingers;
red, purple, pink, orange, cat, horse,
wheel, mouse, bucket and spade

My world is a piece of string banging in the purple sky
My string is a moon bitten by fishes.
My fish is a seagull chased by a raven.
My raven is a pocket full of flute notes.
My flute is the moan of a lover.
My love is the inside of a pure white egg.

Yet I paint because I am a bird,
And I bird because its wednesday.

With best wishes,

Alan Davie
Cornwall. Sept. 1967.

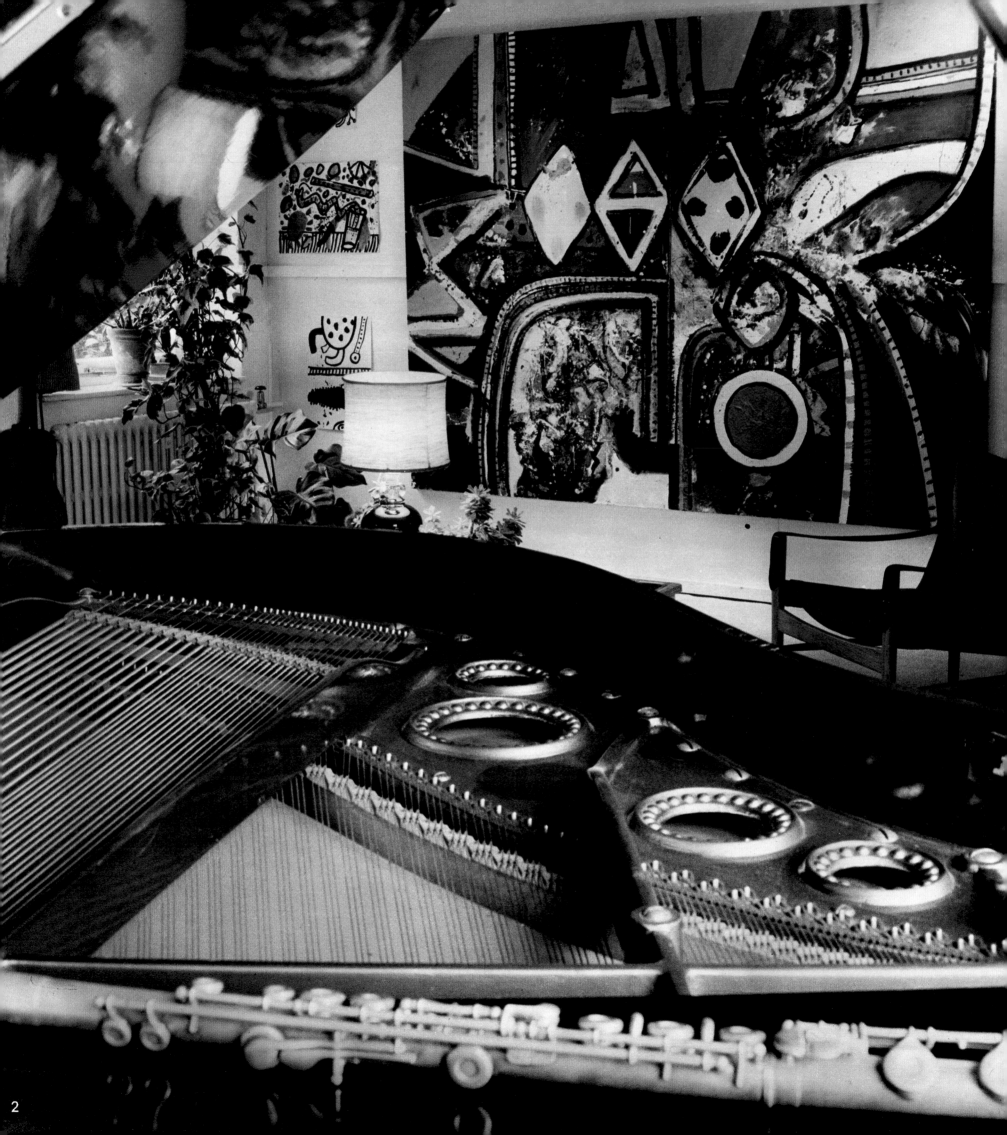

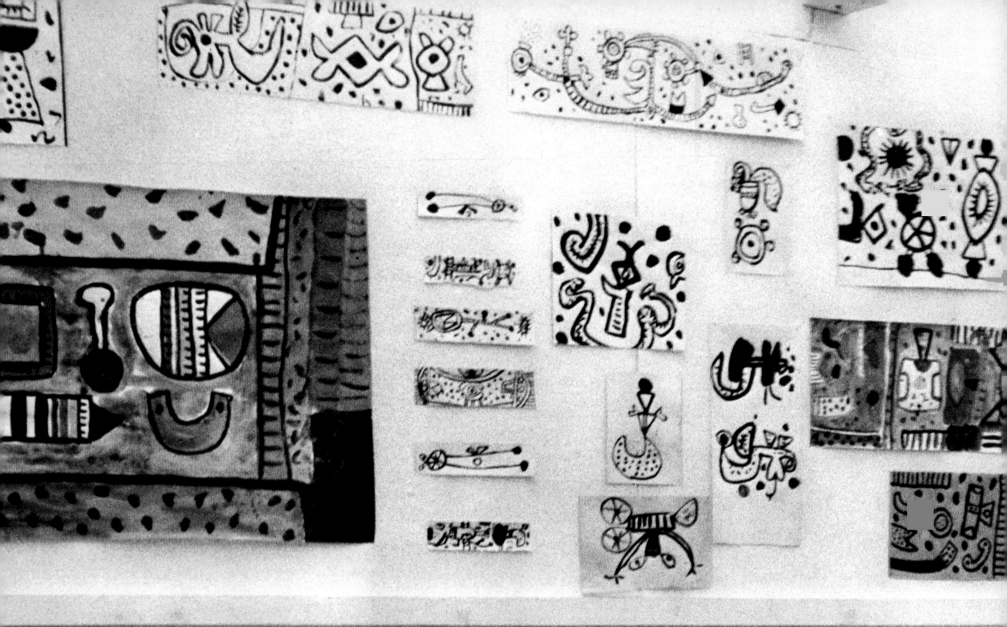
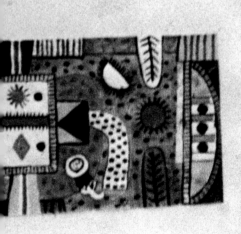

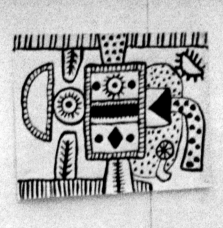
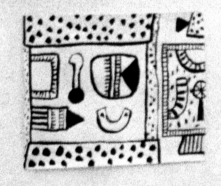

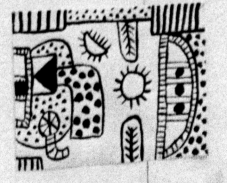
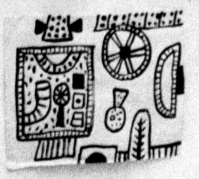

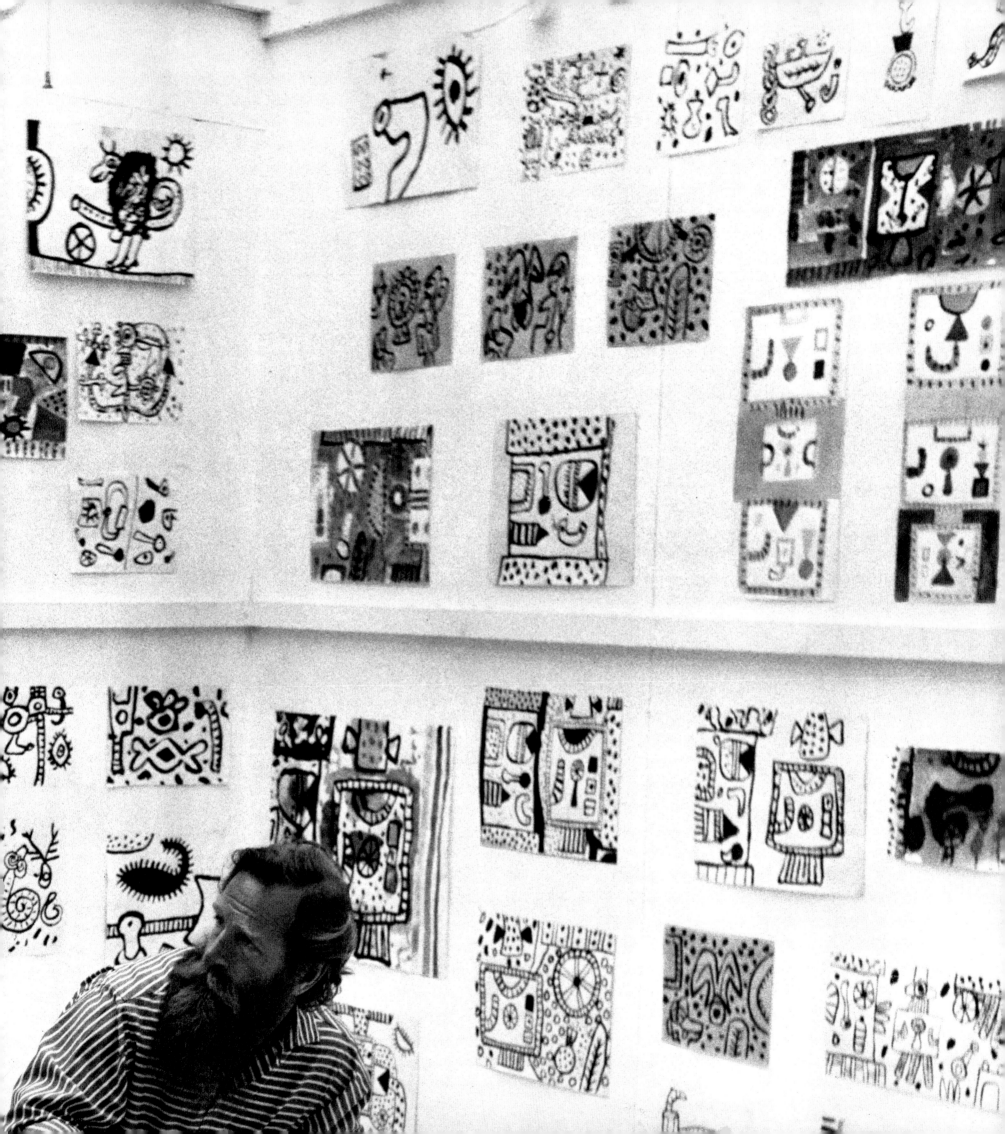

7

6

8

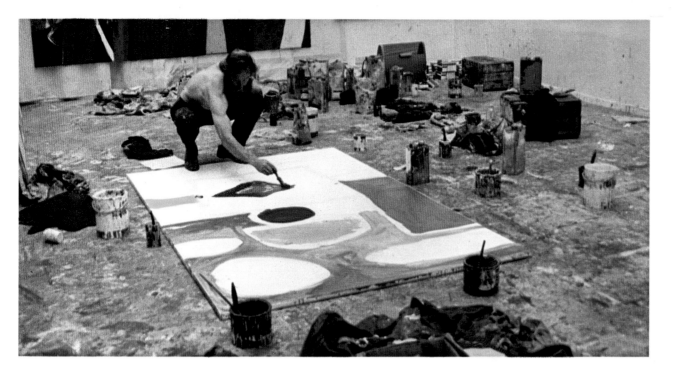

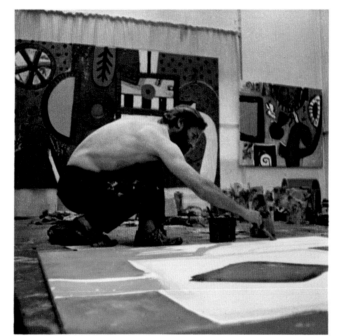

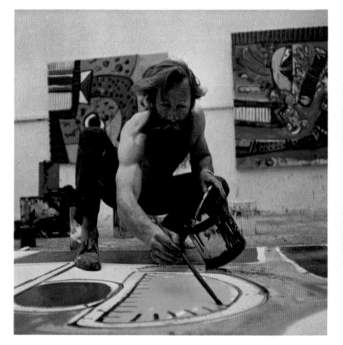

9

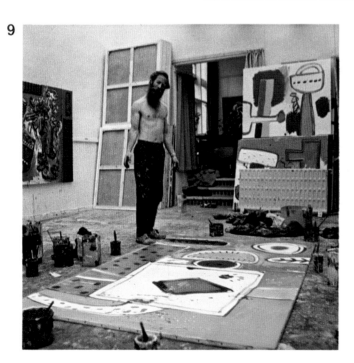

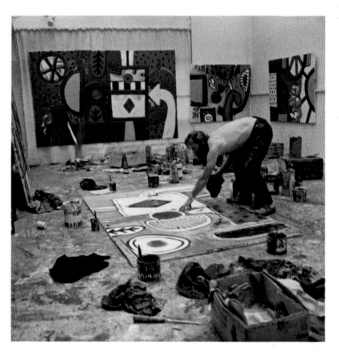

alan davie

1. A few notes on a flute.

2. The flute, the grand piano, and some pictures by Alan Davie.

3-4. The house. . . or, rather, Davie's ark.

5. The drawing studio. On the wall, "Davie's writing."

6-7-8. Pets of "Noah Davie."

9. Davie paints, becoming a sorcerer making magic signs.

10. A hand for a hand.

1920 Born in Scotland in September. (His father was a painter and engraver.)
1937 Student at Edinburgh College of Art (until 1940).
1940 Service in the Royal Artillery (until 1946).
1942 Received Guthrie Prize, Royal Scottish Academy.
1946 Began teaching art to young children.
1947 Became proficient jazz musician.
Married Janet Gaul, artist-ceramist.
1947-1949 Traveled in France, Switzerland, Italy, and Sicily on a scholarship from Edinburgh College of Art.
1948 Exhibited in Florence and Venice.
1949 Birth of daughter, Jane.
Earned living as a goldsmith (until 1953).
1950 Exhibited at Gimpel Fils Gallery, London (again in 1952).
1953 Resumed teaching art to young people.
1954 Exhibited at Gimpel Fils Gallery (again 1955 and 1956).
1956 Sir Herbert Read included his work in exhibition, "A Critic's Choice," at Arthur Tooth Gallery, London.
Exhibited at Catherine Viviano Gallery, New York.
1956-1957 "Guggenheim Prize Exhibition," Musée d'Art Moderne, Paris, and Guggenheim Museum, New York.
1957 Participated in Fourth International Art Exposition in Japan. Exhibited at Catherine Viviano Gallery, New York.
1956 Received Gregory Scholarship, Leeds University. (And through 1958 his broadcast lectures and talks are heard in London, Oxford, Leeds, Liverpool, and Nottingham).
1957 Participated in "New Trends in British Art" exhibition at Rome - New York Foundation gallery, Rome.
1958 Retrospective exhibitions held at Wakefield, Nottingham, London, Liverpool. Included in "A Critic's Choice" exhibition at Arthur Tooth Gallery, London, and "Fifty Years of Modern Art" at Brussels Universal Exposition. Exhibited in "Young Artists" show at twenty-ninth Venice Biennial. Included in International Exposition, Carnegie Institute, Pittsburgh, Pa. Became Professor of Art at London Central School (until 1960). Participated in "Documenta 115" exhibition, Kassel, Germany, and "Vitality of Art" at Palazzo Grassi, Venice.

1960 Included in "British Painting 1770-1960," exhibition in Moscow and Leningrad, and, for the third time, in "A Critic's Choice" at Arthur Tooth Gallery, London.
Showed at Gimpel Fils Gallery, London, and Ch. Lienhard gallery, Zurich.
1961-1963 Exhibited at Naviglio gallery, Milan; Carnegie Institute, Pittsburgh, Pa.; Galerie Rive Droite, Paris; Martha Jackson Gallery, New York; Gimpel Fils Gallery, London; Esther Robles Gallery, Los Angeles.
F.B.A. galleries, London; Stedlijk Museum, Amsterdam; Kunsternes Hus, Oslo; Kunsthalle, Baden-Baden; Kunsthalle, Berne; Kunstgewerbeverein, Pforsheim, Germany.
1963 Received prize for best foreign painter at São Paulo Seventh Biennial. Exhibited at Gimpel Fils Gallery, London; Brazilian Embassy, London; Medusa Gallery, Rome; "Vision and Color," Palazzo Grassi, Venice; S.S.A. Gallery, Edinburgh.
1964-1965 Represented at Tate Gallery, London, in Peggy Guggenheim Collection exhibition organized by the Arts Council.
1965 Exhibited at Martha Jackson Gallery, New York; Zwirner gallery, Cologne; Court gallery, Copenhagen; Blue gallery Stockholm; Galerie d'Aujourd'hui, Brussels; Gimpel Fils Gallery, London; Salon de Mai, Musée d'Art Moderne, Paris.
Retrospective exhibition of his work at the Graves Gallery, Sheffield.
1956-1966 Represented in traveling exhibition in Wales organized by the Arts Council.
1966 Retrospective exhibition at Usher Galleries, Lincoln. Showed at Gimpel Fils Gallery, London; Haken gallery, Oslo; Queen Gallery, Leeds; Edinburgh Festival; Castle Museum, Norwich; Rotterdamsche Kunstring, Rotterdam; Salon de Mai, Musée d'Art Moderne, Paris; "New Reality," Musée d'Art Moderne, Paris.
Received First Prize at first International Engraving Biennial, Cracow, Poland.
1967 Exhibited at Galerie de France, Paris; Gimpel-Hanover gallery, Zurich; Arts Club of Chicago; Salon de Mai, Paris; "New Reality," Paris; and Fondation Maeght, Saint-Paul-de-Vence.

vasarely

Vasarely
 with incorruptible precision
stills man's cry
 amethystine emotion
 starred with despair.

 Scriber-hearted
 he outlines
 in the controlled boundary
 of space
 the sublime prospect
 of a new spatial dynasty.

Vasarely
 master of charivari
 of shapes
 parades before the eye
 the moving figures
 of plastic unities
 geometrical morphologies
 warder of pure color.

Vasarely
 weaves the strands of an optical alphabet
 in wave-image
 energy-color constructions
 echo after echo resounding
 to infinity
 kinetics
 pure particles of that which is best
 in man
 projected
 beyond nature
 through the lens
 of his poetry
 the magic-lantern of his heart.

As a matter of fact, the true realization of what is inherent in "Abstraction" only came to me in 1947, when I understood that pure form and pure color together could express the whole world. Since then my graphic compositions have come about through the interaction uniting forms and colors in the "plastic space" which is their proper place.

If the function of yesterday's art was to feel and construct, today it might be termed "to conceive and make do." If, again, yesterday, the message of the canvas lay in the excellent quality of the materials used, perfection of technique and the master hand behind the work, it now lies in the knowledge we possess of the possibility of re-creating, multiplying and expanding. Thus the myth of the individual masterpiece will vanish with that of the skilled workman, and be replaced by work capable of general distribution with the help of the machine.

The future shapes up as a new geometrical, polychromatic, solar development. In it plastic art will be kinetic, multidimensional and completely communal—definitely abstract and related to the sciences.

My meditations have led me to posit a hypothesis: Proportional aggrandizement of any design springs from the increased speed-up of our every activity, visible in every sector of our existence. This speeding up of things has made us hasty and impatient. We are no longer given to long-drawn-out musing. We've lost interest in minute particulars. Looked at in another way, our technical proficiency has cost us our manual skills while endowing us at the same time with devices (such as the camera) affording us every detail of anything at a glance. We've complicated our lives, encumbered our existence, with all the innumerable gadgets of our civilization. We lose a great deal of time instead of gaining any. Our awareness grows faster and faster, we live for the immediate violent shock we receive. Large images, flat, fierce colors satisfy a new need of mankind.

We would like to put forward following definition: All creative theorizing originates in the straight line—both horizontal and vertical. Parallel lines forming a frame mark the boundaries of any area by cutting out a part of space. To enclose something in a square is both to create a new object and to impart new vigor to the art of the past. In the technique of the plastic

artist, henceforth to be considerably expanded, the plane is always the basis of the original idea. Small-sized work in pure composition is the point of departure for new creativity having multiple bi-dimensional functions (larger-sized work, frescoes, tapestries, print collections). But we are already coming up with a new orientation. The transparency will be to painting what the LP is to music—easy to handle, accurate, complex, in other words a document, a tool, a creative work in itself. It will aid in the transition from the fixed to the moving image. The screen is a plane but since it allows movement it is also space. Therefore there are not only two but four dimensions. The imaginary "Motion-Time" dimension of pure composition changes to actual motion in the new dimension of the screen, as demonstrated by the unifying power of that medium. The epoch of the "pure composition" in which we are living will inevitably lead to a branching off toward the mobile image.

I try to be part of my own times. Viewing the panoramic screen of the motion picture I do not regret the disappearance of the painted landscape. Pursuing the same line of thought I believe that the images granted us by the various scientific disciplines, microphotos, radiographs, oscillographs, sensitive plates, render all that sort of informal painting dealing principally with nature, and especially that on the scale of the infinitely negligible, practically superfluous. I believe that true creative work is not that which identifies itself with nature, but that which rejects it.

In the city of the future the "poetic function" will lean toward the construction of readily reproducible prefabricated structures that can be widely and easily distributed. We shall have more and more self-operating automatic objects. "Space-dynamism" aided by cybernetics will seek to combine all aspects of sound and movement in an entity that no doubt will develop into a sort of superspectacle. Kinetic plasticism will obtain its effects in "mobility" by shifting the focus of its viewfinder across public places and large mass movements of the population. In the end these cinematic developments in art will get us more art films, assuring the unquestionable preservation of the art forms of long ago while incorporating the new canons of shape-color, in motion, extending throughout the length and mechanism of the production.

Painting is now merely the means to an end for me. The goal to be reached lies in researching, defining and integrating the "plastic phenomenon" into everyday life.

Vasarely

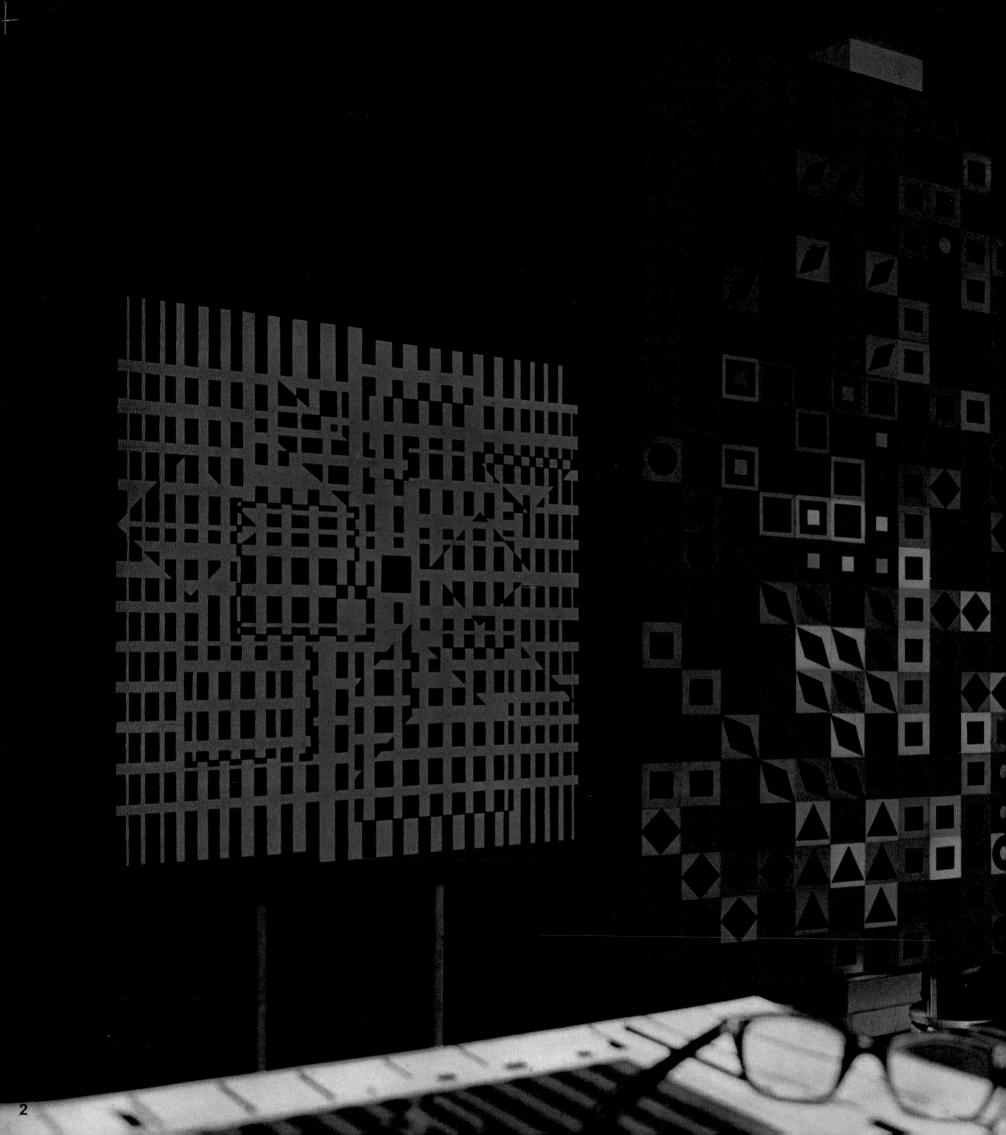

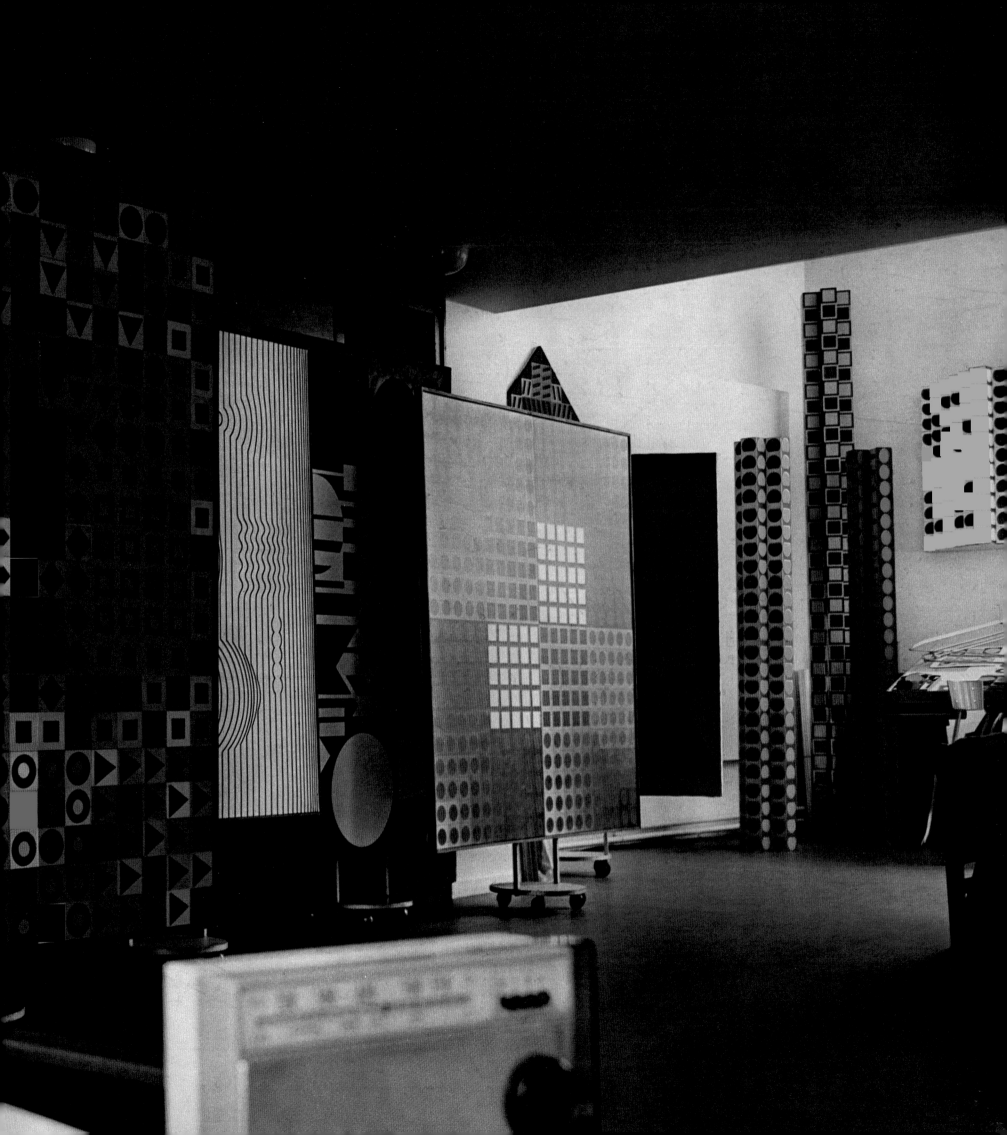

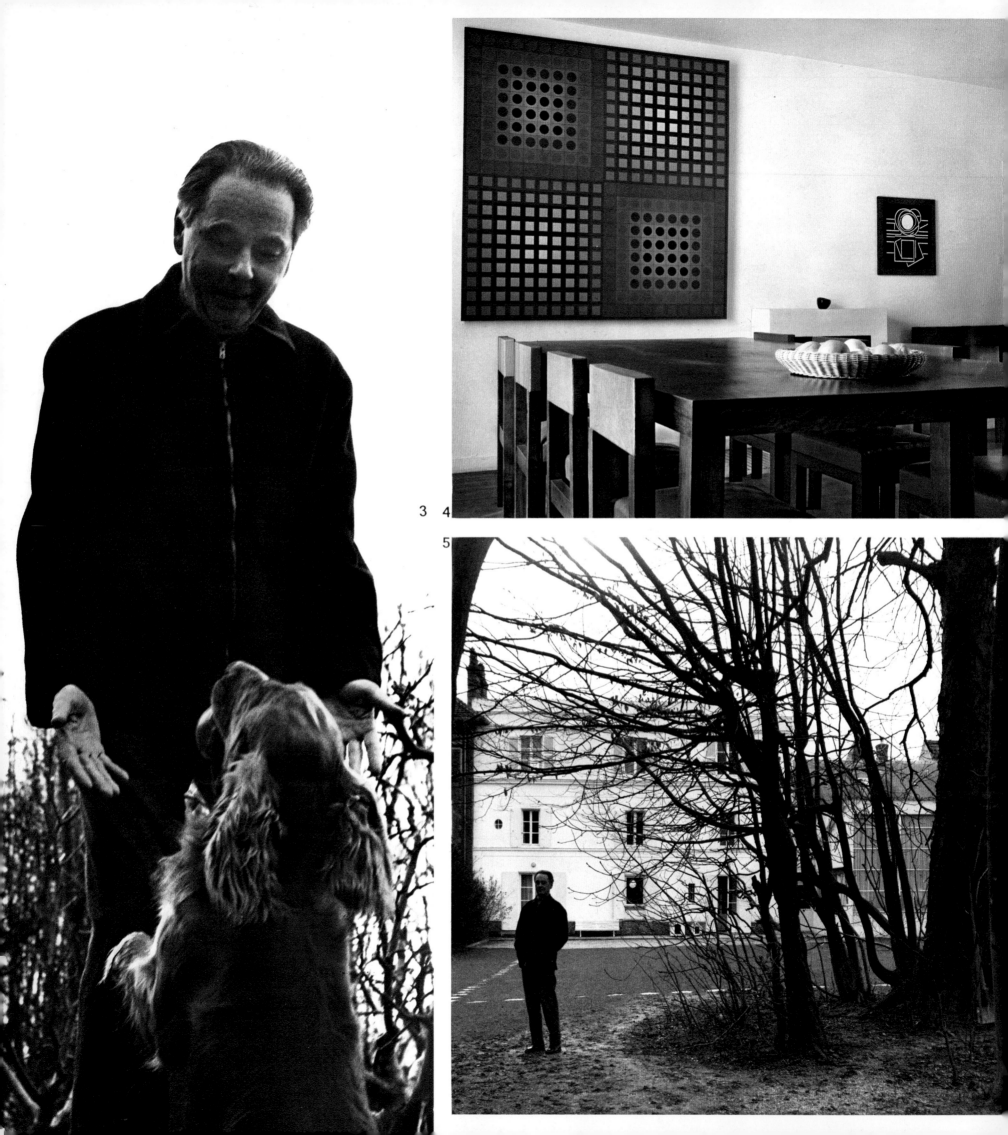

3 4

5

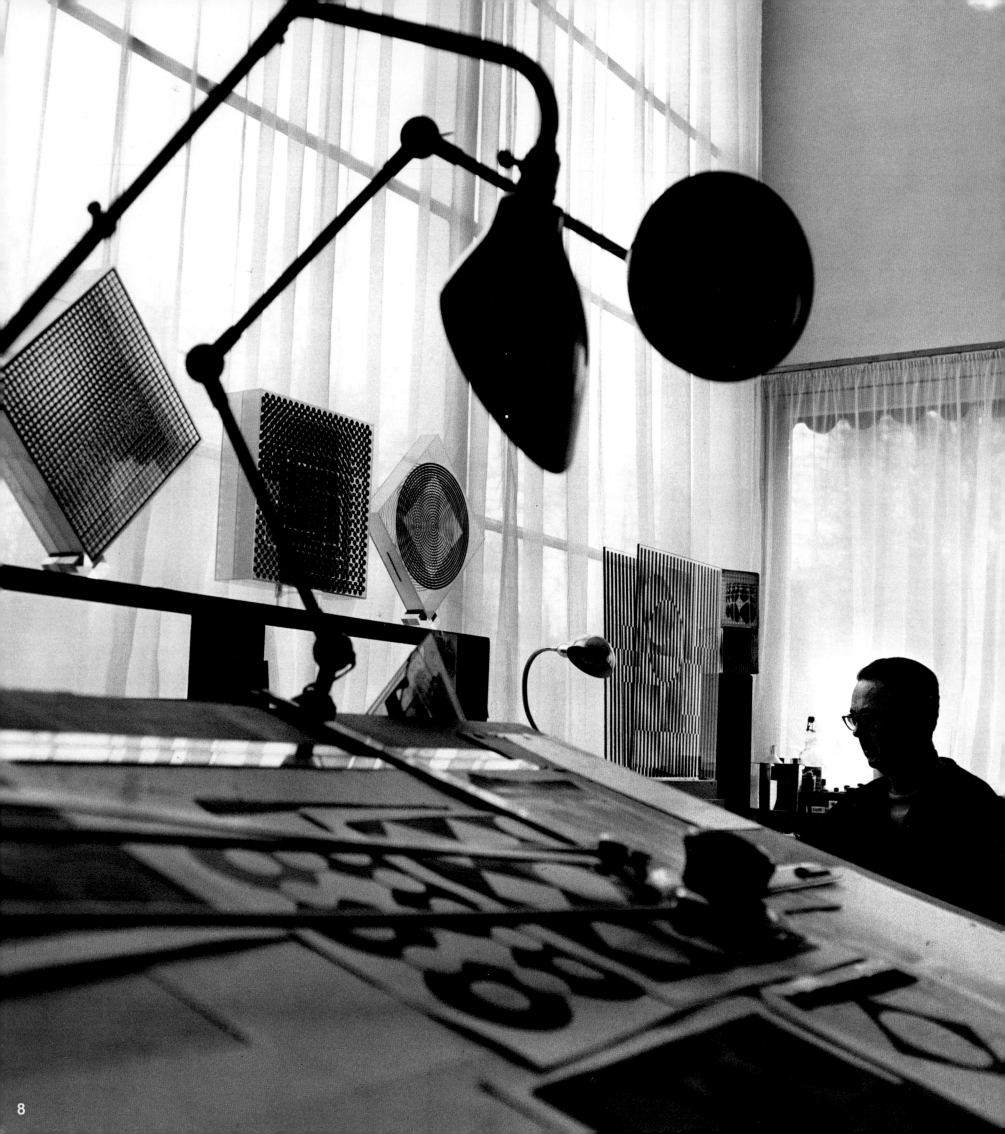

victor vasarely

1. "Poetry? It's always something else" : Vasarely.

2. Vasarely's studio, his "terrestrial" universe.

3. Time to play with his dog.

4. The dining room.

5. The park at the back of the house.

6. The billiard room.

7. Vasarely in the garden, seen through the structures of a miniature golf course.

8. In his laboratory, surrounded by sketches for his kinetic compositions.

1908 Born April 9 in Pecs, Hungary.

1925 Medical student at the University of Budapest.

1927 Abandoned study of medicine to enter Poldoni-Volkmann Academy.

1929 At Muhely Academy of Alexander Bortnyik (the "Bauhaus" of his town) he maintained a strict discipline in systematic graphic research.

1930 Exhibition of his drawings at Kovaes gallery, Budapest. Moved to Paris. Created advertising designs for Draeger, Havas, Devambez.

1933 One-man show at Ernst Museum, Budapest.
Moved to Arcueil. The sight of thin random cracks in tiling of railway stations suggested the motif for drawings, then of his large composition Denfert. For him it was a period of elaboration of prekinetic forms.

1943 Discovered painting and the uses of transparency in capturing and elaborating fugitive impressions.

1944 Became cofounder of Galerie Denise René, Paris, where he held his first one-man show.

1947 During summer at Belle-Isle, linear forms and structures of pebbles and shells fascinated him.
Exhibited at Paris Salon des Surindépendants (having definitely adopted geometric abstract art).

1948 Holiday at Gordes (where the play of clear southern light and shade led him to persevere in his study of geometric art).
Took part in abstract shows at Galerie Denise René, Salon de Mai, Salon des Réalités Nouvelles, and in Denmark.

1951 Experimented in photographic enlargement and film projection of small linear compositions (Photographism).

1952 Published monographs explaining his approach to art : Témoignages pour l'Art Abstrait and Que Pensent les Peintres ?
Studied architectonic movements (to be applied to university compound in Caracas, Venezuela).

1955 Researches on motion led him to start making a full-length 35-mm film.
One-man show at Palais des Beaux-Arts, Brussels.
Published Evolution on Rupture in Belgian magazine Aspect. Held exhibition, "Movement," at Galerie Denise René (the first of its kind), describing it in his Yellow Manifesto (kinetics) as "the coming of a new mobile and moving beauty."
Awarded Gold Medal at Milan Triennale and International Prize at Valencia, Venezuela.
This period marked his quest for movement in his work by use of superimpositions and transparencies.

1959 His "Aphorisms" published in catalogue of Der Spiegel Gallery, Cologne.

1961 Left Arcueil to settle at Annet, Marne. First big international exhibition on "movement" at Municipal Museum, Amsterdam.

1964 Awarded the Guggenheim grand prize for painting.

1965 Received first prize for engraving at Ljubljana, Yugoslavia, and first prize at São Paulo Biennial.

1967 Participated in "Light and Movement" exhibition at Musée Municipal d'Art Moderne, Paris.

I was landing on the island, attracted by the steepness of the rocks and their promise of solitude, when with eyes fringed with spray (was it dry land or ocean depths?) I saw a group of women. Naked, sun-bronzed, some of them were alive, moving. But the others, recumbent, were drawn, painted on large sheets of white paper, with as their sole reality a riot of color and zest for life.

Thus I discovered, in the Balearic Islands, Yvonne Mottet's studio. The models had recovered a biblical serenity. Sitting with her back to a rock, Yvonne Mottet, with bold strokes, was drawing their chaste womanliness, imparting to the colors her sensibility, the emotion of the artist.

And so the waves seemed to contribute the chosen blue, the sun baked the yellows to order, the red bloomed with passion; the whites were wrested from the sunlight, the greens picked nearby with fingertips, curved softly to outline ears, a mouth, a breast.

Both in her home by the sea in the Balearic Isles and in France in her Touraine studio, Yvonne Mottet's work has the same poetical inspiration. A painter of her times, she endeavors to reveal man to us; but her painting is above all a message of human kindness.

If I am to convey its content, I must describe the picture called L'Église de Saint-Denis-sur-Loire; all that is represented is the front of the church, with wide-open doors !

In a simple pictorial language with fresh luminous colors, perceptible in the purity of the whites, in the implied sadness in a patch of orange, there appears all a man hopes for, wishes for, dreams of at the instant when, looking at this picture, he mentally enters the church to kneel down there.

Such is the painter's power to speak without any description, to convey in color images (without classical, academic form) of all the emotions of man.

Purified, channeled, sung in the carnal virtues of painting, liberated to meet the need for spiritual communion, here is the beauty, the magic of a mastery acquired by unceasing practice in the service of acute intelligence and intuition.

Yvone Mottet, a member of the group "L'Homme Témoin" formed in postwar days, takes part in all international events to further "... an art that is not cut off from life."

Her friendship revealed to me that she had joined hands for life with the most turbulent of French painters : Bernard Lorjou.

United for an ideal, "to paint man in his world, with his joys, his suffering, his pride, his reactions, his feelings," with their passion for painting, their unflagging energy, admitting of no concession, they have produced work that is as yet little known. Comparing their studies of form, quest for colors, resetting solved problems, each of them seeking their truth, each nevertheless retains a distinct personality. Lorjou, with violent high-colored brushwork, draws figures in full-brush painting born of a Gargantuan imagination.

Yvonne Mottet paints living reality, as a frank disclosure, as an expression of wonder at having lived another day. Every morning she is up, facing her easel.

The languid Loire uncoils its tresses below the windows of the studio. In the distance, emerging from the haze, all the green shades of the forest surrounding the Château of Chambord fix the luminous blues of sky and water. Yvonne Mottet takes up a brush and draws, to perfection, the face of the woman-child posing there, naked, as if arisen from the river.

The world of the painter is a world created anew.
Beginning with the simplest things,
even the most trivial things,
sometimes the most unwanted things,
the progress made
in the painter's mind,
in his eye,
then his hand,
is mysterious,
inexplicable.

Most treatises on painting
merely touch on the subject,
explain nothing;
they serve no purpose
unless it is to cloud
the issue further.

Painting asks to be loved and to be deeply felt rather than to be understood.

Each canvas is a world apart,
both for the painter
and for the onlooker.

The world of forms is not the same
as the world of color,
nevertheless form and color
modify one another,
and only in their harmonization
does an artist's work
succeed.

It is not true that drawing sustains color;

At its maximum intensity color has no drawing.

Drawing can be color.
Color is always drawing.

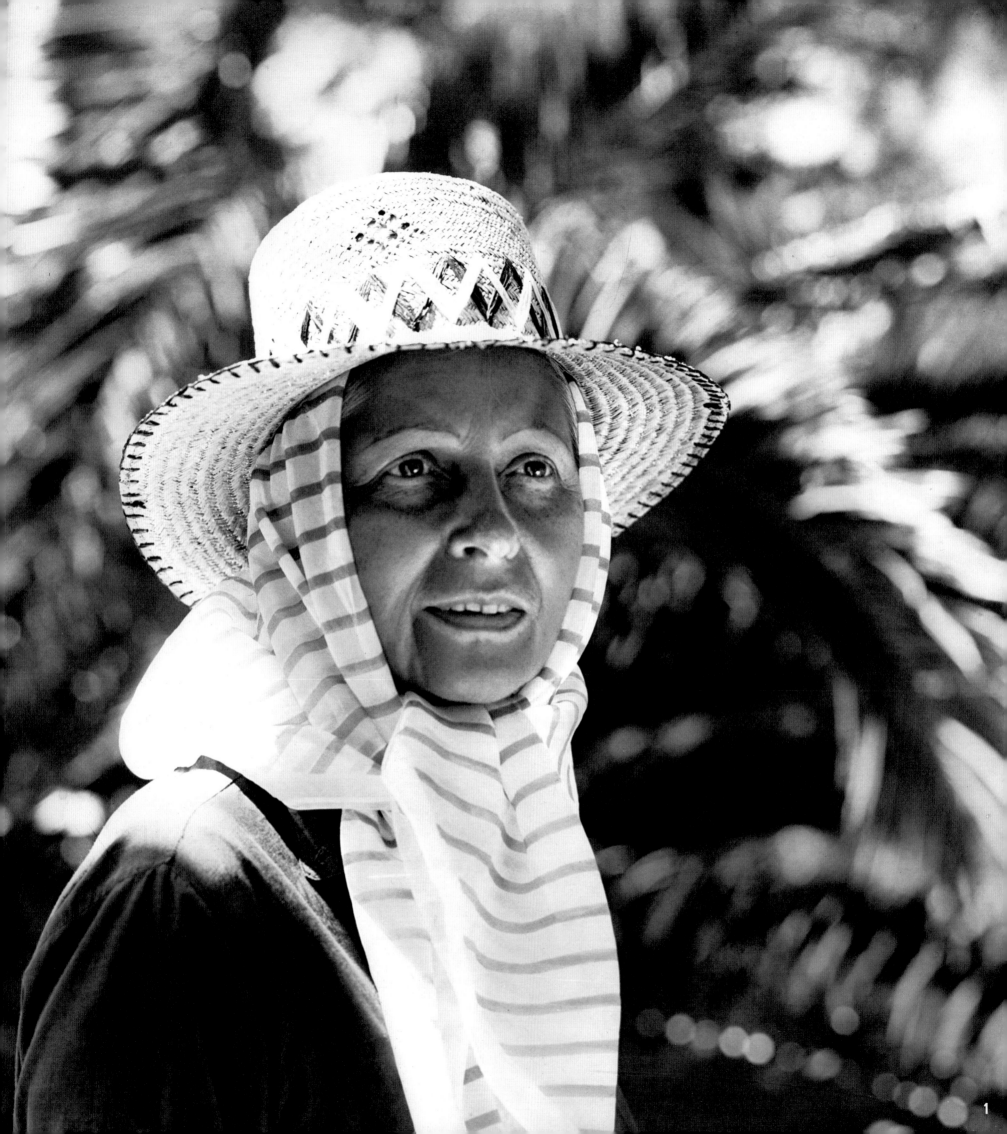

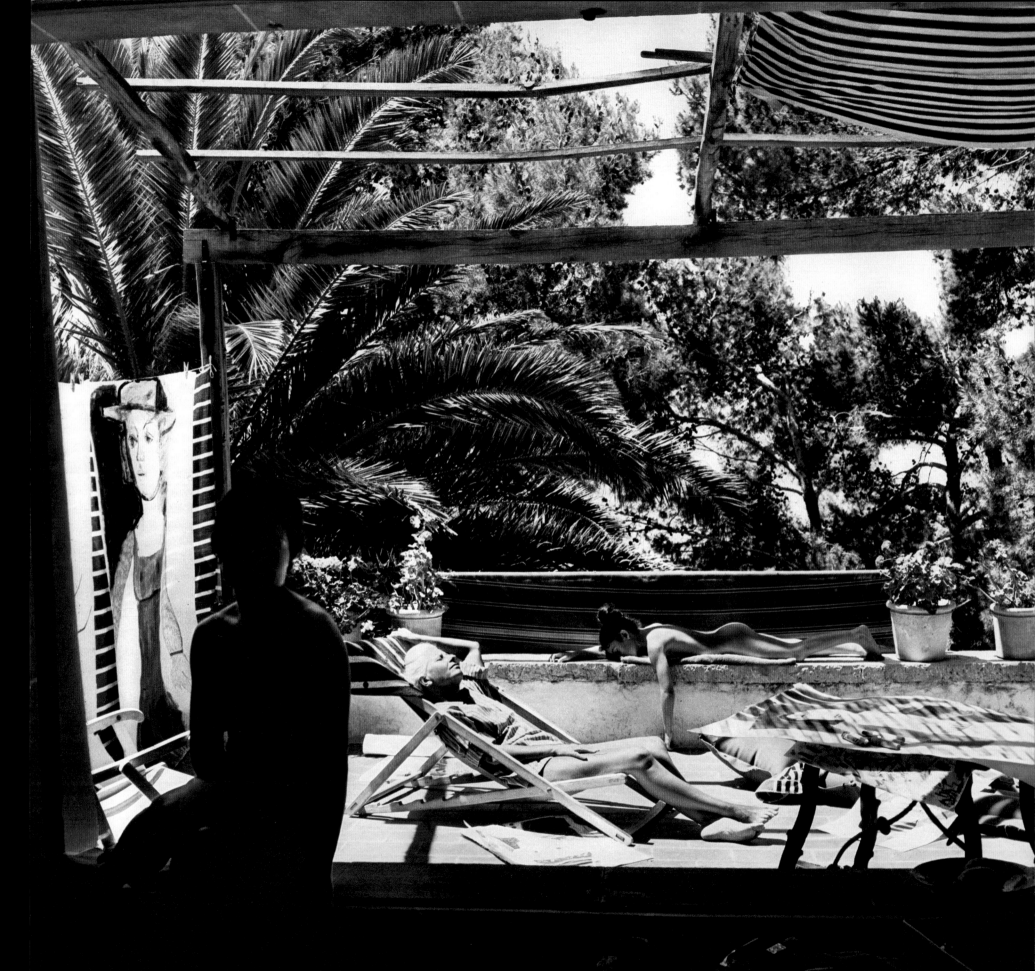

3

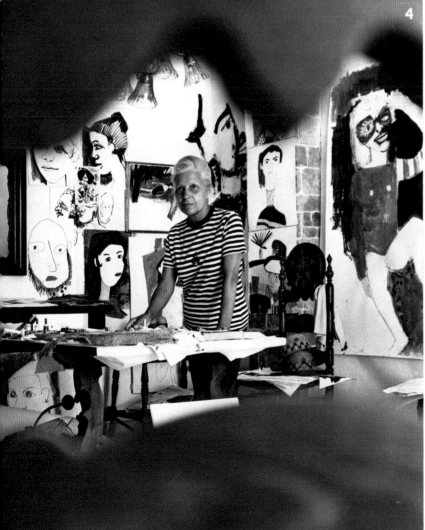

4

5

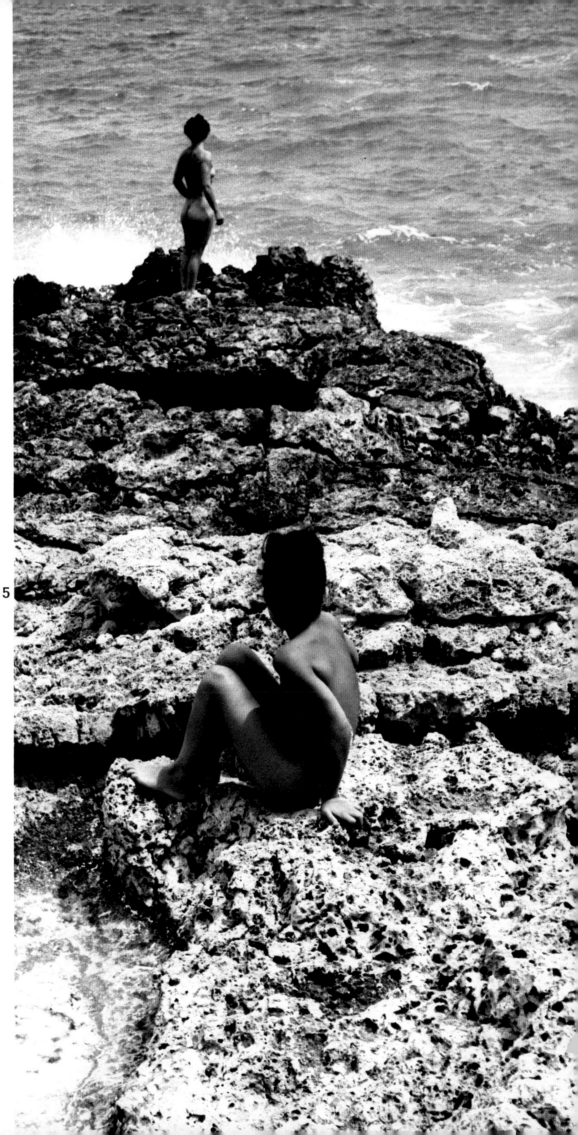

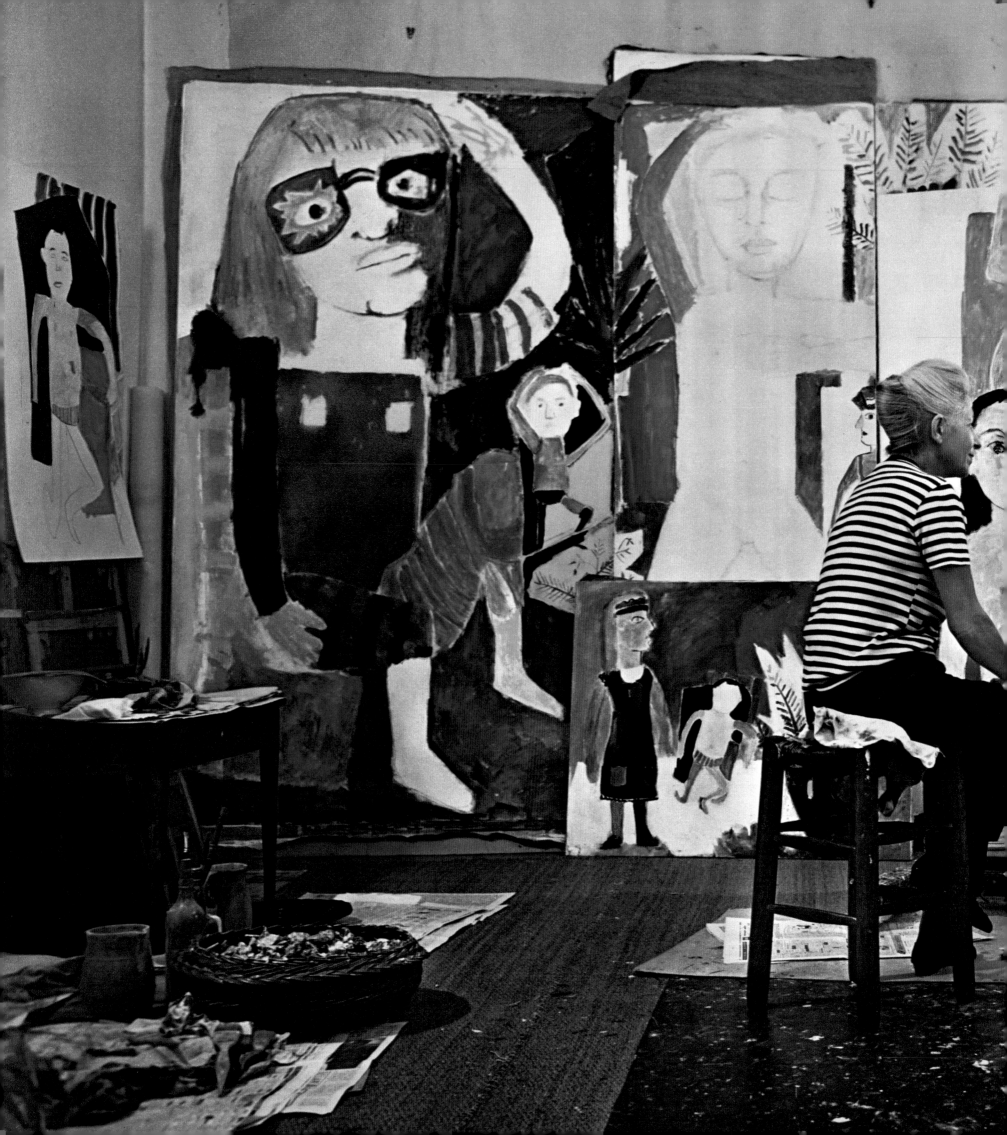

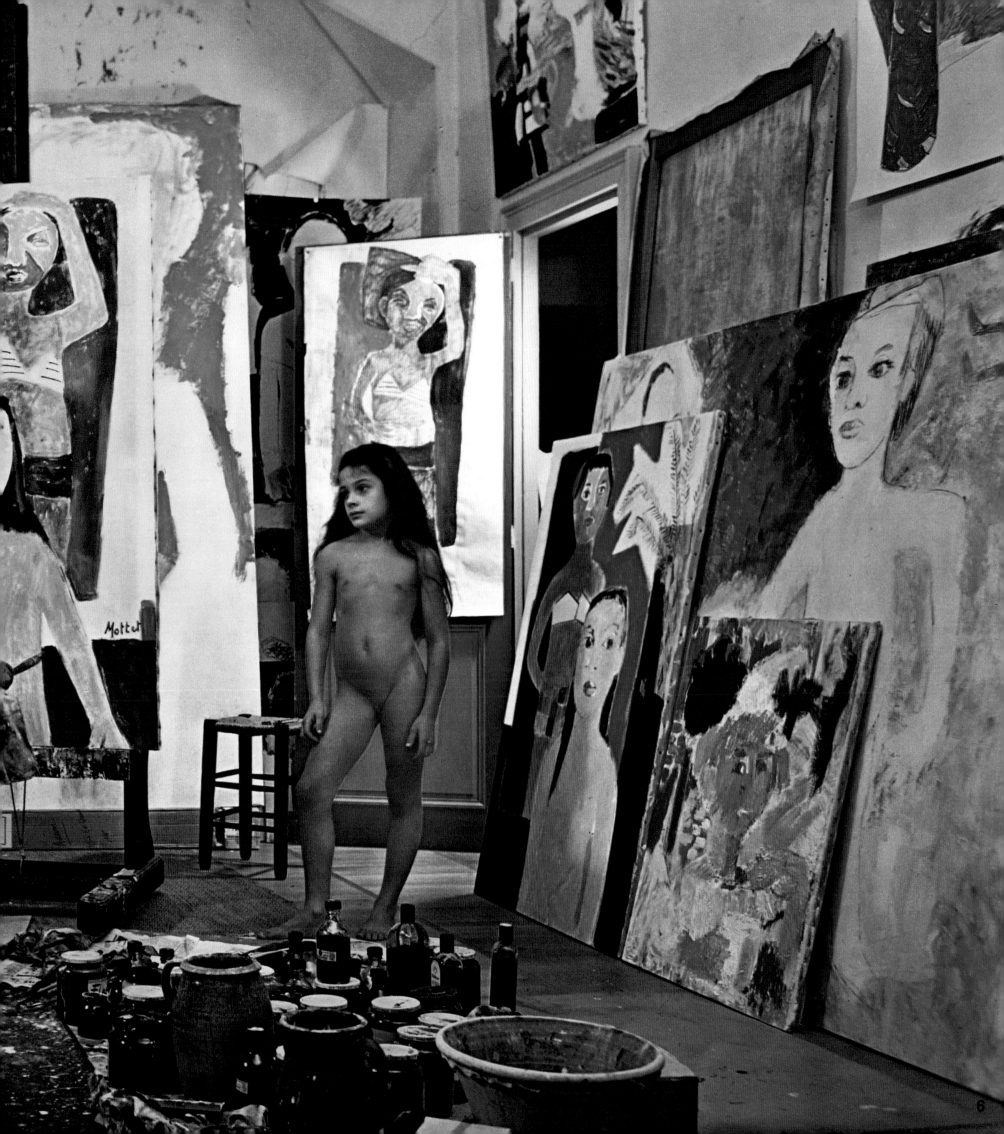

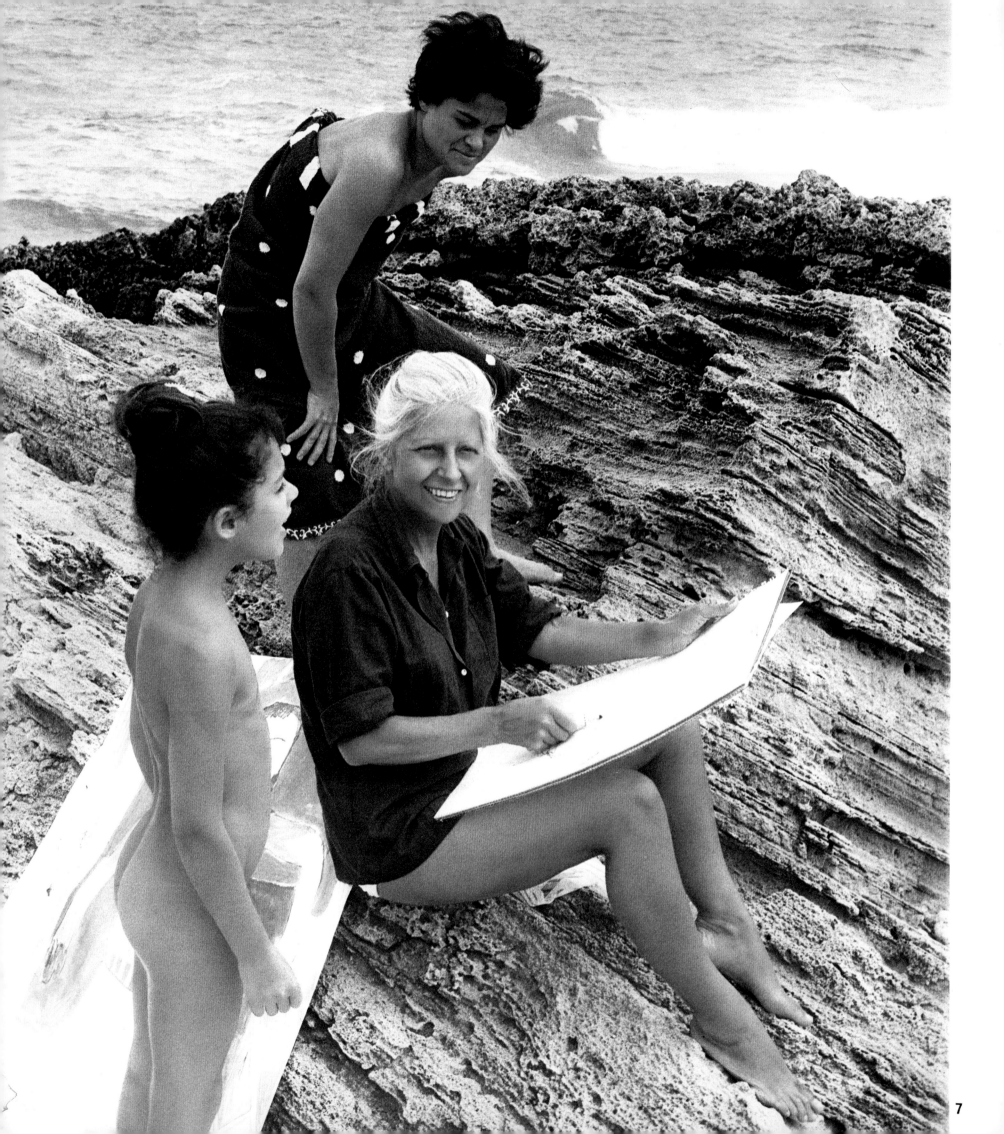

yvonne mottet

1. Heedful of every color.

2. As they all nap in the sun, the figure in the sketch seems suddenly alive to her own reality.

3-4-5. With the help of the painter's eye and hand, a girl of Majorca, translated by the artist's mind, is presented with. . .

6. . . . a new self.

7. Drawing can be a shared pleasure.

1906	*Born at Lyons, France.*
1953	*Awarded Prix de la Critique.*
	Major Works:
1946	Les Baigneuses, *Fujiyama collection, Japan.*
1947	L'Arbre Rouge, *Wildenstein Collection, New York.*
1949	La Fille d'Amsterdam.
1950	La Plumeuse de Poulet.
1952	Nature Morte à l'Olympia, *Collection Pagezy, Paris.*
1953	Séries : Nus aux Fauteuils.
1957	La Femme au Pigeon.
1958	*Curtain for symphony by the Concert Lamoureux at the Théâtre des Champs-Élysées,* Le Roman de Renard.
1959	La Polonaise *(shown at Galerie Wildenstein, Paris).*
1962	Les Opprimés.
1964	La Malaguena.
1965-1967	*Series of canvases painted at Pollensa, Majorca.* Femmes au Rocking-chair, Les Enfants, Cactus-bar.
1967-1968	*Series of twenty canvases:* Orphée et Eurydice.

césar

Pablo Gargarello (1881-1934) was probably the father of metal sculpture. His strikingly rhythmical forged sculptures were really skeletons of invented forms. Mass became implicit in his creative ironwork as he substituted concave surfaces for convex areas and opposed fretwork and pierced metalwork with powerful reliefs. Then in 1927 Barcelona-born Julio Gonzalez (1876-1942) also began working with iron. Use of the blowtorch enabled him to achieve greater malleability with the metal, and oxyacetylene welding made it possible for him to unite previously unconnectible scraps. In doing this Gonzalez created something entirely new, designedly abstract but based on natural forms including the space in the composition. He was the first to assemble junk metal into finished sculpture, restoring to iron its noble power of communication. Picasso, a friend of Gonzalez, then proceeded to borrow the blowtorch to join together whatever metal scraps his poetic imagination caused him to salvage or scavenge from the world around him. Everyday utensils, waste metal, refuse, all were welded together in a combination of effects in which humor, technical skill, and audacity played a part. Lowly components were given a new appearance, a new identity in sculpture that proved gay, original, amusing, erotic, and, sometimes, divine.

Heir to the research and accomplishments of his predecessors, César Baldiccini—known simply as César to the art world—was led by the very conditions of his existence to revise the shapes and forms of metal sculpture and to bring his own personal contribution to the new body of contemporary art by carrying it out in the free spirit of his genius.

Clad in leather,
César lifts his welder's mask
and his mustache pops out.
His Punch and Judy eyes are yet another masking;
by turns insolent, jolly.
A bright mask of humor over a black mask of anxiety—
That is César... unmasked.
He found a gold mine
where others saw nothing but junk.
Grooved metal, strips, coils, bolts, pipes, rivets, rods,
wrecked cars in scattered bits and pieces, dead engines,
heaps of scrap iron, cold sharp metal,
rise Phœnixlike from César's hands.
Metal fragments take on new forms, new surfaces
in the blue flame of his welder's torch.
Trapping his material with his bare hands, César sets free
a seared welded bestiary
of scorpions, bats, and bugs.
He makes busts, colossal nudes,
breathes life into armor plate,
and, with quivering metal strips,
he patterns out an Orpheus,
or, discovering a pair of wings,
equips a metal Nike.

Each new piece of sculpture that César embarks upon poses a problem that can be solved only during the course of the welding. Gradually, as any work proceeds, its nature may change completely; a bug may become a fish, or a fish an owl, according to the kind of metal he holds in his hands or the difficulty he encounters while using it.

"All the configurations I am capable of are distorted, willy-nilly, by the compulsion of their qualities," César says "Everything tends to fall into place according to the viable relationships among the several parts of the work and the specific nature or application of the metal. A production can always become something else. You could keep starting all over again indefinitely."

The fertility of César's imagination springs from the time he spent in the chaos of factories and workshops, where his observant eye helped him calculate the power and potential shapes that lay dormant in the gigantic machinery with which he worked.

"Abstract or figurative?" he asks. "There is really no need to put the question, is there?" César knows how to recognize the validity of a work of art. Sculpture is right, he says, when "it lives in its substance, its content, its own part of space."

1960 : Salon de Mai, Paris : César shows three motorcars crushed and compressed into cubes; solid blocks of steel weighing a ton each— flat but upright ! The squeezed metal, which he hasn't touched himself, he has coldly recognized as "fine art." He has chosen it and made it his own.

1966 : Galerie Claude Bernard : César shows an enormous molding of his own thumb which, by being cast in red plastic, has assumed the provocative attraction of a totem.

1967 : Salon de Mai, Paris : This time he exhibits an "informal reality" created from the coagulation of a resinous synthetic, polyurethane. It has achieved a balloonlike expansion reaching some sixteen feet in diameter, like unchecked foam, or a yellow whale.

Thus César proves that he is not content with merely furthering the permanance of the art in which Rodin, Maillol, and Germaine Richter excelled, but that he intends to reform the quality of the material universe by allowing his hand to alter matter, command the chemistry and inventions of our times, and by the vitality of his poetry expand man's position in the world.

J'aurai bien voulu
vous faire un beau texte sur
la sculpture mais je n'ai jamais
su qu'en dire je la fais c'est tout.
Pour moi c'est instructif c'est
un peu comme aller à la pêche
Il y a ceux qui savent prendre
le poisson et ceux pour qui ça ne
mord pas
Je n'ai pas les moyens de faire de
la litterature n'étant ayant pas eu
la formation

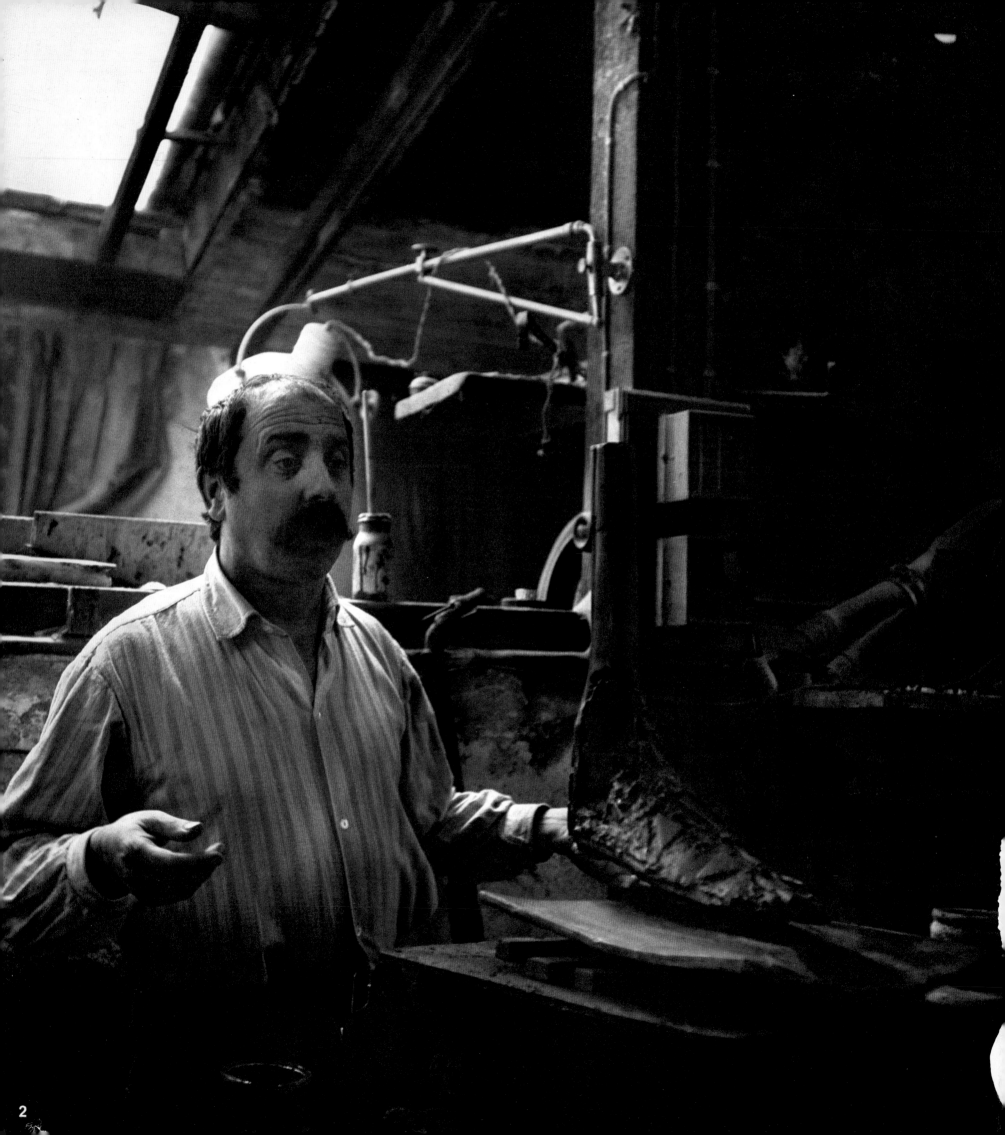

2

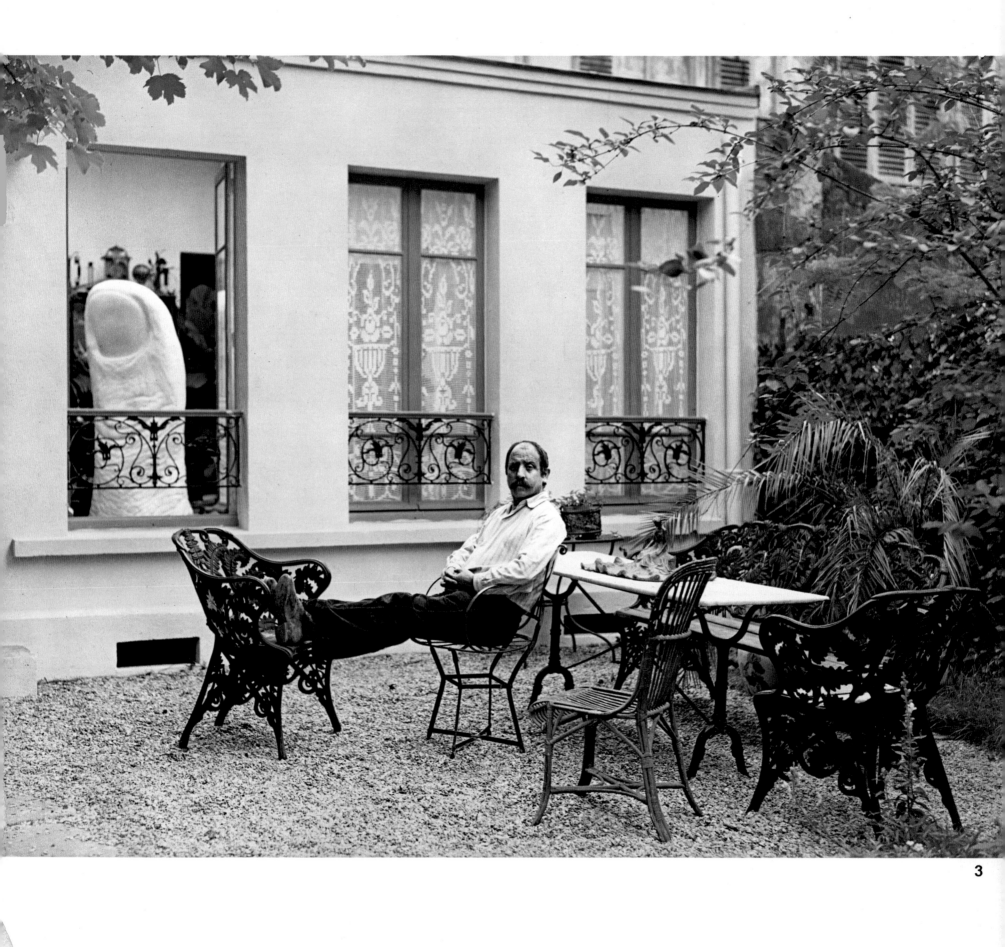

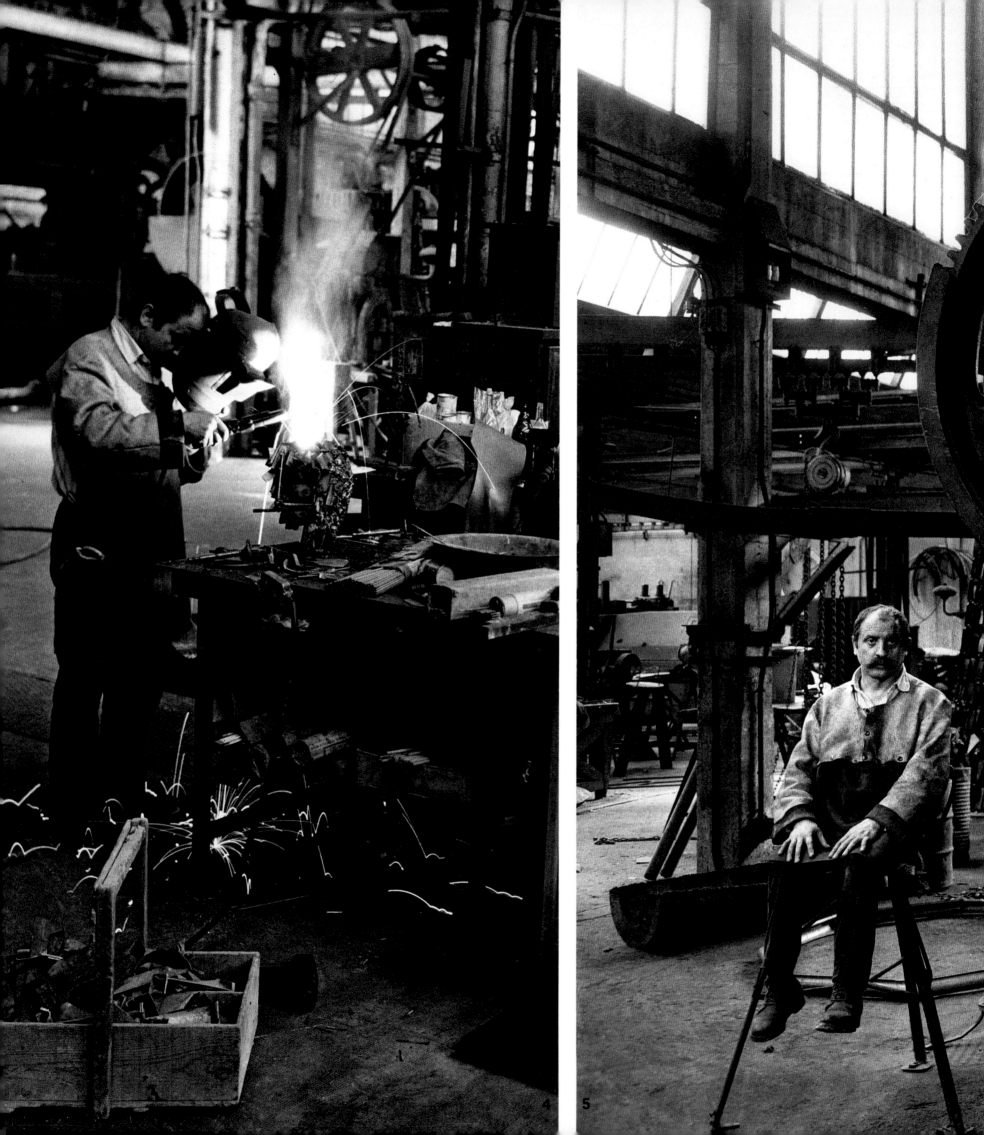

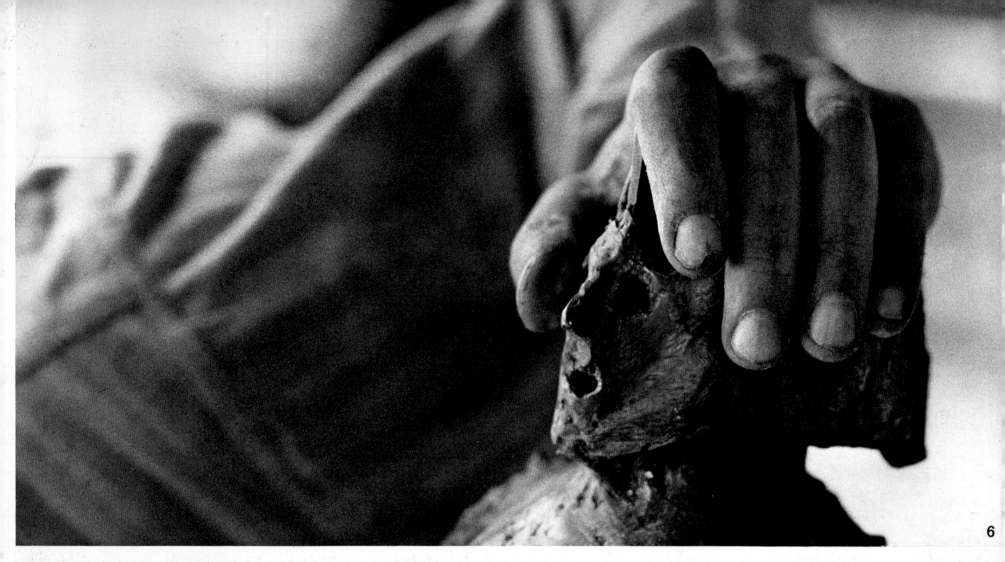

6

7 8

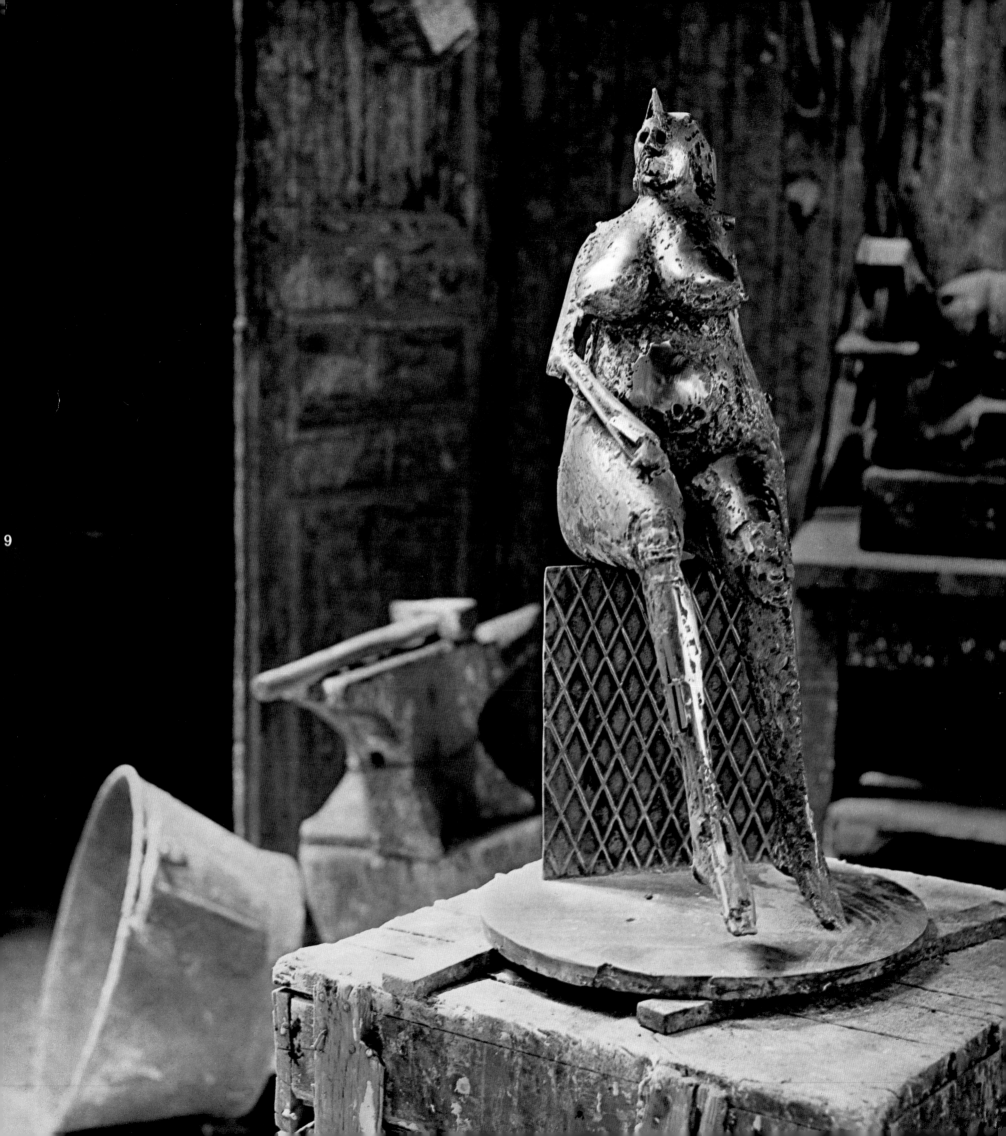

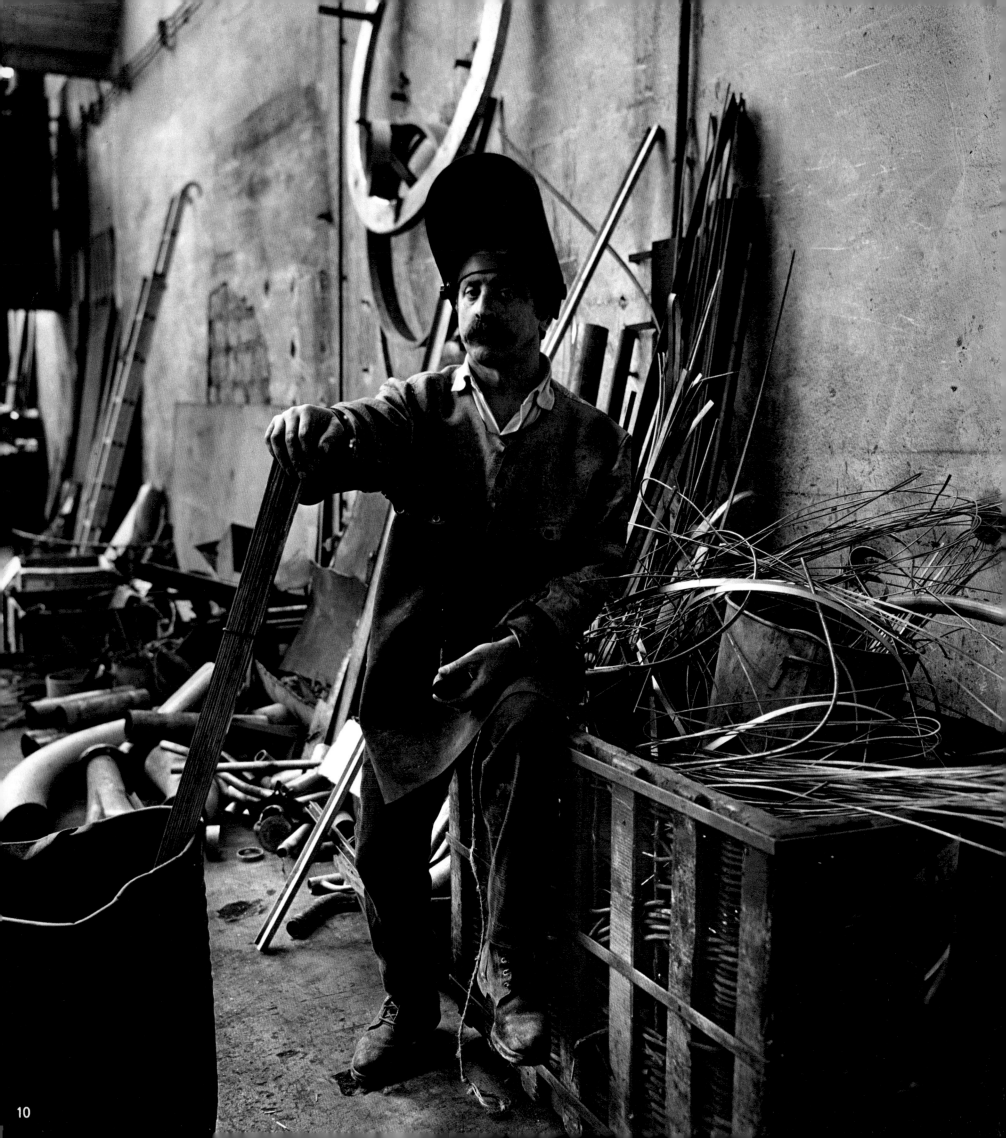

césar

1. Cleaving the darkness, through radiant smoke...

2. ... man and the work, happy, together.

3. *Le Pouce* (1966) is visible inside the house while the sculptor relaxes outdoors.

4. Welding : César unleashes the tempest with which he creates his forms.

5. The man and an enormous machine that has the beauty of a sculpture in the studio-tool shop.

6-7-8. The sculptor polishing a bronze.

9. *Nu.*

10. Hail César !

(Page 360)
I would very much like to write about sculpture, but I have never known just what to say about it. I do it, that's all. It's instinctive with me, somewhat like going fishing. There are people who can catch fish and people for whom fish never bite. I don't have the ability to create literature, never having had the training. Besides I think art should speak for itself.
César

1921 Born January 1 in Marseilles.

1935-1939 At École des Beaux-Arts, Marseilles.

1943 Student at École des Beaux-Arts, Paris.

1954 One-man show at Galerie Durand, Paris.

1955 One-man show at Galerie Rive Droite, Paris.
Exhibited at Salon de Mai, Paris.

1956 Contributed to Venice Biennial.
One-man show at Galerie Rive Droite, Paris.

1957 Exhibited at São Paulo and Carrara Biennials. Italy (foreigners' first prize). Showed in two international exhibitions : Bronzetto, Padua ; and (sculpture alone) Galerie Claude Bernard, Paris. Two one-man shows : at Galerie Creuzevault, Paris ; and Hanover Gallery, London.

1958 Participated in Salon de Mai, Paris, and the Biennial, Antwerp.
Awarded Silver Medal at Brussels International Exposition. Showed at International Sculpture Exposition, Galerie Claude Bernard, Paris.
Received Third Prize at Carnegie Institute, Pittsburgh.

1959 One-man show, Galerie Claude Bernard. Represented in "Vitality in Art" exhibition, Padua; International Sculpture Exposition, Galerie Claude Bernard, Paris; "Documents II," Kassel; "New Images of Man," Museum of Modern Art, New York.

1959-1960 Represented in "European Art Today, 35 Sculptors and Painters" (traveling exhibition organized by Minneapolis Institute of Art).

1960 Showed in Rotterdamsche Kunstring, Rotterdam ; "One Hundred Sculptors, from Daumier to Our Times." Musée de Saint-Étienne ; "Contemporary Sculpture" at Cantini Museum, Marseilles ; Avant-garde Festival, American Pavilion, Porte de Versailles, Paris ; "Little Masked Ball," Galerie Les Mages, Vence ; Salon de Mai, Paris. One-man show, Hanover Gallery, London.

1961 One-man show, Saidenburg Gallery, New York.
Represented in "Mechanism and Organ-ism," New School Art Center, New York ; "Gems from 1890 to 1961," Victoria and Albert Museum, London.

1962 Represented in "The Object," Musée des Arts Décoratifs, Paris ; World Exposition, Seattle ; "Reliefs," Galerie du Vingtième Siècle, Paris ; "International Sculpture Show," Toninelli gallery, Milan.
One-man show of drawings, Apollinaire gallery, Milan.

1963 Exhibition : "Three Sculptors : César, Roel d'Haese, Ipousteguy," Galerie Claude Bernard, Paris.

1964 Participated in "Exhibition of Sculpture, "Royaumont Abbey, France; "Figuration and Disfiguration," Ghent ; "Document III," Kassel, Germany ; "Ten Years of Painting and Sculpture," Tate Gallery, London.

1965 Represented in Biennial, São Paulo (drawings); "Oden-air Sculpture, "Keukenhof Park, Zeist, Holland ; Biennial, Tokyo ; "Object Sculpture and Painting," Galerie Creuzevault, Paris. "Contemporary Graphic Art in France" (traveling show in Germany). "Games, Sports, Youth" exhibition, Musée Rodin, Paris ; Palais de la Méditerranée Nice ; "Group 1965," Musée d'Art Moderne, Paris. Exhibition : "César, Roel d'Haese, Tinguely," Musée des Arts Décoratifs, Paris.

1966 One-man shows at Stedelijk Museum, Amsterdam ; Galatea gallery, Turin ; Galerie Madoura, Cannes ; Wilhem Lehmbruck Museum, Duisburg. Represented : Salon de Mai, Paris ; "Climate 66," Grenoble Museum ; "Sonsbeek 66," Gemeentemuseum of Arnheim, Holland.
Exhibition of drawings at the Cultural Center of Zonnehof, Amersfoort, Holland.

1967 Retrospective exhibition, São Paulo Biennial.
Exhibited in Salon de Mai, Paris ; Musée de Grenoble, "Expo" (International Exposition), Montreal ; Carnegie International Exhibition, Pittsburgh ; Guggenheim Museum, New York ; Darmstadt Museum, Germany.

To reveal *The Artist's World* as I found it, I brought to Draeger Brothers
in Paris photographs, articles, thoughts, ideas for the book to be.
It was René Toutain, the art director,
who managed to convey his unfailing enthusiasm
to the technical personnel in Draeger's
many workshops, so that the staff's masterly knowledge
could bring this book, with its superlative reproductions, to the light of day.
Nor must I overlook the artists, the creators themselves, without
whom the volume would never have come into existence; or BERNARD, YVONNE,
and Simone, my wife, who contributed their hearts and friendship. My respectful
gratitude to all concerned for their total commitment.

In particular I wish to thank :

Mesdames ARP and GIACOMETTI
Mademoiselle CLAISSE
Messieurs C. LAURENS - M. GÉRARD - M.-A. LOUTTRE - D. SYLVESTER
 P. GIMPEL - J. DUPIN - J.-F. JAEGER - M. GARNIER - DAVID

THE TEXT AND PHOTOGRAPHS
IN THIS VOLUME, ASSEMBLED BY DANIEL FRASNAY,
WERE PRINTED IN MAY 1969
ON THE PRESSES OF DRAEGER BROTHERS IN PARIS

D.L. 1969-1 - I. 5618 - E. 5001

ARP | BRAQUE | S. DELAUNAY | MAGNELL

HERBIN | HARTUNG | DALI | TOBEY | BISSIÈ

GIACOMETTI | PIGNON | DE KOONING |

NIVELSON | BACON | APPEL | BUFFET | MA